M000267178

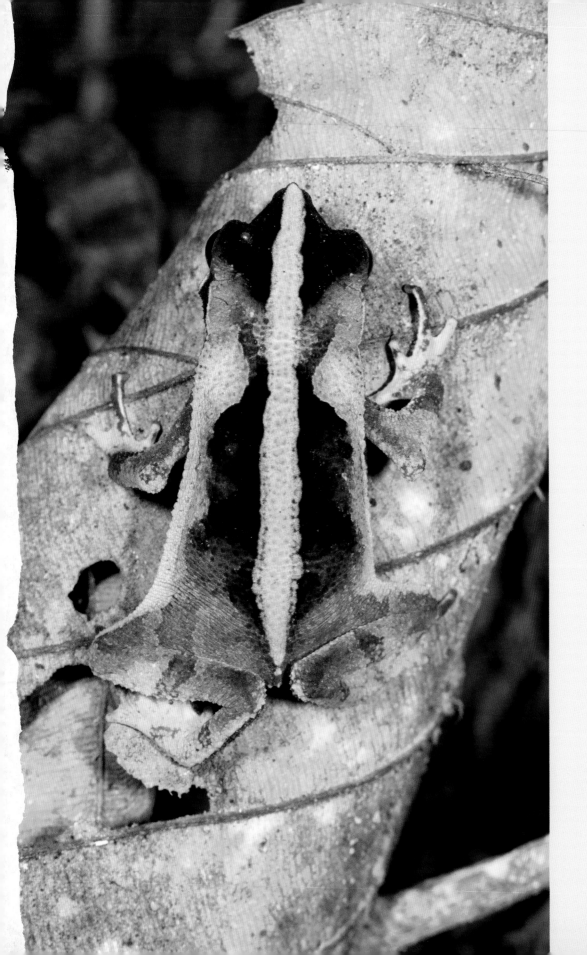

CAMOUFLAGE

NATURE'S
MASTERS OF
DISGUISE

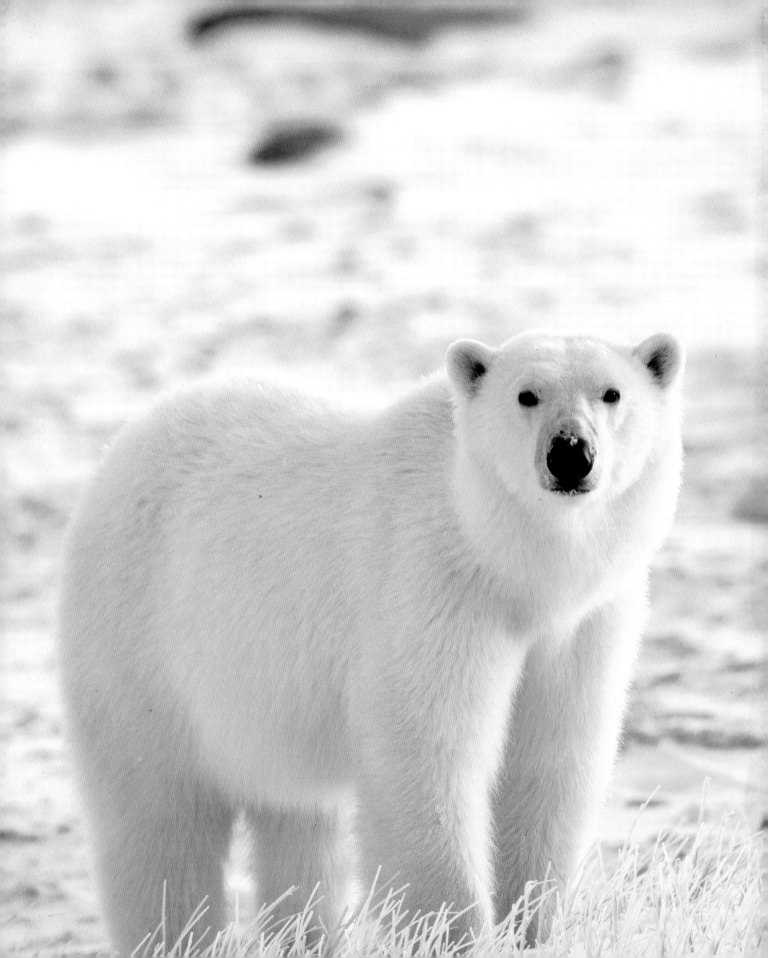

CAMOUFLAGE

STEVE PARKER

IVY PRESS

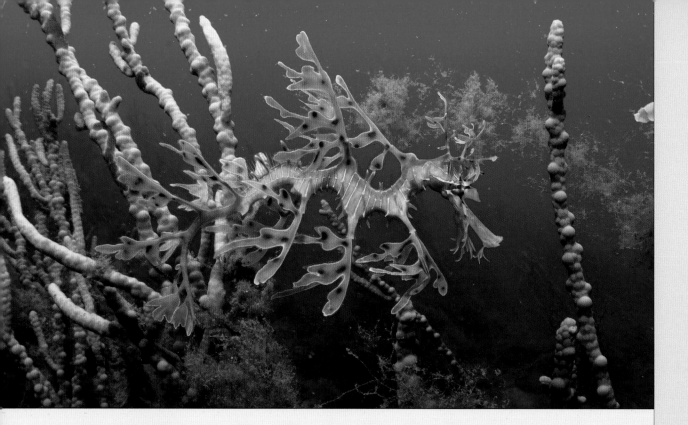

Inspiring | Educating | Creating | Entertaining

Brimming with creative inspiration, how-to projects, and useful information to enrich your everyday life, Quarto Knows is a favourite destination for those pursuing their interests and passions. Visit our site and dig deeper with our books into your area of interest: Quarto Creates, Quarto Cooks, Quarto Homes, Quarto Lives, Quarto Drives, Quarto Explores, Quarto Gifts, or Quarto Kids.

First published in the UK in 2021 by
Ivy Press
An imprint of The Quarto Group
The Old Brewery, 6 Blundell Street
London N7 9BH, United Kingdom
T (0)20 7700 6700
www.QuartoKnows.com

Copyright © 2021 Quarto Publishing plc

All rights reserved. No part of this book may be reproduced or transmitted in any form by any means, electronic or mechanical, including photocopying, recording or by any information storage-and-retrieval system, without written permission from the copyright holder.

British Library Cataloguing-in-Publication Data
A catalogue record for this book is available from the British Library.

ISBN: 978-0-7112-6023-8
E-book ISBN: 978-0-7112-6024-5

Printed in Singapore
10 9 8 7 6 5 4 3 2 1

Captions: (Page 1) South American common toad (*Rhinella margaritifera*), (pages 2–3) Polar bear (*Ursus maritimus*), (page 4) Leafy seadragon (*Phycodurus eques*).

FSC
www.fsc.org

MIX
Paper from
responsible sources
FSC™ C007207

Contents

Introduction

In the natural world an old leaf, brown and withered, is hardly a unique or valuable item. There are billions in almost every habitat. Apart from their appeal to tiny bugs, moulds and microbes, they have little nutrient value and are ignored even by herbivorous (plant-eating) creatures. However, the 'leaf' may actually be a camouflaged butterfly or leaf insect, or perhaps a frog, bird or mouse. Other hugely common and insignificant environmental items have similar camouflage value, such as green leaves, twigs, pebbles, flowers, moulds, rocks, moss – and excrement.

Camouflage is basically about avoiding detection and staying unnoticed, even while out in the open – hiding in plain view – by merging into or blending with the surroundings. There are various types of camouflage, often linked to the closely associated term of crypsis. However, crypsis usually has a wider definition that includes all forms of evading discovery, such as hiding in a thicket or burrow, or climbing into the treetops.

Camouflage is widespread in the natural world. So, this book takes a broadly geographic approach, with chapters looking at examples from various continents and regions around the globe, including seas and oceans. Within each chapter, creatures are organized following the standard zoological system of classification: invertebrates, fish, amphibians, reptiles, birds and mammals. Some of the photographs pose the familiar camouflaging question 'Where's the animal?', while others reveal and explain particular aspects of appearance and biology.

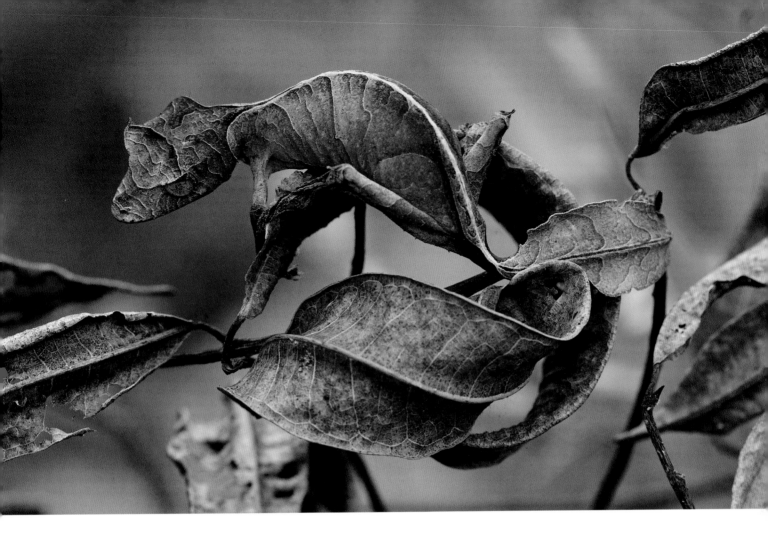

The satanic leaf-tailed gecko is a prime example of visual background matching. However, the illusion only works if the lizard remains still or sways in a breeze, exactly like the leaves around. Movement draws attention from predators such as birds.

CAMOUFLAGE AND THE SENSES

Humans are primarily visual. Compared to most creatures, our eyes see many colours and details. So, we think of camouflage in visual terms. But sight is of little use in habitats such as the deep sea, inside caves, in forests at night, or in the earth. Vast numbers of animals sense the world very differently to us. Some have olfaction (smell) as their main sense, others have hearing or detecting movements and vibrations. Camouflage can work here too. Some moths have sound-absorbing hairy bodies and wing surfaces that disrupt the ultrasonic clicks used by bats to detect prey. Certain caterpillars, fish like the harlequin filefish (see pages 230–231) and a few snakes emit chemical odours gained from their surroundings or their food, so they cannot be sniffed out by predators. Cave crickets, deep-sea fish and burrowing reptiles are able to modify their movements, and the vibrations these send out, again to avoid detection by enemies.

COMMON FORMS OF CAMOUFLAGE

Perhaps the most familiar type of camouflage is visual background matching, also called cryptic or concealing coloration. An animal looks like something common, uninteresting and of little worth in its environment, such as a dead leaf or pebble. However, a hungry hunter would soon notice if a dead-leaf toad (see pages 50–51) spent much of its time hopping, or a green vine snake (see pages 56–57) regularly slithered around, or a stick insect (see pages 172–173) did not sway in the breeze like the twigs around it. This illustrates the importance of behaviour and movement as well as appearance in visual camouflage.

IUCN CONSERVATION STATUS

The Conservation Status included in the information panel for each animal is taken from the International Union for the Conservation of Nature (IUCN) Red List of Threatened Species.

- **NOT EVALUATED, DATA DEFICIENT** – no suitable, or not enough, information to assess.

- **LEAST CONCERN (ALSO LOWER RISK)** – 'doing alright', unlikely to be at risk in the near future.

- **NEAR THREATENED** – increasing threat levels, possible extinction in the medium-near future.

- **VULNERABLE** – at risk of extinction soon, human support required.

- **ENDANGERED** – high risk of extinction, urgent human help vital.

- **CRITICALLY ENDANGERED** – extinction is extremely likely, even with immediate human intervention.

Some kinds, or species, of animals have an extensive geographic distribution across habitats with differing backgrounds. So they have a generalized, all-purpose camouflage, such as complex shades of grey, brown, tawny, rusty, reddish, cream and white for the 'grey' wolf (see pages 96–97). Also, wolves farther north are larger than those from their southern range, following Bergmann's rule – bigger, warm-blooded animal bodies have less surface area compared to bulk volume, and so retain heat better in colder environments. Such variation in physical size also impacts camouflage colours and patterns.

Camouflage can be aggressive, a 'wolf in sheep's clothing', used by a predator to sneak up on or ambush prey. It may be defensive, employed by prey animals to remain unnoticed by predators. In some species, such as the peacock flounder (see pages 220–221), it is both of these. Sometimes camouflage is referred to as mimicry. A leaf mantis might be said to mimic the leaves of its environment. However, in biology 'mimicry' also has more specific meanings. For example, the harmless hoverfly is said to mimic a harmful wasp, since both have black and yellow coloration. Most predators learn to avoid wasps, and so they also avoid similar-looking hoverflies. The mimic, the hoverfly, thereby gains by resembling what is called its model, the wasp.

A very different type of camouflage is disruptive coloration or patterning. The aim is to break up or disrupt a creature's recognizable outline and form with bold, contrasting colours and shapes that are designed to be noticed. Black and white, as in killer whales and Malay tapirs (see pages 156–157), are examples. If the onlooker's attention is even briefly distracted by such a confusing and diverting appearance, there is time to escape – or attack.

Other aspects of camouflage include self-adornment, shadow elimination and countershading. Some insects, snails, crabs (see pages 202–203), octopuses and fish adorn or decorate themselves with common objects to disguise themselves as part of their surroundings. Various spiders (see pages 176–177), insects, birds and others can flatten themselves and press down on to a surface, and also orientate themselves to the sun, to avoid giveaway shadows. Many animals have a darker upper side and are lighter underneath, known as countershading, to reduce the effect of sunlight from above lightening the upper surfaces and shadows darkening the underside.

CAMOUFLAGE AND THE STRUGGLE TO SURVIVE

Chameleons (see pages 114–115) and cuttlefish (see pages 208–209) are often cited as 'masters of disguise'. They drastically change their appearance, often within seconds, using clusters of microscopic cells or bag-like sacs called chromatophores. In these, miniscule grains of different pigments, such as ommochromes in crab spiders (see pages 16–17), are spread out or grouped into lumps, and also covered or uncovered by surrounding tissues. This modifies the way different wavelengths of light rays are reflected, so altering what the animal looks like. However, the primary aim of changing appearance may well not be camouflage, but the opposite.

Bright, stand-out colours and conspicuous patterns can send many kinds of social signals, convey mood and intent, advertise for a mate, compete against breeding rivals, or be a defensive strategy in the face of threat. This illustrates the many demands facing an animal in order to survive, and not just in the moment, but through its life cycle to produce viable offspring. Find food, locate a mate, seek shelter, avoid predators and diseases and other threats – all of these pressures contribute to an organism's size, shape, attributes and appearance. Natural selection means those less suited to face such a suite of demands will perish, while the better adapted survive to breed and produce offspring like themselves. Sometimes camouflage is not top of the list.

Why does the orca (killer whale) have such a distinctive two-tone pattern? Camouflage-related factors include disruptive coloration combined with countershading, along with individual recognition for social interactions, possibly even preventing sunburn.

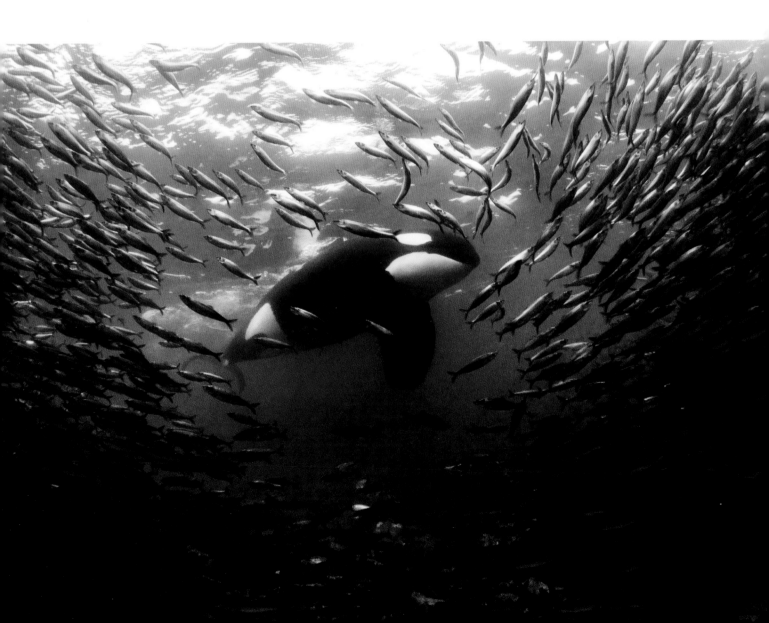

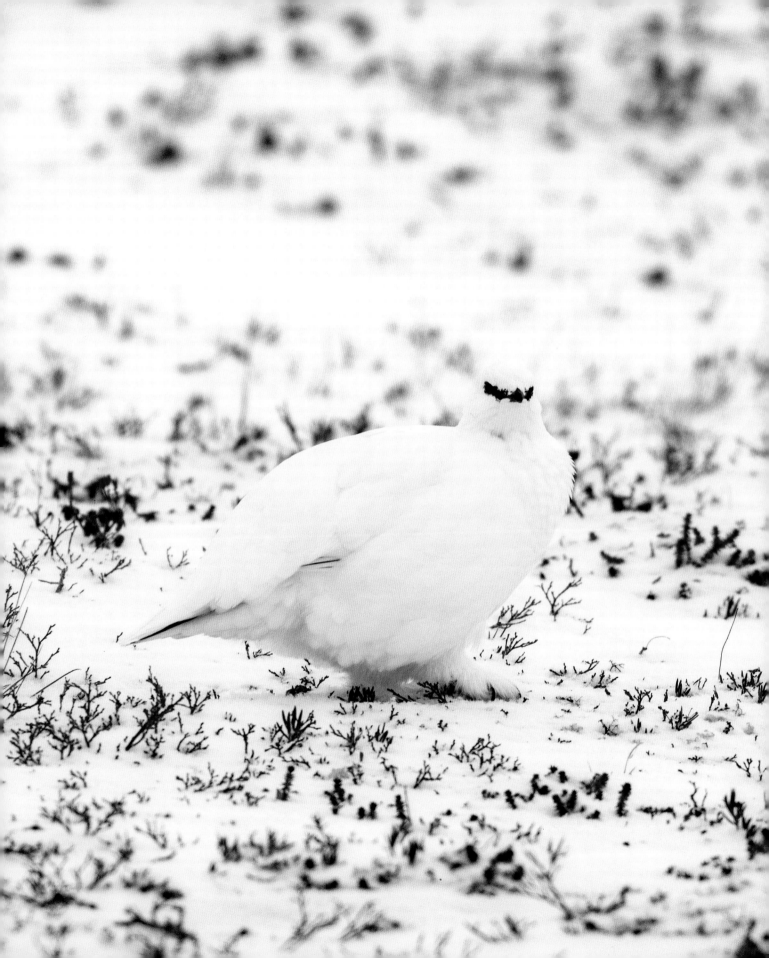

1

North America

Tulip-tree beauty

HIDING IN THE DAYLIGHT

Many nocturnal animals hide away in the glare of day, in burrows or under logs, or among thick vegetation. Camouflage allows this relatively large geometer moth to remain efficiently unnoticed in plain sight – to the woes of gardeners, horticulturalists, arborists and blossom-fanciers, since its caterpillars (larvae) feed hungrily on a range of ornamental and commercial trees.

DISTRIBUTION MAP

The adult moth is on the wing throughout spring and summer, and even during mild winters in Florida and other southern zones of its range. It rests on any suitable bark, often scaly and lichen-covered, where light areas fade to darks, with curving ridges, edges and furrows. The moth's scalloped wing edges and broken, fractured stripes and zigzag lines melt into the bark patterns, and the entire moth's low profile, wings held flat against the bark, means it hardly casts a shadow even in a low sun. These features help it to evade its main predators, namely birds and small arboreal hunters such as lizards.

COLOUR MORPHS

Like many lepidopterans (moths and butterflies) and also numerous other insects, the tulip-tree beauty species has a number of body colours and patterns, known as morphs. The 'dendraria' morph has wider, paler, perhaps ivory bands across the middle area (median) and trailing edge (terminals) of the wing, while the 'carbonaria' morph has darker, even black bands, which are edged with contrasting pale greys or creams to almost white. There are also regional colour variations, with moths in some areas being browner, while others are predominantly grey. These variations are under genetic control and in some places a spectrum of intermediate forms occurs – contrasting morphs have even been seen resting on the same tree trunk.

- **LOCAL COMMON NAMES**
 Tulip-tree beauty, Sassafras moth; Poplar worm or magnolia worm (for larva)

- **SCIENTIFIC NAME**
 Epimecis hortaria

- **SIZE**
 Wingspan 4.5–5.5cm (1¾–2in), body length 1.5–1.8cm (⅝–¾in)

- **HABITATS**
 Woods, forests and their margins

- **DIET**
 Caterpillars consume and damage leaves, buds and other soft parts of tulip trees, pawpaws and other magnolias, also sassafras, redbay, spicebush and related laurels

- **CONSERVATION STATUS**
 IUCN Not evaluated
 (See key page 8)

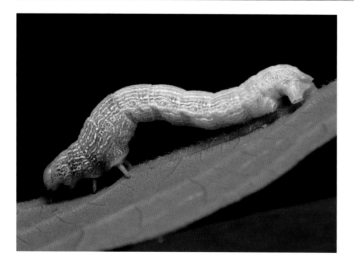

LOOPING LARVAE

Tulip-tree beauty adults may be beautiful, but the caterpillars (larvae) are unwelcome pest guests that feed on a variety of trees and bushes, mainly in the magnolia and laurel groups. They are geometers or 'loopers', about 4 centimetres (1½ inches) long when fully grown and ready to pupate (turn into a chrysalis). Individual colours vary from yellows through greens to browns, again helping camouflage in their food plant.

▶ Individual colours vary among tulip-tree beauties, but more constant is the overall wing design. Approximately four darker zigzag bands are separated by grading paler areas also with zigzag or wavy tracing. A species identifier is the repeated scoops or scalloping, and the delicate fringing of the wing trailing edges, which lend a soft outline to enhance blending with the bark below.

◀ The tulip-tree beauty caterpillar.

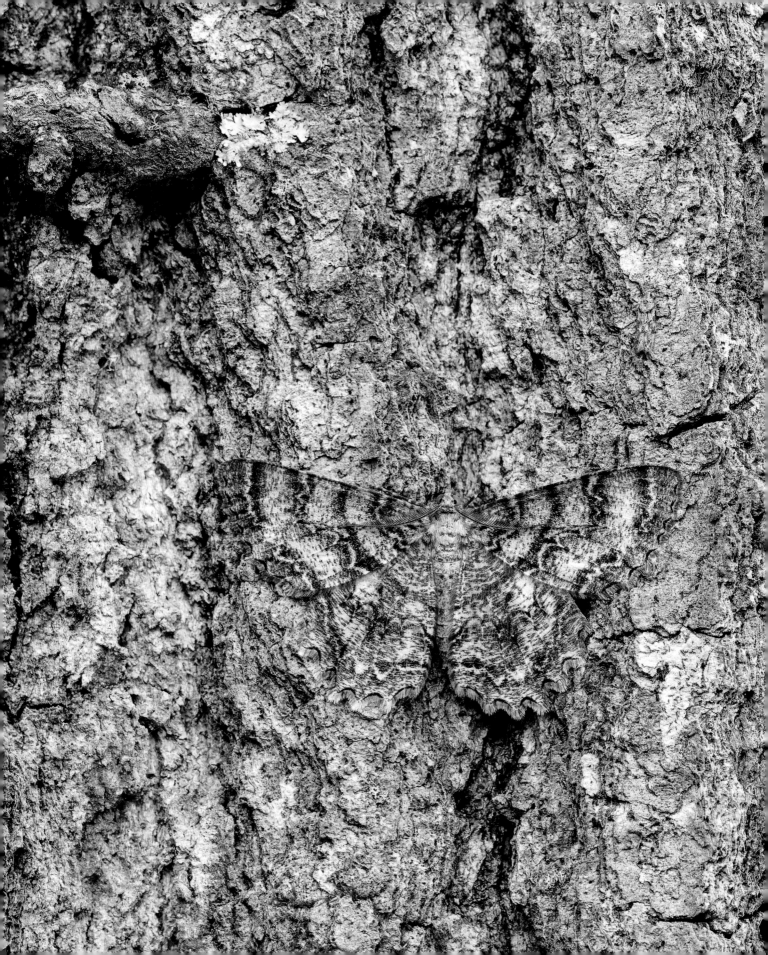

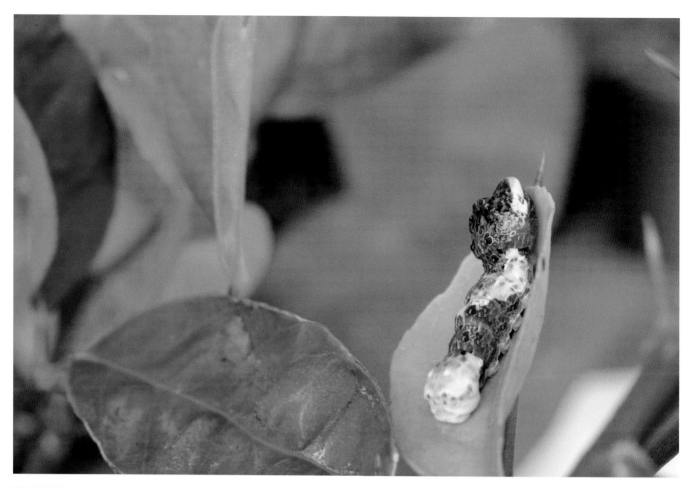

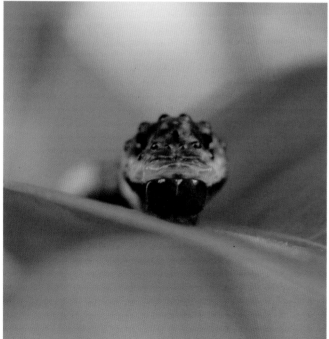

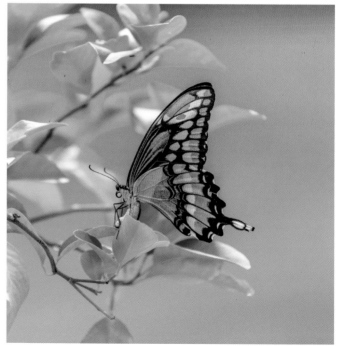

Bird-dropping caterpillar

AN UNAPPETIZING MORSEL

A long, slug-like dribble of slimy, shiny bird excrement is hardly appealing. For most animals, as well as people, it is to be avoided, and certainly not considered a tasty snack. For this reason, widely applicable across the natural world, dozens of creatures in many regions and habitats camouflage themselves as bird poo. Caterpillars – the larvae of butterflies and moths – are common examples, especially those of swallowtail butterflies in the genus (species group) *Papilio*.

DISTRIBUTION MAP

- LOCAL COMMON NAMES
 Orange puppy, Orange dog

- SCIENTIFIC NAME
 Papilio cresphontes

- SIZE
 Adult wingspan 15–20cm (6–8in); caterpillar length up to 5cm (2in)

- HABITATS
 Woods and forests, including orchards and plantations, especially citrus

- DIET
 Adult: nectar of various flowers such as azalea, verbena, honeysuckle, milkweed, goldenrod
 Caterpillar: leaves, shoots and other parts of citrus and rue family

- CONSERVATION STATUS
 IUCN Least concern
 (See key page 8)

TWO-TONE MIXED WASTES

One of the finest examples is the caterpillar of the American giant swallowtail butterfly, with well-demarcated, bird-dropping-like patches along its body of black or dark brown and pale or white. The former represents the bird's semi-solid excrement from its gut or intestinal tube, being parts of food that cannot be digested or utilized; this is equivalent to human faeces. The white or pale parts of the caterpillar's colouring imitate the bird's liquid wastes filtered from its blood by its kidneys and then turned into a pale paste; this is equivalent to human urine. In birds, the two types of waste leave their respective digestive and urinary tracts but are still within the body cavity. Then they are squashed together as they exit through the bird's single common outlet for wastes, called the cloacal vent. Hence the caterpillar's two-tone colouring gives the appearance of bird droppings.

As the giant swallowtail caterpillar feeds and grows many times larger, it exploits another deception. Its 'neck' area, or thorax, just behind the head, enlarges and develops markings that resemble a snake's head. To further the ruse, the caterpillar when threatened can rear up at the front, resembling a snake about to strike. If still in danger, the caterpillar startlingly protrudes or everts two long, red 'feelers', its Y-shaped osmeterium, from its front end – just like a snake's forked tongue. For added effect, these feelers emit foul odours.

◄ (Clockwise from top) Especially when young and small, the giant swallowtail's caterpillar often sits in the middle of a leaf, which is where a bird might well leave its excrement. Its glistening body looks moist and slippery, but is really the typical dryish, semi-flexible caterpillar skin. A female giant swallowtail lays an egg on a lemon tree. When threatened the caterpillar can rear up at the front, resembling a snake's head.

ORANGES IN PERIL

Towards the warmer south of its range, giant swallowtail caterpillars or 'orange dogs' are feared by citrus growers. Feeding mainly at night, they can destroy areas of orange and lemon trees and similar trees and bushes. To the north, in the more temperate climate, their main food includes hop trees (skunk bush). Over months and years, the butterfly's range extends farther north with mild weather, but then shrinks back. However, with climate change, the long-term distribution is gradually spreading northward.

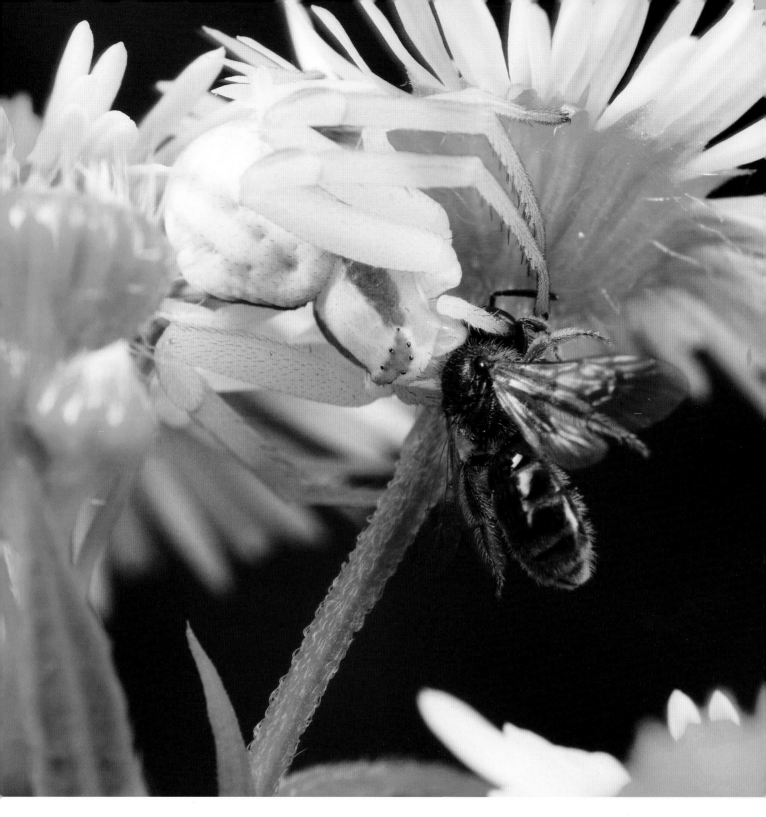

The goldenrod crab spider is an ambush hunter, shown above feeding on a
bee. Out in the open, its colour mimicry conceals it both from unsuspecting
prey and from predators such as larger spiders, birds, lizards and shrews.
Only if physically molested will it scuttle into a narrow recess.

Goldenrod crab spider

LURED TO A BEAUTIFUL DEATH

A native of North America, the goldenrod crab spider has spread to parts of Europe and Asia. It was probably transported in commercial shipments of flower blooms, even though these have been checked for stowaways that in new lands might become an invasive species – a tribute to the spider's camouflage abilities.

Crab spiders, family Thomisidae, number more than 2,000 species. Many secrete themselves in cracks and crevices, waiting for passing victims. The goldenrod crab spider is perhaps the most remarkable, because of its ability to change colour. However, this takes not minutes or hours, but two or three weeks.

MEDIATED BY THE EYES
The goldenrod crab spider's common name comes from being prevalent on these striking flowers during late summer and autumn, although it does inhabit a range of other flowers with different colours. Usually noticed is the female, which is twice as large as the male.

The spider's default colour is white. When on white flowers, this is how it remains. The colour is due to microspots of pigments called ommochrome type I granules in the body's outer layer, the epidermis. On a creamy or buttery flower, these granules merge and change into type II granules with a yellower hue. On a bright yellow flower, type IIs change into type III granules, which may even take on a red hue.

These changes are mediated through the spider's two rows of four eyes. They detect the colour of its immediate surroundings and signal to the spider's metabolism (body chemistry) to react accordingly and form a match. The reverse also occurs; if the spider moves to a white flower, its yellow fades back to white, usually in about a week.

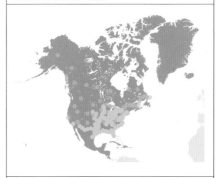

DISTRIBUTION MAP

- LOCAL COMMON NAMES
 Yellow crab spider, White crab spider, Mimetic crab spider, Flower crab spider

- SCIENTIFIC NAME
 Misumena vatia

- SIZE
 Head-body length, female 6–10mm (¼–³⁄₈in), male 3–6mm (⅛–¼in)

- HABITATS
 Varied, including wood edges, parks, gardens, grasslands, scrub, other places with flowers

- DIET
 Smaller insects including bees and flies, butterflies and caterpillars, grasshoppers and crickets, beetles, various insect grubs

- CONSERVATION STATUS
 IUCN Not evaluated
 (See key page 8)

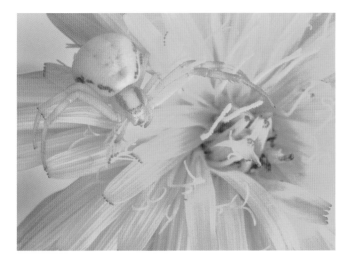

SIDEWAYS SCURRY
Crab spiders are named from their appearance and habits. Most are flattened, wide-bodied, hide away privately in nooks and crannies, hold out their two pairs of front legs like pincers ready to grab prey, and can scurry sideways and backwards. All of these features echo their sea-dwelling namesakes. Most species have small fangs and their venom is not especially potent, so they are virtually harmless to humans.

Bark scorpion

SECRETIVE NIGHT CRAWLER

Scorpions are widely feared for the venomous 'sting' from their sharp-tipped, arched tail. A traditional view holds that the smaller, better camouflaged and less conspicuous the scorpion, the more powerful its venom. In this respect, those of the group *Centruroides*, commonly called bark scorpions, are a good example.

Most species of *Centruroides* bark scorpions are found in southern North America, through Mexico to northern South America. Reputed to possess the most powerful venom of the group is the Arizona bark scorpion. The one most familiar to people is probably the striped bark scorpion, since it occurs in so many habitats, from deep forest and rocky scrub, to farm buildings and outhouses, even inside our dwellings.

REVEALED IN THE DARK
Despite the name 'bark scorpion', most kinds hunt mainly on the ground; the name applies as much to the animal's appearance – reminiscent of a piece of old flaking bark – or hiding under a fallen bark fragment on the floor. Bark scorpions are essentially dull yellow, sandy, tan to darker brown, with variable, restrained spots, stripes or patches on different parts of the body. In general, those species in deserts and drier lands are paler in colour; those in woods and moister environments are darker.

Bark scorpions hide in a vast range of holes, cracks and crevices by day, and emerge at night to hunt small prey among leaf litter, fallen twigs and bark flakes, and other debris. Their nondescript colouring and ability to suddenly stop scuttling and remain stock-still if danger is detected, are remarkably effective at making them visually disregarded even when they are out in the open. Despite their venom, bark scorpions have a range of pursuers, from larger scorpions, centipedes and spiders, to lizards, owls and other nocturnal birds, shrews and bats.

DISTRIBUTION MAP

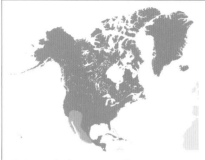

● Arizona bark scorpion and similar venomous species

- LOCAL COMMON NAMES
 Names mostly derived from local regions, such as Florida bark or brown scorpion, Chiapas bark scorpion; Escorpión marrón (Spanish)

- SCIENTIFIC NAME
 Genus *Centruroides* including *C. sculpturatus* (Arizona bark scorpion), *C. vittatus* (Striped bark scorpion) and many others

- SIZE
 Head–tail length mostly in the range 6–12cm (2¼–4¾in)

- HABITATS
 Varied, from deep forest to rocky hillsides, coastal dunes, human habitation

- DIET
 Small insects, worms and other little creatures, including fellow-arachnid scorpions, spiders and mites

- CONSERVATION STATUS
 IUCN Not evaluated (See key page 8)

TOO MANY GUISES
At one time there were almost 100 different species of bark scorpions on various zoological lists, distinguished by stripes, spots and other markings. However, captive breeding experiments from the 1970s showed that, for example, some offspring of striped bark scorpions had no stripes, while the usually plain Arizona bark scorpion could produce striped progeny. It seems that in many species, individuals occur (probably determined by genetic changes) showing differently patterned forms known as 'phases'.

▶ The bark scorpion's small size and low-slung, flattened shape allows it to creep or slide into spaces such as under loose bark or fallen twigs. In areas where its sting presents a significant danger to human life, it can be seen in the dark by shining an ultraviolet 'blacklight', which causes its outer covering to glow (fluoresce).

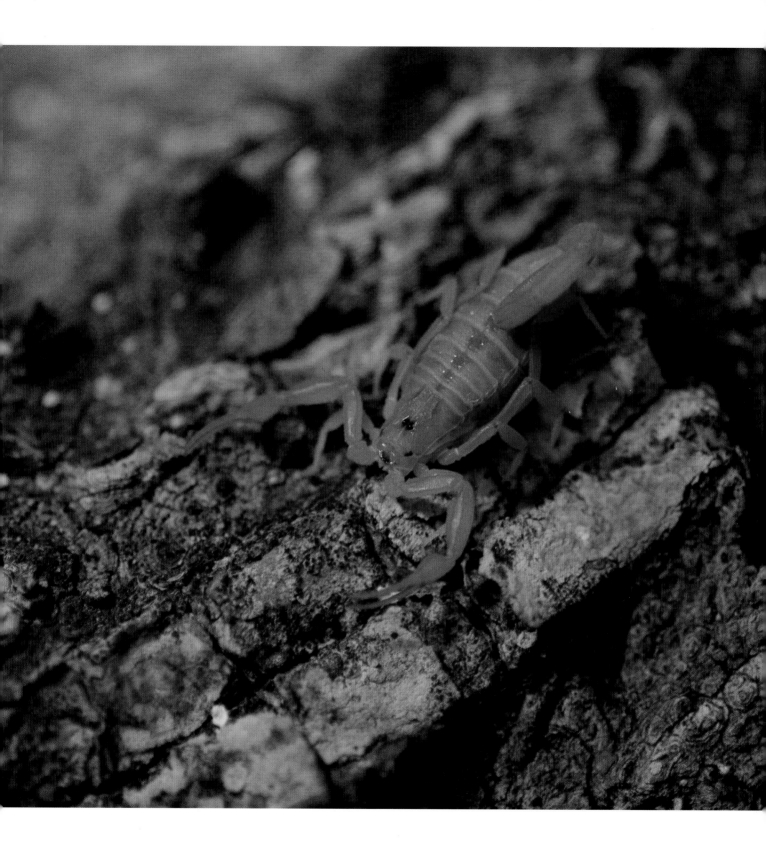

Largemouth bass

FAMOUS FISHY FIGHTER

The largemouth has many local names, and many admirers due to the way it fights against being hooked by anglers (although others protest against such alleged cruelty). This has made it a well-known fish throughout its native range. Due to its prominence in angling sport, it has also been introduced into numerous and exceptionally wide-ranging localities, from South America, and across Europe and Africa, to far East Asia. Its success as both a native and invasive species is due to several basic survival attributes, including what ichthyologists (fish biologists) call its 'trophic plasticity', that is, adjusting its diet to eat whatever is available – plus its camouflage.

DISTRIBUTION MAP

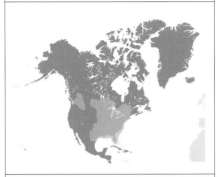

- LOCAL COMMON NAMES
 Huge variety depending on locations, such as Widemouth and Bigmouth bass, Green bass, Black bass, Bucketmouth, Gilsdorf bass, Oswego bass

- SCIENTIFIC NAME
 Micropterus salmoides

- SIZE
 Length up to 90cm (3ft), weight up to 10kg (22lb)

- HABITATS
 Lakes, dams, reservoirs, slow rivers, usually with plentiful vegetation

- DIET
 Almost anything that the fish can fit into its (large) mouth

- CONSERVATION STATUS
 IUCN Least concern
 (See key page 8)

BOLD AND AGGRESSIVE

The largemouth bass is a substantial fish, with the biggest individuals exceeding 70 centimetres (2 feet 3 inches) in length. It has a relatively common form of camouflage for fish found in lakes and slow rivers. Base colours consist of some mix of green, olive and grey on the upper surfaces of the head and back, occasionally with a shiny, brassy glow, also a mid-flank series of lengthways darker blotches forming a vague, jagged horizontal stripe, and all this grading to the silvery underside. Generally, the greens and olives are lighter in deeper, clearer waters, and darker and more silver in shallower, weedy environments. This reflects the penetration of sunlight and the contrasts it provides in such settings, and which, in either situation, is ideal for hiding among waterweeds and aquatic vegetation.

From its lurking hideaway, the bold and aggressive largemouth attacks almost any kind of prey it can fit into its – large – mouth. Insects, crustaceans like shrimps and crayfish, and smaller fish go in, as well as frogs, salamanders, and also land creatures, such as lizards, birds and small mammals that happen to be in the water.

CALCULATING THE HAVOC

Like many invasive species, the largemouth has forced its way into new habitats in different ways. Studies in South Africa have shown that relatively fast-flowing, 'stones-in-currents' aquatic environments (those where the currents wash away mud and other small particles, leaving a relatively 'clean' stream bed) have not lost significant small-animal communities to these new fish. However, in 'marginal vegetation' (near the bank, shallow and weedy), active small creatures such as dragonfly and beetle larvae (young stages) were much reduced, while the local well-camouflaged sedentary snails and caddisfly larvae fared better. Such details are important in working out how to cope with the invaders.

▶ Vertical waterweed leaves and stems, and grey and brown rocks that glint in the light (like fish scales), make an ideal backdrop and hiding place for the largemouth bass.

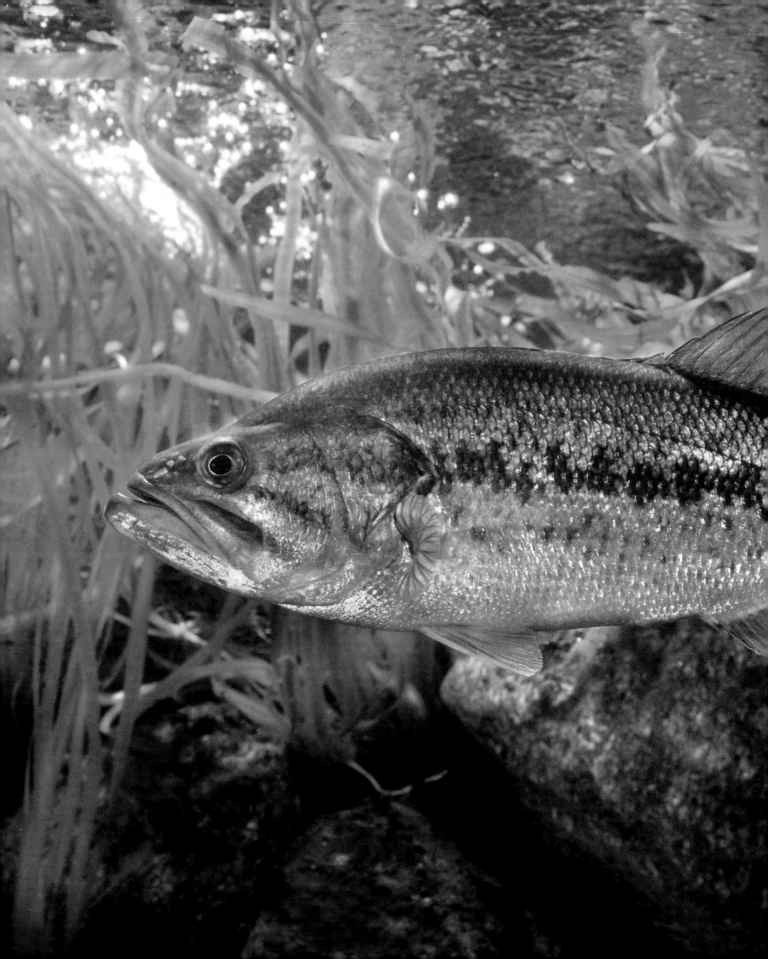

Spring peeper

OFTEN HEARD, SELDOM SEEM

A welcome sound of spring in eastern North America is the dusk and night chorus of male spring peeper frogs, just emerged from winter inactivity, vocalizing to attract females. Their high-pitched calls have been likened to peeps, cheeps, piping, whistles and even sleigh bells, with each male producing 15–20 sounds per minute. While they can certainly be heard, these thumb-sized amphibians are seldom seen – due to their innocent-looking camouflage.

FOUND ON THE GROUND

Most spring peepers are a shade of mid-brown or tan. Some individuals are tinged with grey while others are more olive, and a few approach yellow or even rusty red. The coloration is not even but shows darker gradations and vague wandering stripes, especially in front of and behind the eyes, and on the back and legs. A feature is the darker 'X' or cross mark on the back, as indicated by the species name *crucifer* (cross-carrier), although this pattern is sometimes blurry or indistinct.

The peeper's overall coloration merges almost seamlessly with old leaves, twigs, stems, stalks and other ground-level debris. Despite being a hylid, or member of the tree frog family, with the soft toe-tip pads or discs for climbing that are typical of this group, the peeper is far more often found down on the floor than clambering higher among the greenery. It tends to stay semi-hidden, except when lured into the open for food, since it is a common food item for numerous woodland predators, such as lizards, salamanders, snakes, owls and other birds, and large spiders and centipedes.

DISTRIBUTION MAP

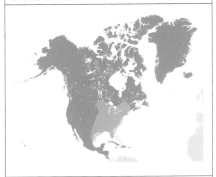

- **LOCAL COMMON NAMES**
 Peeper, Spring frog, Calling frog, Cicada frog

- **SCIENTIFIC NAME**
 Pseudacris crucifer

- **SIZE**
 Head–body length 2–3cm (¾–1¼in), weight 4–7g (⅛–¼oz)

- **HABITATS**
 Woods, forests, shrubs and grasses, with fresh water such as ponds, swamps and ditches for breeding

- **DIET**
 Small insects, spiders, worms and similar creepy-crawlies

- **CONSERVATION STATUS**
 IUCN Least concern
 (See key page 8)

◄ Many members of the tree frog family are green, yellow or a comparable colour to match fresh stems, leaves and flowers. Spring peepers are toned to harmonize with old vegetation and leaf litter, with their delicate roving marks echoing the stalks and veins of old leaves.

WINTER SHUTDOWN

In the more northern parts of the spring peeper's range, freezing conditions are common and prolonged during winter, when the frog assumes a hibernation-like state known as torpor. Yet its specialized body metabolism can withstand sub-zero temperatures, sometimes even below –5°C (23°F). Antifreeze-like constituents in its bodily fluids delay the formation of ice crystals, or even allow a certain amount of reversible solidification without harm, so the frog can peep again next spring.

Hellbender

SALAMANDER IN THE SHALLOWS

Measuring the length of a human arm, few creatures this large are as difficult to discover in their natural environment as the hellbender. Its coloration is mainly brown, brown-grey, brown-tan, brown-olive or similar, with multiple irregular darker splodges, blotches and splashes. The hellbender melds fluently into the boulders, pebbles, weeds, stones, waterlogged wood and hollows of its home – a relatively swift-flowing creek or stream. The wide, low, flattened body has wavy skin folds along the sides that obscure its typical salamander shape; its four legs are short, squat and stubby; and its powerful tail can propel the amphibian against the strongest current.

Added to these cryptic features is that by day – when the hellbender rests after its nocturnal feeding – it is adept at sliding into a crevice or niche under a log or rock. Here it is hidden from predators, such as large carnivorous fish, turtles and snakes. And even during the day, it may gulp into its wide mouth any chance passing prey – predominantly crayfish, but also small fish, frogs and aquatic insects.

AN EXCLUSIVE CLUB

The hellbender is a member of the exclusive giant salamander group known as cryptobranchs. The name means 'hidden gills' and refers to the lack of obvious gills on the head or neck for breathing, since these amphibians absorb oxygen from the water through the thin skin of their frilly body folds. The only two other cryptobranchs, in East Asia, are even larger. The Japanese giant salamander reaches 1.4 metres (4 feet 7 inches) in length, and the Chinese species may exceed 1.6 metres (5 feet 3 inches). Collectively, these are by far the world's largest amphibians.

DISTRIBUTION MAP

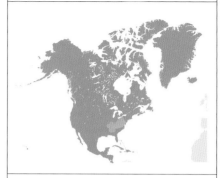

- LOCAL COMMON NAMES
American giant salamander, Snot-otter, Devil-dog, Mud-dog, Mud-devil, Grampus, Allegheny alligator, Lasagna lizard, Lasagna-sides

- SCIENTIFIC NAME
Cryptobranchus alleganiensis

- SIZE
Length up to 70cm (2ft 3in), weight up to 2.5kg (5lb 8oz)

- HABITATS
Larger, faster-flowing creeks and streams with plentiful hiding places and crayfish

- DIET
Crayfish, fish, frogs and toads, aquatic insects and worms, other salamanders including smaller hellbenders

- CONSERVATION STATUS
IUCN Near threatened (See key page 8)

INDICATOR SPECIES

Hellbenders are important indicators of waterway health. They have disappeared from up to half of their original range due to various forms of pollution caused by humans. A major threat is mud and silt washed in from roads, farmland, and housing and industrial development. The waterways clog up and hellbenders can no longer dwell there. Many conservation projects aim to restore such habitats and welcome back this most intriguing creature.

▶ Hellbenders usually prowl for food at night, in particular using their acute sense of smell to pinpoint prey animals and also carrion such as dead fish. Their low-slung, compact shape puts up minimal resistance to flowing water as they rest on the bottom or walk and tail-swish along.

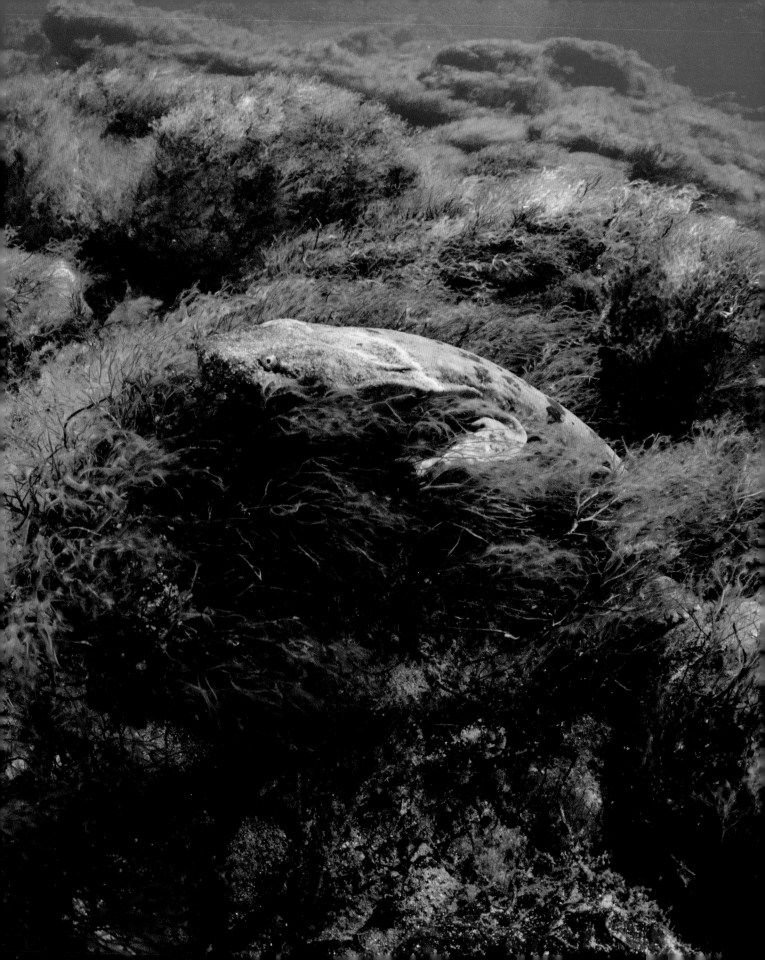

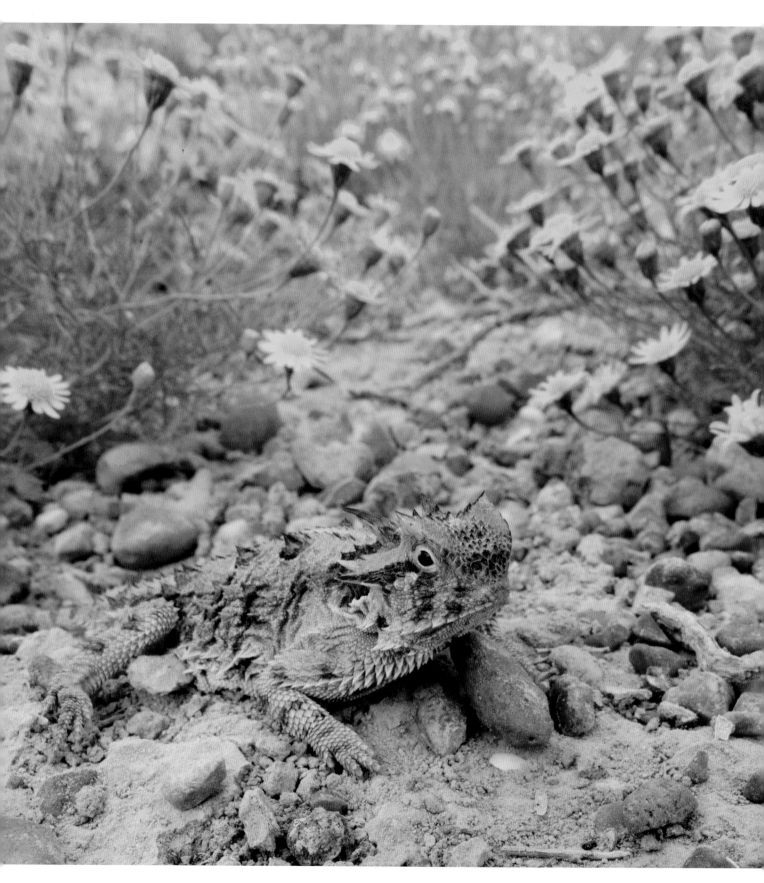

Texas horned lizard

SPIKY, POINTY ANTEATER

Official Texan state reptile, the 'horny toad' is not a toad, or frog, or any kind of amphibian, although its blunt head and squat body may give that impression. It is a true lizard, related to anoles, iguanas and chameleons. Distinctive are its two main horns, one above each eye, and more sharp points on its cheeks, each with a core of a bony extension from the skull. There is also a row of larger, sharply pointed scales along each side of the body and tail, plus smaller, spiky scales over most other body regions.

The horny's coloration is sandy yellow, reddish, grey or olive, with irregular stripy or rounded darker patches over the upper sides of the body, tail and legs; the underside is considerably paler. These are ideal markings for being disregarded among dry, grassy, rocky, pebbly, scrubby habitats.

Moving to a place with different soil, rocks and vegetation, over days and weeks the Texas horned lizard alters its hues for better camouflage in the new surroundings. This change is influenced by visual messages from the eyes affecting hormone-producing parts of the brain, including MSH (melanocyte-stimulating hormone), and also shifts in its proportions of food items, chiefly ants, which themselves contain pigments.

HEAT AND LIGHT

But this is not the whole story. Ambient temperatures also affect coloration. In the cooler morning or evening, the lizard darkens to match its duller, shadowy setting, and also to absorb more heat and stay warm and active. In the bright sun of midday, the surroundings are lighter and brighter, and so is the horny, again to fit in with its background, and also to reflect the sun's rays and reduce the risks of overheating. In this way the lizard's appearance delivers camouflage and body temperature control, or thermoregulation.

- LOCAL COMMON NAMES
 Texas horned toad, Horny toad, Horned frog; Texas-krötenechse (German); Camaleón común (Spanish)

- SCIENTIFIC NAME
 Phrynosoma cornutum

- SIZE
 Head–body length 7–14cm (2¾–5½in), weight 30–80g (1–3oz) (females are larger than males)

- HABITATS
 Arid regions including dry grass, shrub, scrub, sand, rocks and pebbles

- DIET
 Ants, termites, other small invertebrates

- CONSERVATION STATUS
 IUCN Least concern (declining in some areas)
 (See key page 8)

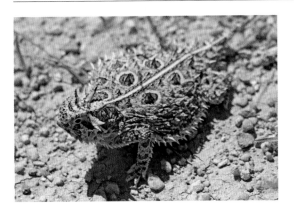

WHITE STRIPE

A thin cream or white stripe stretches from the Texas horned lizard's neck along the upper centre of the back and tail. Studies show that this may play a part in camouflage. A threat can make the lizard take cover among plants, especially grassy tussocks. Here the pale stripe looks like just another dry grass stem, while the irregular outline and fringing scales disguise the lizard-type shape.

◄ (Opposite) Among mixed scrub, grass, rocks and pebbles, the Texas horned lizard roams in search of its favourite food – harvester ants. If it senses danger from a predator such as a large snake or bird of prey, it remains motionless, or quickly moves into nearby cover in vegetation or among rocks. (Left) the lizard's white stripe is clearly visible.

Copperhead

STILL AMONG THE LEAVES

Old and dead leaves on a woodland floor are the copperhead's favoured camouflaging habitat. As its name suggests, this member of the pit viper family is recognized by its metallic-looking, burnished, copper-coloured head, with matching coloured eyes adding to the effect. The head is arrow- or dart-shaped, and behind it is a distinctive neck and then the body, strong and stout, tapering rapidly near the end to the thin tail.

IRREGULARITY IS THE KEY

Apart from the head, the copperhead's coloration is contrasting shades of brown (sometimes grey-brown or creamy brown) with two alternating sets of bands or patches around the body. The darker, reddish or chestnut bands are variously described as shaped like saddlebags or an hourglass, narrower on the top of the back and widening down the sides. They alternate with paler brown, tan or beige bands that do the opposite. Each pale or dark band is vaguely similar but has its own particular detailed, variable shape, which may or may not lighten towards the interior of the band. This means there is no accurately repeated pattern along the body, which could otherwise attract attention.

The copperhead's contrasting, irregular bands ideally mimic old, brown, curled leaves. Also, the copperhead's habit of resting in a rather loose, random coil disguises its serpentine outline. Thus, the snake is virtually invisible when surrounded by leaf litter. It usually waits for a passing mouse, vole or similar rodent, whose body warmth it detects using two heat-sensitive pit organs – small depressions, one on each side of the head between the nostril and the eye.

- **LOCAL COMMON NAMES**
 Red snake, Chunkhead, Whiteoak snake, Dart-head, Leaf snake; Cantil cobrizo (Galician Spanish)

- **SCIENTIFIC NAME**
 Agkistrodon contortrix

- **SIZE**
 Length 60–80cm (2ft–2ft 7in), weight 100–250g (4–9oz)

- **HABITATS**
 Varied, from dense forest to open woods, rocky upland, scrub, swamps, riverbanks, lakesides

- **DIET**
 Small mammals such as mice and voles, birds, lizards, frogs, larger insects

- **CONSERVATION STATUS**
 IUCN Least concern
 (See key page 8)

CAREFUL WHERE YOU TREAD

Across this snake's range, more people are bitten by copperheads than by any other venomous snake – for several reasons. They are locally common; found in varied habitats, including human settlements; are so well camouflaged, people may unknowingly step on or disturb them; and behaviourally, the snake tends to freeze rather than retreat, and then strike. Fortunately, it's usually a warning 'dry' bite, and no venom is injected. The venom itself is not especially powerful, so fatalities are rare.

▶ Woodland floor leaves, twigs and similar debris are ideal surroundings for the copperhead. It usually keeps watch for prey while coiled near a bush, tree trunk or rocks, still and silent and ready to strike. The overall colour ranges from brown, as here, to brown-grey, but the hourglass shapes are relatively constant.

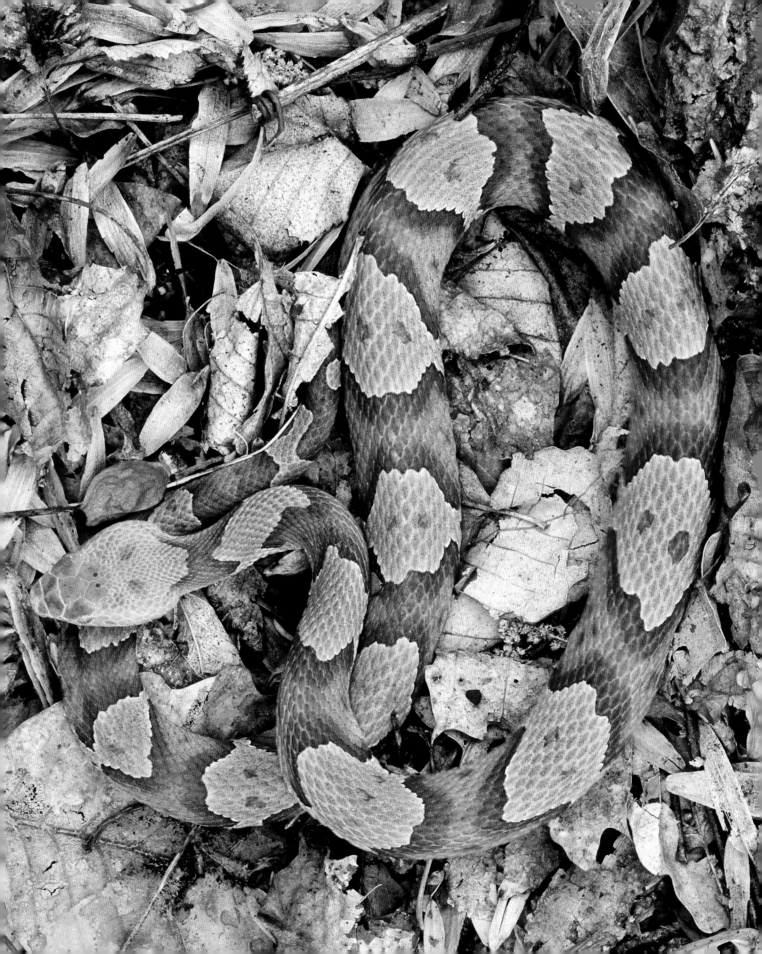

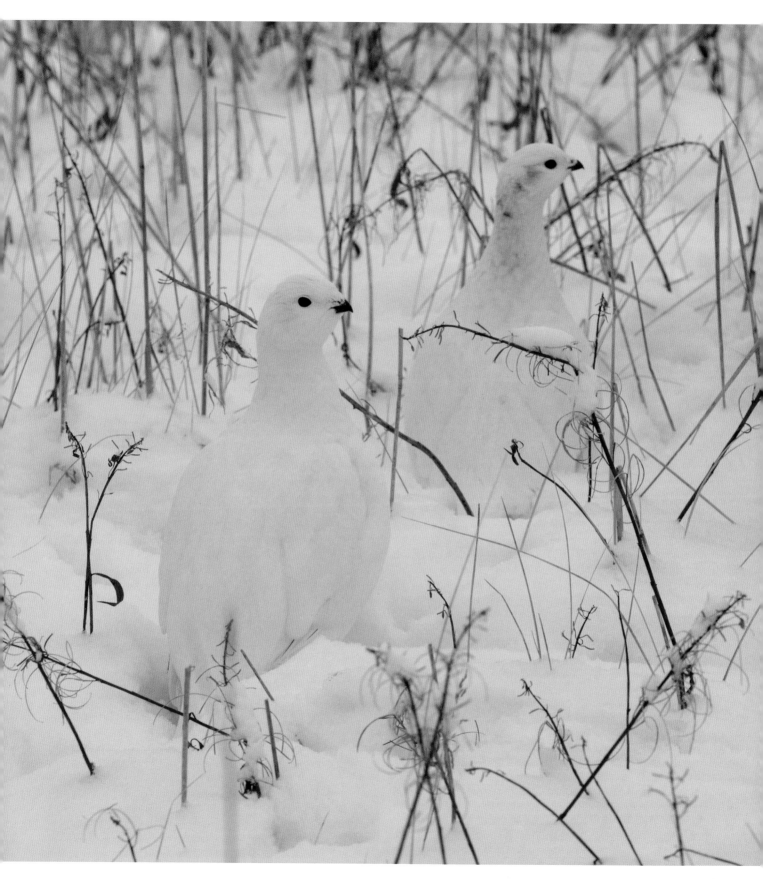

Rock ptarmigan

SNOW CHICKEN OF THE TUNDRA

The Arctic tundra is an especially harsh habitat: treeless, little shelter, windy, sub-zero temperatures for months in winter, with blizzards, snow and ice blanketing the land, ground frozen for part of the year, and underlain by permafrost. Few animals live here year-round. In the farthest north of its geographic range, the rock ptarmigan is one of the few.

Also known as 'the' ptarmigan, the survival of this member of the gamebird family depends on its changing camouflage. In spring its all-white feathers are shed, or moulted, and in their place grows a plumage of mostly nondescript black, brown, grey and pale bars and other markings. This plumage provides concealment among the snow-free rocks, pebbles, stunted shrubs and bushes, grasses, sedges and other tundra vegetation.

THE PERILS OF COURTSHIP
Male ptarmigans are slower in spring to lose all their white feathers. These, along with the all-important head comb – a cardinal sign of fitness and ability to breed – are important in their courtship display to the females. The male's lingering whiteness at this time is designed to impress potential mates, but being conspicuous now the snow and ice have melted, it also attracts the attentions of predators such as gyrfalcons, snowy owls, golden eagles and Arctic foxes. The females, on the other hand, are already well camouflaged for the season, ready to make a nest, incubate the eggs and tend the chicks, all without male assistance. In autumn the summer plumage of both sexes is replaced by the all-white winter feathers once again, and the rock ptarmigan blends into the glaringly white Arctic backdrop.

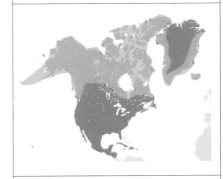

DISTRIBUTION MAP

- **LOCAL COMMON NAMES**
 Snow chicken, Snow partridge, Ptarmigan; Aqiggiq atajulik (Inuit)

- **SCIENTIFIC NAME**
 Lagopus muta

- **SIZE**
 Overall length 40–45cm (1ft 3in–1ft 5in), wingspan 50–60cm (1ft 7in–2ft), weight 400–600g (14oz–1lb 5oz)

- **HABITATS**
 Tundra, rocky hills, mountains, moors

- **DIET**
 Plants, including buds, catkins, shoots, berries, grasses and sedges

- **CONSERVATION STATUS**
 IUCN Least concern
 (See key page 8)

IT'S OFFICIAL
In 1999, eastern parts of Canada's Northwest Territories were separated off as a new territory, Nunavut – 'Our Land' to the Inuit. This change meant establishing many kinds of new bodies and systems for government and running the territory, and also selecting the region's official emblems and symbols. The rock ptarmigan was chosen as the official bird, due to its year-round residence in the territory and its place in Inuit folklore, art – and diet.

◄ From sparse cover, two ptarmigan in winter plumage keep a wary eye on the snowscape.

► On her nest, the female's summer plumage ideally matches the colours and shapes of the surrounding area.

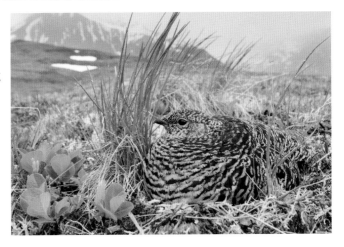

Great grey owl

PHANTOM OF THE NORTH

One of the world's largest owls, the great grey (gray) is essentially a forest and woodland bird. In particular, it inhabits the great stretches of conifers and other evergreens termed boreal forests in North America and taiga across Asia. It also occurs in mixed deciduous woodlands farther south, especially at altitude where, like the boreal and taiga, the climate is cool to cold, with snow at least a few months of the year.

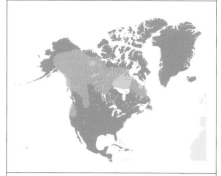

- LOCAL COMMON NAMES
 Sooty owl, Lapland owl, Cinereous owl, Spectral owl

- SCIENTIFIC NAME
 Strix nebulosa

- SIZE
 Bill–tail length 65–75cm (2ft 1in–2ft 5in), wingspan 1.35–1.45m (4ft 5in–4ft 9in), weight 1–1.3kg (2–3lb)

- HABITATS
 Woods and forests, including coniferous and deciduous, with open areas such as meadows, bogs, fens, rough grass and scrub

- DIET
 Small rodents, especially voles, mice, gophers, lemmings, also shrews, smaller birds and amphibians

- CONSERVATION STATUS
 IUCN Least concern
 (See key page 8)

Like most owls, the great grey's actual body size is startlingly small – only about half of the outline created by its plentiful, thick, fluffed-up outer feathers. These form fuzzy, indistinct mottled patterns in numerous shades of grey to match the lichen-covered tree trunks and branches of its roosting and hunting perches.

THE PHANTOM REVEALED

Throughout its range, the great grey owl likes to be near open areas with low vegetation. Living up to its impressive alias Phantom of the North, it suddenly appears as if from nowhere – although in reality it has been sitting unnoticed, merging in with twigs, boughs and stumps, watching and listening for prey. It then swoops silently through the trees or cruises noiselessly over marshes and rocky grasses to localize a vole, mouse or similar quarry.

The owl's camouflage is somewhat helpful for such hunting techniques, but perhaps even more vital to avoid the attention of predators. These include the even more powerful great horned owl and Eurasian eagle owl, occasionally bears, cats such as lynx and bobcat, and smaller but fierce carnivorous mammals such as wolverines.

FOCUSING IN

To detect prey, an owl twists and turns its head so that its huge eyes and also its ears can face and then zero in on a potential meal. The facial disc or ruff of feathers – more pronounced in the great grey than any other species of owl – is designed to catch the faintest noises and channel them to the ear openings in the skull. One opening is higher than the other, and this asymmetry aids pinpointing sound sources. Such incredibly keen hearing can locate a small creature moving even under 50 centimetres (1 foot 7 inches) of snow.

▶ The great grey's camouflage works best among tree trunks and limbs, especially where these are covered with furrows and scaly, peeling patches of bark and grey-green lichens. Its species name *nebulosa* refers to its hazy, soft-edged colouring and outline. Often the only clue to the owl's presence is its penetrating stare.

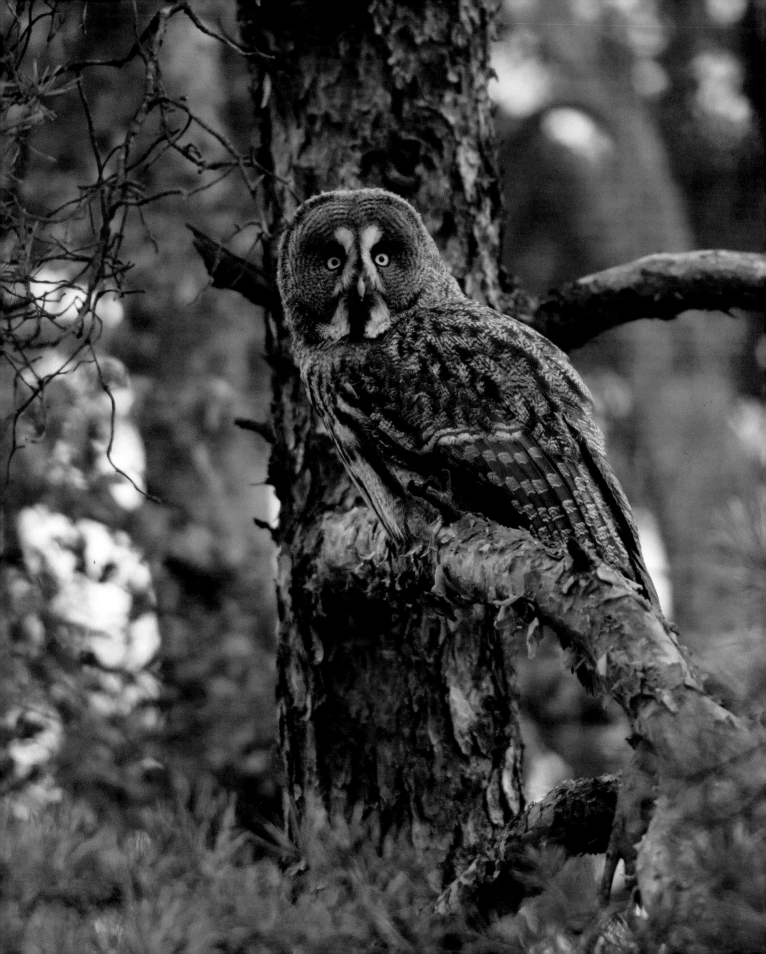

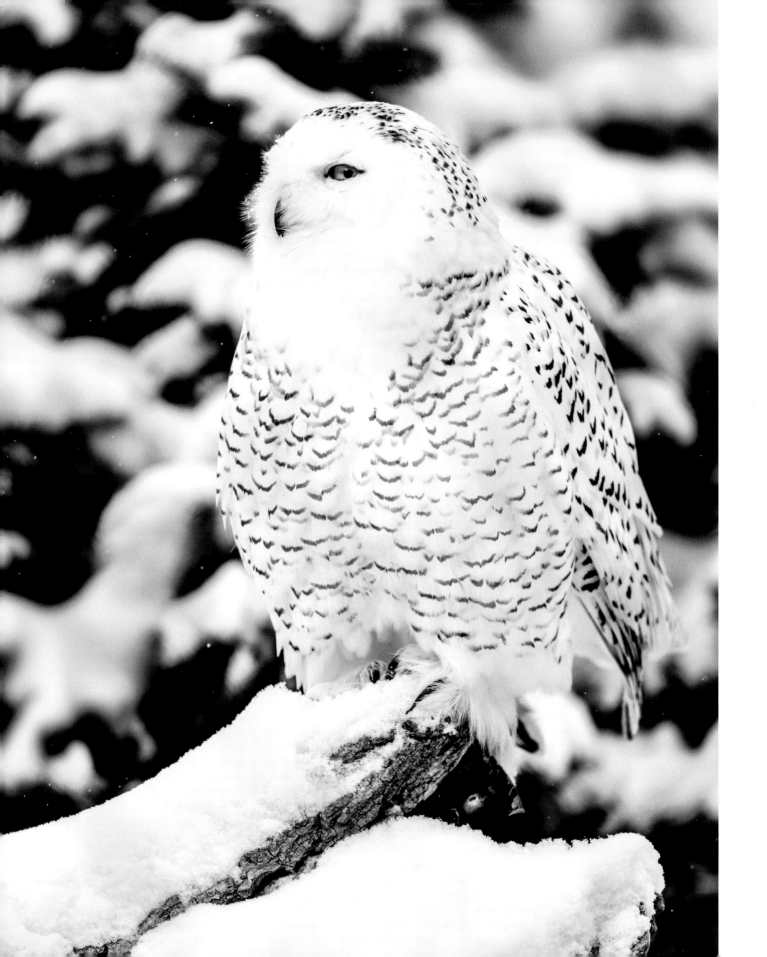

Snowy owl

DAYTIME GHOST OF ARCTIC LANDS

Many polar animals are white, for camouflage against snow and ice. The snowy owl, which is found all around the far north of the world, is no exception. If it was a typical owl, hunting at night, colour for camouflage might not be so vital. Unlike most of its kind, however, this owl is diurnal, on the wing mainly in daylight – which in the high Arctic varies from twenty-four hours in summer to very little in winter. More precisely, the snowy owl is mostly crepuscular; that is, out and about in the twilight of dawn and dusk. Hence its ghostly paleness.

Several Arctic creatures are virtually pure, all-over white, especially in their winter fur or plumage. Snowy owls, however, have at least a few dark brownish-black flecks and barring all through the year. The extent of these markings varies among individuals, but they are more numerous and prominent in females; in some males they are few and faint, so the owl can approach pure white, except for the wingtips.

NOT QUITE PURE WHITE
These markings aid camouflage. In the treeless high Arctic, snowy owls have to perch on the ground as they rest, prepare to fly and hunt, or consume their meals. The ground is rarely completely snow-white, rather it is usually windblown, with bits and pieces of grassy hummocks, rocks, dwarf shrubs and lichens showing though. The owl's markings mimic this random darker, mottling patchiness in the landscape. Also, the female sits on the nest for up to two months as she incubates the eggs and broods the nestlings, while the male brings food, hence her more prominent markings.

DISTRIBUTION MAP

- **LOCAL COMMON NAMES**
 Arctic owl, Polar owl, Great white owl, Ghost owl, Ermine owl, Tundra owl, Tundra ghost; Ookpik (Inuit); Snæugla (Icelandic); Tunturipöllö (Finish); Snøugle (Norwegian); Fjälluggla (Swedish); Снежная сова (Russian)

- **SCIENTIFIC NAME**
 Bubo (Nyctea) scandiacus

- **SIZE**
 Bill–tail length 55–65cm (1ft 9in–2ft 1in), wingspan 1.4–1.5m (4ft 7in–5ft), weight 1.6–2.2kg (3lb 8 oz–4lb 13oz) (females are usually larger than males)

- **HABITATS**
 Varied, including tundra, grasslands, marshes, shorelines and dunes, rocky shrub and scrub; rarely forests or woods

- **DIET**
 Primarily small rodents, especially lemmings, voles and mice, also rabbits, hares, small–medium birds such as ptarmigan and ducks, occasionally fish, shellfish, large insects

- **CONSERVATION STATUS**
 IUCN Vulnerable (declining across most of its range)
 (See key page 8)

◄ Atop an old stump, a snowy owl scans for food during the short daylight hours of winter. Males usually have fewer darker flecks than females, and these lessen with age.

YEAR-ROUND MOULT
In contrast to Arctic inhabitants who shed their summer browns to become wintry white, snowy owls have a protracted, year-round moult. The body feathers are usually all superseded each year, in a gradual cycle. However, the flight feathers may take three or more years for total replacement. In such a harsh habitat, where catching food to maintain body warmth is paramount, the owl cannot afford to take time out while these feathers are shed and regrown.

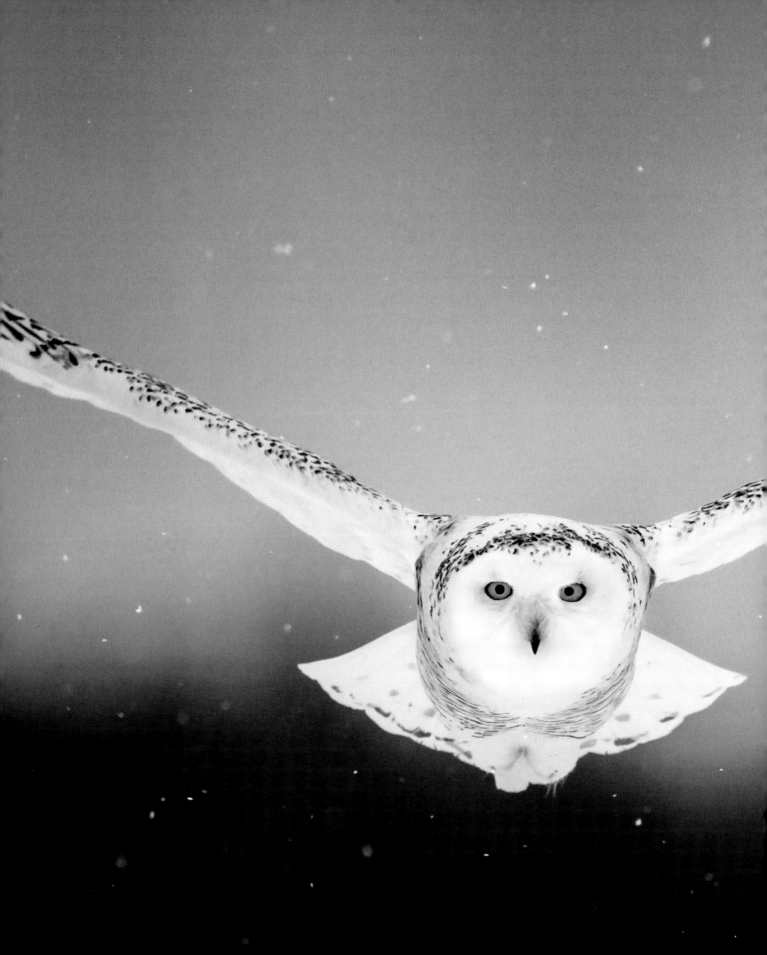

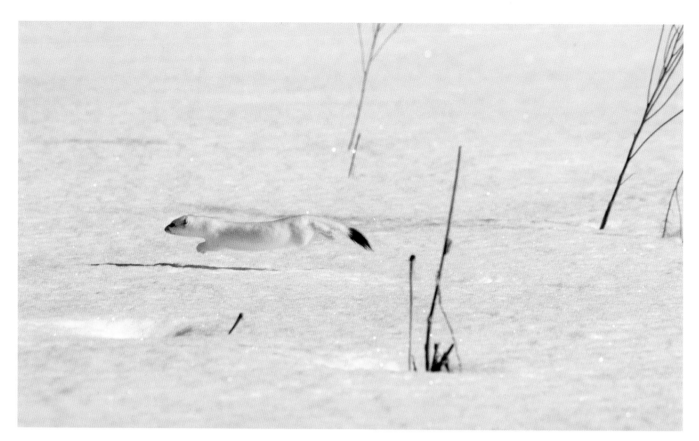

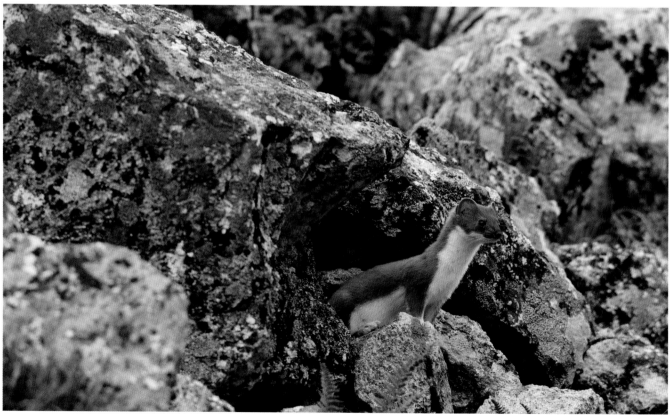

Stoat (Ermine)

A COAT FOR ALL SEASONS

One of the best-known colour-change mammals is the stoat: brown in summer and white in winter, when it is often called the ermine. It is an excellent example of seasonal camouflage. The underparts, chest and chin are pale to white, but the mainly brown summer fur on the head, neck, back and flanks blends with brown soils, older plant material, and tree trunks and branches (stoats are skilled climbers). The fur is shed or moults in autumn, head and back first progressing to the underside, as the stoat grows its finer, more silky, all-white winter coat. The tail end is tufty black all year round. The spring moult sees the summer coat return, and so on.

INITIATED BY DAY LENGTH

This marked colour change only occurs in the far north of the stoat's extensive geographic range, where snow and ice lie for months in winter. To the south the change is less marked, and in its southernmost range it hardly occurs at all, the winter coat being a slightly paler brown version of the summer fur. Moulting is dependent on environmental temperature and also photoperiod, that is, length of daylight and its speed of change. In northernmost latitudes the period of daylight becomes rapidly much longer in spring, and in autumn the reverse, compared to farther south where changes in day length are less marked and slower.

Stoats are fierce, violent killers of any smaller creatures, such as mice, voles and lemmings – and animals considerably larger than themselves, too, including hares, rabbits, and birds such as ducks and ptarmigan. Their camouflage also helps conceal them from their own predators – owls and birds of prey, foxes, coyotes, and their bigger cousins in the group known as mustelids (weasels, wolverines and badgers), including the fisher and American marten.

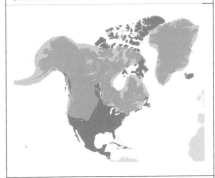

- **LOCAL COMMON NAMES**
 Short-tailed weasel, Ermine, Bonaparte weasel; Tiriaqpak, Tiqiak (Inuit)

- **SCIENTIFIC NAME**
 Mustela erminea

- **SIZE**
 Nose–tail length 25–45cm (10in–1ft 5in), weight 150–350g (5–12oz) (males are larger than females)

- **HABITATS**
 Varied including forests, woods, scrub, farmland, human habitation, mountains, tundra

- **DIET**
 Mainly small mammals such as mice, voles, lemmings, also insects, fish, frogs, birds and eggs, and sometimes prey up to five times larger than itself

- **CONSERVATION STATUS**
 IUCN Least concern
 (See key page 8)

◄ (Top) Even racing across the snow, the stoat's winter 'ermine' fur furnishes superb camouflage among the wintry snowscapes of the far north. (Bottom) The summer coat retains white only on the underside. All through the year, the tail tip is black.

PLENTY OF VARIATION

The stoat's widespread distribution and diverse habitats mean this single species varies greatly. There are more than thirty-five different forms or subspecies that differ in size, details of shape and fur colour, and prey preferences. About ten of these are found in North America. One of the biggest is the tundra stoat, *Mustela erminea arctica*, from Alaska, north-west Canada and some Arctic islands.

Cougar

A MOST ADAPTABLE CAT

Often cited as the fourth largest species in the cat family, the cougar is many things to many peoples in many habitats. It has a vast geographic range, from south-west Canada almost to the southern tip of South America, and is a consummate survivor in a wide variety of habitats. Also known as the puma, it is found from the high, cold Rockies as the 'mountain lion', across woods and grassland and farmland, to the subtropical swamps as the 'Florida panther' and is the official animal of that state.

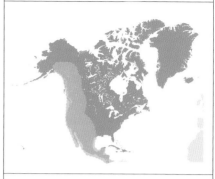

- **LOCAL COMMON NAMES**
 Puma, Mountain lion, Panther, Catamount, Painter, Mountain screamer, America lion; León montaña, Suçuarana, Cuguacuarana (Spanish); and many more

- **SCIENTIFIC NAME**
 Puma concolor

- **SIZE**
 Length 2–2.5m (6ft 6in–8ft 2in), shoulder height 60–80cm (2ft–2ft 7in), weight 40–80kg (88lb 3oz–176lb 6oz)

- **HABITATS**
 Wide tolerance from high mountains to sea level

- **DIET**
 All kinds of mammals, from large deer to small rodents, also birds, reptiles, amphibians, fish, insects

- **CONSERVATION STATUS**
 IUCN Least concern (although declining across most of its range) (See key page 8)

Being so adaptable, with a wide variety of backgrounds and surroundings, it may be surprising that the cougar lacks the spots, stripes or patches of many other cats. It has a relatively plain, unadorned coloration, hence its species name *concolor*, 'same or even colour'. There is some variation from the typical lion-like tawny brown towards grey-brown, lighter browns, creamy beige and chestnut, although the 'black panther' form found in other large cats – an individual that is very dark, almost black, due to a genetic change – has not been recorded. But the only variations of hue on an individual animal are pale to almost white areas on the chin, jowls and throat down to the underside, along with a black tail-tip.

UNSEEN AT CLOSE QUARTERS

Despite such austere coloration, cougars have an almost mythical ability to remain unnoticed even when just a few steps away. They merge with dry brush, grasses and shrubs, rocks, boulders and scree, logs, boughs and tree trunks, and sedges and reeds along waterways. They have a tremendous ability to assess a threat (as they usually perceive approaching humans) and either remain perfectly still, or judge a moment to slink off unseen, or suddenly leap away in a quickfire flurry of retreat.

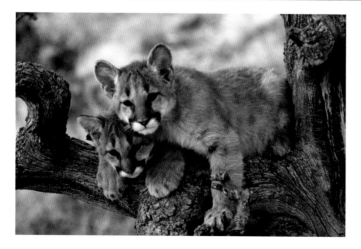

SPOTTY YOUTH

Despite its plain adult coat, cougar cubs are more like those of other cats. Infants have a pale background with dark, elongated body spots, a ringed tail and striking blue eyes. These markings fade with age to be confined to the flanks in juveniles. Such an appearance is ideal to conceal the cubs when they are left in their den among rocks, tree roots or a similar hideaway nook, while the mother is away hunting.

▶ At home in almost any habitat, from rocky mountains to humid swamps, the cougar is mostly a loner. The female and male come together only briefly to mate, while a youngster stays with its mother for two years or so. Otherwise, this cat is secretive and solitary.

◀ Cougar cubs have more pronounced markings that fade as they mature.

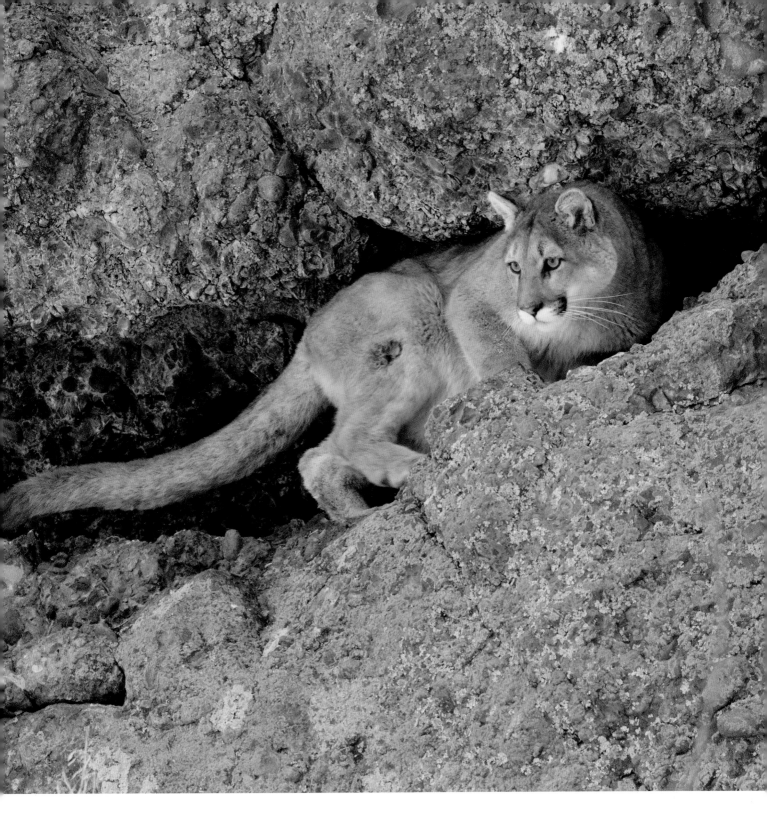

Polar bear

RULER OF THE ARCTIC

One of the world's most famous animals is also one of the most famous examples of camouflage. The polar bear's Arctic world is white, ice and snow, and therefore so is the bear.

However, the situation is more complex. The hairs of polar bear fur have no white pigment and the skin is black. Also, when full grown these bears have no natural predators (although male rivals tussle at breeding time), so the camouflage is not for self-defence, only for hunting. It conceals them when stalking seals, their principal food, or waiting next to a breathing hole for one to surface after chasing fish. Like many mammals, the bear has, in effect, two fur coats: longer, stronger hairs of the outer or guard coat; and shorter, denser hairs of the underfur. These hairs are transparent and also the guard coat hairs are hollow. By design, this double-layered furry covering obscures the bear's black skin.

SCATTERED LIGHT

How do the transparent hairs appear white? When sunlight hits a guard hair, some of the light rays pass into the hollow core. This is lined with sub-microscopic particles that split, or refract, and scatter the white light into its constituent colours of the rainbow, and these rays head off in all directions. The same happens on the outside of the guard hair due to particles and crystals of salt from the bear's last swim. All these vast quantities of individual rainbow rays reflect and emit away from the hair as a massive confusion of colours. As the coloured light rays leave the hair and the bear, they combine back into white light.

DISTRIBUTION MAP

- LOCAL COMMON NAMES
Arctic bear, White bear, Ice bear, Snow bear; Nanook, Nanuq (Inupiat/ Inuit, Yupik/Siberian); Isbjørn, Snøbjørn (Norwegian); Ledyanoy medvéd, Oshkúj, Bélyj medvéd (Russian); Umka (Chukchi)

- SCIENTIFIC NAME
Ursus maritimus

- SIZE
Head–body length 1.8–3m (5ft 10in–9ft 10in), height 1.1–1.6m (3ft 7in–5ft 3in), weight 150–700kg (331–1,500lb) (males are almost twice the size of females)

- HABITATS
Arctic and sub-Arctic coasts, seas and ice

- DIET
Primarily seals, also caribou/reindeer, musk ox, Arctic mammals such as hares and lemmings, birds, fish, crabs and other crustaceans, carrion

- CONSERVATION STATUS
IUCN Vulnerable (See key page 8)

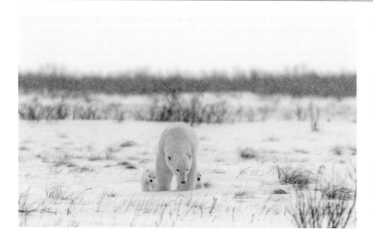

ADAPTING TO CHANGE

Polar bears are perhaps the best-known animals threatened by climate change. As the Arctic warms, sea ice of all kinds becomes less widespread and is also melting back earlier each spring. In some places the bears are adapting their diet; for example, hunting more birds and their eggs, and a wider range of mammals, from lemmings to caribou/reindeer. Near human habitation, the bears have also taken to raiding garbage heaps.

▶ Polar bears hunt mainly at the ice-sea boundary, including pack ice, drifting floes and breaking bergs. These are the areas frequented by their seal prey.

◀ Cubs stay with their mother for between two and three years.

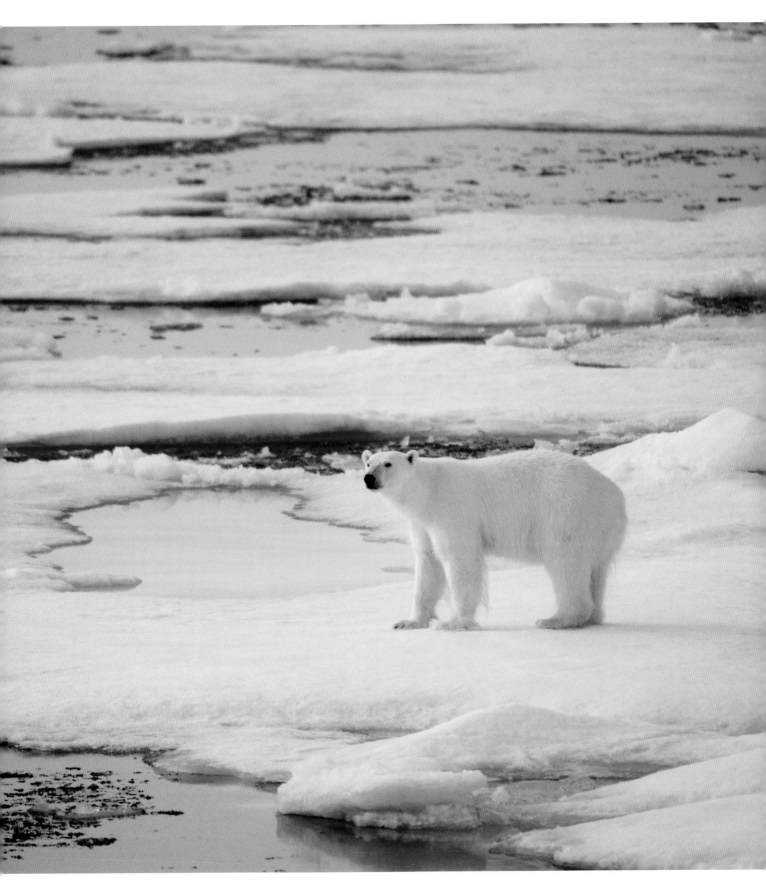

2

Central and South America

Bark lanternbug

BIG HEAD BUT NO GLOW

The bark lanternbug is a substantial and bulky insect, the head and body reaching the size of a human finger and the wings spanning a human hand. Yet this weird creature can flatten itself to rest at ease on old tree trunks. The upper surfaces of its light grey to mid-brown head, body and forewings have plentiful light spots and speckles that copy, to a remarkable degree, the peeling, patchy bark and growths of moulds and lichens found on almost any tropical forest tree.

There are hundreds of kinds of lanternbugs around the world, most in tropical forests. One of the best known is the South American species identified simply as 'the' lanternbug, bark lanternbug or, often, lanternfly. But it is not a fly; it is a member of the insect group called true bugs, hemipterans, which are mostly suckers of plant fluids. Nor can it emit light like a lantern. The origin of this common name is confused. One explanation is that certain similar big-headed insects do emit light due to glowing bacteria in the bodies and this ability was incorrectly transferred to the lanternbug. Another is that the head shape is said to resemble an old-fashioned oil lamp.

PRETEND TEETH

The lanternbug is also nicknamed peanutbug because of its extraordinary head shape, and alligator bug due to the patterns resembling eyes and teeth along the sides of the head's forward protuberance. However, all this is for display, part of the insect's anti-predator defences. The tooth markings cannot bite, and the actual mouth under the head is harmless, shaped like a stout straw to suck vegetative juices.

- LOCAL COMMON NAMES
 Peanut bug, Alligator bug, Air snake, Flying snake; Jequitiranaboia, Tiramboia (Portuguese); Chicharra, Machaca (from Spanish)

- SCIENTIFIC NAME
 Fulgora laternaria

- SIZE
 Body length 7–8cm (2¾–3in), wingspan 12–14cm (4¾–5½in)

- HABITATS
 Tropical forests, parks and gardens

- DIET
 Plant juices such as nectar and sap from stems, buds, flowers and fruits

- CONSERVATION STATUS
 IUCN Not evaluated
 (See key page 8)

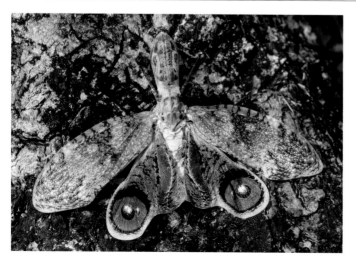

SURPRISE IN STORE

If the bark lanternbug's crypsis is rumbled and it is harassed, the molester has a surprise in store. The bug flicks forward its forewings to reveal menacing eyespots on the hindwings. This trick is known in other insects, including butterflies – the eyes mimic a more fearsome predator such as a cat, snake or owl. If even this fails, the bug squirts a foul liquid from its rear end.

▶ Deep in the Amazon rainforest, a bark lanternbug's wings are a close match to the mossy, lichenous bark. Its bizarre head is also overlooked at a glance, but when it is recognized, its tooth-like pattern may well put off a potential predator.

◀ A lanternbug reveals its menacing eyespots.

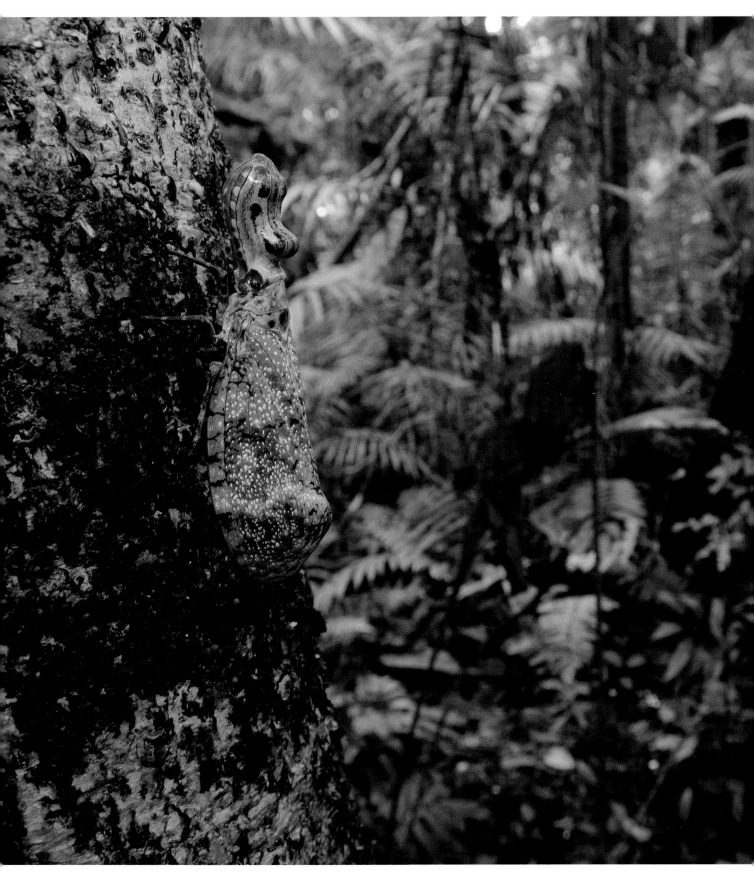

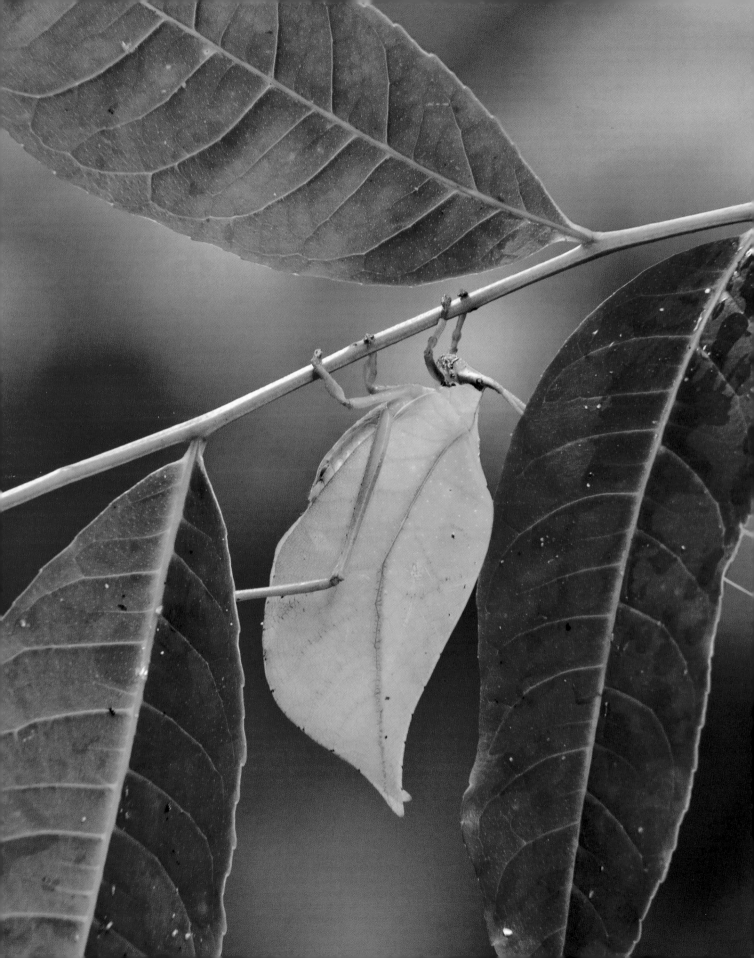

Leaf katydid

SOPHISTICATED SIMULATION

Many tropical trees have glossy, bright green leaves with one central stiffening vein, the primary, extending from the leaf stalk, or petiole. Slightly thinner secondary veins branch alternately from this. Narrower tertiary veins continue the branching or network, which is known as the leaf's venation pattern. Leaf veins contain two sets of microscopic tubes, one (xylem) bringing water up from the roots, the other (phloem) carrying sugars made during photosynthesis from the leaf to the plant's other parts.

DISTRIBUTION MAP

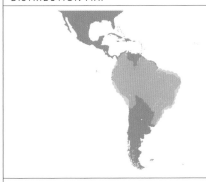

- LOCAL COMMON NAMES
 Leaf-mimic katydid, Leafy longhorn grasshopper, Leafy green bush-cricket; Grillo verde (Spanish, Italian)

- SCIENTIFIC NAME
 Cycloptera speculata

- SIZE
 Head–body length 3–5cm (1¼–2in), wingspan 10cm (4in)

- HABITATS
 Tropical forests

- DIET
 Plant matter, from soft buds to leaves and flowers

- CONSERVATION STATUS
 IUCN Not evaluated
 (See key page 8)

LEVELS OF CAMOUFLAGE

Similarities between these leaves and the leaf katydid are astonishing. The venation pattern of the insect's forewings copies to an amazing degree the leaves all around. Overall size, surface glossiness and transparency are also comparable. In addition, the insect's greenish, yellow or brown body and legs copy the stalks and twigs of its tropical forest home. Provided the katydid remains still or moves in a leaf-like fashion, it represents one of nature's foremost examples of camouflage.

Katydids are also known as bush crickets and there are more than 6,500 different species – one-third of these living in the forests of South America. The majority exhibit cryptic appearance as green or brown leaves, or various stems, stalks, twigs, or even flowers. Katydids are cousins of other kinds of crickets, wetas and grasshoppers. All of these insects, collectively termed orthopterans ('straight wings'), feed by biting and chewing plant matter and are active at night, regularly filling the forest with their strident chirps and other calls.

◄ As it settles to rest for the day, the leaf katydid usually orientates itself to match the leaves around it. Should it be detected, its first line of defence is to leap away on its powerful rear legs, simultaneously flashing and fluttering its wings. It can also deliver strong kicks with its clawed back feet.

LONG 'HORNS'

Crickets including katydids are sometimes called longhorned grasshoppers. The 'horns' are actually their antennae or feelers and may be more than twice the body length. They tap and stroke the surroundings as the insect moves around by feel at night, looking for suitable food plants. They are also extremely sensitive to air movements and surface vibrations which may warn of an approaching predator, and to odours carried as airborne chemicals.

South American common toad

CREATURE OF MANY GUISES

Leaf toad, forest toad, leaf-litter toad, dead-leaf toad, crested toad, mitred toad – the South American common toad has many common names. It also varies hugely in appearance across its wide range, with many patterns and colours. Most of these mimic old brown leaves on the forest floor. Here the toad sits and waits for small prey, predominantly ants and other insects such as flies and beetles, to come within reach of its wide, fast-gulping mouth.

MAY BE, MAY NOT BE

The toad's back (upper or dorsal surface) is gently curved to match a leafy shape. Individuals have varying leaf-litter colours, from cream-brown through grey-brown and red-brown to dark brown. There may or may not be random dark or black spots and blotches scattered over the back. It may have a stripe along the middle of the back that copies the main strengthening strip or vein in a leaf. If there is a mid-dorsal stripe, it is light in some individuals but dark in others. There may or may not be a bony crest over each eye. If there is, it could be large and noticeable (like a mitre hat), or almost imperceptible. When they do occur, crests are more common in females. There may or may not be other bony protrusions on the face and jaws. And there may or may not be a row of bony lumps, tubercles, along the back.

All of this variation is only part of the complexity and diversity of the South American common toad. Its main scientific species name is *Rhinella margaritifera*. However, there are at least fifteen and perhaps twenty different, closely related species, which scientists are still trying to sort out.

DISTRIBUTION MAP

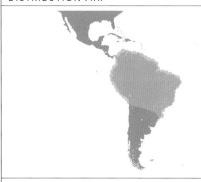

- LOCAL COMMON NAMES
 Leaf toad, Forest toad, Leaf-litter toad, Dead-leaf toad, Crested toad, Mitred toad; Sapo crestado (Spanish)

- SCIENTIFIC NAME
 Rhinella margaritifera and about 15–20 other species of *Rhinella*

- SIZE
 Head–body length 4–7cm (1½–2¾in), weight 20–70g (⅔–2oz) (females are larger than males)

- HABITATS
 Tropical rainforests

- DIET
 Ants and similar small insects, worms, slugs, millipedes

- CONSERVATION STATUS
 IUCN Least concern
 (See key page 8)

A COMPLEX SPECIES

Biologists continue to study the 'species complex' of *Rhinella margaritifera* toads, including their body shapes, colours, patterns and other anatomical details, and also their genetic material and geographic distribution. Regularly there are scientific reports that re-identify, rename and reassign certain species, or recognize a new one, such as *R. magnussoni* in 2007 and *R. yunga* in 2014.

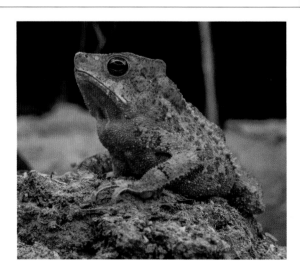

▶ This common toad individual has a well-demarcated pale stripe mid-dorsally, that is, down the middle of its back. Others may have a thinner version, or a partial broken stripe, or none at all.

◀ Another individual demonstrates a paler, more even colouring and also the ridges over the eyes and neck that give it one of its many common names – crested toad.

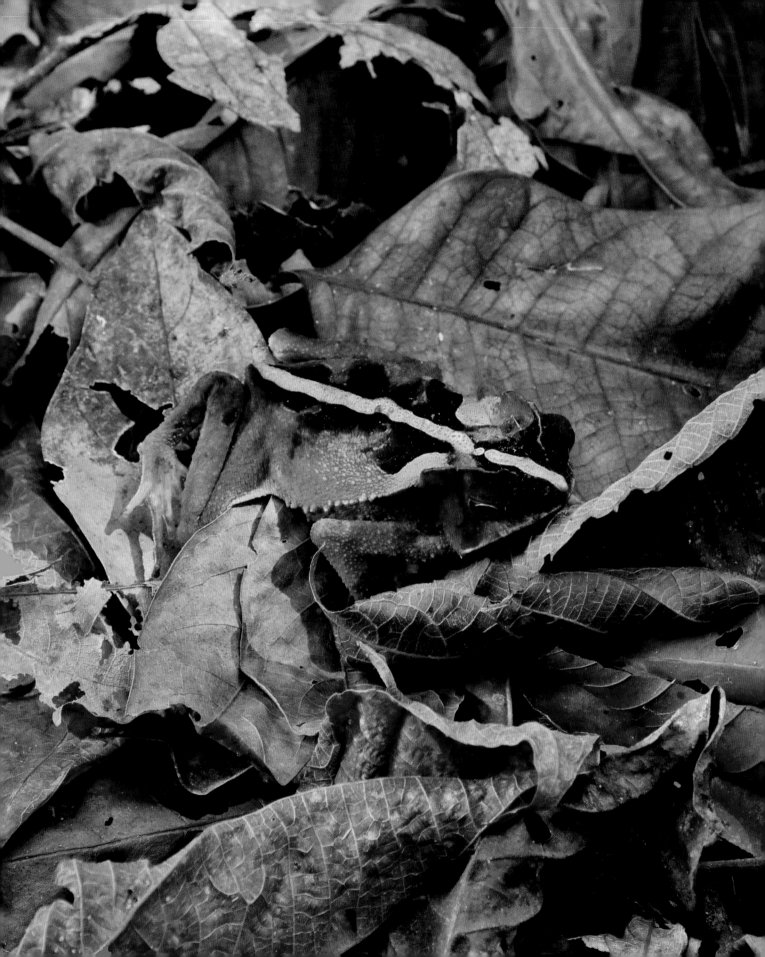

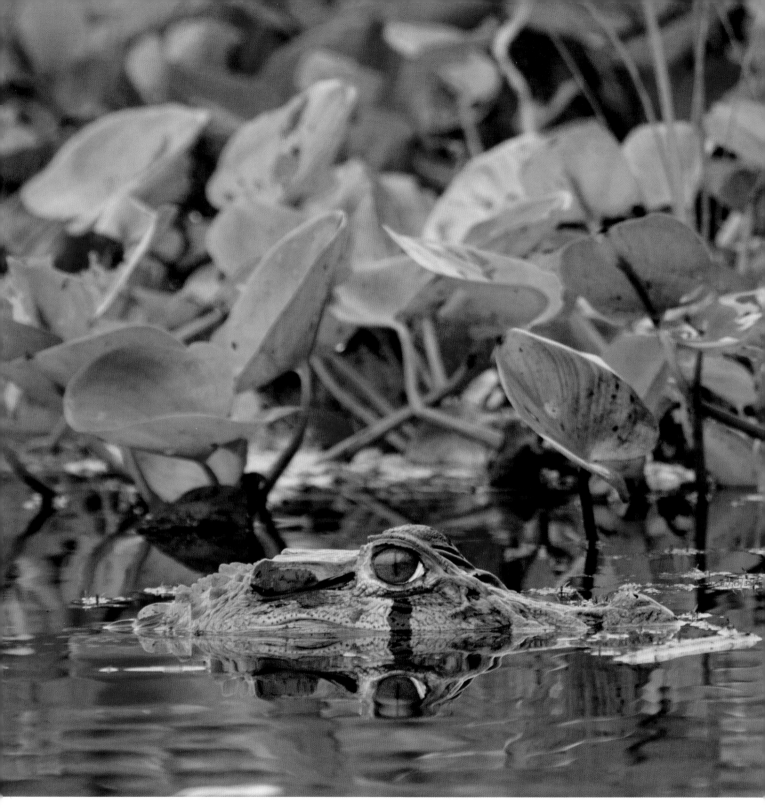

Loitering with intent, a black caiman waits in one of its favourite hunting spots among water plants. Its dark or black coloration develops gradually with age, from the more distinctive patterns when young (opposite).

Black caiman

SAME OLD LOG STORY

With the largest black caimans – all males – exceeding 5 metres (18 feet) long and scaling 400-plus kilograms (900 pounds), this is one of the true apex (top) predators of the Amazon region. It is rarely troubled by its ecosystem equivalents in this area, which include the jaguar, green anaconda and giant otter, so its camouflage is mainly adapted for hunting.

The black caiman feeds principally at night. In typical crocodilian fashion, it impersonates an old log, often partly hidden by leafy plants, entwined sticks and stems, and other tangled vegetation. Its scaly armoured skin resembles furrowed bark. Its coloration is mainly dark grey, olive, tan or brown; in some mature individuals it is so murky as to be almost black. There are lighter yellow or greenish, irregular, strips and stripes on the pale chin and encircling the main body, where they form vague hoops, although much fainter or imperceptible on the back and underside. These markings, prominent when young, fade over time to become almost unnoticeable in aged individuals; their function is to intermingle with plant shoots and leaf stalks to complete the visual effect.

AT THE WATER'S EDGE

The black caiman hunts on land as well as in water. One of its habits is to be at the water's edge, lurking in thick undergrowth as animals come for a night-time drink. When it senses a victim, the caiman lurches or charges forward in a surprise attack and clamps its powerful jaws with about seventy teeth onto the prey's head or neck. Almost any sizeable animal is quarry, including all kinds of reptiles, birds and mammals, from younger caiman, turtles, snakes and lizards, to monkeys, sloths and also domestic stock, such as goats, horses and cattle.

- LOCAL COMMON NAMES
 Caimão, Jacaré negro, Jacaré açu (Portuguese); Caimán negro, Cocodrilo negro (Spanish); Chamana, Acayouman (Amazonian native languages)

- SCIENTIFIC NAME
 Melanosuchus niger

- SIZE
 Length up to 5.5m (18ft), weight up to 500kg (1,100lb)

- HABITATS
 Most freshwater bodies like slow rivers and streams, lakes, swamps and other wetlands, seasonally flooded savanna and bush

- DIET
 Mainly large prey, including fish, turtles and other reptiles, birds, mammals such as capybaras, peccaries and tapirs

- CONSERVATION STATUS
 IUCN Lower risk/Conservation dependent
 (See key page 8)

RIGHT FIRST TIME

The crocodilian group includes crocodiles, gharials (gavials), alligators and caimans. Traditionally there were 22–23 different kinds, or species, but recent genetic studies have increased this to perhaps twenty-seven. Ten are in the alligator-and-caiman group; six of these are caimans, and the black caiman is the biggest of the caimans. Apart from size, all crocodilians have a similar appearance, body form and lifestyle, which dates back to early dinosaur times, more than 200 million years ago. The design is one of evolution's greatest 'right first time' successes.

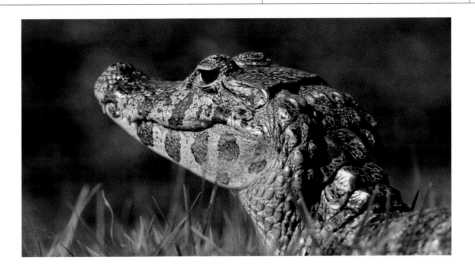

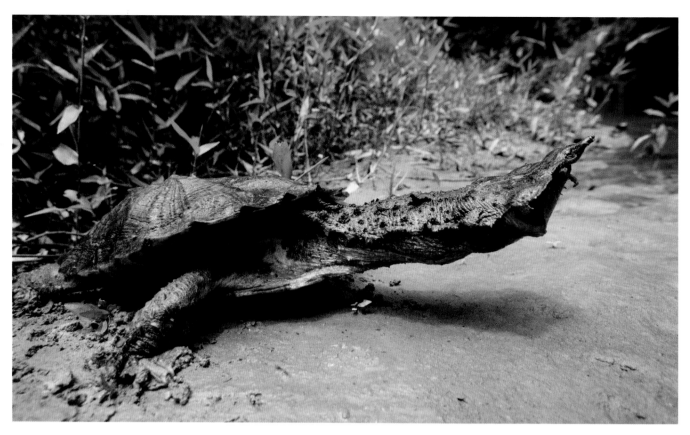

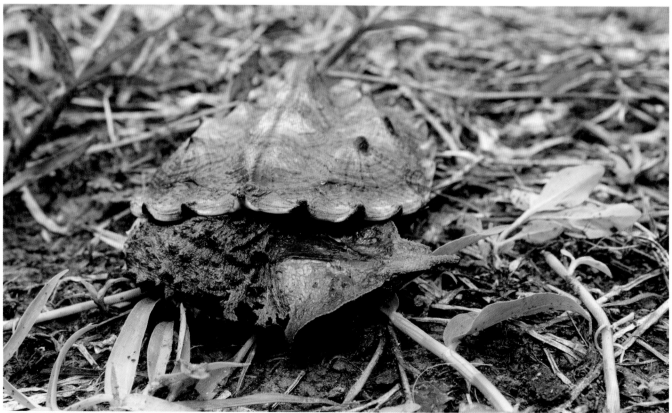

Matamata

STICKING ITS NECK OUT

One of the weirdest shapes in the natural world, the matamata is distorted in almost every direction, apart from its fairly typical turtle shell. This metre-long (3-feet 3-inch), well-built reptile has a flattened triangular head with an almost head-wide broad mouth and a wide, frilled, muscular neck, which both seem far too large for its body. Its dull brown, olive and grey scales and skin, with plentiful flaps and fringes, blend perfectly with old leaves, moss, boulders, bark, aquatic plants and other vegetative remains in its murky, swampy Amazonian home.

Capitalizing on its appearance, the matamata is seriously sedentary. It hardly moves at all for days, even weeks. It allows bits of mud and decaying plant matter to settle over it, adding to its concealment. But what it does do is acutely monitor its surroundings. Its skin fringes and flaps detect even the faintest water currents and vibrations. It can hear very well with its large eardrums. It also has reasonable vision, despite its small, beady eyes, although it usually feeds at night when sight is less useful in the muddy water.

SUCKER FOR FOOD
The matamata's primary hunting method is to lie still, seemingly doing nothing, and wait. Sooner or later a small fish or other potential quarry is bound to come near. The turtle still seemingly does nothing, nothing, not a lot, until – gulp! Its neck swipes sideways, its massive mouth opens, and its throat muscles expand, sucking in water and the food; then the mouth and throat push out the water through almost closed jaws, while the meal is retained and swallowed. All this happens in less than a second. Then it's back to wait, wait, wait.

DISTRIBUTION MAP

• LOCAL COMMON NAMES
Mata mata, Mata-muta

• SCIENTIFIC NAME
Chelus fimbriata

• SIZE
Head and neck 40–50cm (1ft 3in–1ft 7in), carapace 40–50cm (1ft 3in–1ft 7in), weight 15–20kg (33–44lb)

• HABITATS
Slow rivers, pools, swamps and similar wetlands, usually with murky water and much vegetation

• DIET
Fish, frogs, crabs, other aquatic animals, birds, small mammals

• CONSERVATION STATUS
IUCN Not evaluated
(See key page 8)

◀ (Top) Emerging from the water, a matamata shows its outstretched head and neck, seemingly disproportionately large compared to the shell and body. (Bottom) The main defensive posture is bending the head to one side.

BENDY NECK
A member of the side-necked turtle group, pleurodires, the matamata cannot withdraw its head and neck directly rearwards into its shell, as can the members of the other main turtle group, the cryptodires. This seems obvious from the matamata's proportions. It even struggles to do the typically pleurodire trick of bending its neck sideways, and so the neck and head are tucked under the shell's front overhang, positioned in front of one foreleg. Such defence is usually towards its main enemies, caimans and jaguars.

Green vine snake

EMERALD AMBUSH SPECIALIST

Slim, speedy, day-active, agile, tree-dwelling, venomous to small creatures – and very green. This species is one of four vine snakes in the Americas. Vivid green on its back, the underside is paler, especially so on the long, pointed-snout head, where the two shades are well demarcated along a line through the golden eye. This serves as disruptive coloration, breaking up the head shape. Even the tongue is green, flicking out of a wide mouth designed to swallow victims even larger than the head, by unhinging the jaws.

The green vine snake is a lie-in-wait ambush specialist, relying on its colour and shape to provide amazing crypsis and remain undetected, while small creatures go about their business among the rainforest foliage or along the ground below. The reptile's slim profile resembles lianas and other vine stems that themselves snake among the leaves and twigs in this all-green world. Even sharp-eyed small birds and tree mice may fail to notice the stationary reptile, which sometimes does not move for many hours until a suitable chance arrives to grab a meal.

LIGHTNING STRIKE

Some green vine snakes learn to ambush hummingbirds. They wait next to a suitable bloom and, as the bird hovers to collect nectar with its long tongue, the vine snake darts its head and front body forward in a lightning strike; the rear body remains twisted around boughs and anchored in the foliage.

Another hunting technique is to descend from a tree to the forest floor and track the victim by smell, taste, vibration and sight. Once in the mouth, the snake rapidly re-ascends into the branches where the prey is subdued and swallowed.

DISTRIBUTION MAP

- LOCAL COMMON NAMES
 Cobra papagalo (Spanish); Paranabola (Portuguese); Bejuquilla verde (Italian); Cipo, Cobra bicuda (local dialects from Spanish)

- SCIENTIFIC NAME
 Oxybelis fulgidus

- SIZE
 Length 1.5–2m (5ft–6ft 6in), width 2cm (¾in), weight 100–300g (4–10oz)

- HABITATS
 Tropical forest

- DIET
 Lizards, frogs, small birds including nestlings, mice and other small mammals

- CONSERVATION STATUS
 IUCN Least concern
 (See key page 8)

CHEWED-IN VENOM

Vine snakes are rear-fanged, having the two longest sharp teeth towards the back of the mouth. After grabbing prey, the snake makes chewing motions to jab in the venom. The prey is quickly overcome, ceases to struggle, and the snake continues to swallow at leisure. The venom disables small creatures but has little effect on humans, and in any case, the rear fangs cannot be brought into action during a normal strike-bite on a bigger creature.

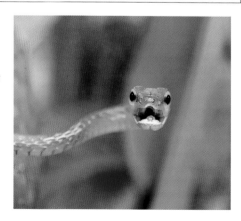

▶ The combination of leaf-green colour, disruptive tones on the head, overall body shape and sneaky ambush-trap behaviour all make the green vine snake a truly striking example of camouflage.

◀ The green vine snake is rear-fanged.

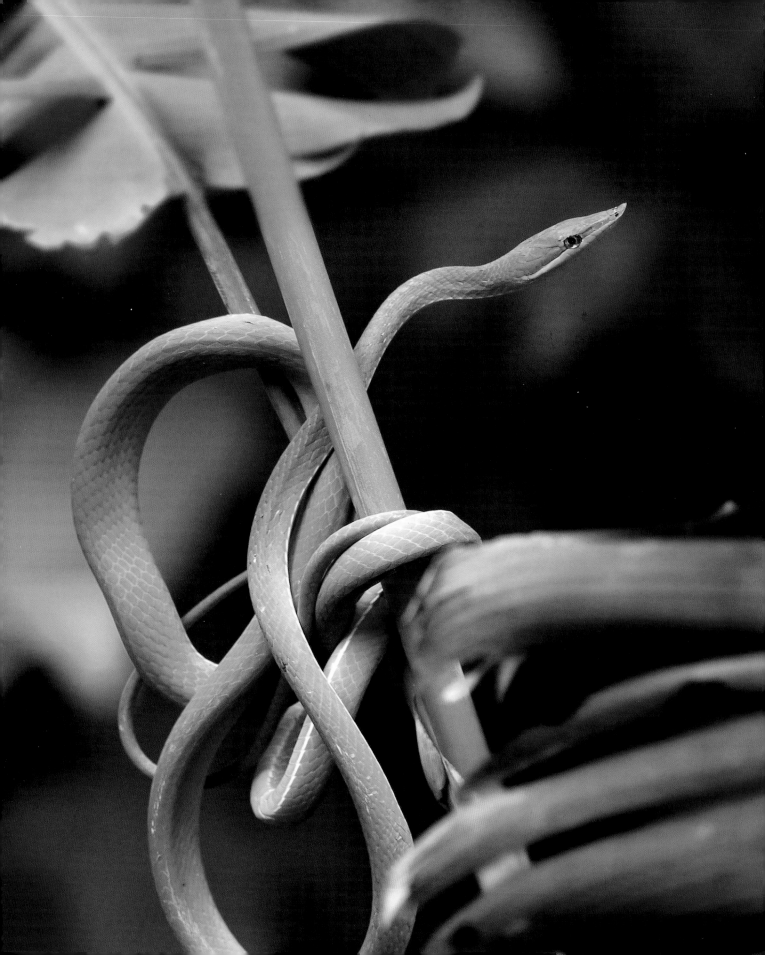

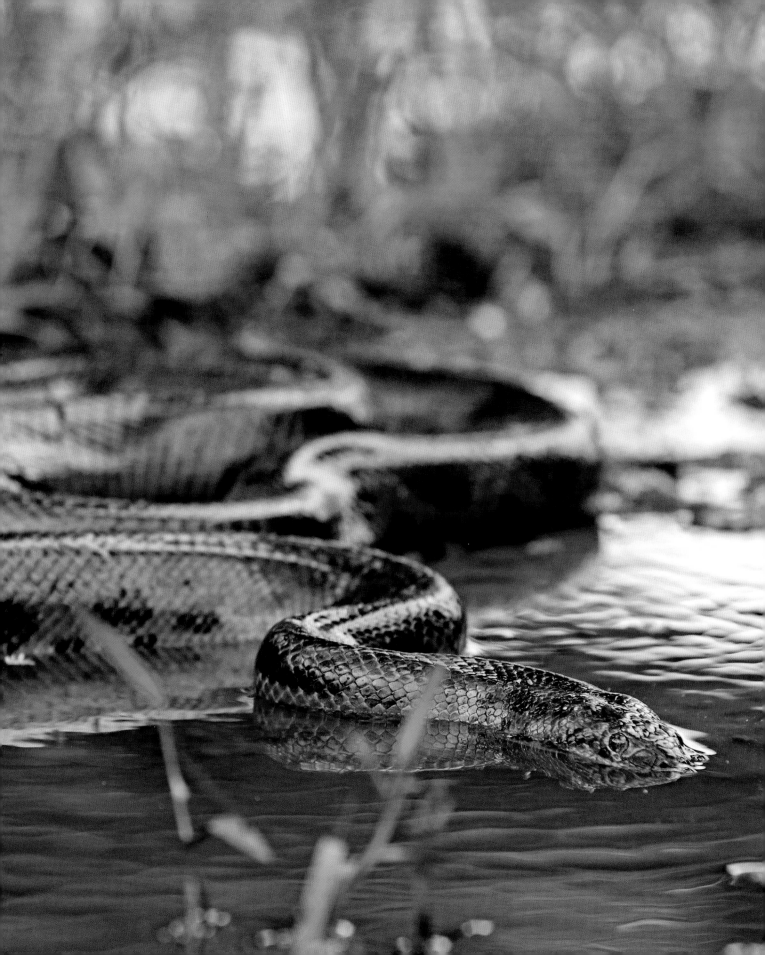

Green anaconda

WATER MONSTER OF THE DEEP AMAZON

Certain types of Asian pythons may grow slightly longer than the green anaconda, but no other snake matches this one's bulk and sheer muscle power. There are four kinds of anacondas, members of the boa and python family, and all in the Americas, with the green being the most massive. These snakes have no venom, but they do have enormous coil-and-crush force that kills their victim by shock, heart stoppage or suffocation.

A VARIABLE SNAKE

The 'green' anaconda's background colour is predominantly dark olive-green, perhaps with shades of brown or grey, although there is considerable variation, with some individuals being lighter pale grey-green or yellow-olive. The main markings are oval or rounded, dark to black splotches with brown or olive centres, variable in size, some merging together, along the back and sides of the body. However, again, these vary in colour, being almost solid black in some individuals. The snake's chin and belly usually have a much paler background, mainly yellow, so the markings stand out more in contrast. Also, the head has a stripe on either side running from the rear of the eye diagonally down to the angle of the jaw, which helps to distract from or disrupt the head's shape so it looks less snake-like. The green anaconda's overall appearance is ideally suited to skulking loosely draped or coiled among forest floor leaves, twigs and other debris, or in the tangle of leaves and stems at the waterside. This predator feeds mainly at night, when its patterning is even less noticeable, especially if the snake is semi-submerged. It is not especially rapid on land, but sleek and speedy in the water as it attacks land animals approaching the water's edge for a drink.

DISTRIBUTION MAP

● Includes Yellow anaconda, (*E. notaeus*) ranges overlap

- LOCAL COMMON NAMES
 Giant anaconda, Anaconda, Water boa; Sucuri, Jibóia (Brazilian Portuguese); Kamudi, Kamodo (local Arawak dialects)

- SCIENTIFIC NAME
 Eunectes murinus

- SIZE
 Length up to 6m (19ft 8in), diameter up to 40cm (1ft 3in) (after large meal), weight up to 150kg (330lb 11oz) (females are significantly larger than males)

- HABITATS
 Wetlands such as swamps, rivers, streams and lakes, rainforest, seasonally flooded bush and grasslands

- DIET
 Fish, reptiles including turtles and caimans, birds, mammals up to the size of deer, capybaras, peccaries and tapirs

- CONSERVATION STATUS
 IUCN Not evaluated (See key page 8)

◄ Shallow-water swamps with fringing vegetation make excellent hunting for the green anaconda. It is able to lunge at speed and grab a victim either on land or in the water.

IT WAS THIS LONG, REALLY!

Like many truly big, powerful animals, the size of the green anaconda is often highly exaggerated. Tales are told of enormous specimens more than 12 metres (39 feet) long, with weight guesses exceeding 250 kilograms (551 pounds) (equivalent to four average humans). Estimating difficulties for length include the snake being semi-submerged or partly coiled and among thick vegetation. Semi-scientific measurements of exceptional examples are mostly around 7–8 metres (23–26 feet) and 150–200 kilograms (330–440 pounds).

Potoo

ON THE WING, OPEN WIDE

Nightjars, frogmouths and potoos all have similar lifestyles. They fly at twilight and night-time. They hunt mainly by vision, their big, bulging eyes wide open and their very wide mouths extremely wide open. They swoop at and scoop in small nocturnal insects, such as moths, mosquitoes and gnats. They can even swipe or snatch the occasional spider or centipede from a leaf or twig.

By day, these birds rest in the open, relying on their camouflage to avoid discovery by their predators, such as falcons, monkeys and large snakes. The potoo's chief defence, which does not sound so glamorous, is pretending to be a bit of an old tree. But at this it is supremely successful. Old wood tends to pale and accumulate spots and splashes, and growths of lichens, moulds and other agents of rot and decay. Splits appear and branches fall off, leaving short stumps and snags. This is the potoo's skill. Its feathers are haphazardly marked creams, browns, greys and charcoals, with ragged edges. It sits tight, stays still and looks like a bit of ageing, broken-off stump. It chooses a bough of appropriate width and also adopts the pose of a stump, inclined at a realistic angle to the main limb.

JUST AN OLD, BROKEN STUMP

The potoo's eyes are usually partly open in daylight, ready to spot problems. But if it is worried, the slitted eyelids close and the eyes become barely perceptible, yet still allow vision, and the bird adopts its rigid, just-an-old-stump posture. The eyes do not fully open unless danger is unavoidably near and the bird is ready to flee, since the dark-centred, glowing-yellow staring balls would be an immediate giveaway.

DISTRIBUTION MAP

- LOCAL COMMON NAMES
 Potu, Lesser potoo, Grey potoo, Poor-me-one; Nibijau gris (French); Nictibi (Portuguese); Nictibio (Spanish, from Latin)

- SCIENTIFIC NAME
 Nyctibius griseus

- SIZE
 Bill–tail length 35–40cm (1ft 2in–1ft 4in), wingspan 85–95cm (2ft 9in–3ft 2in), weight 160–180g (5–6oz)

- HABITATS
 Varied, from open and marginal tropical forests to bush, grasslands, plantations, parks

- DIET
 Nocturnal insects and other small invertebrates

- CONSERVATION STATUS
 IUCN Least concern
 (See key page 8)

NO-NEST NEST

During the breeding season, potoos continue their camouflage even when away from their nest. In fact, there is no nest as such; at least, no gathered nesting materials. The single egg is laid in a nook, hollow or depression in an old stump or the angle of a branch, uncovered and able to be seen, yet rarely detected. The chick has similar behaviour and plumage as its parent, although usually paler in hue.

▶ The common potoo chooses its daytime perch carefully. The tree branch's coloration, diameter and angle must all be suitable to match its size and plumage.

◀ The potoo typically stretches its head and bill in line with the body and presses its wing and tail feathers down onto the bark to disguise its outline and blend flawlessly with the wood. The deception continues even at the egg site.

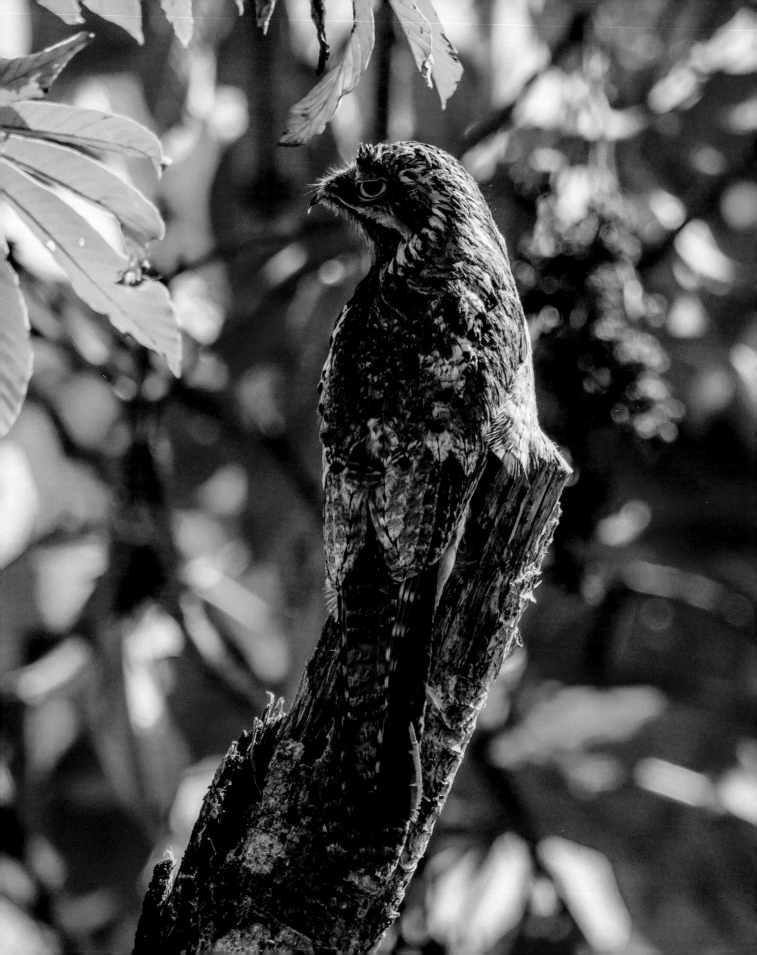

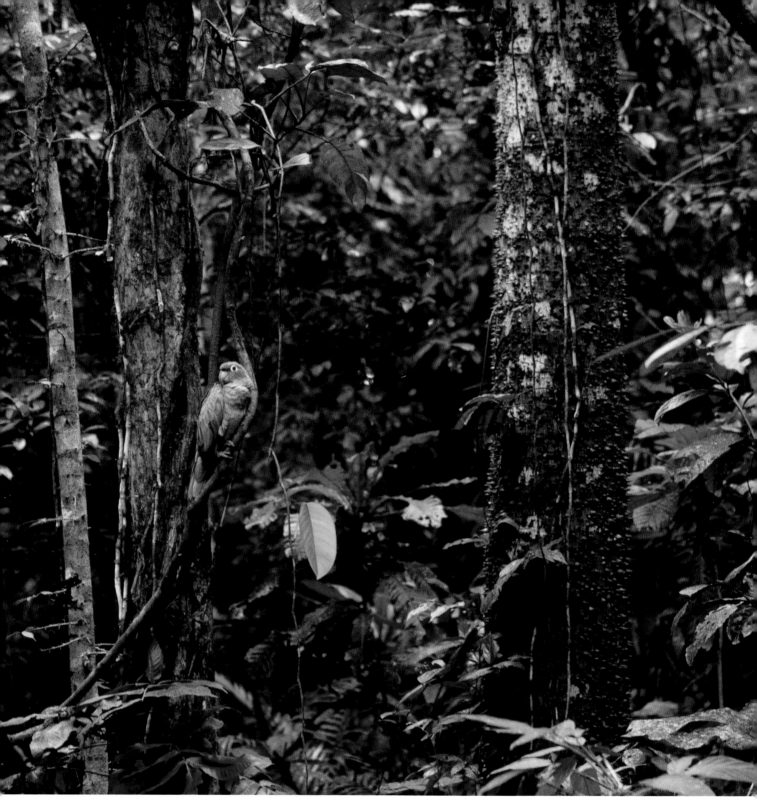

When not feeding, flocking or squawking, the
amazon parrot becomes just another mostly
green item in the rainforest. Closer to, the
powerful hooked bill is more clearly visible and
a serious defensive weapon (opposite).

Amazon parrot

MAINLY GREEN, BRIGHT TRIMMINGS

About thirty kinds of amazon parrots make up the genus (species group) *Amazona*. Often simply called 'amazons', certain species are familiar from the trade in, and keeping of, exotic birds. However, the exact number of amazon parrot species, the physical characteristics of each, and where it lives, are the subject of lively ongoing debate for ornithologists. There are different amazon parrots on numerous Caribbean islands, and on the American mainlands from Mexico through Central into South America, and south to Paraguay and Argentina. Also, some have been introduced to other regions, for example, the United States.

● Yellow-crowned amazon

- **LOCAL COMMON NAMES**
 Amazon, Green parrot; many individual species names such as Yellow-crowned amazon (*Amazona ochrocephala*), Blue-cheeked or Dufresne's amazon (*A. dufresniana*), Tucumán amazon (*A. tucumana*)

- **SCIENTIFIC NAME**
 About 30 species in the genus *Amazona*

- **SIZE**
 Most species in the range bill–tail length 25–40cm (10in–1ft 3in), weight 250–500g (9oz–1lb 2oz)

- **HABITATS**
 Mostly forests and woods, some species also mangroves, grasslands, farmland, plantations, suburbs, parks

- **DIET**
 Seeds, berries and other fruits, buds, shoots, leaves, other plant materials

- **CONSERVATION STATUS**
 IUCN varies from Least concern (about 7 species) to Critically endangered (e.g. Imperial amazon, *A. imperialis*) (See key page 8)

ACCENT MARKINGS

Despite the complexity of all these species and their relationships, almost all amazon parrot species are basically leaf-green. Forests and woods are their chief habitats, and when sitting quietly among the leaves and branches, these parrots are most easily overlooked. Their foods are almost all plant-based, so their camouflage is not for their own hunting purposes, but defensive (anti-predator). Despite being mid-sized birds with extremely strong, hooked bills and powerful, sharp-clawed toes, amazon parrots can fall victim to hunters. These include cats ranging from jaguars to ocelots, also snakes such as boas, large monkeys, and bigger birds of prey – especially the American harpy eagle, one of the world's largest eagles, and a fearsome, agile rainforest hunter.

Added to the basic green, each amazon parrot species has its own distinguishing and usually smallish 'accent' colours or markings that give its common name: blue-cheeked amazon, red-necked amazon, yellow-shouldered amazon, orange-winged amazon, red-tailed amazon, and so on. Where species ranges overlap, these markings help the birds identify members of their own kind for purposes such as flocking for travel and safety, feeding together, and, of course, for mating.

EVER-POPULAR PETS

Amazon parrots figure prominently in aviculture (keeping and breeding wild birds in captivity). Their bold personalities, lively appearance, ability to mimic sounds including human speech, sedentary habits, amenability to captive conditions and food, manipulative feet and toes, and especially their remarkable intelligence, are all endearing traits. However, collecting from the wild has brought some species to the brink of extinction.

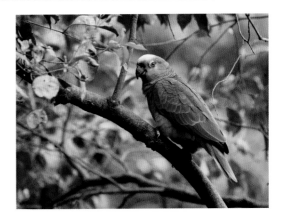

Three-toed sloth

SLOW ANIMAL, BUSY FUR

It is partly the three-toed sloth itself which has evolved remarkable camouflage. It is also the tiny plant-like growths called algae, and various kinds of fungi or 'moulds', populating the sloth's fur. These provide tinges of green and grey that ideally match the surrounding leaves and branches where this extremely arboreal (tree-dwelling) mammal is totally at home.

The most common and widespread of the four kinds of three-toed sloths is the brown-throated species. As in other sloths, and many other mammals, it has a soft underfur or undercoat of short, dense, flexible hairs, and an outer coat of longer, stiffer guard hairs. The sloth's guard hairs are unusual in several ways. They do not grow and lie, or point, in the direction of the extremities (limbs), as in most mammals, but away from them. This is due to the sloth's customary position of hanging upside down from a branch, so that rainwater and falling debris, such as bits of leaves, are easily shed downwards rather than becoming trapped in the fur.

A THRIVING ECOSYSTEM

Also, a sloth's guard hairs are not smooth-surfaced. They have many tiny crevices and cracks, which are miniature shelters for flourishing colonies of algae and fungi. In fact, the sloth's fur hosts a wide range of life, including blood-sucking parasites such as ticks, flies and lice. There are also small beetles, moths and flies, which are not parasitic but commensal. This means they live in the fur and gain nourishment from the other organisms around them – including from their excrement, eggs and other products – without harming their sloth host. In this sense the sloth's fur is not only superb camouflage but also an entire miniature, thriving ecosystem.

DISTRIBUTION MAP

- LOCAL COMMON NAMES
 Brown-throated sloth; Perezoso tridáctilo, Perezoso bayo, Perezoso grisáceo, Guasa (Spanish); Preguiça comum, Bicho preguiça, Preguiça de óculos (Portuguese)

- SCIENTIFIC NAME
 Bradypus variegatus

- SIZE
 Head–body length 50–70cm (1ft 7in–2ft 3in), weight 3.5–5.5kg (7lb 11oz–12lb 2oz)

- HABITATS
 Tropical forests of many kinds

- DIET
 Leaves, flowers, fruits, shoots, buds

- CONSERVATION STATUS
 IUCN Least concern (See key page 8)

FINGERS AND TOES

The 'three-toed' sloth might be more accurately named 'three-fingered'. All six kinds of sloths have three clawed toes on each hind foot, so anatomically they are all three-toed. The difference is the front feet, or hands. Each of the four 'three-toed' species has three digits or fingers, while the two kinds of 'two-toed' sloths have two digits. Despite such details, all sloth species are similar in appearance, habits and camouflage.

▶ Sloths are true to their sluggish reputation. They hang around, eating leaves, for six to eight hours daily, but often move only a few tens of metres. The remainder of the day and all night they rest and sleep, often in the angle of a branch, camouflaged from predators such as eagles and cats such as ocelots and jaguars.

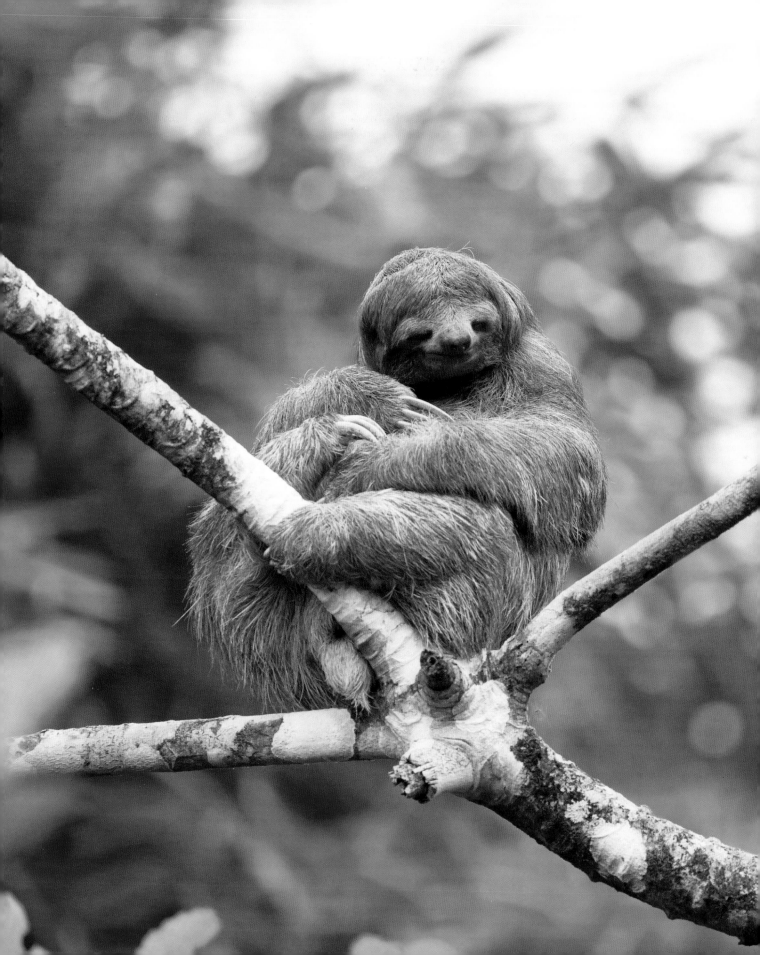

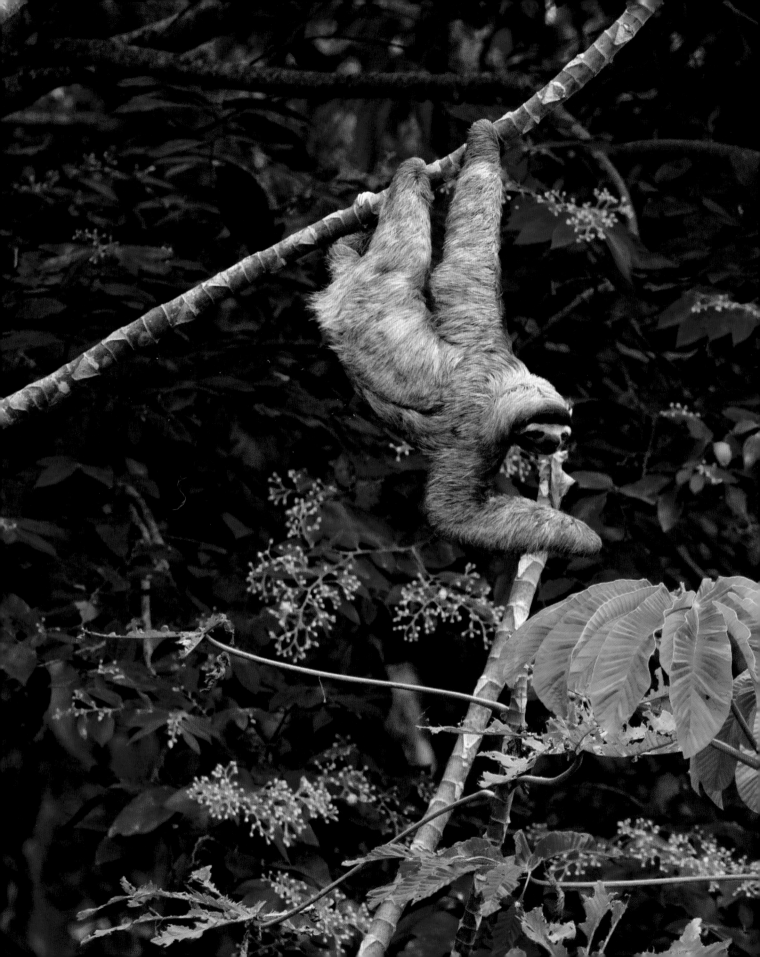

Proboscis bat

EXPOSED ROOSTER

Bats are famous for roosting by day in caves, rocky overhangs or similar concealed places, including human structures such as barns, outhouses and store-sheds. Not the proboscis bat. It rests by day in the open, usually on a tree trunk, branch or woody equivalent in a building such as a beam or rafter. In some areas the bats choose rocky surfaces such as crags and cliffs. Hence the need for camouflage from enemies such as large spiders and centipedes, tree snakes, and hawks and other birds of prey. These bats rest in groups, often in a line when few in number (5–20), and in an oval configuration for larger groups (approximately 20–50).

As the name suggests, the proboscis bat is characterized by its large, fleshy nose. Its soft, thick fur is brown-grey and the hairs change hue along their length to give a faint speckled or 'grizzled' effect (as in the grizzly bear) to tone with the wood or rock it rests on. The animal actively searches out a surface which has a similar colour to itself, and also into which it can dig its sharp claws to hold on safely and with little effort.

SYNCHRONIZED ROCKING
A scientific study at proboscis bat roost sites used electric fans to mimic different wind speeds. The results indicated that in stronger winds, the bats were more likely to sway or rock their bodies slightly, and also to groom themselves and urinate, all individuals in unison. The scientists suggested this behaviour helped the bats to camouflage as patches of vegetation that naturally swayed in stronger breezes, and that the rocking motion masked other necessary activities such as those mentioned above.

DISTRIBUTION MAP

- LOCAL COMMON NAMES
 Brazilian long-nosed bat, Sharp-nosed bat, River bat; Murciélago narigón (Spanish)

- SCIENTIFIC NAME
 Rhynchonycteris naso

- SIZE
 Head–body length 4–6cm (2in), wingspan 10–14cm (4–5½in), weight 4–6g (⅛–¼oz)

- HABITATS
 Varied, mainly lowland, always associated with water and wetlands, streams, rivers, lakes, mangroves

- DIET
 Small insects such as flies, mosquitoes, gnats

- CONSERVATION STATUS
 IUCN Least concern
 (See key page 8)

PUZZLING STRIPES
A puzzle are the two wavy pale lines that approach each other and then diverge, two or three times, in mirror-image fashion along the bat's back. There are also small patches of pale fur along the forearms. These may serve as disruptive coloration – a pattern or feature that draws attention away from the animal's overall outline, which would otherwise be more easily spotted. Other explanations include female and male display when mating, or perhaps recognizing roost mates.

▶ Proboscis bats rest head down during the day, often choosing a roost site that matches their fur colour. Each group has up to five or six sites that they visit in approximate rotation, so that predators do not become accustomed to finding them in one regular place.

Pygmy marmoset

GUM-SUCKING MINI-MONKEY

Dwelling in much of the Amazon Basin, pygmy marmosets – there are two very similar kinds, western and eastern – are very specialized creatures. They are the smallest of all monkeys, hardly the size of a human hand. They tend to frequent the forest understorey, that is, the lower, shadier branches and leaves just beneath the brightly sunlit topmost layer, the canopy. They also avoid the forest floor undergrowth. Agile leapers and clingers, they are usually found near waterways. They have teeth and digestion adapted to their predominant diet of plant fluids, being chiefly gums, saps and resins that flow when they gnaw and gouge bark. Rather than the usual monkey-and-ape finger- and toenails (like ours), theirs are shaped like claws to cling to bark, although the thumbs and big toes do have nails. And in their rather twilight world, crisscrossed by trunks, boughs, vines and creepers, they have exquisite camouflage.

DISTRIBUTION MAP

- LOCAL COMMON NAMES
 Mono pigmeo (Spanish); Zari (local Amerindian dialect); Minúsculo sagui (Portuguese); Sagoin, Saguin (Tupian)
- SCIENTIFIC NAME
 Cebuella pygmaea (Western), *C. niveiventris* (Eastern)
- SIZE
 Head–body length 12–15cm (4¾–6in), tail length 18–22cm (7–8¾in), weight 100–150g (3–5oz)
- HABITATS
 Rainforests and moist forests
- DIET
 Plant saps and gums, also insects, flowers, nectar, fruits
- CONSERVATION STATUS
 IUCN Vulnerable (both species) (See key page 8)

A MESS OF MOTTLING

The pygmy marmoset's long, lush fur has a subtle series of hues and mottles that match the bark, lichens, mosses, algae, moulds and other growths of their surroundings. The main colours are buff, dull orange or gold, and grey, with plentiful flecks, smears and 'ticks' of green, yellow, and perhaps black on the main body. The longer, lion's-mane-like fur on the head and neck is more gold-grey and grizzled. Looking more closely, most individual hairs have strips or bands of mainly browns and blacks, known as agouti coloration. All the markings lighten slightly to the underside. Such camouflage protects this miniature monkey from its many enemies, such as snakes, cats, hawks and eagles.

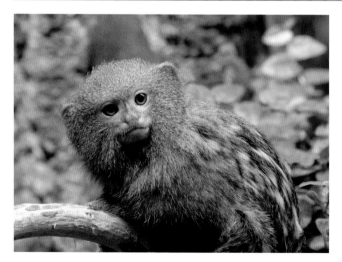

BALANCING AID

Some New World monkeys have a grasping or prehensile 'fifth limb'-like tail, which can support the entire body weight as the monkey hangs from a branch and gathers food with the other four. Marmosets, about twenty-two different species, lack this ability. Their tails are long – in some cases exceeding the head–body measurement. But the tail is used more like a squirrel tail, for balance and as a rudder when twisting and turning in mid-air.

▶ As well as safety from predators, the pygmy marmoset's bark-matching camouflage conceals it in wait for butterflies, flies and other insects that feed on the runny sap it has exposed, and which it then grabs to supplement its diet.

◀ The long, mane-like head hairs' coloured bands give a 'grizzled' effect.

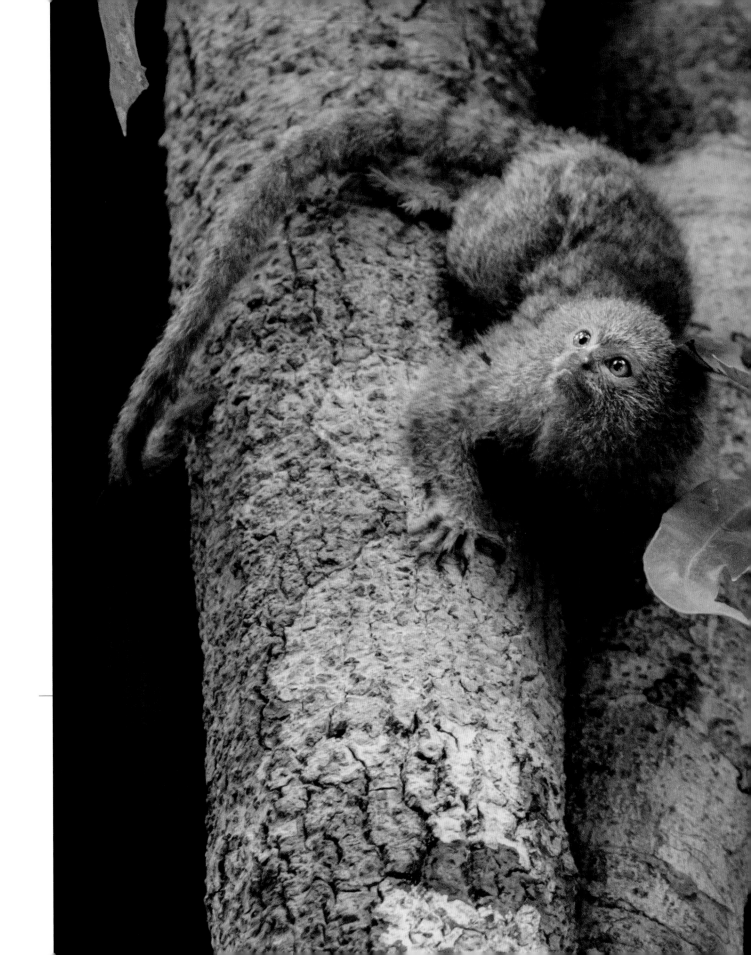

Grey fox

CUNNING HUNTER OF GREY LANDS

Biologists regard one of the world's most widely distributed and ecologically destructive mammals, the red fox, along with its close foxy cousins, as 'true' foxes. This is predominantly because both the red fox and the biologists who devised the classification system were mainly European. Around the world there are many other fox-like creatures, also members of the main canine (dog-and-relatives) group, which evolved similar appearances, cunning habits and lifestyles. One such group is the 'false foxes' of South America. These are more closely related to jackals and wolves than to 'true' foxes. One of these six kinds of 'false foxes', is the grey (gray) fox or chilla.

HAIRS OF MANY COLOURS

The grey fox inhabits mainly dry, windy, sandy, pasty-hued, relatively barren landscapes, such as foothills, steppe, pampas and scrub in the far south-west of South America. Here the soil, rocks and plants tend to be largely greyish, and often the skies and the water's reflecting surface are grey too – sometimes unremittingly so. On close inspection, the 'grey' hairs of the fox's coat are brindled; that is, have flecks or streaks of varied browns, russets, tans or silvers within the predominant grey. The fox's legs and head tend to have more rusty tan or brown shades, while the chin, chest and body's underneath are considerably paler. There may also be darker transitional rings or stripes on the shoulders and hips. The result is an overall grey-brown vagueness which chimes well into this canid's environment.

Like its namesakes on other continents, the grey fox is a consummate opportunist. There is almost nothing it does not devour, from carrion, other creatures' droppings, worms and insects, to birds and mammals ranging from mice to armadillos.

DISTRIBUTION MAP

- LOCAL COMMON NAMES
Patagonian fox, Argentine grey fox, South American grey fox; Zorro chico, Zorro chilla (Spanish); Raposa cinza (Portuguese); N'uru, Nguru (Araucano); Atoj (Quechua); Yeshgai (Peulche)

- SCIENTIFIC NAME
Lycalopex (Pseudalopex) griseus

- SIZE
Total length 0.7–1.1m (2ft 3in–3ft 7in), weight 2–5kg (4lb 6oz–11lb)

- HABITATS
Hilly, rocky, stony, scrubby and shrubby dry regions of extreme south-west South America

- DIET
Hugely varied, from excrement and carrion to fruits, berries and medium-sized birds and mammals, including livestock such as lambs, hens and gamebirds

- CONSERVATION STATUS
IUCN Least concern
(See key page 8)

DOUBLE INVASIONS

The grey fox has benefitted from invasive European and African species such as rabbits and hares introduced to South America. In this regard it is viewed as something of a helpful pest controller. However, the fox has itself been introduced to some islands in the Falklands Group, about 500 kilometres (310 miles) from the South American mainland. Here it has had a strongly negative impact, especially on bird life. Like several kinds of 'true' foxes taken to various new regions around the world, the grey 'false' fox is also proving resistant to eradication.

▶ Mostly grey and windswept, the habitats of the grey fox vary from mountains and bare rocky flatlands (top), to scrublands and bushy, grassy plains and coasts (bottom). Its thick fur is an essential adaptation in such cold places.

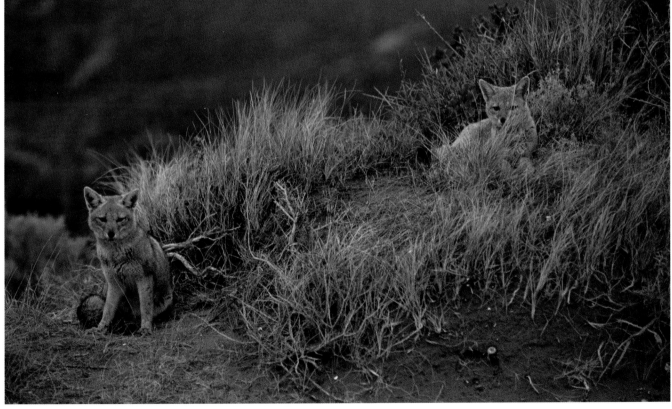

Jaguar

STEALTH AND POWER

Animal species from very different geographic locations have come to resemble each other closely in looks because they occupy similar habitats and have similar ways of life. This is known as convergent evolution. The leopard in Africa and the snow leopard in Asia are spotted largely for camouflage purposes, and they are joined by the jaguar in southern North, Central and South America. The jaguar is the world's third largest big cat, after the tiger and lion, although it has the strongest bite of all cats. It is robustly well-muscled and an expert stalker and swimmer, but less adept at high-speed pursuit and tree-climbing.

ROSETTES AND SPOTS

Like the leopard (see pages 132–133), the jaguar is not truly 'spotted'. Its fur coat varies from pale yellow to yellow-brown, tan, tawny or rust-red, with markings termed rosettes. These are small groups of dark or black, rounded shapes that usually, unlike the leopard's rosettes, each have a central dot or patch. The markings are largest and clearest on the back and flanks. Towards the neck and head, and down the lower limbs, they become smaller and the separate shapes forming each rosette merge into one. Towards the end of the tail they form rings. And on the cream to white underside they fade and become absent.

Dark rosettes or spots on a light background are ideal for concealment among trees, where light filters down between the leaves, blooms and twigs to create small patches of glow and shadow amid the gloom of the forest floor. Such woods and forests are the preferred habitats of jaguars, although they have also adapted to bush, swamps and savannas. Here they tend to stay low amid thick vegetation and undergrowth, rather than prowl out in the open as they do in forests.

- LOCAL COMMON NAMES
Yaguara (native Amazonian language)

- SCIENTIFIC NAME
Panthera onca

- SIZE
Head–body length 1.2–1.7m (4ft–5ft 6in), tail length 50–70cm (1ft 7in–2ft 3in), shoulder height 65–75cm (2ft 1in–2ft 5in), weight 50–100kg (110lb 3oz–220lb 7oz)

- HABITATS
Almost always near water in woods and forests, including mangroves, also swamps, wetlands, grasslands, scrub

- DIET
Larger mammals such as deer, peccaries and tapirs, also fish, reptiles, birds and smaller mammals

- CONSERVATION STATUS
IUCN Near threatened (See key page 8)

INADEQUATE PROTECTION

Despite varying levels of persecution, such as revenge killings by farmers for supposed attacks on livestock, the jaguar is still widely distributed in the Americas. It is protected both regionally and globally, such as the CITES agreement prohibiting trade in live specimens or any of its body parts. However, its population and range are gradually shrinking, chiefly due to loss and fragmentation of its habitats.

▶ Dappled forest shade is the jaguar's main environment. Most prey is caught in the half-light after dusk and before dawn, with the big cat leaping or charging a short distance from cover to execute a surprising and deadly pounce.

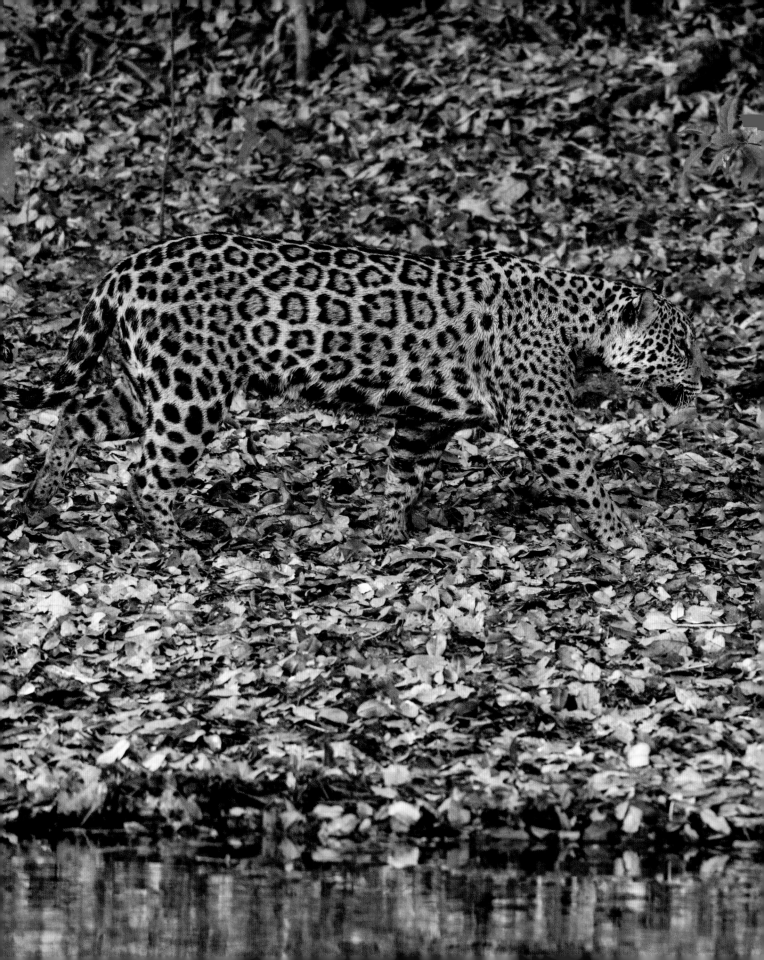

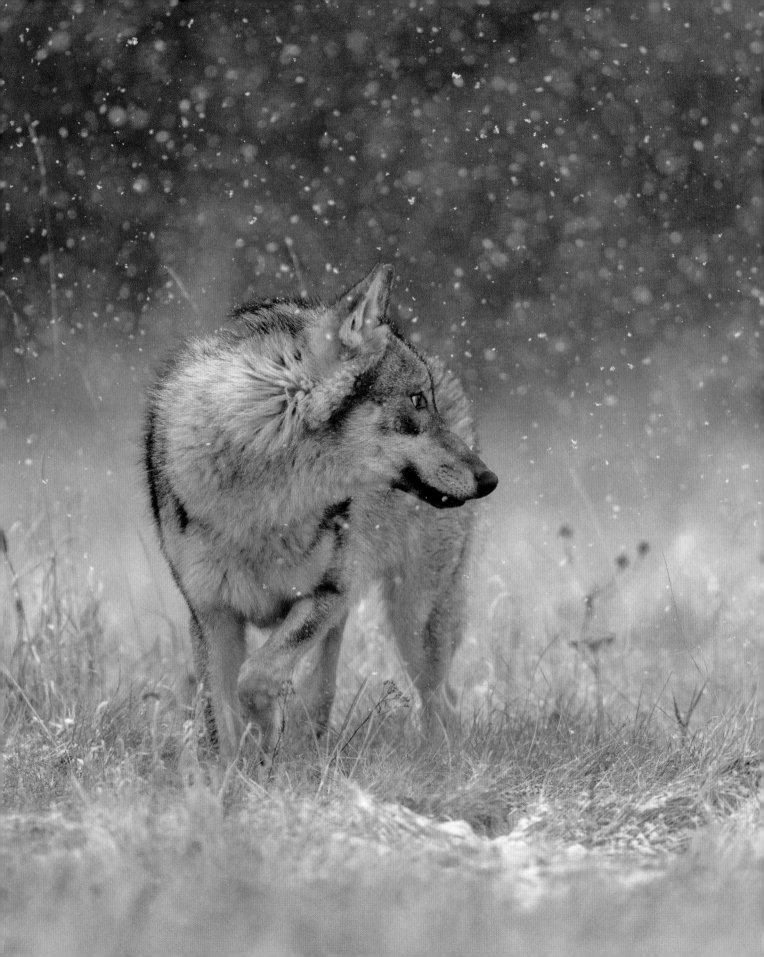

3

Europe

Green tortoise beetle

HIDING UNDER ITS SHELL

Few creatures match the greenness of leafy vegetation as accurately as the green tortoise beetle. Colours vary among individuals (although not much) from slightly paler 'washed-out' green to a rather darker, more intense shade, but most of these beetles are bright, semi-shiny, perhaps slightly golden emerald green. This is an excellent match for all kinds of leafy plants, especially those the beetle feeds on. These are chiefly members of the mint group (*Mentha*), such as common or wild mint, water mint and horse mint, as well as related hemp-nettles, sages and woundworts.

ALL-OVER PROTECTION

Even if a green tortoise beetle is noticed on a leaf, it has almost no features that betray it as an insect, apart from two thread-thin, brown antennae (feelers). It looks more like a patch of swollen, lumpy tissue, or gall, made by a tinier insect within the leaf, such as a leaf-mining fly or moth larva (young stage), than a living creature. The beetle is very flattened and its upper surfaces are covered by curved, tough, shield-like casings, reminiscent of a tortoise's shell, which hide the eyes, mouthparts, legs and other creepy-crawly giveaways beneath.

The front section of its 'shell' is part of the insect's middle body section, the thorax, and extends forward over the head. The paired rear covers are actually the front pair of wings, which have evolved to become hard protective casings, known as elytra, shielding the rear pair of wings underneath. Elytra are a trademark of the whole beetle group and safeguard the much larger, thinner, flimsier, folded-up rear wings underneath them. Should the camouflage be detected and a predator approach, the beetle raises its elytra and unfolds its rear wings to fly away.

DISTRIBUTION MAP

- LOCAL COMMON NAMES
 Green leaf beetle, Leaf beetle, Green shieldbug (in error)

- SCIENTIFIC NAME
 Cassida viridis

- SIZE
 Length 6–10mm (¼–⅜in)

- HABITATS
 Grasslands, wood edges, hedgerows, waterway banks, meadows and other places with host plants

- DIET
 Members of the mint group, hemp-nettles, sages and woundworts

- CONSERVATION STATUS
 IUCN Not evaluated
 (See key page 8)

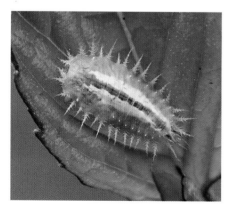

FAECAL SHIELD

Green tortoise beetles belong to the leaf beetle family, the chrysomelids. They are sometimes called shieldbugs, but shieldbugs are not beetles, they are a different insect family, 'true' bugs or hemipterans. The beetle's young form, the grub or larva, is similar in size and colour to the adult, but it has hairy spikes around the edge of its body. It tends to stick its own droppings or faeces, plus cast-off skins as it grows, onto these and onto its back to deter enemies, known as faecal shielding.

▶ (Clockwise from top) A perfect match in colour, the beetle's shape also copies the mound-like leaf bulges. As the beetle prepares to take off, its antennae are visible and its wing covers begin to open. The thoracic shield hides and protects the head.

◀ As a grub, the beetle covers itself with its own faeces.

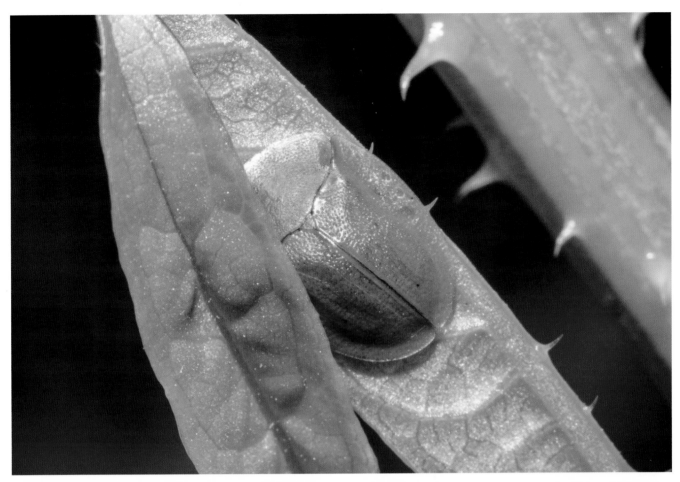

Comma

JUST AN OLD DEAD LEAF

Many butterflies have beautifully smoothed, rounded wing edges, although with age these tend to show frays, tears and splits. Not the comma. Its wing margins look unkempt and ragged, even when the adult is freshy emerged from its pupal case, the chrysalis. The insect rests in the characteristic butterfly posture with its two pairs of wings folded together, against each other over its back. This shows the wing undersides, which have patchy, dusky, indistinct patterns of colours, ranging from pale yellows and oranges through greys and light browns to darker browns and charcoal – ideally complementing withered, tattered, notched and generally rough-edged old leaves nearby. Even the wing veins mimic the leaf veins. And when there are no old or dead leaves around, at a glance the comma with its wings folded looks like one.

The comma is named from a distinct curved or comma-shaped marking roughly in the middle of the hind wing's underside. This is referenced in its species name *c-album*, meaning 'white c'.

YEAR-ROUND BUTTERFLY
Old, withered leaves are especially suitable as a background because commas are around at almost any time of year. Those emerging in late summer feed well on autumn fruits and hide among dying leaves, then enter a hibernation-like condition known as diapause for winter, to 'wake up' in early spring to breed. They may even rouse and fly during a particularly mild spell in mid-winter. Known as the diapausing morphs, these individuals tend to have darker wing undersides. Commas that hatch from eggs, grow and breed during the middle of the year, called direct-developing morphs, have lighter wing undersides that blend better with paler, summer-ageing leaves.

DISTRIBUTION MAP

- LOCAL COMMON NAMES
 Anglewing, Brown anglewing, Raggedy-wing; Robert le Diable (French)

- SCIENTIFIC NAME
 Polygonia c-album

- SIZE
 Body length 2–2.5cm (1in), wingspan 5.5–6cm (2¼in)

- HABITATS
 Woodland clearing and edges, hedges, parks, gardens, orchards

- DIET
 Flower nectar, juices of rotting fruits and berries (adult)

- CONSERVATION STATUS
 IUCN Least concern (See key page 8)

BUTTERFLY OF TWO HALVES

When the comma spreads its wings, it has an entirely different, neat and tidy appearance. The wings' upper surfaces have beautifully organized patterns of patches and spots in hues ranging from cream through to very dark brown. This is mainly for display to potential mates, making sure that each individual chooses a partner whose wing condition and flight abilities show that it is healthy and well-fed.

▶ The bright, sharp-edged white 'c' or comma, and the notched, scalloped wing edges –already looking like they have been pecked by birds – are diagnostic of this species.

◀ It is a member of the nymphalid butterfly group, whose species have mainly large and colourful upper wing surfaces and dull, camouflaging lower undersides.

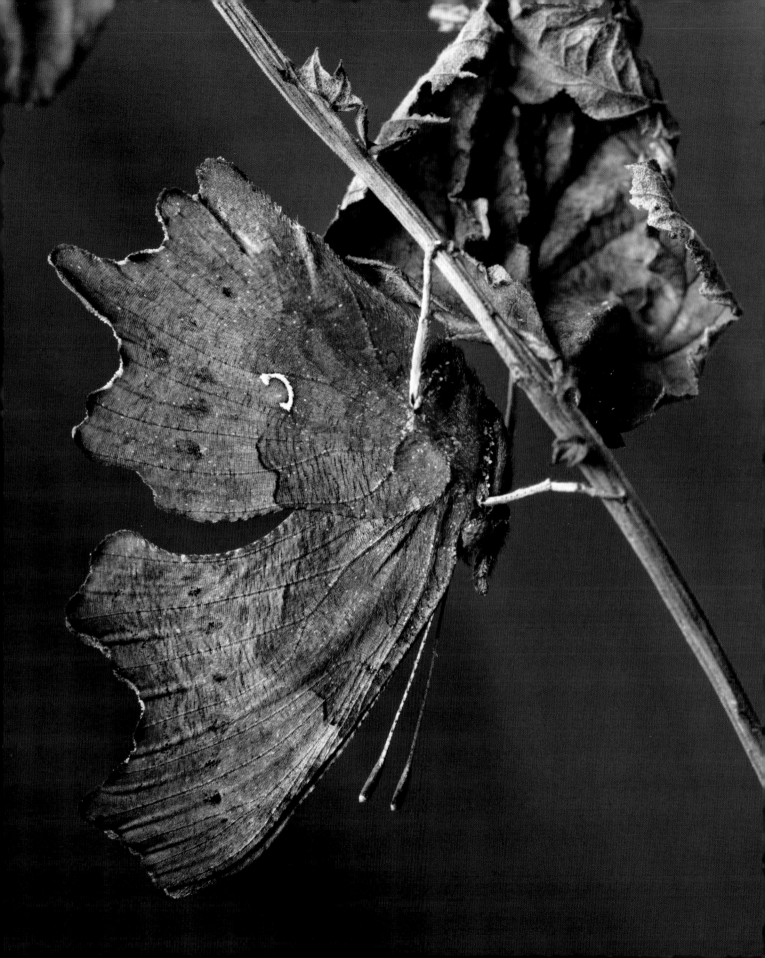

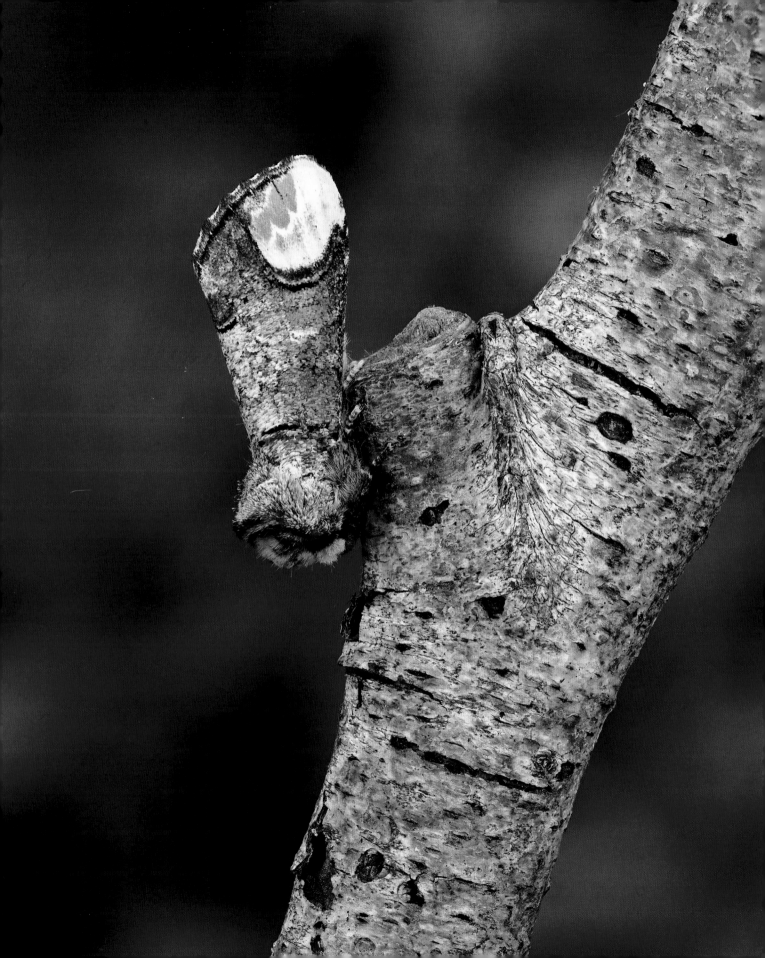

Buff-tip

A TWIG THAT BROKE OFF

Many animals, especially insects, have a form of camouflage that mimics the shape and colour of bark, branches and twigs. The buff-tip moth goes one better and copies a twig that has been broken off or snapped away. The moth resembles a squared-off end of what looks like inner, very pale brown or buff, slightly streaked 'wood' exposed beneath a darker, double-ring of the outer 'bark'.

DISTRIBUTION MAP

DOUBLE-ENDED DECEIT

In fact, the moth goes not one, but two better, because this trickery is at both its front and rear ends. The camouflage is most impressive at the rear. Here the rounded tips, or apices, of the front wings show the broken twig appearance. The buff-tip rests with its wings along its sides and slightly twisted and part-rolled so that the wingtips are close together, which heightens the twig-stub effect. At its other end, the moth has a repeat performance from the plentiful buff hairs on its thorax (middle body section), which partly obscure its eyes and mouthparts and give a blunt-ended appearance. To complete the deceit, between these two areas is the sliver-grey, streaky coloration of the rear of the hairy thorax and also on the main surfaces of the front wings, which provide a stunning resemblance to bark, in particular, of birch trees, and even more especially, silver birch.

Buff-tip adults emerge from their chrysalis (pupal) cases in spring. Through late spring and early to mid-summer they rest by day on suitable branches, relying on their camouflage to be overlooked. At night they fly to gather nectar from many kinds of blossoms and flowers.

- **LOCAL COMMON NAMES**
 Twig moth; Bombyx bucéphale (French)

- **SCIENTIFIC NAME**
 Phalera bucephala

- **SIZE**
 Head–body length 3–4cm (1½in), wingspan 5–7cm (2–2¾in)

- **HABITATS**
 Widespread, mainly mixed woods but also meadows, hedges, farmland, parks, gardens

- **DIET**
 Adult: flower nectar
 Caterpillar: leaves of birches, sallows, willows, maples, oaks, alders, elms, beech and sycamore

- **CONSERVATION STATUS**
 IUCN Not evaluated
 (See key page 8)

◄ A side view of the buff-tip shows the very convincing twig-broken-at-an-angle effect at its rear end, which is uppermost in this image, and a similar, but more subdued, twig-broken-at-right-angles look at the head.

► The caterpillars have an opposite strategy, advertising their distastefulness with warning or aposematic colours.

COLOURFUL YOUNGSTERS

Buff-tip caterpillars, or larvae, are as colourful as the adults are not. They are mainly yellow with black stripes and lines of ovals in a net-like arrangement, and are also very hairy when they grow larger. This is a warning sign that they are noxious and foul-tasting to predators such as birds. They feed on a variety of leaves from birches, sallows, willows, maples, oaks, hazels, alders, elms, beech and sycamore.

Wels catfish

LURKING GIANT OF THE DEEP LAKE

Even at arm's length, this fish – which can grow bigger than a human – is almost invisible in its home of a deep lake or deep, slow-flowing river, often with murky water. Even in clearer water, its ability to blend in with the mud, stones, plants and other bottom matter is truly uncanny.

Wels show colour variation among individuals, varying from slightly pale creams, browns, olives and greens in random mottling patterns, to darker blends of these colours; the seldom-seen underside is usually pale and silvery. Their habit of lying on the bottom, with just occasional slow-swimming excursions to check for food, also helps them to stay undetected. So does their habit of wriggling into the mud where this is deep enough. And they can lurk among water plants, rocks or tree roots, using their strong pectoral (front side) fins to excavate a lair. All these behaviours aid the camouflage of this somewhat monstrous fish.

MOUTH WIDER THAN HEAD

Although they resemble eels, with a long, sinuous, slime-covered body, wels are true members of the catfish group. They have the typical cat-whisker-like 'feelers' or barbels around the mouth, two long ones above and four shorter ones below, which are smell-taste-touch organs. The mouth is almost wider than the low, broad head, and gulps in any kind of prey that fits, from other fish and amphibians, to swimming snakes, lizards, birds and mammals. Like a killer whale chasing seals at the water's edge, the wels also deliberately 'beaches' itself, wriggling almost entirely out of the water to grab a victim on the bank, before squirming back in.

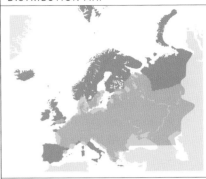

- LOCAL COMMON NAMES
 European catfish, Sheatfish; Silure glane (French); Wels, Schaden, Wälin (German); Uels som (Bulgarian); Wels harcsa (Hungarian); Sumec obecny (Czech); Sumec obycajný (Slovakian); Iaprac, Somn (Romanian)

- SCIENTIFIC NAME
 Silurus glanis

- SIZE
 Rarely exceeds length 2.2m (7ft 2in) and weight 100kg (220lb 7oz)

- HABITATS
 Wide range, including large lakes and rivers, channels, reservoirs, quarry pits, brackish coastal waters

- DIET
 Any suitable-sized prey

- CONSERVATION STATUS
 IUCN Least concern
 (See key page 8)

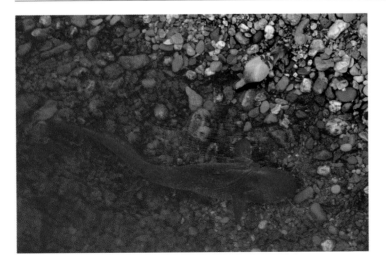

MONSTERS OF OLD

Wels originated in Eastern Europe but have since spread west as far as France and Italy, both naturally and as a result of deliberate introductions, including into the UK. Centuries-old tales describe them as being truly massive, up to 5 metres (16 feet) in length and scaling 300 kilograms (661 pounds), and easily able to swallow a human child. It seems that such giants are long gone. In recent times, outsized specimens include one caught in 2015 in Italy, measuring 2.6 metres (8 feet 6 inches) and weighing in at 130 kilograms (286 pounds 9 ounces).

▶ Almost submerged in the mud, the wels' voluminous mouth and 'whisker' barbels are visible in the shafts of sunlight.

◀ Even in the shallows, and with a pigeon in immediate peril, the wels is a dark, indistinct shadow.

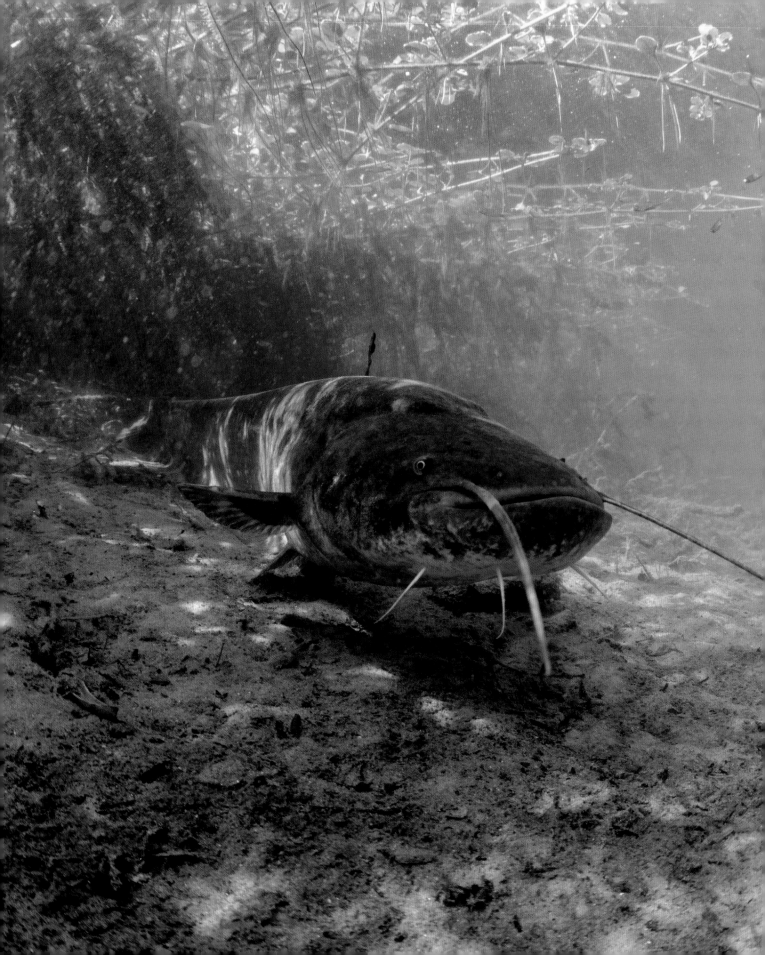

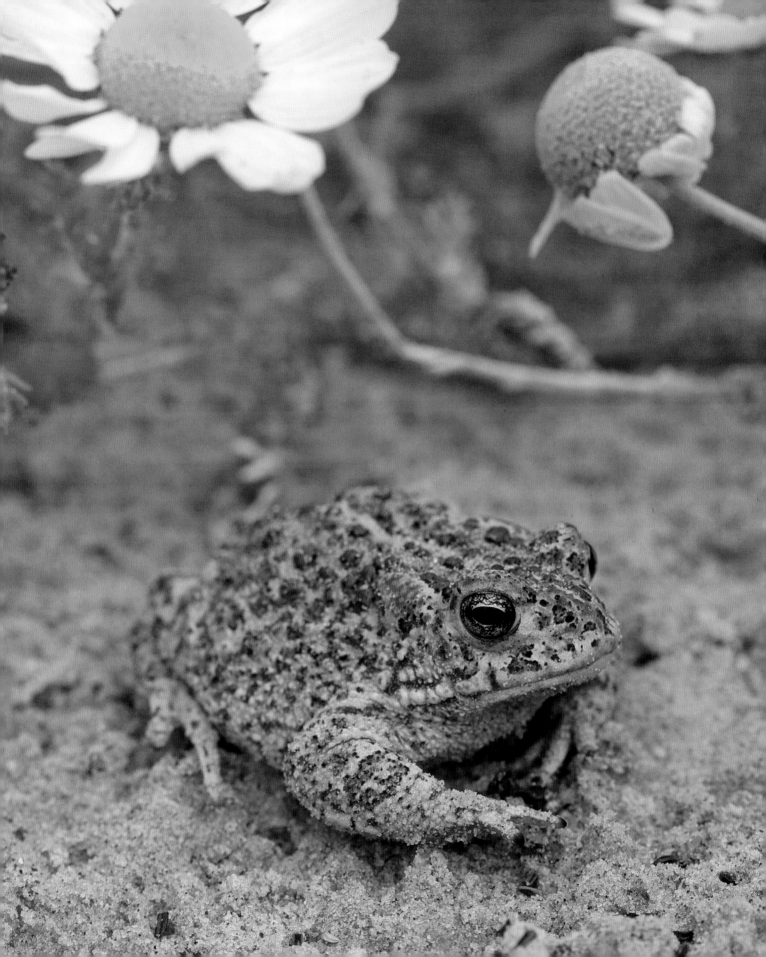

Natterjack

NOISY DRYLAND DWELLER

The popular image of toads involves dark, damp, dank places. Natterjacks are found in mainly dry, open, sun-warmed habitats, such as coastal dunes, lowland heaths, brightly lit openings in woods and forests, sand quarries, parks and other sites with light, sandy, well-drained soils. Here the toad capitalizes on its resemblance to the pale earth, pebbles and stones, and bits of twigs, grass and other vegetation, and is rarely noticed.

DISTRIBUTION MAP

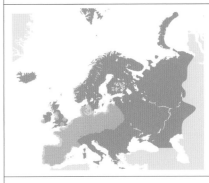

- LOCAL COMMON NAMES
 Running toad; Calamite, Crapaud des joncs (French); Sapo corredor (Spanish); Smilšu krupis ('Sand toad') (Latvian); dozens of other names across Europe

- SCIENTIFIC NAME
 Epidalea calamita
 (formerly *Bufo calamita*)

- SIZE
 Head–body length 6–7cm (2½in) (females are larger than males), weight 4–20g (⅛–⅔oz)

- HABITATS
 Light, dry soils with open sunlight, including heaths, dunes, woodland clearings, farmland

- DIET
 Small worms, slugs, beetles and other insects

- CONSERVATION STATUS
 IUCN Least concern
 (See key page 8)

GO-FASTER TOAD

The natterjack's main colours are grey, olive, sandy and green, perhaps with touches of bronze or orange, interspersed with darker blotches, with a paler belly. In this it resembles a lighter-hued but slightly smaller version of its fellow amphibian, the common toad. A distinguishing feature is that the natterjack has a yellow 'go-faster' stripe along the middle of its back. This is appropriate since, rather than waddle like its common cousin, it tends to almost trot or run when disturbed, giving it another common name of running toad. Also, its 'integument is dorsally tuberculate', meaning the skin on its back has many small, wart-like lumps or tubercles. These prevent light reflecting in a uniform way and tend to obscure or confuse its overall shape – a form of disruptive camouflage. In addition, as in other toads, tiny poison glands in its skin, and also the large parotid glands on either side of the neck, manufacture a foul, noxious fluid.

Usually natterjacks feed under cover of darkness and hide away or burrow into the earth by day. If discovered in the open despite their camouflage, they rear up and inflate their bodies and hiss. Most potential predators recognize this warning behaviour and, probably having learned from bitter experience about the skin poison, move on.

NATTERING JACK

The origin of the term 'natterjack', widely used across this toad's geographic range, is obscure. An English-language suggestion is that 'natter' refers to it being talkative and vocal, while 'Jack' is a common term for a male who is no one or anyone in particular, as in 'Jack the lad' and 'Jack of all trades'. Both parts of this suggestion ring true. The natterjack is often cited as Europe's loudest amphibian: its spring mating call – likened to running a fingernail along a hair comb – is audible hundreds of metres away; and, as with most frogs and toads, only the male emits this plea for a partner.

◄ Highly textured skin and multiple mottling blend the natterjack into its sandy, loamy-soil surroundings.

► The back stripe helps our identification of the species, but its survival purpose is unclear.

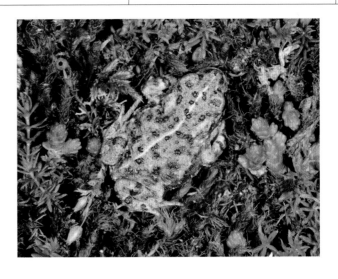

Wall lizard

FROM ROCKS AND STONES TO WALLS

Prior to the walls we construct for our dwellings and outbuildings, and around our fields, pastures and farming enclosures, there were natural 'walls'. Rocky outcrops, piles of boulders, stony slopes, crags and cliffs were the natural habitats of what we now call wall lizards – about twenty-five different kinds in the genus (species group) *Podarcis*. These small–medium reptiles are highly adapted to racing about on rock-hard surfaces, with small, sharp claws that dig into and grip any miniscule cracks or crevices. They are fast, agile and snap up any small animal prey.

Wall lizards have an extensive array of colours and patterns, mostly cream and yellow to brown and grey, with dashed-line stripes or reticulated (net-like) arrangements in darker shades. Why these vary so greatly, and how they are inherited, are being unravelled by intricate scientific studies, both out in nature and inside the laboratory. Some of these studies show wall lizards exercise substrate choice – that is, they actively select what they are sitting on to match their own colouring, and so be better camouflaged.

A complicating factor is that some individuals, especially males, have body areas such as the throat, flanks or tail coloured blue, or pink, lime green, 'high-vis' red or some other garish hue, which does not correspond at all with their substrate. Biologists interpret this as the need for males to advertise themselves as fit fathers to females, despite their colouring also being an advert to prey. Meanwhile, most females remain splendidly camouflaged as, after mating, they must nourish the eggs developing within their body before these are laid.

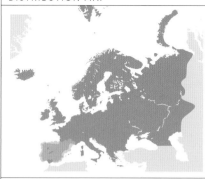

DISTRIBUTION MAP

• LOCAL COMMON NAMES
Stone lizard, Climbing lizard; numerous names across Europe in many languages for the various kinds, such as Agartija ibérica, Lagartija italiana (Spanish); Primorska kuščarica ('Coastal lizard') (Slovenian); Ruïnehagedis ('Ruin lizard') (Dutch)

• SCIENTIFIC NAME
About 25 species of *Podarcis*, including *P. muralis* (Common or European wall lizard), *P. erhardii* (Erhard's wall lizard), *P. pityusensis* (Ibiza wall lizard)

• SIZE
Most species in the range head–tail length 10–25cm (4–10in), weight 4–12g (1/8–3/8oz)

• HABITATS
Rocky outcrops, pebbles, boulders, crags, cliffs and other stony habitats; also similar human structures from house walls to bridges, parapets, reinforced road and rail cuttings

• DIET
Small creatures such as insects, spiders, centipedes, worms

• CONSERVATION STATUS
IUCN Least concern
(See key page 8)

AN INTRICATE TASK

Disentangling genetic and environmental influences of wall lizard colouring, camouflage, and mating displays is a convoluted task. For example, researchers record the positions and behaviours of captive wall lizards in large compounds of different artificially built habitats, according to conditions such as light intensity, temperature, background colour and food availability. Even the exact number of *Podarcis* species is not clear. What was assumed to be a single species, the Iberian wall lizard, *P. hispanica*, may be in the process of evolving into several species.

Reasonable eyesight allows the wall lizard to exercise 'substrate choice', choosing a place where its camouflage works well. This is a female of the species named Erhard's wall.

Montpellier snake

FADING INTO OLD AGE

Essentially a serpent of dry, warm-to-hot places, the Montpellier snake is adapting well both to the spread of human land use and to the gradually warming temperatures of climate change. In winter its activity is chiefly diurnal, it's as busy as a snake can be at this cooler time, waiting to ambush or slinking after lizards and other small prey. In the heat of summer, it is out and about in twilight and perhaps at night-time.

The Montpellier snake's general appearance is well-suited to its semi-arid habitats. In middle age its adult base colours are subdued tones of green, olive, brown or grey, with small, repeating, vaguely chequerboard darker patches along the back. The underside is lighter with a background colour of cream or pale yellow-brown, so the darker areas show in greater contrast, but the snake is usually slithering along sand or rocks and rarely visible from the sides or above.

AGE-RELATED CHANGES
The whole coloration of the snake fades with age. Juveniles have more contrast between the base colour and patches, looking almost spotty and 'freshly painted'. At this age the young snakes tend to rest in cover more, where their looks match the contrasting brightly lit and dark shadowy areas created on sunny days.

In comparison, older adults tend to bask more often in the open, being confident in their size and their ability to deliver a venomous bite, which most potential adversaries recognize. Their coloration shows much less contrast and seems 'washed out'. In particular, the darker areas along the back may fade completely to leave a uniform grey, olive or brown seen from above.

DISTRIBUTION MAP

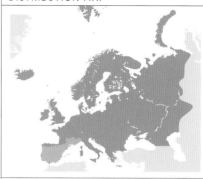

- LOCAL COMMON NAMES
 Lizard snake; Serpent de Montpell (French); Serpiente Montpellier, Culebra-contra-lagarto, Culebra bastarda (Spain); Eidechsennatter (German)

- SCIENTIFIC NAME
 Malpolon monspessulanus

- SIZE
 Length up to 2.2m (7ft 2in), weight 1.5–2kg (3lb 4oz–4lb 6oz)

- HABITATS
 Dry woods, rocky and sandy scrub and coasts, dense shrublands, farmland, suburbia

- DIET
 Lizards, occasionally smaller snakes, frogs, small birds and mammals; juveniles take larger insects and spiders

- CONSERVATION STATUS
 IUCN Least concern
 (See key page 8)

THERMAL WINDOWS
Overall, the Montpellier is profiting from climate change and its geographic range is spreading. Like most reptiles, its ability to move and feed depend on temperature. The warming climate means temperatures are increasing, giving the snake longer 'thermal windows' – both during individual days and on average over a whole year – to move fast and chase down victims. However, its search for heat also means many Montpelliers end up killed by road traffic as they soak up the warmth of the dark tarmac.

▶ Adult Montpellier snakes' camouflage helps them bask in the open to gain body warmth, yet not be spotted by enemies such as hawks, eagles, foxes and mongooses.

◀ The snakes tone best with old wood, dry sandy soil and sun-blanched rocks.

Wryneck

UNDETECTED ON ANY LEVEL

The wryneck is sometimes called the European wryneck or Eurasian wryneck, to distinguish it from the red-throated wryneck of the savannas in East and Southern Africa. However, it does migrate south in winter to West-Central regions of Africa south of the Sahara, returning to Europe in spring to breed.

A member of the woodpecker family, the wryneck is a busy bird as it forages at various levels in trees and bushes, among undergrowth and particularly on the ground, for ants, beetles, other bugs, worms and small animal prey. In all these places, when the bird becomes suspicious, it ceases movement to look and listen – and becomes astonishingly difficult to detect. Its appearance is a masterpiece of camouflage, with shades of brown, buffy-brown, tan-brown, reddish-brown, blackish-brown and greyish-brown, in a variety of irregular bars, stripes, spots and patches, large and small, over its head, body and wings. The bill, legs and feet are also brown. Perhaps most conspicuous are wider dark streaks on the shoulders and from the rear of the head along the back. On the throat and chest, the background colour is paler, with bars on the former and spots on the latter, showing vague similarities to a smallish thrush.

Such delicate patterning intermingles with many kinds of natural vegetation, from bark and twigs to grasses, ferns and general ground herbage, and also open, earthy patches where the wryneck prods and pecks for its favourite foods of ants and their 'eggs', or pupae. In this it resembles some of its fellow woodpecker cousins, although the wryneck has few other woodpecker traits and is an unusual member of its family.

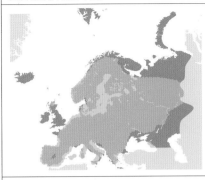

DISTRIBUTION MAP

- **LOCAL COMMON NAMES**
 European, Northern or Eurasian wryneck; Torcecuello euroasiático (Spanish); Torcicollo (Italian); Wendehals (German); Nyakferdülés (Hungarian); many other names across Europe

- **SCIENTIFIC NAME**
 Jynx torquilla

- **SIZE**
 Bill–tail length 16–18cm (6¼–7in), wingspan 25cm (10in), weight 30–60g (1–2oz)

- **HABITATS**
 Open forests, woodland clearings, other habitats with scattered trees and bushes including farmland, parks, gardens

- **DIET**
 Insects, especially ants, also spiders, woodlice, worms and similar small prey

- **CONSERVATION STATUS**
 IUCN Least concern
 (See key page 8)

◄ Old wood, leaves and other plant parts pass through various shades of brown as they shrivel and decay, and the wryneck has most of these in its plumage. It feeds mainly at ground and low levels.

► Unlike its woodpecker cousins, it is less sure-footed on tree trunks and bark.

NOT A WOODY PECKER
The wryneck's common name refers to its ability to twist its head so as almost to look backwards, in the manner of an owl. This is one of its many un-woodpecker-like features. It spends little time pecking into tough bark for food or to make a nest hole; it lacks strong tail feathers on which it can lean back in a secure position; and it certainly lacks the lively plumage of species such as the green woodpecker.

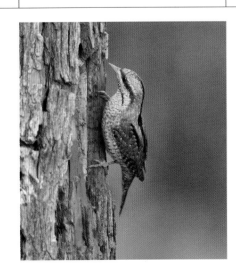

Buzzard

SWOOP FROM THE PERCH

There are about thirty different kinds, or species, of buzzards and hawks, *Buteo*. 'The' buzzard, also referred to as the common, European or Eurasian buzzard, is one of the larger, most widespread, and more common species. It lives as a year-round resident in most of Europe, while other populations spend summer in colder Northern Europe and North-Central Asia and then migrate to winter in Southern Africa and India.

A substantial bird, with wings as long as human arms, the buzzard's camouflage is not so much to conceal it from predators but, due to its hunting techniques, from prey. However, it does suffer occasional predation by larger hunting birds, such as the golden, Bonelli's and other eagles, the Eurasian eagle owl, and also from mammals such as red foxes, wolves and wildcats – again, this is linked to its hunting methods.

CATCH, KILL, CONSUME

Buzzards are perhaps most familiar as they soar on high, making their cat-like 'mee-ow' calls. However, apart from spotting carrion, they spend most time perched in trees that overlook open ground, watching for prey below. Here the buzzards are well camouflaged, although their appearance does vary across their extensive range. Overall, the plentiful streaks, bars, mottles and other markings, in many shades of brown, plus occasional white, cream and grey, allow the buzzard to blend with the trunks, boughs and twigs. This affords concealment from its sharp-eyed victims below, mostly mammals ranging from mice and voles to rabbits and hares, who are alert to danger from any direction.

Spotting a meal, the buzzard swoops rapidly to grab its prey and then consumes it at once on the ground – and it's at this time the bird is at risk from terrestrial predators mentioned above.

DISTRIBUTION MAP

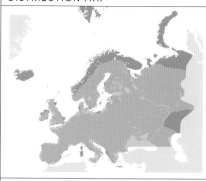

- LOCAL COMMON NAMES
 Common buzzard, 'Tourist eagle'; Hiirihaukka (Finnish); Buse variable (French); Mausebussard (German); Buizerd (Dutch); Ratonero comun (Spanish); Közönséges ölyv (Hungarian); many other names across Europe and East Asia

- SCIENTIFIC NAME
 Buteo buteo

- SIZE
 Bill–tail length 45–60cm (1ft 5in–2ft), wingspan 1.1–1.3m (3ft 7in–4ft 3in), weight 0.70–1.2kg (1lb 8oz–2lb 10oz) (females are larger than males; birds in the northern parts of the range are larger than those farther south, see page 8)

- HABITATS
 Varied but often at the edges or margins of woods and forests, clearings and glades, also near tree clumps on moors, heaths, grasslands, farmland; rare in treeless habitats

- DIET
 Hugely varied, from worms and beetles to small–medium reptiles, birds, mammals and carrion

- CONSERVATION STATUS
 IUCN Least concern
 (See key page 8)

THE 'TOURIST EAGLE'

Buzzards soar for various reasons – to look for a suitable hunting area, court a mate, and check on breeding territory. Also, as well as regularly perching in trees, they may sit on man-made structures such as fences and electricity poles. In both these situations, soaring and open perching, people unfamiliar with bird life may exclaim that they have seen a golden or other eagle – even though the golden eagle's wingspan and length are both half as much again as a buzzard's. This has led to the buzzard's nickname of 'tourist eagle'.

▶ In classic on-the-lookout pose, and well concealed among autumn foliage, this buzzard scrutinizes the surroundings for likely food.

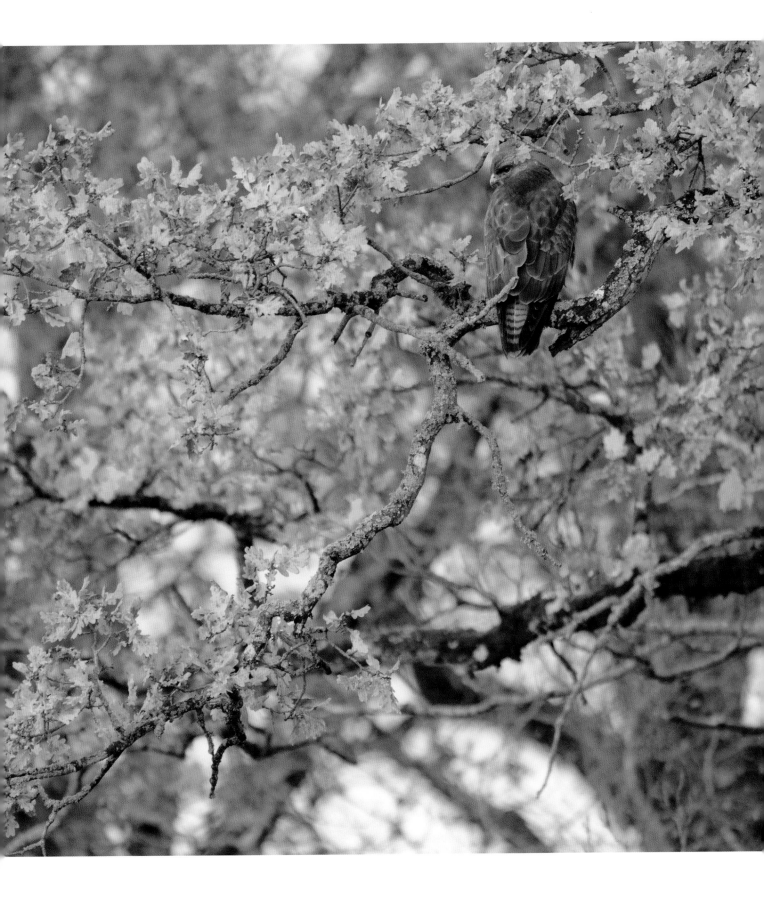

Eurasian wolf

THE 'ORIGINAL' WOLF

Few beasts have so many starring roles in so much human narrative – folklore tales, nursery rhymes, novels, music, stage, screen and much, much more – as 'the' wolf. There are three canid (dog family) members commonly called wolves, including the Ethiopian and African golden wolves. But pre-eminent is the grey (gray) wolf, species name *Canis lupus* and the ancestor of our domestic dogs. This species has at least thirty and perhaps forty different varieties, or subspecies, all around the Northern Hemisphere, such as the steppe, Himalayan and Indian wolves of Asia, to America's fifteen-plus kinds, from the Arctic and Greenland wolves south to the Mexican wolf, and also Australia's dingo.

ALL-PURPOSE DISGUISE

Recognized by biologists as the 'nominate' subspecies – in effect the original, first kind described for science – is the Eurasian wolf *C. l. lupus* of Europe and parts of Asia. Like other grey wolves, it has legendary powers of appearing as if from nowhere with the intention of fierce attack, often in numbers as a pack, or conversely, seemingly melting away quietly into the landscape.

These powers are a combination of the wolf's acknowledged intelligence, cunning and adaptable behaviour, knowing when and where to confront, slink off or hide away, and its camouflaging coloration. This is typically rusty, tawny or grey-brown on the face, neck and back, usually with speckly greyish or 'grizzled' overtones, paling to lighter, less grey shades on the chin, throat, flanks and the legs. It is an all-purpose appearance, visually adapted to many habitats, from cold northern forests and rocky hills to warm, dry scrub and bush around the Mediterranean, and suited to creeping up on many kinds of prey, from mice to large deer and cattle.

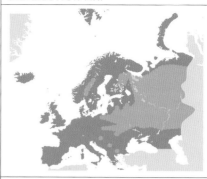

- **LOCAL COMMON NAMES**
 Huge numbers of regional names including Loup (French); Ujku (Albanian); Vlk (Czech); Lup (Romanian); Hunt (Estonian); Ulv (Danish, Norwegian); Varg (Swedish); Farkas (Hungarian); Kurt (Turkish), Volk (Russian)

- **SCIENTIFIC NAME**
 Canis lupus lupus

- **SIZE**
 Head–body length 0.9–1.5m (3–5ft), tail length 30–60cm (1–2ft), shoulder height 50–80cm (1ft 7in–2ft 7in), weight 20–75kg (44lb–165lb 5oz) (males are larger than females, also geographic variation, see text)

- **HABITATS**
 Extremely varied, from forests and woods to open bush and scrub, grasslands, farmland, human habitation

- **DIET**
 Highly omnivorous, from fruits and berries to insects, worms, fish, reptiles, birds, and mammals up to the size of deer, sheep and cattle (both wild and farmed); also carrion, human refuse and garbage

- **CONSERVATION STATUS**
 IUCN Least concern
 (See key page 8)

A VARIABLE ANIMAL

The grey wolf species as a whole is highly variable. In the far north are almost white subspecies such as the Arctic wolf, while others are much more reddish. Very pale and almost black individuals occur in most subspecies. Size alters too, being greatest in northern or colder regions, such as Asia's tundra wolf at 50-plus kilograms (110 pounds), and least to the warmer south, such as the Arabian wolf at only 20 kilograms (44 pounds). Such variation is a common feature of animals with an extensive north–south range and is known as Bergmann's rule (see page 8).

▶ A frontal view shows the subtle blends of greys, browns, creams and white that mask the 'grey' wolf among twigs, trunks, foliage and snow in a central European winter woodland.

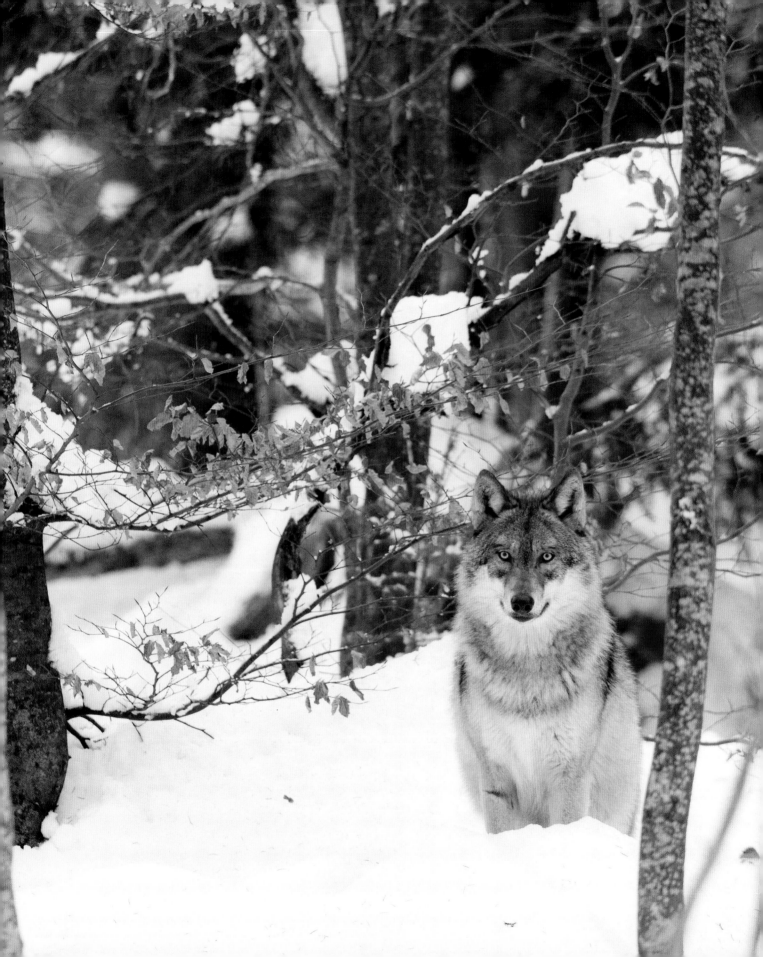

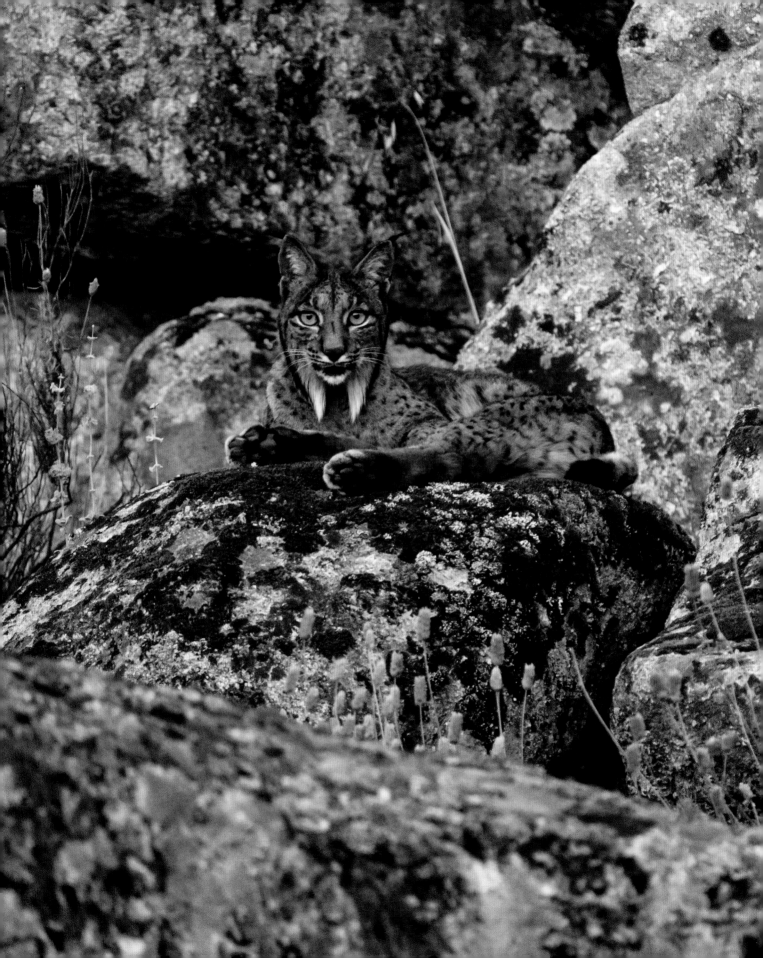

Iberian lynx

STRUGGLING BACK TO SAFETY

Of the thirty-seven different kinds, or species, of cats (family Felidae), about two-thirds have adult coats sporting spots, blotches or stripes. The Iberian lynx's complex markings are petite, very numerous and somewhat indistinct. They are mainly smallish, dark grey to black, appearing as rounded or elongated patches, some merging together, very approximately arranged in head-to-tail rows, and becoming smaller from the back down the sides and legs. The base fur colour is tan, tawny or some similar shade of brownish-yellow, fading rapidly to the pale or white underside. The whole intricate effect wonderfully conceals the cat as it prowls in the half-light through its favourite habitat – mosaics of dry woodland, dense scrub and shrub, and assorted grassy tussocks and clumps of herbs.

INTENSIVE CONSERVATION

There are four species of lynx. The Iberian has the black ear tufts, long legs and short tail (in its case, black-tipped) typical of the group, and also a white double-point beard. Active mainly at dusk and dawn, its major prey is rabbit. However, myxomatosis and other rabbit diseases have decimated this food source, while habitat loss due to agriculture and other human appropriation have vastly constrained its range. Added threats include roads and getting caught in traps, often set illegally, for foxes and rabbits. Censuses around the year 2000 yielded fewer than 100 individuals in the whole Iberian peninsula, focused in just two separate areas in the south-west, Doñana and Sierra Morena.

Responding to this perilous situation, Spain and Portugal began intensive conservation efforts including habitat restoration, aided by other countries whose captive-bred individuals were reintroduced into the cat's former range. Within twenty years the overall Iberian lynx population rose to an estimated 400 and, along with re-established habitat, continues to expand. However, the Iberian lynx remains the world's most threatened cat species.

DISTRIBUTION MAP

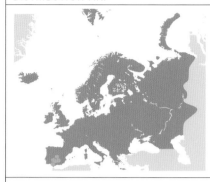

- LOCAL COMMON NAMES
Spanish lynx, Pardel lynx; Lince español, Lince ibérico, Gato ibérico (Spanish, Portuguese)

- SCIENTIFIC NAME
Lynx pardinus

- SIZE
Head–tail length 85–100cm (2ft 9in–3ft 3in), shoulder height 45–60cm (1ft 5in–2ft), weight 8–14kg (17lb 10oz–30lb 13oz)

- HABITATS
Woods, forests, grasslands, pastures, maquis (dense scrublands)

- DIET
Rabbits (by far the most common prey), other small–medium mammals from rats to young deer, birds such as ducks and partridges

- CONSERVATION STATUS
IUCN Endangered
(See key page 8)

LYNX IN TROUBLE

As well as the Iberian species, the lynx group includes the Eurasian lynx (largest), and in North America, the Canadian lynx and the bobcat (smallest). These three other species are all classed on the official Red List of threatened animals as Least Concern. But all are decreasing in numbers due to a range of human activities, from the relentless spread of farming and forestry to persecution for supposed livestock kills.

◀ Iberian lynx prefer habitats that are a patchwork of rocks, trees, shrubs, grasses and herbs. During the twentieth century, managed single-species forest plantations and other monoculture crops, known as habitat homogenization, took away more than 80 per cent of this mixed landscape.

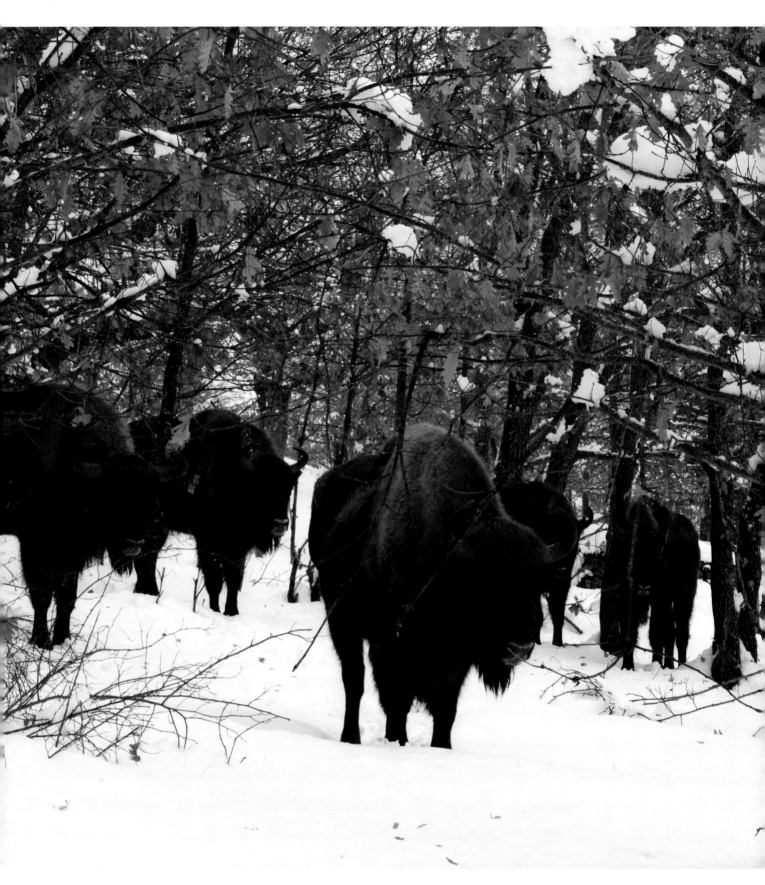

European bison

DEEP IN THE SHADE

Europe's biggest native land animal, this bison is a close cousin of the American 'buffalo' species. For such a massive, hulking animal, weighing in at one tonne or more, it is amazingly difficult to detect in its favourite habitat of deciduous or mixed deciduous-conifer woodland: a common alternative name is (European) wood bison.

A typical European bison herd numbers about 5–15 animals. Anecdotes from old-time hunters, before the bison became accustomed to non-aggressive human presence and activity, tell of how they reacted if one or more members detected potential danger. They all tended to move, quietly and unhurried, perhaps from a patch of open grassland where they were grazing, into an area with a more closed tree canopy and deeper shadows. Here, their brown coats merged effortlessly with the tree trunks and low shrub layer boughs. The bison stood still, watching, listening and sniffing, as they monitored any possible threats.

SLOW RECOVERY

For such a big, powerful animal, what could be a threat? Long ago it may have been a wolf pack, a brown bear, or possibly a Caspian tiger, before this tiger subspecies' slow demise and presumed extinction in the 1970s.

In more recent times virtually the only enemy of the bison was the human. They were killed for meat, fur, materials such as hide, sinews and bones, as punishment for raiding farm crops, and for trophies and drinking horns. Their range shrank vastly, from most of wooded Northern Europe to a few remnant populations, principally in Poland-Belarus's Białowieża Forest. Their predicament was recognized in the early twentieth century and since the 1930s concerted conservation efforts have seen their total numbers rise, from surviving only in captivity to more than 7,000 in some twenty countries.

DISTRIBUTION MAP

Original remnant populations

- **LOCAL COMMON NAMES**
 Wood bison; Wisent (from German); Zubr (Polish)

- **SCIENTIFIC NAME**
 Bison bonasus

- **SIZE**
 Head–body length 2.3–3.3m (7ft 6in–10ft 9in), shoulder height 1.7–2m (5ft 6in–6ft 6in), weight 500–1,000kg (1,100–2,200lb) (males are larger than females)

- **HABITATS**
 Extensive woods and forests, broad-leaved and broad-leaved-coniferous mixed, that include clearings and wood-shrub-grass areas

- **DIET**
 Grasses, sedges, herbs, leaves, shoots, twigs, bark

- **CONSERVATION STATUS**
 IUCN Near threatened (See key page 8)

◄ As autumn progresses, deciduous woodlands lose the deep shade in which bison can rest and hide. However, the browns of the fading leaves, and the woody trunks and boughs, provide a different backdrop to match their coats.

CONSERVATION ATTEMPTS

Sporadic attempts to protect European bison are known from as early as the sixteenth century. But in many parts of its range, people – especially those battling poverty – never understood the situation and continued to hunt them. From about 1920 conservation became more scientific, coordinated and publicized. Białowieża Forest became their sanctuary where they were closely scrutinized and fed hay and other supplements. Classed as Endangered in the official 1996 Red List, in 2008 they were moved to the less critical Vulnerable category, and in 2020 to the safer Near Threatened.

4
Africa

Orange-winged cicada

INCESSANT YET INVISIBLE CHIRPER

In warmer regions of the world, it is common to hear the loud, persistent, chirping or grating calls of the insects called cicadas, especially soon after sunset – yet be unable to locate the callers. Cicadas belong to the 'true bug' group of insects, Hemiptera, and like many other bugs, they feed by sucking saps and other plant juices. Most of the 3,000-plus cicada species are bulky insects with a large head, two prominent, wide-set eyes, a stout form, and long front wings that extend well beyond the end of the body. In many kinds, the insects are carefully patterned with patches, mottles and speckles to correspond with the bark of their favourite food trees.

SEE-THOUGH WINGS

More than sixty kinds or species of *Platypleura* cicadas – the name means 'broad-sided' – are widespread, especially across Africa, with some in Asia. Among their food trees are various acacias, mimosas and poincianas. In general, they are quite small for cicadas, with a head and body the size of a large grape. Also, the long pair of front wings is thin and flexible, and in some kinds these front wings have partly transparent areas, like 'windows', although the extent of these varies between species. What colouring there is on the wings usually matches the tree bark on which the cicada sits, while the bark and cicada's similarly patterned body can be seen through the 'windows', which all adds to the camouflage effect.

In species such as Haglund's cicada, *P. haglundi*, in south-east Africa, there is also geographic variation. Specimens from the north of its range are dark or even black, changing further south to mottled green-brown, and then to mottled brown as the climate becomes drier.

DISTRIBUTION MAP

● Platypleura plumosa
● Platypleura hirtipennis

- LOCAL COMMON NAMES
 Ochre-winged cicada; Icicada (Zulu)

- SCIENTIFIC NAME
 About 65 species of *Platypleura*

- SIZE
 Most species in the range head–body length 1.5–2.5cm ($^5/_8$–1in), wingspan 4–6cm (1½–2¼in)

- HABITATS
 Forests, woods and bush with suitable food trees such as acacias

- DIET
 Plant sap and other juices

- CONSERVATION STATUS
 IUCN Least concern
 (See key page 8)

FLASH OF COLOUR

Like many insects, cicadas have two pairs of wings. Their long forewings have see-though panels and coloration to match tree bark, so why are some kinds called orange-winged or ochre-winged cicadas? The answer is obvious when the cicada is disturbed and takes flight. The forewings raise to flap and expose the hindwings with their rich yellow, orange, red or ochre pigmentation. This sudden, unexpected flash of bright colour is often enough to confuse or deter a possible predator such as a bird or lizard.

▶ Its yellow or ochre underwings (rear wings) hidden, the cicada's front wing pair have veins, panels and patterns of green, brown and cream that mimic many kinds of tree bark. Large eyes notice approaching objects so that a cicada which is chirping at once goes quiet to avoid location by sound.

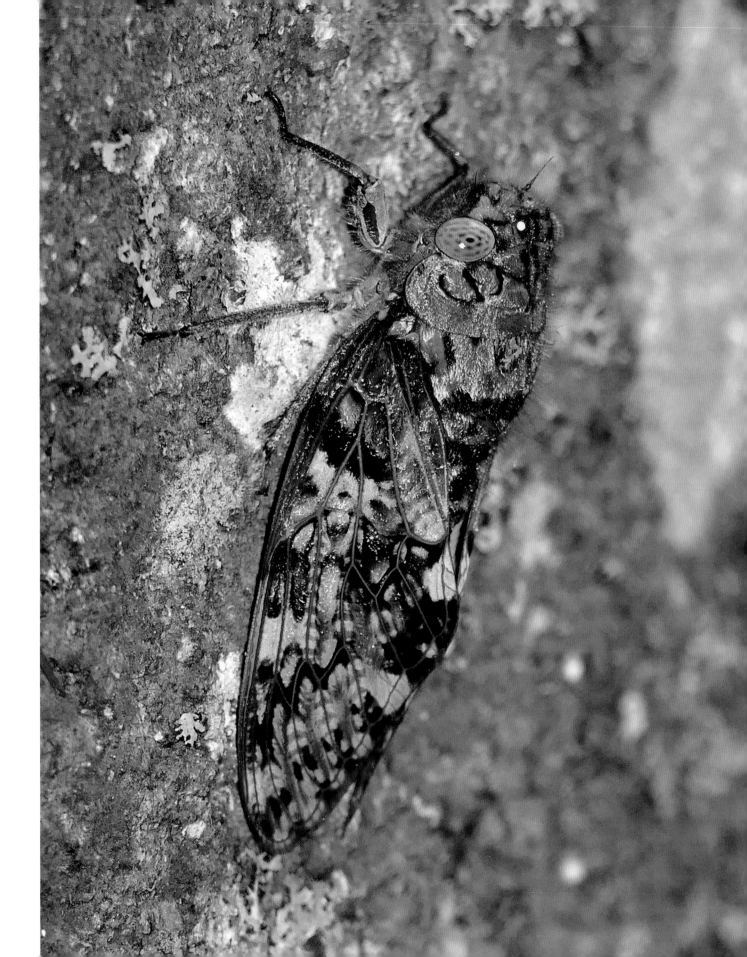

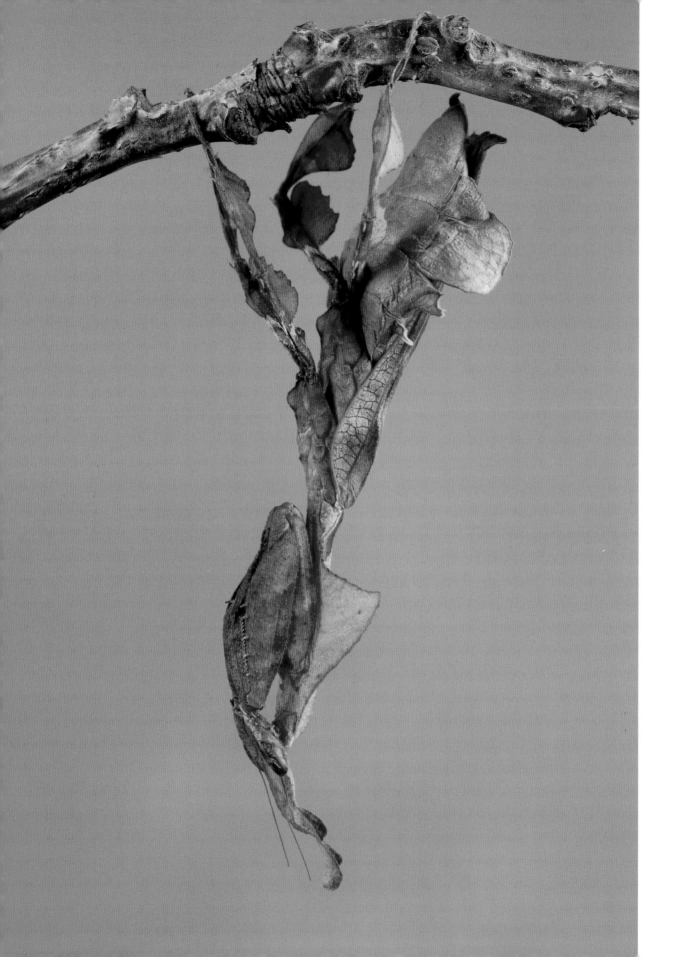

Ghost mantis

A BUNCH OF DEAD LEAVES

With a scientific name *Phyllocrania paradoxa*, meaning 'contradictory leaf-head', this species is unexpected-looking even for the mantis group. When finally detected as it sits camouflaged among old leaves, it is even then tricky to make out which body part is which, be it head, main body or legs, especially with the head's extraordinary adornments (see below).

Leaves are common objects to copy for camouflage. Older, curling, dark green or brown leaves are especially uninteresting even to folivores (leaf-eating animals). The ghost mantis takes its guise to the maximum with dead-leaf-like flaps for its wings, as well as around the sides of its body, on each of the main sections of its two rear pairs of legs, and even on the fearsome, fold-back, prey-grabbing front legs with their vicious spines.

INFLUENCE OF HUMIDITY

The ghost mantis is usually all-over brown, ranging from mid-dark to pale, with leaf-like vein lines, small spots and mottling to add interest. Lighter brown, green-brown and grey-brown individuals also occur. These are usually in slightly more moist, humid environments, such as lowlands or wooded areas. Here leaves tend to be greener, fade to brown more slowly, and, once brown, decay more rapidly, crumble and disappear. So, it pays for the mantis to mimic a greener shade rather than all-out brown.

This species' coloration is chiefly aggressive or predatory crypsis, as the mantis stays still and waits for a likely fly or similar meal to come within reach of its lightning-fast, front-leg grab. However, there is a defensive element too. It is relatively small for a mantis and so it is at risk from birds, lizards and other insectivores. Its petite dimensions, fascinating camouflage, predictable growth stages and placid temperament make it a popular terrarium inhabitant.

DISTRIBUTION MAP

- LOCAL COMMON NAMES
 Dead-leaf mantis

- SCIENTIFIC NAME
 Phyllocrania paradoxa

- SIZE
 Length 4–5cm (1½–2in)

- HABITATS
 Varied, mostly warm-to-hot vegetated regions including bush, shrub, open woods

- DIET
 Small insects such as flies, young grasshoppers and crickets

- CONSERVATION STATUS
 IUCN Not evaluated
 (See key page 8)

THE UNUSUAL LOP-HEAD

One of the most curious attributes of the ghost mantis is atop its head – a tall, witch-hat-like projection that is just as curled and asymmetrical as the rest of its garb. A head in which the two sides are not mirror images is unusual in the animal world, and this mantis's front-end lop-sidedness only helps further to prevent its shape being recognized.

◄ Every part of the ghost mantis has dead-leaf characteristics. Finding the two relatively short antennae is an aid to identifying which end is which, here at the bottom of the image.

▶ Close-up view of the head with its distorted, irregular protuberance or crown.

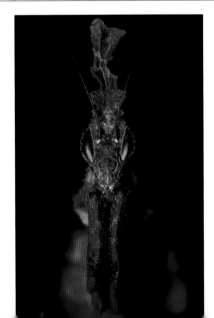

Sleeper cichlid

PLAYING DEAD OR EVEN DECAYED

Sleeper cichlids are five fish species originally from East Africa's Lake Malawi (Lake Nyasa) and nearby waters. Their biology and lifestyles are well known since they are popular with aquarists and have fascinating behaviour. The name 'sleeper' comes from the fish's habit of sometimes lying on its side on the lakebed as though sleeping. Smaller fish come near to investigate, and the feigning sleeper flashes into action and tries to consume them.

Sleeper cichlid colours and patterns are similar among the species. Livingstone's cichlid has a combination of giraffe-like, silver-grey tracery with large irregular patches of dark brown or brown-grey; the *polystigma* species is similar but the patches may be more organized into broad, broken horizontal bars; the *venustus* species is more yellow with the patches forming wide, fragmented, vertical streaks. Such appearances correlate with each species' microhabitat in the lake, such as thick vegetation in the shallows, or deeper where the bottom is sandy, or rocky, or well-shaded.

BURSTING INTO LIFE

A living fish lying on its side is very unusual, unless it is unhealthy in some way; it is a common position for a dead fish. As sleepers adopt this pose, they may purposely 'fade' their coloration so they look diseased and dying, or even dead – as rotting carrion. This is a form of aggressive mimicry that lures other fish scavenging for an easy meal – who then become one. Or the sleeper loiters in plants, among stones or under rocks, where its blotchy, patchy camouflage disrupts its fish-like shape, and it can then dash out to snatch prey. The *venustus* sleeper is also known to part-bury itself in mud or sand and then rush out to seize a passing feast.

DISTRIBUTION MAP

- LOCAL COMMON NAMES
 Sleeper fish; species names include hap, such as Spothead or Fusco hap (*Nimbochromis fuscotaeniatus*), Elephant-nosed cichlid or Linn's hap (*N. linni*), Giraffe hap (*N. venustus*); Kalingo, Kalingono (Bantu dialect); Chingwe (Tumbuka dialect)

- SCIENTIFIC NAME
 Five species of *Nimbochromis*

- SIZE
 Length 20–35cm (8in–1ft 2in), weight 150–250g (5–9oz)

- HABITATS
 Varied within Lake Malawi and adjacent waters

- DIET
 Smaller fish and other creatures

- CONSERVATION STATUS
 IUCN Least concern, except *N. fuscotaeniatus* Vulnerable (See key page 8)

'SWALLOWED' BABIES?

The huge cichlid fish group has probably more than 2,000 species, mainly in Africa and South America. They are noted for parental care, which is generally rare among fish. In sleeper and many other cichlids, this takes the form of mouthbrooding. The female holds her 100-plus eggs within her roomy mouth, and when the fry (young) hatch, they leave to feed but return at any sign of danger. During this time, about two to three weeks, the female forgoes feeding herself.

▶ (Top) When not faking death on the bottom in Lake Malawi, the leopard or hyena sleeper (*Nimbochromis/ Haplochromis polystigma*), here a female, tends to hide among rocks and reedy vegetation. Its colours provide excellent camouflage so it can ambush smaller fish. (Bottom) At breeding time, the male Livingstone's sleeper (*Nimbochromis livingstonii*) forsakes camouflage and 'colours up' to attract females. It is a delicate balance between showing off in order to breed, and being so noticeable that he becomes a meal.

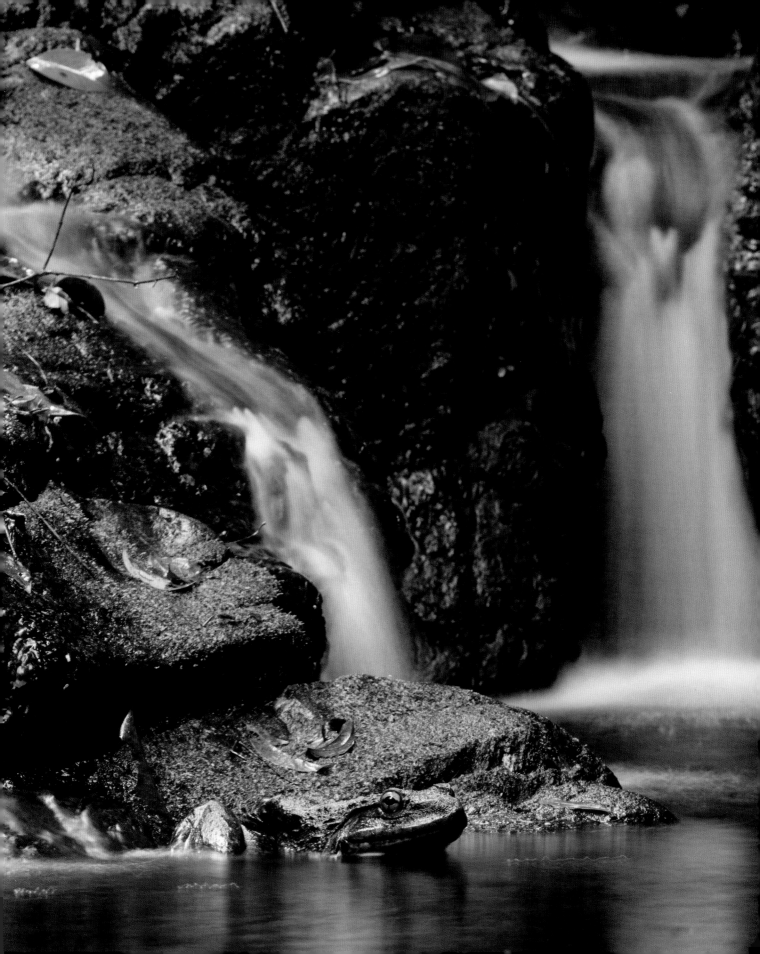

Goliath frog

BIGGEST BUT ALSO SMALLEST

Anurans are amphibians without tails – that is, frogs and toads. Notable as both the world's biggest anuran, and also as one of the anurans with the smallest geographic range, is the massive and muscular goliath frog. Its total length with rear legs and wide, webbed feet extended is up to 75 centimetres (2 feet 5 inches). However, its size and power are no defence against human activities. Found in only a tiny area of West Africa, it suffers from human predation for meat, trophies and the illegal pet trade, together with extensive habitat loss and deforestation, water pollution and degradation, and damming of watercourses.

SHINY, STREAMSIDE BOULDER

Despite its size, when the goliath frog has its limbs drawn to its body to present a rounded shape, at a glance it easily passes for a shiny, water-soaked, football-sized, streamside boulder. Its body is wide, the back gently curved and covered in small rounded lumps. The main coloration is darkish green, perhaps with faint tinges of olive, brown or dull orange on the upper surfaces; perhaps vaguely showing darker spots on the back and splodges or irregular cross-bars on the limbs. This is admirable camouflage among lush water plants and rocks covered with slimy algae and slippery mosses. The frog's seldom-seen undersides are paler greenish-yellow.

Perhaps the main clue to it being a frog is the eyes. Each of these is some 2½ centimetres (1 inch) in diameter – about the same size as a human eye. They give good night vision since the frog is active during darkness, both in the water and in damp undergrowth along the banks, where it is ready to grab and gulp down any creature that it can get into its capacious mouth.

DISTRIBUTION MAP

- LOCAL COMMON NAMES
 Giant frog, Goliath bullfrog, Giant slippery frog; Grenouille géante (French)

- SCIENTIFIC NAME
 Conraua goliath

- SIZE
 Head–body length 30–35cm (1ft–1ft 2in), weight 2–3.5kg (4lb 6oz–7lb 11oz)

- HABITATS
 Fast-flowing rainforest rivers and streams

- DIET
 Varied prey in and near water including worms, insects, shellfish, fish, also smaller amphibians, reptiles, birds and mammals

- CONSERVATION STATUS
 IUCN Endangered (See key page 8)

FUSSY BABIES

Adult frogs and toads are carnivores. Goliaths seize and swallow a huge variety of prey. But their young – the tadpoles (larvae) – are very fussy. When newly hatched, as with other tadpoles, they are vegetarian. However, they rely on only one kind of plant, a particular type of riverweed (podostemacean) specialized to grow on rocks in fast currents with watery splashes and sprays. It may be the restricted habitat and range of this plant that constrains the frog's geographic range.

◀ The goliath frog effortlessly impersonates a water-splashed, algae-covered riverside boulder or pebble. It is especially fond of fast currents, waterfalls and rapids with plentiful spray and high air humidity.

▶ Even in deeper, slower watercourses and pools, the goliath frog's rounded head and domed back are easily mistaken for a sizeable boulder.

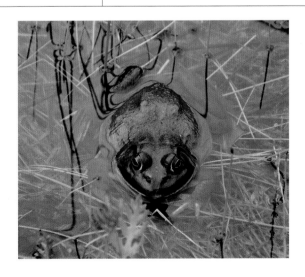

Satanic leaf-tailed gecko

MADAGASCAR'S FANTASTIC PHANTOM

Hardly the length of a human middle finger, this little lizard dwells in a small area in the east of Madagascar, Africa's largest island. Madagascar is an amazing biodiversity hotspot where, isolated from the Indian and African mainlands for almost 90 million years, evolution has produced some of the world's most distinctive, fascinating, precious – and sadly, highly threatened – animals and plants.

About twenty kinds or species of leaf-tailed or flat-tailed geckoes are found in Madagascar's wooded habitats. The satanic is one of the smallest, and also impeccably masquerades as a dead leaf or leaves. Its tired, patchy, mottled brown hues, sometimes with lighter orange or tan, has arced lines that resemble a dead leaf's veins. Its low triangular head, long, flat body and tail are bowed to match a curling, decaying leaf. There are even nicks and notches, especially on the tail, to emulate bits of a leaf, perhaps already nibbled by caterpillars or similar, that have rotted or fallen away.

A LEAF AMONG LEAVES
By day this gecko rests in the open among areas of dead and dying leaves, especially where old branches or twigs have broken so the foliage no longer receives nutrients and begins to deteriorate. It is usually positioned head down, and in a breeze it can rock its body and twist its tail slightly, moving precisely like the withering old leaves around it. In general, this gecko keeps to lower levels in the forest, rarely above 3 metres (10 feet) from the ground. At night, the satanic leaf-tail is a keen-eyed predator of insects, spiders and other small creepy-crawlies. On its splayed grippy toes, it prowls along trunks and branches, or perhaps descends to the forest floor leaf litter where its camouflage is even more effective.

DISTRIBUTION MAP

- LOCAL COMMON NAMES
 Fantastic (or Phantastic) leaf-tailed gecko, Eyelash leaf-tailed gecko

- SCIENTIFIC NAME
 Uroplatus phantasticus

- SIZE
 Length 7–9cm (2¾–3½in), weight 20–30g (¾–1oz)

- HABITATS
 Rainforests at various altitudes

- DIET
 Insects, slugs, snails, worms, similar small animals

- CONSERVATION STATUS
 IUCN Least concern
 (See key page 8)

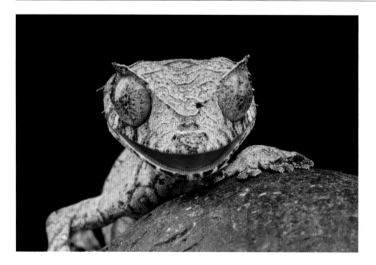

SCARY DEFENCE

Like its fellow leaf-tailed geckos, if the satanic is at risk of being molested, it has a startling surprise. It flicks its tail up and over like a scorpion's, lifts its head, opens its wide mouth to show the interior lining which is vivid pink-red-orange, and produces a loud distress call like a combination of a snake hissing and a human baby wailing.

▶ The correspondence is remarkable between the strengthening veins of the withering leaves and the gecko's ridged, pale lines.

◀ Head on, a worried gecko begins to open its mouth with brightly coloured interior, a sudden 'flash colour' that can startle the worrier while the lizard leaps away.

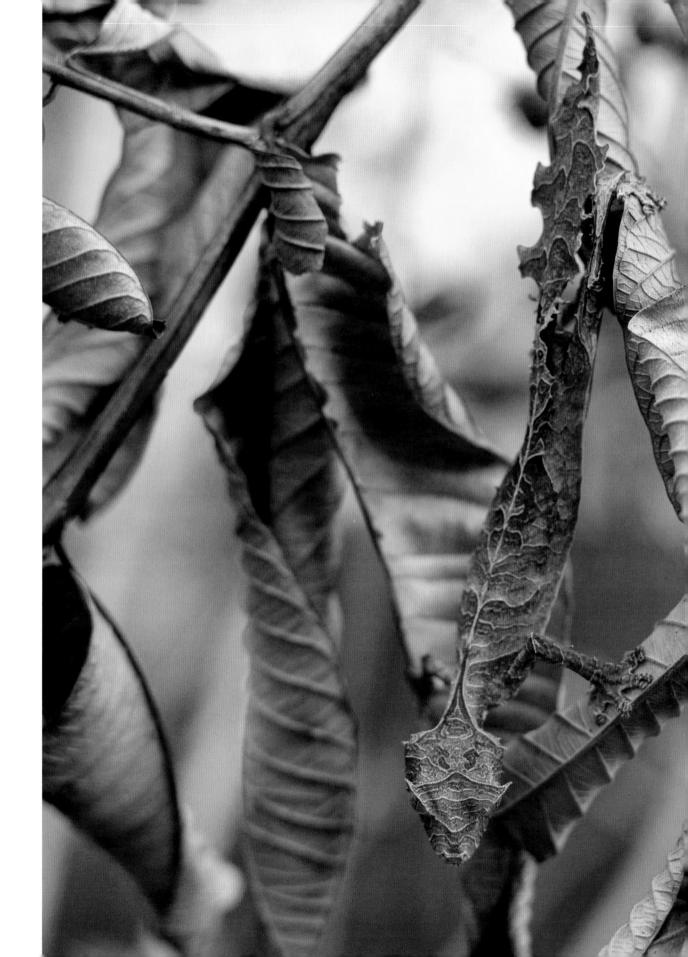

Panther chameleon

A TRUE MASTER OF DISGUISE?

Few creatures are more associated with camouflage than chameleons. There are more than 200 kinds of these lizards, chiefly on the African mainland and nearby islands, Southern Europe and West Asia. However, there are several misconceptions about their powers of camouflage.

The panther chameleon is one of the largest, most famous, most studied, and most commonly kept as an exotic pet. It cannot, as reputed, change its look to match almost any background. Chameleons can certainly alter appearance, but only within the limits of their genetically inherited coloration. And the purposes of colour change are complex.

One reason is social signalling, to send visual messages to, for example, a rival male or a potential female mate at breeding time, or to an intruder in the chameleon's territory. Another reason is body temperature regulation. A cool chameleon may become darker to soak up more of the sun's warmth or turn lighter to prevent overheating. Colours also vary according to ambient light levels and the chameleon's general health and state of nourishment.

Female panther chameleons are relatively uniform in pale green, pink, orange, tan or brown. Males vary greatly in their bright markings, mainly inherited according to their geographic location. Those on the north-west Madagascan island of Nosy Be are especially vibrant, with emerald green, blue-green or turquoise bodies. In north-east Madagascar, a predominant colour is pink, often with a pale yellowish side stripe. Other colours include dark green, brown, orange and red. Added to all this is the enormous variation in bars, stripes and bands, especially around the head, and also legs or a tail that look as if they belong to another chameleon. The overall outcome is that the chameleon's appearance may well have little to do with camouflage.

DISTRIBUTION MAP

- LOCAL COMMON NAMES
 Parder chameleon; Verkleurmannetjie (Afrikaans); Bilimankhwe (Chewa); Malagasy dialect names include Tana, Kandrondro

- SCIENTIFIC NAME
 Furcifer pardalis

- SIZE
 Total length 30–50cm (1ft–1ft 7in), weight 60–180g (2–6oz) (males are larger than females)

- HABITATS
 Woods and forests, especially around clearings and edges

- DIET
 Insects and similar small animals

- CONSERVATION STATUS
 IUCN Least concern
 (See key page 8)

CHAMELEONS WITH REAL CAMOUFLAGE

Research work continues on how chameleons change colour (see page 9) using mainly panther chameleons as subject animals. Panthers are relatively large and strong, not commonly preyed upon, and so being bright and gaudy is not too problematic for them. Smaller, more vulnerable species such as the leaf chameleons, *Brookesia* – some species are shorter than this word 'chameleon' – have conventional and masterful camouflage, mostly as dead leaves.

▶ (Clockwise from top) For large male panther chameleons, brightness overtakes concealment and equals being noticed by females leading to breeding success. Females tend to be less showy. However, the much tinier *Brookesia* finds leafy camouflage a better strategy.

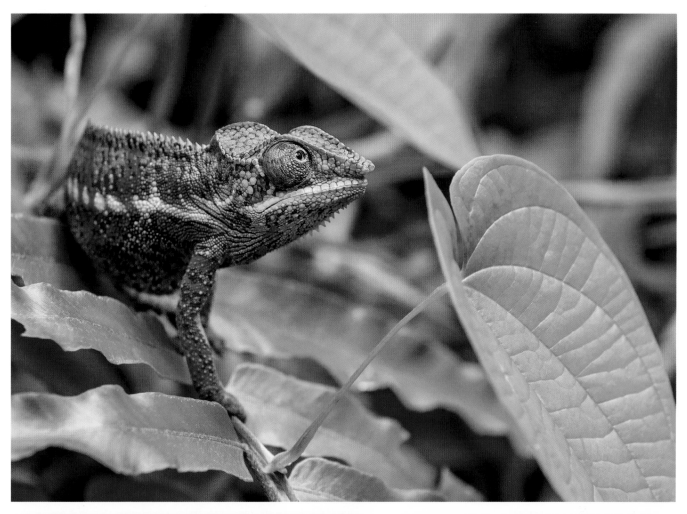

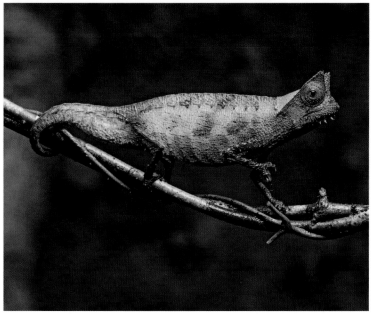

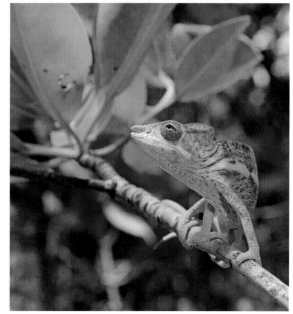

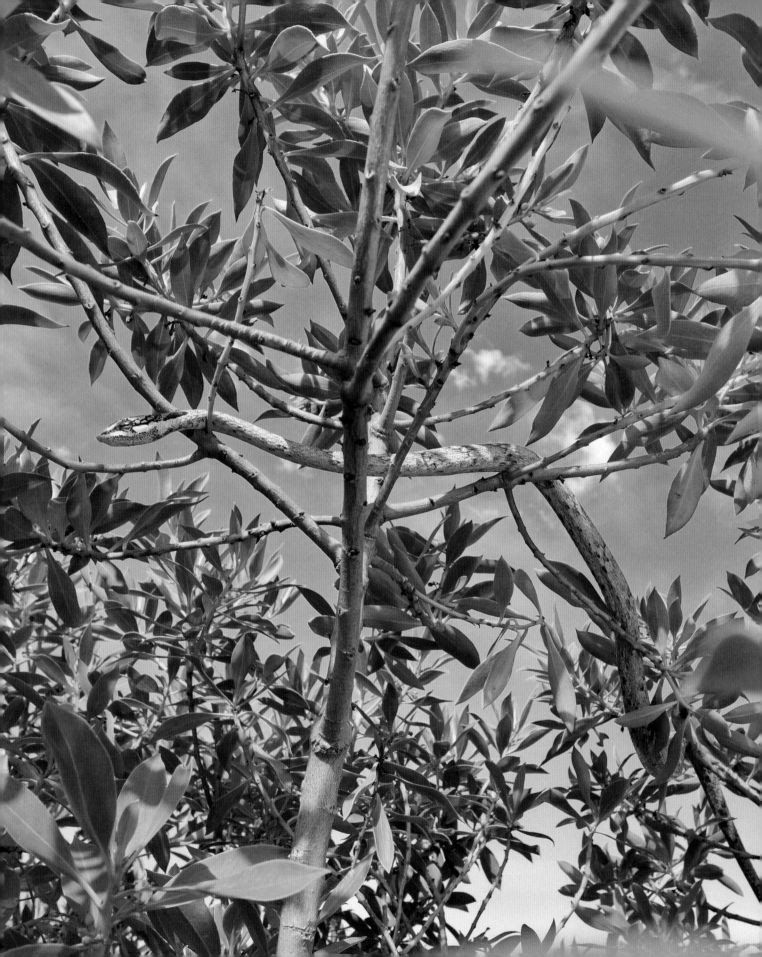

Twig snake

SMALL AND SLIM, BUT LETHAL

Twig snakes, also known as bird snakes, are the reptilian camouflage equivalents of stick insects or walking sticks – although there are some notable differences. Unlike a stick insect, a twig snake does not have six legs which mimic smaller twiglets, so it pretends to be one long, woody stem.

Also, the bite of a stick insect cannot kill a human. In fact, we hardly feel it. But the twig snake's bite may be lethal. This small, slender, yet highly venomous African reptile has two venom-jabbing fangs in the rear of its jaws, and its bites have been known to kill people.

SWAY AWAY
There are several kinds of twig snakes in the genus (species group) *Thelotornis*. Averaging 1 metre (3 feet) long but hardly thicker than a human thumb, all dwell in Africa and are almost totally arboreal (tree-dwelling). They are shades of browns and greys with random, mottled, wandering stripes, patches and other markings. Importantly, the behaviour of these snakes maximizes their stick-like form. Often, from a larger branch or trunk, a twig snake holds out the front section of its body relatively straight into mid-air, adopting an angle that aligns with the smaller branchlets and twigs around – and also swaying like them in a breeze.

Twig snakes are sometimes referred to as vine snakes, but they are not closely related to the green vine snakes *Oxybelis* of South America (see pages 56–57) or *Ahaetulla* in Sri Lanka. They are also known as bird snakes, although small birds are not the most common prey. The more usual diet is tree-living lizards, small snakes, tree frogs, mice and other small mammals.

DISTRIBUTION MAP

● Southern/Cape vine snake
● Usambara vine snake

- **LOCAL COMMON NAMES**
 Vine snake, Bird snake, Branch snake, Southern or Cape or Savanna twig snake (*Thelotornis capensis*), Usambara vine snake (*T. usambaricus*), Forest twig snake (*T. kirtlandii*)

- **SCIENTIFIC NAME**
 About 4 species in the genus *Thelotornis*

- **SIZE**
 Total length 1–1.5m (3ft 3in–5ft), weight 0.5–1.5kg (1lb–3lb 4oz)

- **HABITATS**
 Forests, woods, bush

- **DIET**
 Small reptiles, amphibians, birds and mammals

- **CONSERVATION STATUS**
 IUCN varies according to species; for example, Vulnerable for Usambara vine snake, Least concern for Southern twig snake
 (See key page 8)

READY TO STRIKE
The twig snake is usually cautious and slides away from danger. However, if threatened, it has no hesitation in warning that it may strike. It inflates its throat and opens its jaws wide to reveal the fangs at the back. If the aggressor persists, the snake may well bite hard and fast, and stab in the venom. It can and does defend itself like this against animals hundreds of times its size.

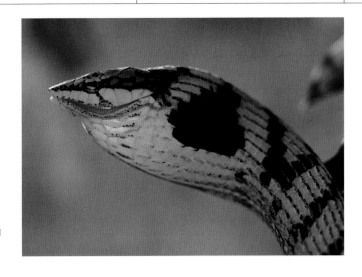

◄ A long, narrow head, which merges into a similar neck, that continues to a similar body, and on to the tail, with little change in width all along, allow the forest twig snake to disguise its identity.

▶ Throat extension is a common snake defence display and this southern twig snake's first sign against threat. The mouth is poised to open and reveal the fangs.

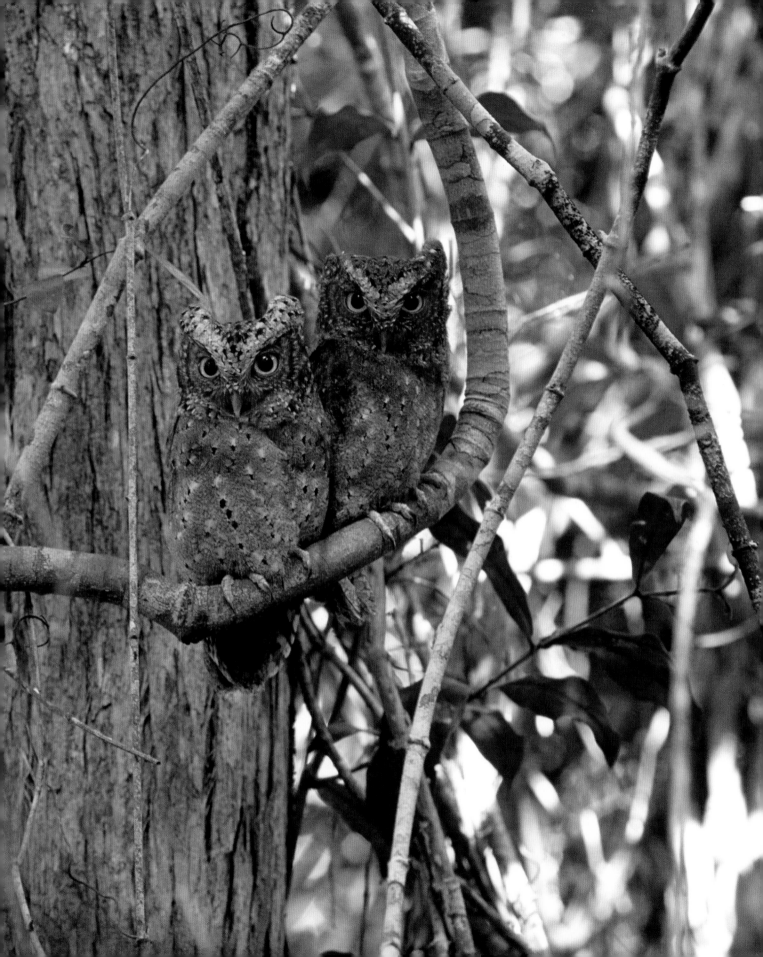

African scops owl

PART OF THE BARK

Scops owls number fifty-plus different kinds, or species, in the group *Otus*, ranging from Africa to East and South East Asia. They are generally small–medium for owls: even the giant scops owl is only 30 centimetres (1 foot) from bill to tail, while the Sokoke scops of East Africa is barely half this length.

Scops owls are essentially birds of forests, woodlands, bush and scrub, with open areas to swoop on prey on the ground or catch in mid-air. Their relatively short wings are designed for quick twists and turns and manoeuvrability in flight, rather than gliding and soaring. And their coloration blends magnificently with the bark on tree trunks and large branches as they roost during the day before setting off to hunt by night.

As an example, the African scops owl presents a blurry, indistinct form of grey, brown, rufous and pale flecks, streaks and bars, with wavy lines known as vermiculations on

its face. This is a close match for the striations and furrows of the bark at the owl's perch. Its ear tuft feathers may be erected when roosting to further confuse its head shape against the background. (Owl ear tufts are not anatomically linked to the actual ear openings, which are on the sides of the skull; they are so-named because they are in a similar position on the head as the ears of many mammals.) The owl may also perch on a horizontal bough and pose as a broken-off branch stump. By day its startlingly yellow eyes, which would otherwise be a highly noticeable clue to its presence, are usually closed or almost so.

DISTRIBUTION MAP

● African scops owl

- **LOCAL COMMON NAMES**
 Many English local names depending on species, location and habitat; Bundi (Swahili); Isikhova (Zulu)

- **SCIENTIFIC NAME**
 50-plus species in the genus *Otus*, including *O. senegalensis* (African scops owl), *O. rutilus* (Madagascan or Malagasy or Rainforest scops owl)

- **SIZE**
 African scops owl: bill–tail length 18–20cm (7–8in), wingspan 40–45cm (1ft 3in–1ft 5in), weight 30–80g (1–3oz)

- **HABITATS**
 African scops owl: woodlands, tangled bush and scrub, parks and gardens, usually with mature trees and open areas

- **DIET**
 African scops owl: insects, spiders and similar invertebrates, also small frogs, lizards, birds, mammals such as mice, bats

- **CONSERVATION STATUS**
 IUCN varies from Least concern (about 26 species) to Critically endangered (Annobón scops owl, *O. feae*) (See key page 8)

SCOPS OR OTUS?

The name 'scops' is probably derived from the Greek term *sköps*, meaning 'little owl'. It was given to one of these owl species as the scientific name *Scops* by French zoologist Marie Jules de Savigny in the early nineteenth century. However, Welsh naturalist Thomas Pennant had already used the name *otus*, another Greek term for 'eared owl', for a related species about forty years earlier. After a huge amount of discussion and chopping and changing, most ornithologists settled on using *otus* as the scientific name and scops as the common name.

◄ A pair of Sokoke scops owls (*Otus ireneae*) pose against a suitable woody creeper and tree trunk. This is the smallest scops species, just 15cm (6in) tall.

Nubian ibex

LIFE IN THE DEEP DESERT

Frequenting some of the world's driest, hottest, rockiest, most inhospitable terrain is the Nubian ibex. It is found only in the far north-east corner of Africa, and around the west and south of the Arabian Peninsula. The landscape is hilly to mountainous, with sand, pebbles, boulders, crags and cliffs in varying shades of tan, tawny, beige, light brown and, of course, sand hues. When it stays stationary in this undulating, unremitting, unvarying backdrop, the similarly coloured ibex is almost impossible to detect. Perhaps its only indications are the long, slim, recurving horns (up to 1 metre/3 feet long in males, half this for females), black eyes and muzzle tip, and lower legs and feet with dark and light patterns.

To shelter from the fiercest daytime sun, and also to rest at night, the Nubian ibex finds a retreat somewhere up a seemingly unscalable crag or cliff. If threatened at a distance, its instincts are to keep still as it watches, listens and smells to assess the situation. At closer range, it abruptly dashes away with astonishing speed and agility, finding footholds among the steepest and loosest rocks as it escapes to an even more inaccessible refuge.

EXPERT SURVIVOR

Ibexes are members of the goat group, caprids, which includes about ten wild species plus the many breeds of domesticated goats. Like its cousins, the Nubian ibex is a tough, expert survivor with a hugely wide diet. It can cope with the prickliest, thorniest desert plants, from stringy grasses and fibrous herbs, to spiky shrubs and bristly bushes.

DISTRIBUTION MAP

- LOCAL COMMON NAMES
 Middle Eastern ibex; Beden (Arabic); Je'el, Yael (Hebrew); Bouquetin de Nubie (French)

- SCIENTIFIC NAME
 Capra nubiana

- SIZE
 Nose–tail length 1–1.6m (3ft 3in–5ft 3in), weight 30–80kg (66lb 2oz–176lb 6oz) (males are larger than females)

- HABITATS
 Arid and semi-arid rocky plains, hills and mountains

- DIET
 Most kinds of plant matter

- CONSERVATION STATUS
 IUCN Vulnerable
 (See key page 8)

◀ On a seemingly unreachable ledge on sandstone cliffs, a sandy-hued Nubian ibex watches as the sun begins to set. In the cool of dusk, it will venture down to search for almost any kind of plant food.

ROCKY ROAD AHEAD

Declining numbers of the Nubian ibex have been known for many years, but its populations were formerly grouped with the Alpine or 'the' ibex, *Capra ibex*, whose numbers in the European Alps have increased due to energetic conservation efforts. When the Nubian ibex was classified as the separate, *C. nubiana*, its numbers as a species (now without those of *C. ibex*) were, at a stroke, reduced to very low, between 1,500 and 4,000 individuals. New wildlife laws and sanctuaries will hopefully reverse the decline.

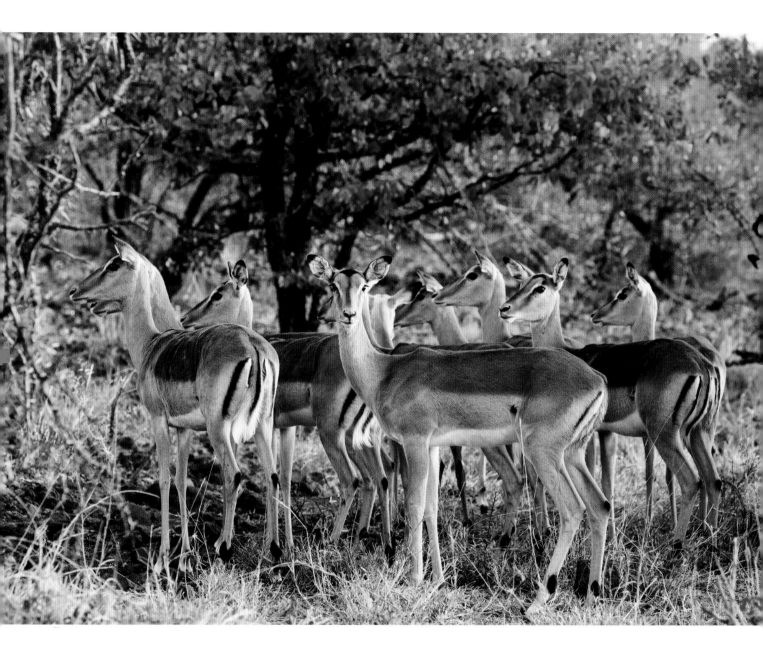

Africa's impala population of more than 2 million make it one of the continent's most numerous large wild mammals. The clearly delineated three-tone countershading is just one of an array of self-defence traits, which also include sharp senses, speed, safety in numbers, adaptable diet, and a rapid breeding cycle. Flash signals also enourage an impala herd that flees together to stay together (opposite).

Impala

THREE-TONE SHADING

In East Africa's woods, bush and savanna, impala are among the most common larger prey of varied top carnivores, including lions, leopards, cheetahs, hyenas and wild dogs. It is no surprise that this medium-sized antelope has a battery of anti-predator features. They include a lightweight, slender, agile build with long legs for speed; super-senses of sight, hearing and smell; long, sharp, curving horns (although these are males only); dwelling in groups, where many eyes and ears are alert for danger; and a complex system of body colours and markings.

LIGHT TO DARK, DARK TO LIGHT

The impala's fundamental colours involve browns to blend into the tones of dry soils, woodland trees and bushes, arid scrub, and often parched savanna grasses. However, seen from the side, the antelope displays three definite zones of shading.

The upper and lateral areas of the neck and main body are mid- to darker brown or reddish-brown. Below this on the flank is a well demarcated paler zone of lighter tan, while the neck and legs gradually fade down to this same tan. The belly and insides of the legs have another well-defined zone which is much lighter, approaching white.

This multi-tone look is seen in many kinds of creatures across the animal kingdom, although unlike impala, it is usually two zones which grade into each other. It adds to basic colour camouflage by an effect known as countershading. Sunlight from above tends to brighten the darker upper surfaces, while shadows below tend to darken the lighter under areas. The result – especially in twilight – tends to confuse the animal's outline and three-dimensional form, and so lessen chances of predator detection.

DISTRIBUTION MAP

- LOCAL COMMON NAMES
 Rooibok (Afrikaans); Phala (Tswana Bantu); Mpala (Zulu and others)

- SCIENTIFIC NAME
 Aepyceros melampus

- SIZE
 Head–body length 1.2–1.4m (4ft–4ft 7in), height 70–90cm (2ft 3in–3ft), weight 45–70kg (99lb 3oz–154lb 5oz)

- HABITATS
 Woodlands, savanna (grasslands), bush, often a mosaic of all three

- DIET
 Leaves, grasses, buds, shoots, fruits, twigs

- CONSERVATION STATUS
 IUCN Least concern (See key page 8)

QUICK, FOLLOW ME!

The impala's rear end has dark strips on the buttocks and lowered tail. Should a group be disturbed, each flicks its tail up to reveal the white beneath and another stripe between the legs. This sudden flash signal alerts others in the group and says, 'Follow me!'. As the impala flee, those behind follow the rumps of the ones in front. Otherwise, if the herd scattered, the isolated members would lose their safety in numbers and be more exposed to attack.

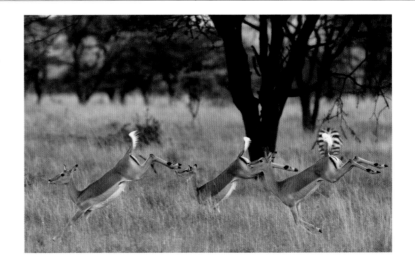

Giraffe

NEVER TOO TALL TO HIDE

Is it really possible for the world's tallest animal, weighing in at more than a tonne, to melt into the background? Yes – in certain places. Much giraffe imagery features these all-neck-and-leg browsers loping across Africa's savannas, because this is an open habitat where giraffes stand out clearly against the grasses and skyline, and make a clear and dramatic scene. But giraffes spend much of their time in open woodland, especially among spiky acacias and also winter-thorn (*Faidherbia*), hanza (*Boscia*) and sausage tree (*Kigelia*). Telltale signs of their feeding is a browse line about 5 metres (16 feet) from the ground, above which the trees keep their twigs, flowers, fruits and leaves.

Each giraffe has a unique 'fingerprint' coat pattern. The patches vary from light tan, chestnut, even orange, to dark brown or virtually black, while the separating lines may be almost white, cream or very light tan. These appearances vary in different areas of Africa.

BRIGHT AND GLOOM

In open, more sparse, wooded areas, the giraffe's patchy, interlacing, reticulated (net-like) appearance comes into its own. With no dense tree layer canopy, shafts of sunshine penetrate easily through the gaps in the foliage to create a strongly dappled, shadowing effect on the ground vegetation, bushes, trees and other background. The whole scene is vividly mottled and blotchy, just like the giraffe's coat. The edges of the giraffe's polygonal patches match the crisscrossing branches and stems of bushes and shrubs. And the giraffe's long, vertical legs and neck mimic upright tree trunks. This camouflage is especially useful since the giraffe's main predators lurk in these types of woodland – lions, leopards, hyenas, even wild dogs – trying visually to locate their quarry.

- LOCAL COMMON NAMES
Twiga (Swahili); Nduida (Kikuyu); Kameelperd (Afrikaans); Ndhlulamithi (Zulu)

- SCIENTIFIC NAME
Giraffa camelopardalis

- SIZE
Height 4.5–5.5m (14ft 9in–18ft), weight 1–1.5 tonnes (2,200–3,300lb)

- HABITATS
Open woodlands, savanna, shrub and bush

- DIET
Leaves (especially acacia), twigs, stems, fruits

- CONSERVATION STATUS
IUCN Vulnerable
(See key page 8)

I KNOW WHERE YOU LIVE

Regional variations in giraffe coat markings and also extent, such as how far the pattern spreads down the legs, have been used to recognize up to nine varieties, or subspecies, of the main giraffe species across Africa. By appearance, an expert can pinpoint where an individual giraffe comes from. However, more recent genetic studies suggest there are not one but three giraffe species, with ongoing work to decide how many varieties there are of each.

▶ In the harshly sunlit, starkly contrasting patches of light and shade of open woodland, a giraffe may remain unnoticed even when a few metres/feet away. Its unusual tall, spindly outline, compared to more familiar large herbivores, such as antelopes, adds to the effect.

Spotted hyena

SPOTTY SUCCESS STORY

Largest of the three kinds of hyenas, the spotted is also Africa's second most common large carnivore, after another 'spotty' – the leopard (see pages 132–133). Spotted hyena total numbers probably exceed 30,000 and may be more than 40,000, which is far greater than, for example, the (spot-free) African lion at an estimated 20,000–25,000. As well as this hyena and the leopard, another sizeable hunter which is also spotted is the cheetah. So, spots seem to be a successful component for visual camouflage of these big predators. Even so, populations of these top carnivores, and others such as African wild dogs, are regrettably all decreasing.

SUBTLE MARKINGS

Compared to other 'spotties', the spotted hyena's patterns are more understated, with less contrast between the spots and other markings and the base colour. With considerable variations between individuals, the background is usually grey-brown with a hue of sandy, tan or dull yellow; the spots, or sometimes streaks or broken bars, are basically brown but vary from reddish or rufous to nearly black. The clearest spots are on the back, shoulders, flanks and rump. They lighten towards the face, throat, belly and feet, and also with age, so older hyenas have more faded coats. The neck crest of longer hairs may be redder or rusty.

Like its big cat counterparts, crouched in the grass or undergrowth, the spotted hyena's camouflage conceals its form and shape, even to super-watchful prey animals such as zebras and gazelles. These hyenas have a traditional reputation as scavengers, but field studies show that as much as two-thirds of their food comes from hunting and killing. The pack or clan do this in a highly organized and coordinated fashion, selecting a likely victim to follow for kilometres before attack.

DISTRIBUTION MAP

- LOCAL COMMON NAMES
Laughing or Bear hyena; Bere (Shona); Mpisi (Zulu); Gevlekte hiëna (Afrikaans); Phele (Venda); Fisi (Swahili)

- SCIENTIFIC NAME
Crocuta crocuta

- SIZE
Head–tail length 0.9–1.7m (3ft–5ft 6in), shoulder height 70–85cm (2ft 3in–2ft 9in), weight 40–75kg (88lb 3oz–165lb 5oz) (females are larger than males)

- HABITATS
Mostly drier, open places, such as savanna, bush, scrub, semi-desert, scattered woodland; rarely in dense woods or forests

- DIET
Massively varied, from insects and worms to zebras, antelopes, gazelles, even buffalo, giraffes and elephants; scavenging for carrion is significant but less common than usually supposed

- CONSERVATION STATUS
IUCN Least concern
(See key page 8)

FEMALES RULE

Unusually for mammals, female spotted hyenas are larger than males. Females also dictate the complex clan (group) organization, social interactions and breeding habits. Indeed, this dominance extends to the female having genitalia that look like the male's, with an enlarged clitoris that resembles a penis and can become erect.

▶ Spotted hyenas spend much time among scrubby vegetation (top), or crouched in low grass (bottom), watching groups of prey to pick out an old, young or unhealthy individual. Their exceptional bite force tears and crushes almost any tissue, from skin and sinew to horn and bone.

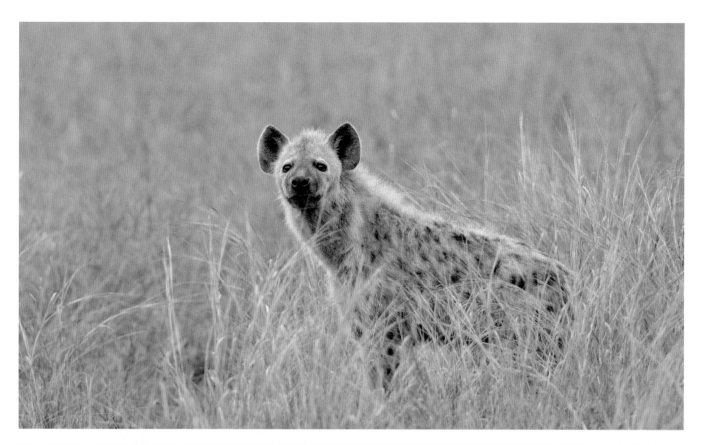

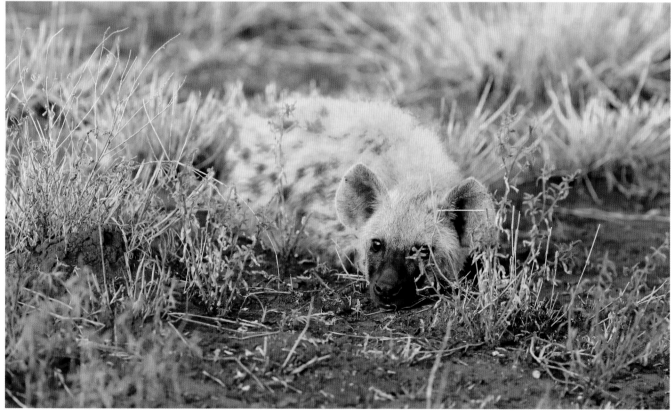

Caracal

FELINE HIGH-JUMP CHAMP

An alternative name for the caracal, descriptive but not scientifically accurate, is 'desert lynx'. It is certainly a creature of semi-arid regions in Africa and West Asia, although not found in the depths of the driest deserts such as the Sahara. Also, its ear tufts do resemble those of cats in the lynx group, but again, the caracal is not a member, being more closely related to one of Africa's spotted felids, the serval. However, the caracal's almost uniform light sandy, reddish, tan or tawny coat is a powerful indicator that it is camouflaged for mostly dry habitats, although some individuals tend to darker reddish-brown, while others may have more silver or grey. When this body fur is not smoothed neat and flat, it can give the impression of faint mottling or patchiness.

In all caracals, the underside is usually very pale, and other markings are minimal – dark facial stripes from the inner eyebrows down to the nose, and dark hairs on the backs of the tall ears and their pointy tips. All in all, the appearance is ideal for resting secretively among rocks, on stony plains, in dry scrub and bush, and open woodland, which the caracal does by day, before rousing itself at dusk to hunt.

ATHLETIC PROWESS

One of the biggest small cats, strongly built yet relatively slim, short-tailed and long-legged, the caracal is famed for its athleticism even among the cat family. It is a prodigious leaper, springing straight up 3 or even 4 metres (around 10–13 feet) to swipe at a low-flying bird with its claws-out paws. It also stalks and pounces upon a wide range of terrestrial prey, from mice to small–medium antelopes.

DISTRIBUTION MAP

- LOCAL COMMON NAMES
 Persian lynx, Desert lynx; Ch'ok anb'esa (Tigray); Klossie oor (Afrikaans); Simbamangu (Swahili); Karakulak (Turkish)

- SCIENTIFIC NAME
 Caracal caracal

- SIZE
 Head–body length 0.7–1m (2ft 3in–3ft 3in), shoulder height 40–50cm (1ft 3in–1ft 7in), weight 9–17kg (20lb–37lb 7oz) (males are larger than females)

- HABITATS
 Dry scrub, bush, savanna and woodlands, rocky hills, stony plains

- DIET
 Rodents such as rats, hares, hyraxes, birds, snakes and lizards; occasionally young gazelle, springbok and similar small–medium antelopes

- CONSERVATION STATUS
 IUCN Least concern
 (See key page 8)

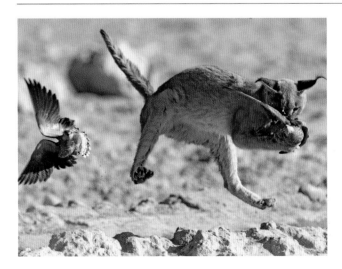

CAT AMONG THE PIGEONS

Like cheetahs, caracals were once semi-tamed and kept, usually by high-ranking individuals, as part of a hunting menagerie. Their ability to jump vertically was especially encouraged as a spectacular and widely admired feat, and also an opportunity for wager. Caracal were stationed near a flock of pigeons which were then released, and some of the cats would bring down several birds in quick succession, winning bets for people who had staked money on them.

▶ Red-brown aridity is the caracal's natural environment. It may cover many kilometres until it identifies a suitable location for prey, such as behind a ridge or near a waterhole.

◀ The caracal's mid-air spring is unmatched even among the cat family. This individual has batted a sand grouse into its grasping paws.

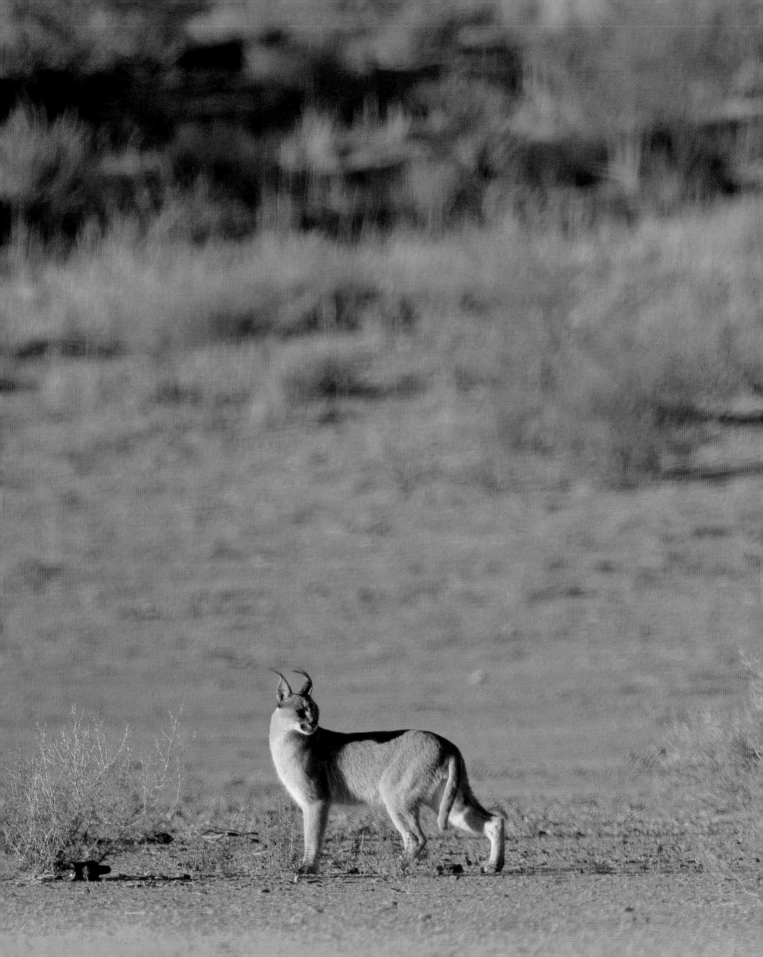

Leopard

THE CAT FOR ALL SEASONS

This most 'spotted' of cats is also the most widely distributed member of the entire cat family (apart from domestic pets). Its spotty coat fulfils a similar camouflage purpose to other spotted cats. It mimics the mosaics of light and shade, of brightness and gloom, in many habitats – under trees in all kinds of woodland and forest, and among bushes, scrub and general undergrowth. It helps to confuse and obscure the body's otherwise recognizable outline. All these effects are magnified in low light levels when most cats are on the prowl.

However, technically leopards do not have spots. They have rosettes, which are groups of dark marks arranged so that they vaguely resemble the petals of rose flowers.

GENES AND COAT MARKINGS

The genetics of cat coat colour and pattern have been much investigated, mainly in the domestic species. There are several genes involved, with names such as *Tabby* and *Dkk4*. Each of these genes has several variants. The variants interact to control the amount of colouring substances produced, pigments, mainly the dark brown-black pigment melanin.

At a microscopic level, melanin and other pigments are made by cells called melanocytes. Certain combinations of genes make some groups of melanocytes more active, so they make more pigment, which results in a darker area of skin and fur. This happens in very early development, when the animal is still a tiny embryo. Gradually the cat grows and its spots or other coloured areas grow with it. The complete process is not fully understood, but it seems to apply to all cats, from domestic pets to tigers and leopards.

DISTRIBUTION MAP

- LOCAL COMMON NAMES
Panther; fahad (Arabic); Chui (Swahili); Ngwe (Zulu); Mbada (Shona); also regional names for up to 10 subspecies, such as African leopard, Arabian leopard, Anatolian leopard

- SCIENTIFIC NAME
Panthera pardus

- SIZE
Head–body length 1–1.8m (3ft 3in–5ft 10in), shoulder height 55–70cm (1ft 9in–2ft 3in), weight 30–80kg (66lb 2oz–176lb 6oz) (males are larger than females and also subspecies vary in size)

- HABITATS
Extremely varied, from rocky mountains to most kinds of forests, bush, scrub, savanna, desert, human habitation, even city centres

- DIET
Extremely varied, from insects to large antelope and deer, including occasional livestock

- CONSERVATION STATUS
IUCN Vulnerable
(See key page 8)

VERSATILE AND ADAPTIVE

The leopard's amazing power-to-weight ratio, its stalking and killing prowess, and its ability to adapt to so many habitats – including those altered by humans – have been admired yet feared for millennia. These big cats seem to 'pop up' totally unexpectedly in suburbs and even in big cities. However, like all big cats, their range and numbers are diminishing.

▶ In leopard rosettes, the fur between the dark marks of a single rosette is tan or tawny, while the background between the rosettes is paler. On some body areas, such as head and lower legs, the rosettes are smaller and merge into solid dark spots. The cat's whole coloration is lighter in drier areas, such as semi-desert, and darker in wetter regions like tropical rainforests.

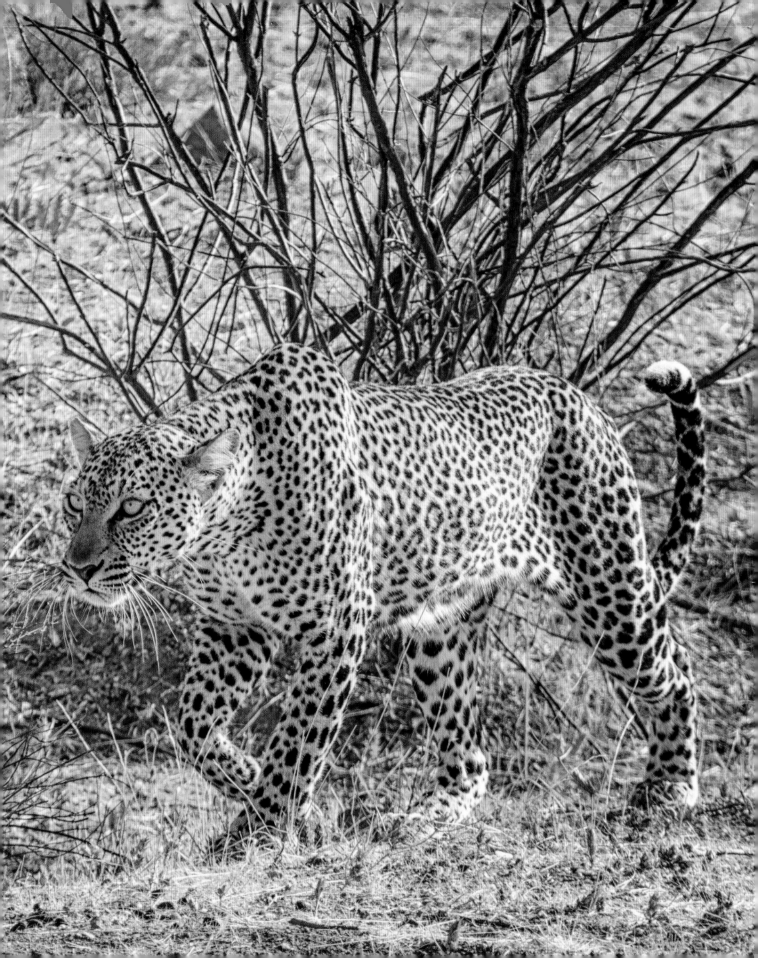

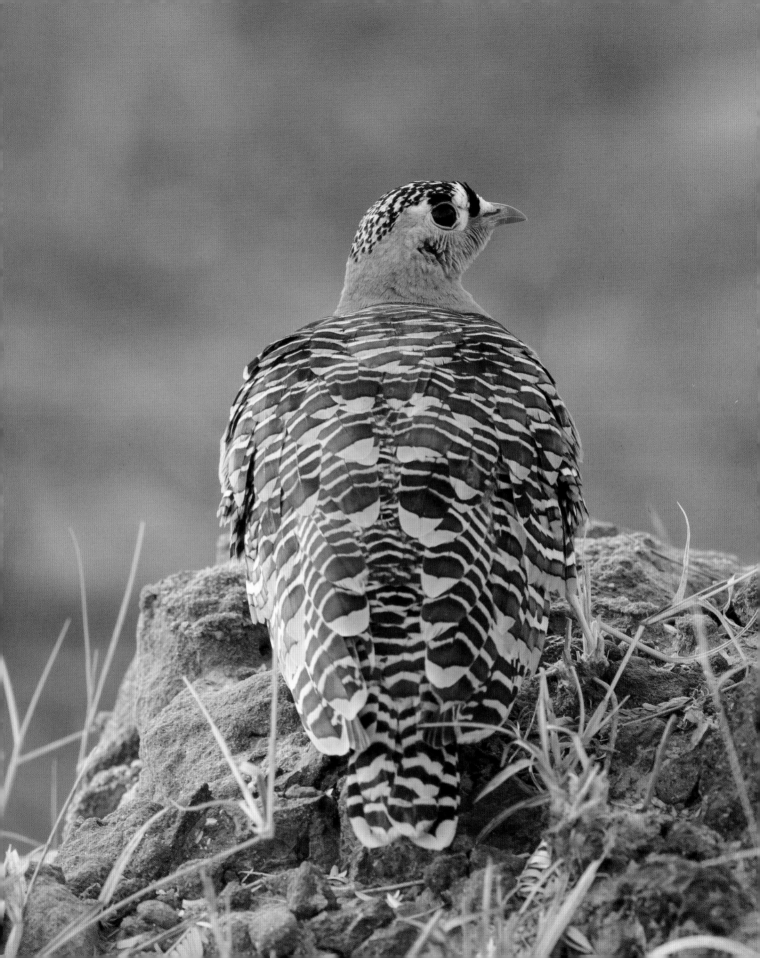

5

Asia

Mango baron

FEATHERY, FRILLY GREENERY

In appearance, adult baron butterflies are relatively subdued insects. The male is usually mid-brown with white spots and dark-bordered ovals on the front wings, and similar ovals on the rear wings; the female is overall paler and lacks the white spots. Like hundreds of brown butterfly species, they usually rest unnoticed, camouflaged in a general way among the common and widespread foliage of old leaves, twigs and branches.

The appearance of the baron's young stage, the caterpillar or larva, means it can also rest unobserved – but it is a very different and highly specific form of camouflage. This extraordinary caterpillar has been likened to a walking feather, animated pinecone or crawling television aerial. It is very flattened, with ten pairs of long, spike-like protrusions along each side of the body, which themselves have further side sets of delicate fringes, similar to hair combs or bird feathers. The whole creature is bright green except for a pale yellow stripe along the back.

DISAPPEARING TRICK
It would seem that the baron caterpillar's elaborate form is totally conspicuous in almost any setting. But when the caterpillar flattens down and presses itself onto a bright green leaf, the feathery, plant-like growths almost vanish into the leaf's own mazy network of small, pale, greeny-yellow minor veins, while the yellow back stripe looks like just another larger leaf vein. The caterpillar often takes up a position where its back stripe aligns with the leaf's major central or midrib vein, and then the amazing disappearing trick is complete. The caterpillar is hardly visible even in full view to birds, lizards and similar insectivores.

DISTRIBUTION MAP

- LOCAL COMMON NAMES
 Baron, Common baron

- SCIENTIFIC NAME
 Euthalia aconthea

- SIZE
 Mature caterpillar length 3–3.5cm (1¼in); adult butterfly wingspan 6–7cm (2¼–2¾in)

- HABITATS
 Forests, woods, parks, gardens, plantations

- DIET
 Caterpillar: leaves of plants such as mango, cashew, mistletoe
 Adult: ripe blossoms and fruits including rhododendrons, guavas

- CONSERVATION STATUS
 IUCN Not evaluated
 (See key page 8)

BARONS, DUKES AND DUCHESSES
The baron's camouflage works best on fresh green leaves, especially those of mango trees, *Mangifera*, and also cashew trees, *Anacardium*. It can sometimes become a pest in orchards and plantations, and the spread of mango and cashew cultivation has also helped the spread of this baron species. Other kinds of barons, *Euthalia*, include the gaudy baron, blue baron, green duke and grand duchess.

▶ Camouflage of the baron caterpillar depends on finding leaves of matching green (which it also eats), usually those of mango and related trees, and aligning its back stripe with the leaf's midrib or main vein.

◀ Away from a leaf, the crawling caterpillar reveals its hugely complex, fragile, feather-like side protrusions.

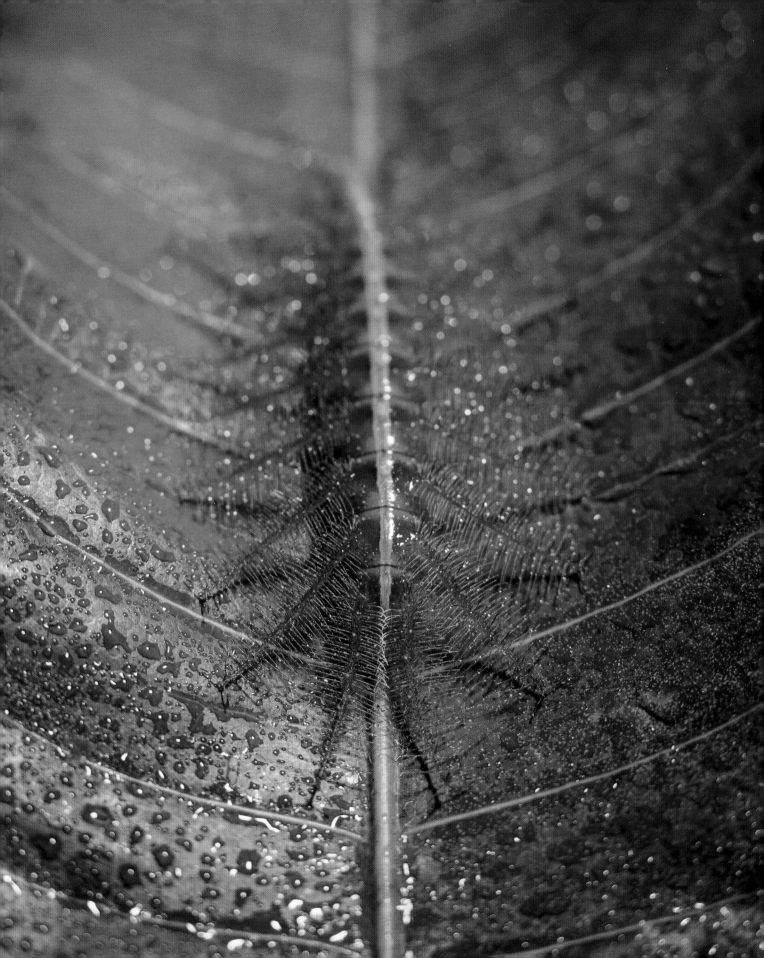

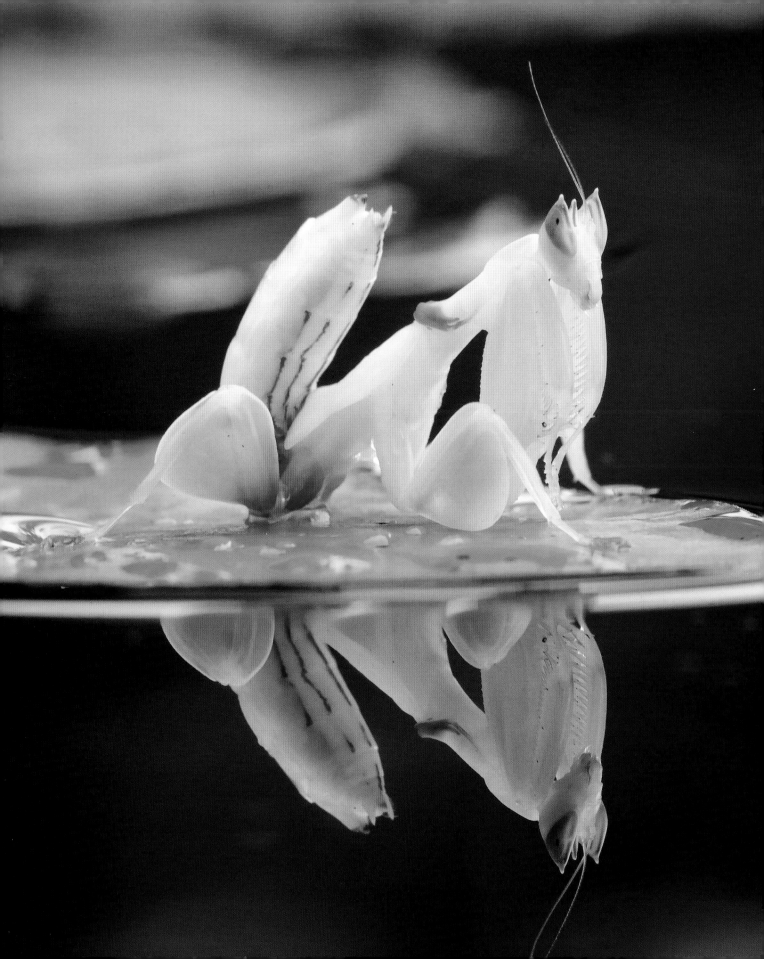

Flower mantis

SUPER-FLOWER SUPER-MEAL

Famous as lightning-fast grabbers of small insects, using their spiky, folding front legs, mantids or mantises are insects related to cockroaches. With as many as 2,500 kinds, they are camouflaged to resemble all kinds of natural items, from leaves, twigs and mushrooms to other insects such as wasps. A particular mantis family is the Hymenopodidae or flower mantids. Their aggressive mimicry takes after blossoms, blooms and other flowers, in order to ambush victims that come to drink nectar, gather pollen, or perhaps hide from another predatory pursuer within the petals.

One of the best-known flower mantids is the orchid mantis. It occurs in various hues, from almost white to various shades of pink, purple, yellow and nearly golden. It is commonly pictured on orchids and similar flowers of virtually the same colour as itself. The story has arisen that the orchid mantis nestles within the orchid, pretending to be part of it, waiting for a visit from a fly, butterfly, moth, bee or other snack.

GENERIC RESEMBLANCE
Recent studies have partly dispelled this story. In the wild, the orchid mantis is not often seen masquerading as part of an orchid, or of any similar flower. The mantis is usually on its own, among leaves and twigs, although there may be orchids and comparable blooms nearby. It seems that the mantis is actually impersonating 'a flower' – a generalized bloom. It could be an orchid or it could be a similar kind; that level of detail is not needed. It seems that insect eyes and brains, being very tiny, simply see and identify an object with a generic flower-like shape and colour, and so they zoom straight to it for sustenance or shelter.

DISTRIBUTION MAP

● Orchid mantis

- LOCAL COMMON NAMES
 Malaysian orchid mantis, Pink or Yellow or White flower mantis, Walking orchid; Belalang bunga, Belalang sembah bunga anggrek (Malay, Indonesian)

- SCIENTIFIC NAME
 Mantis family Hymenopodidae, e.g. *Hymenopus coronatus* (Orchid mantis)

- SIZE
 Head–body length, female 6–7cm (2¼–2¾in), male 2–2.5cm (¾–1in)

- HABITATS
 Tropical rainforests, occasionally parks, gardens

- DIET
 Smaller insects including other mantids

- CONSERVATION STATUS
 IUCN Not evaluated
 (See key page 8)

◄ Perhaps admiring its reflection in the water, an orchid mantis rests on a lily pad. Crafty biology research shows it does not need to be hidden in a matching flower – it is itself a prey-attracting 'super-flower'.

PLASTIC PROOF

In a series of observations and experiments, biologists placed plastic mantis models of different colours in different locations, such as within blooms, among leaves and twigs near them, or in more isolated, exposed sites. The reactions of possible prey items such as bees were then recorded. The results showed the (plastic) orchid mantis's mode of operation was most successful, not as part of or part-hidden in a flower, but on its own as a whole flower, large and colourful, and – the visitor hopes – brimming with nectar.

Giant Malaysian leaf insect

A LEAF TO THE LAST DETAIL

Being camouflaged as a leaf is a common trick in the animal kingdom. Many kinds of insects, from butterflies and moths to beetles and mantids, employ this ruse. Leaf insects, numbering some 40–50 species, are probably the most dedicated group of leaf mimics. They are close cousins of stick insects (walking sticks), and with them form the group known as the phasmids (Phasmatodea).

- LOCAL COMMON NAMES
 Giant leaf bug, Great walking leaf; Pepijat daun, Bergerak daun (Malay/Indonesian)

- SCIENTIFIC NAME
 Phyllium giganteum

- SIZE
 Head–body length 10cm (4in)

- HABITATS
 Tropical forests

- DIET
 Leaves of many trees and shrubs

- CONSERVATION STATUS
 IUCN Not evaluated
 (See key page 8)

The Malaysian giant leaf insect, as its name implies, is one of the largest phasmids. Female head–body length may exceed 10 centimetres (4 inches), while the male is – well, males were unknown to science until the 1990s. It seems that in nature, females nearly always reproduce without them, by the one-parent or asexual method known as parthenogenesis.

THE SMALLEST SPECIFICS

Almost every aspect of this leaf insect's size, shape, colour, pattern and behaviour is dedicated to total camouflage among the large, lush, bright-green foliage of its tropical forest home. The whole body outline is complex and un-insect-like with wide, flattened, leafy shapes termed foliate flanges for the abdomen, forewings and on the legs. The patterns of colours and the strengthening, branching, stripe-like veins faithfully simulate leaves. The details extend to wear and tear and tattiness. Small brownish edges around the leaf insect's parts suggest a leaf beginning to age. Scallop-like cutouts mimic bug bites and caterpillar nibbling. Brown, grey or other or dark patches, usually on the back, represent areas of mould or leaf tissue senescence.

Movement complements the imitation. When a breeze sways the twigs and foliage, so the giant leaf insect sways with them, rather than trying to remain stationary. And when it moves to a new feeding station, it takes slow, discreet, one-leg-at-a-time steps, rather than the usual speedy insect gait with all limbs in frantic action.

NO MALES ... ALMOST

Nearly all known Malaysian giant leaf insects have been females. Their reproduction is asexual, by the method called parthenogenesis, with no need to mate with a male. This is well known among bugs such as aphids and other insects. It results in offspring that are clones, meaning they all have the same genes as the mother and each other. In 1994 two overlooked museum specimens, very different to the females, were identified as males. They are barely half the female's size, slimmer and lighter. Over the following years several more males have appeared in captive colonies. Presumably they arise every so often to vary the species' genetic variety.

▶ Each Malaysian leaf insect has differing specifics in its hues, venation, and the bits and pieces of nibbles, moulds and other intricacies. The head nestles between the forward-stretched front pair of legs.

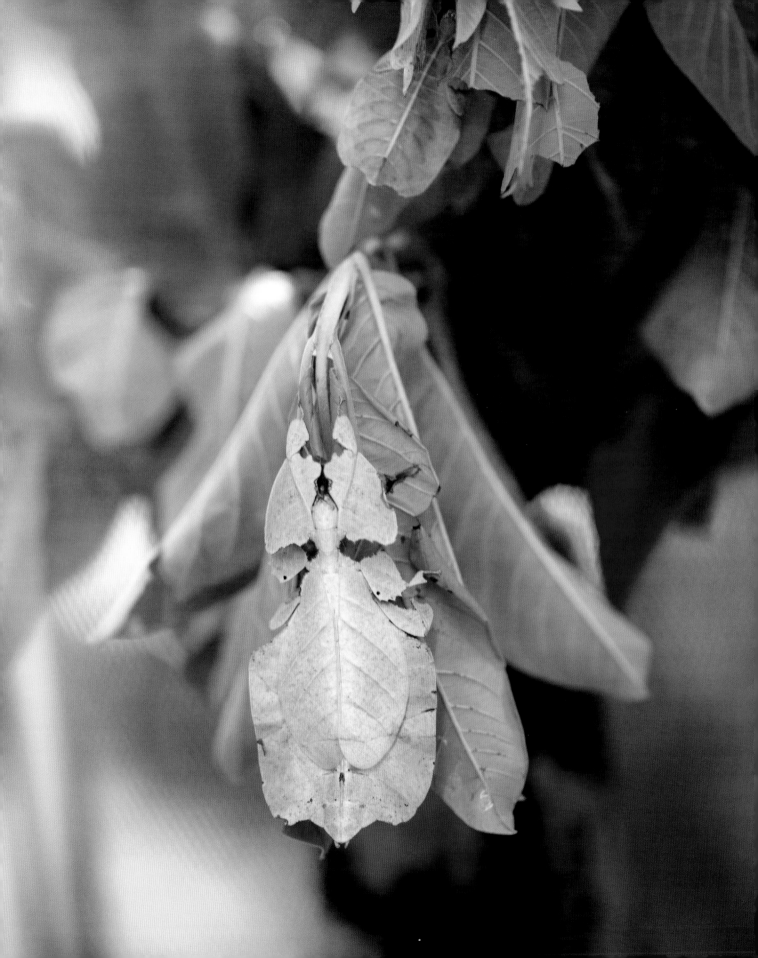

Lichen huntsman

LONG HAIRY LEGS, VENOM-STABBING FANGS

For some people, huntsman spiders are the stuff of nightmares. They are mostly big and long-legged, some with legspans that would fill a dinner plate, although they are not especially large-bodied. Certain tarantulas equal their size, but within the spider group, tarantulas are not closely related to huntsmen.

Named for their prey capture methods, huntsmen spiders are fast and agile. They chase after or ambush victims, rather than spinning webs. Their common names, such as bat-killers and lizard-eaters, reflect these habits. All spiders are carnivores, so the lichen huntsman spider does not, as its name might suggest, eat lichens (which are mixed colonies of moulds and plant-like algae). Rather, it is camouflaged to hide among them, as well as among similar low growths, such as mosses, liverworts and moulds, which abound on almost any surface in warm, damp habitats, especially rainforests. The lichen huntsman is relatively small for its group but proficiently tackles prey its own size or even larger.

FLAT AND HAIRY

Lichen huntsmen vary from light grey, olive or green, to darker shades of greeny-grey or greenish-brown. This depends partly on their habitat and the prey they eat, and also on their genetic inheritance. Most individuals have a series of contrasting hoops around the legs, and the legs are hairy; both of these features obscure the legs' long, linear, spidery shape. There are also patchy marks on the proportionally small body. The whole spider is flattened so that as it presses down onto its chosen surface, such as lichenous, mossy bark or rock, visually it almost becomes part of that surface. Such amazing camouflage works for ambushing likely prey and also against predators such as birds and lizards.

DISTRIBUTION MAP

- LOCAL COMMON NAMES
 Lichen spider, Hunty; Pemburu, Laba-laba besar (Indonesian)

- SCIENTIFIC NAME
 Pandercetes gracilis

- SIZE
 Head–body length 0.8–1.5cm ($^3/_8$–$^5/_8$in), legspan 3.5–7.5cm (1½–3in) (females are larger than males)

- HABITATS
 Tropical moist forests and woods

- DIET
 Insects and similar small creatures

- CONSERVATION STATUS
 IUCN Not evaluated (See key page 8)

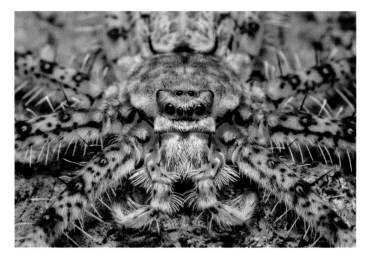

MAIN COURSE: SOUP

The lichen huntsman feeds in typical spider fashion. First, it jabs in venom with its fangs so the victim ceases to struggle. Next, it ejects or 'vomits up' its own digestive juices so the prey starts to soften and dissolve. Then it starts to chew the meal, repeating the vomit-and-chew technique until the victim eventually becomes a 'soup' that the spider sucks up.

▶ Not only where is it, but which way up is it? This head-down huntsman's first and second pairs of legs stretch forwards. The third pair are at right angles to the body, with the lower sections forwards, while the rearmost pair form a 'V'.

◀ A face-to-face view shows how the larger, outer two upper eyes face outwards; the beady-black two between them look slightly up, while the four-in-a-row gaze to the front and down, for all-round vision.

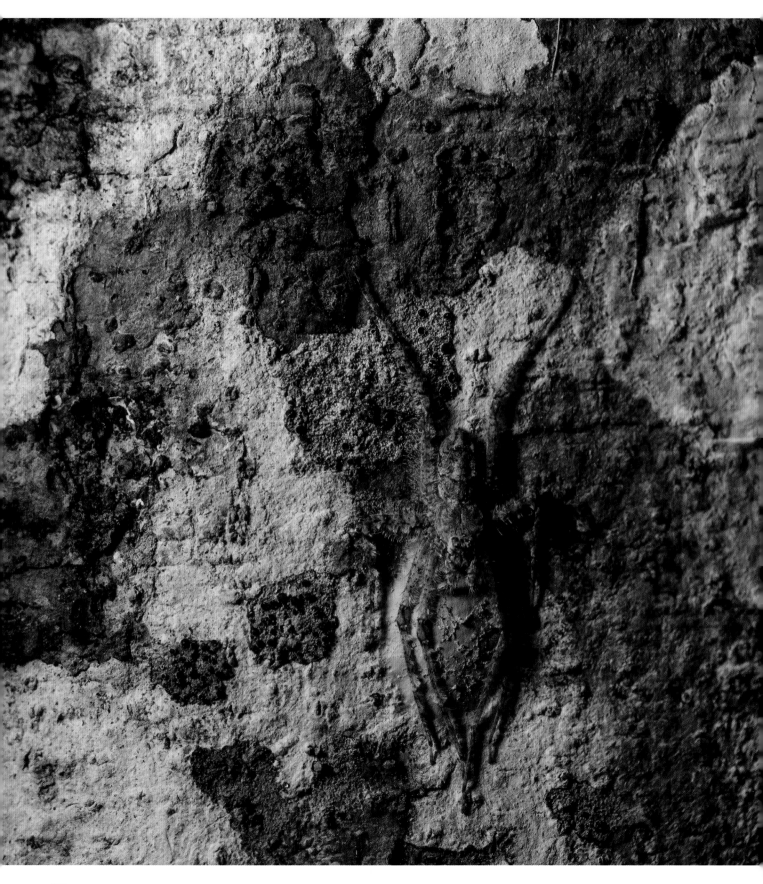

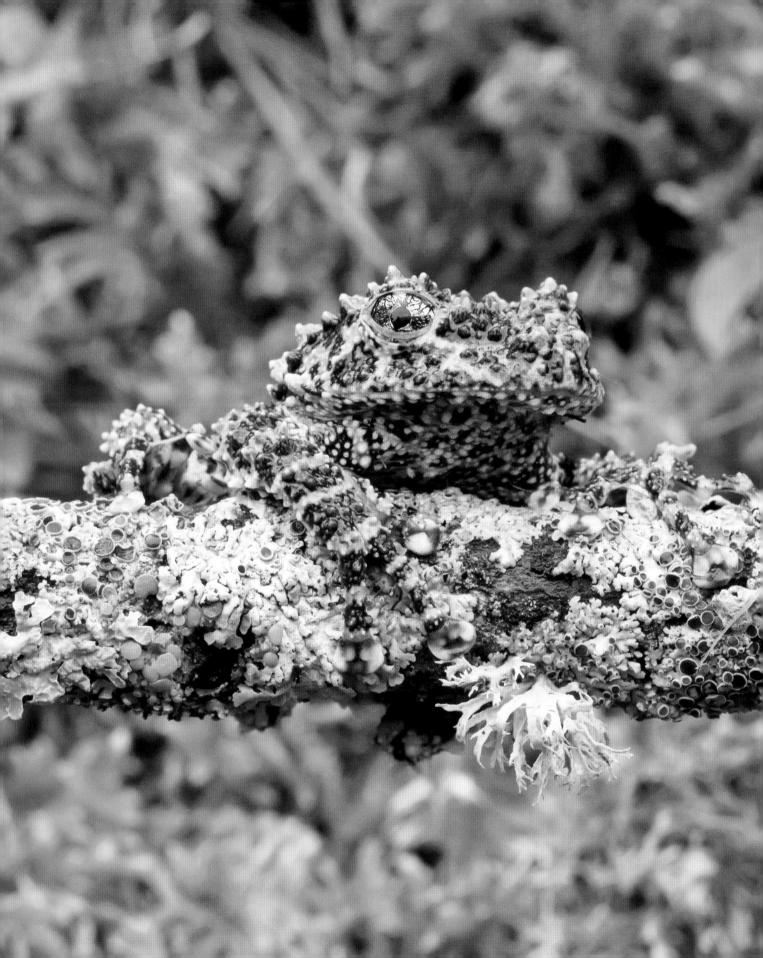

Vietnamese mossy frog

MOSSY MOUND THAT MOVES ABOUT

Clumps of mosses, liverworts, squat ferns and similar low-growing plants, along with boulders and old wood, such as fallen logs, are common along the shaded, splashy banks of rapid streams, creeks and brooks. In hilly subtropical and tropical rainforests, the Vietnamese mossy frog takes full advantage of this habitat. Crouched and still, legs and toes tucked in, it is hardly distinguishable from the squat mounds of vegetation all around, especially those covered by the tiny green leaves of mosses, and of lemna and allied aquatic plants commonly known as 'duckweeds'.

JUMBLE OF GREENS

The preferred habitat of the Vietnamese mossy frog is rocky banks, caves and overhangs of streams in the hills and mountains. It secretes itself by day and readies for action at dusk, waiting to grab or chasing after many kinds of small prey. Decked out in multitudinous shades of green, from creamy-pale lime green, through bottle green and olive to dense greeny-brown, the mossy frog has darker green, brown or black pigmented spots, and pointy lumps, fleshy folds and wart-like knobbles known as tubercles, plus occasional dots of red or orange, all over most of its upper surfaces. The undersides of the body and legs are paler and smoother. Semi-aquatic – at home both in and out of the water – the frog can clamber rapidly, swim fast at the surface and below, even in a strong current, and is an able leaper, covering up to 2 metres (almost 7 feet) in a single jump.

Native to the Tonkin region of North Vietnam, and small neighbouring areas of China and Laos, this mossy frog is one of about twenty-five kinds or species of *Theloderma*. They are known as mossy, warty or bug-eyed frogs. Other *Theloderma* species are camouflaged as old leaves, bark, stones or boulders, and even bird or mammal droppings.

DISTRIBUTION MAP

- LOCAL COMMON NAMES
Tonkin mossy frog, Bug-eyed moss frog, Tonkin bullfrog; Ếch rêu (Vietnamese)

- SCIENTIFIC NAME
Theloderma corticale

- SIZE
Head–body length 5–9cm (2–3½in), weight 10–20g (⅓–⅔oz) (females are larger than males)

- HABITATS
Hilly and mountainous rainforests with fast-flowing rocky streams, rubble-rich ponds and pools, plentiful aquatic and bank vegetation

- DIET
Small creatures such as worms, aquatic insects

- CONSERVATION STATUS
IUCN Least concern
(See key page 8)

TEMPORARY HOMES IN LONG-TERM DOUBT

The Vietnamese mossy frog has colonized some areas of human disturbance such as artificial waterways and logged areas. These places provide temporary homes, but they soon deteriorate and wash away with the high rainfall to leave degraded habitat. The species is also collected from the wild and kept as an exotic pet. Consequently, its future is uncertain.

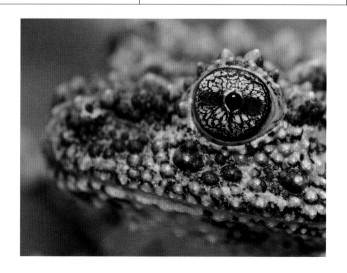

◀ Even the frog's long toes, with their splayed, sticky tips to hang onto wet, slippery leaves, branches, rocks and boulders, are factored into this amphibian's incredible visual deception.

▶ A facial close-up demonstrates the frog's abundant lumps or tubercles, each a deviously different shade.

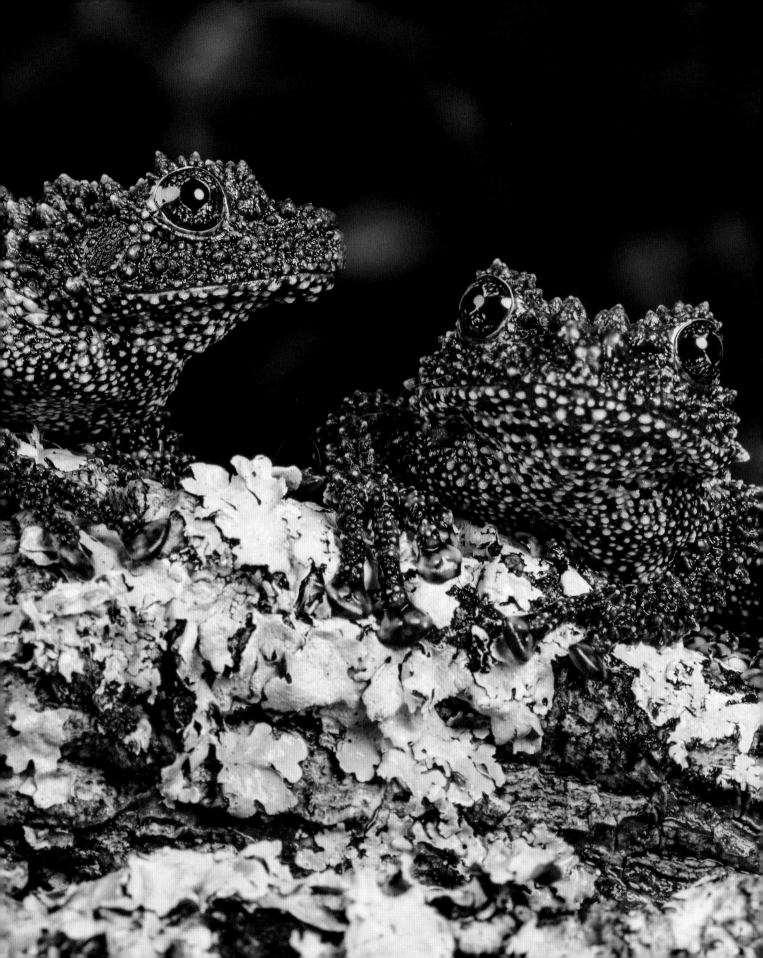

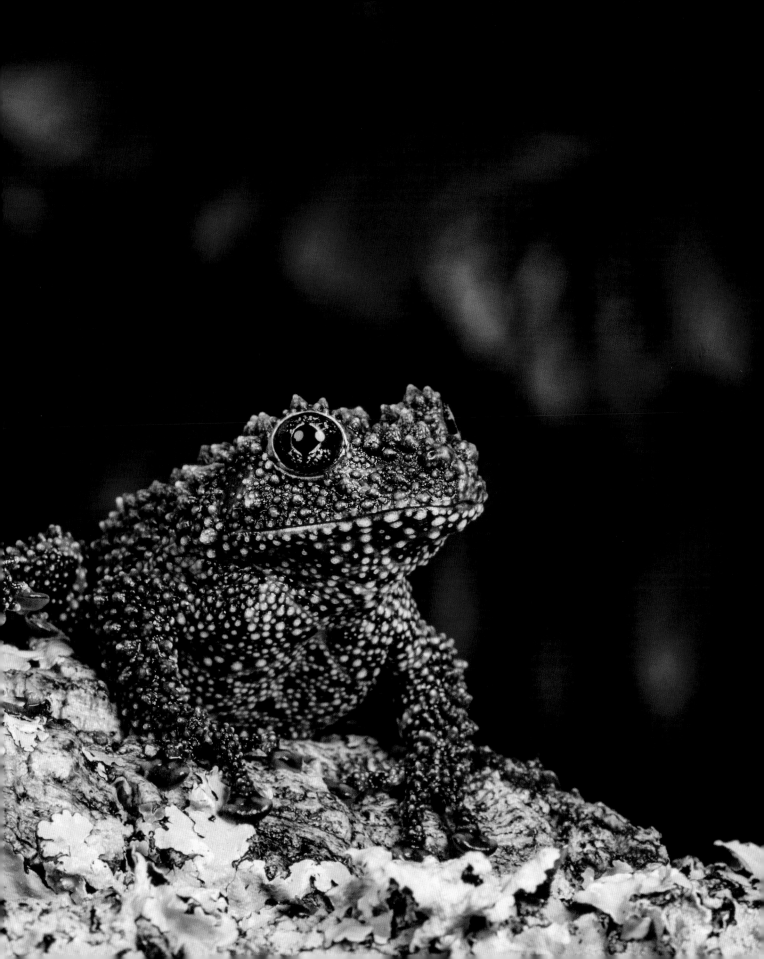

Komodo dragon

LAZY LIZARD SUPREME

A fully grown, well-fed Komodo dragon waddling across a dusty, sunlit clearing may not seem especially well camouflaged. But a hungry dragon, partly curled up and waiting, totally stationary and patient, in the patchy light and loose scrub under a shady tree or among long grass, is very different. Its scaly, speckly body is basically earth-coloured in shades of yellow, brown and grey, perfectly breaking up its outline and matching its surroundings.

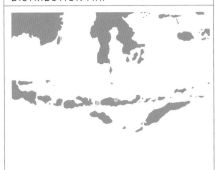

- LOCAL COMMON NAMES
Komodo monitor; Buaya darat, Biawak raksasa (Malay); Ora (Mangarrai); Biscobra (Hindi)

- SCIENTIFIC NAME
Varanus komodoensis

- SIZE
Total length 2.3–3m (7ft 6in–9ft 10in), weight 70–120kg (154lb 5oz–264lb 8oz)

- HABITATS
Woods, scrub, grasslands

- DIET
Any animal it can overpower, from small mammals, birds and lizards, to deer, pigs, buffalo; also carrion

- CONSERVATION STATUS
IUCN Vulnerable
(See key page 8)

EXPLOSIVE ACTION

Biggest of the lizard group, the Komodo is a truly fearsome hunter. After waiting for days, weeks, even a month or two, it may attack a victim many times larger than itself, such as a deer or water buffalo. As the animal wanders near, the dragon charges at amazing speed, more than 20 kilometres (12 miles) per hour, sprinting to launch itself at the prey's throat. It clamps on its powerful jaws with sixty-plus sharp, serrated, 2.5-centimetre (1-inch) teeth, makes violent biting and chewing motions, and also scratches and gouges frantically with its strong, pointed claws, each the length of a human middle finger. At this moment the dragon is a brief eruption of ferocious activity.

Most prey succumb there and then, from a combination of shock, suffocation due to a compressed windpipe, and lacerations and bleeding. Even if the animal manages to break free, the dragon's saliva contains both venom and a cocktail of toxic bacteria. The predator follows its victim until these poisons, and continued blood loss, take effect. It then tears chunks off the carcass and swallows these whole. It eats almost its own body weight if the meal is big enough, and then selects another shady spot where it is well camouflaged, to rest and digest.

CLIMBING TO SAFETY

Young Komodo dragons are more brightly coloured than adults; dark green with reddish orange patches on the body and hindlimbs, and dark stripes on the neck and forelimbs. As soon as they hatch from eggs they climb into trees for safety, away from the cannibalistic adults. Here they are well camouflaged and eat insects, small lizards and similar food. They only venture down to the ground after several years when they are large enough to defend themselves.

▶ Despite being so massive and formidable, the Komodo dragon's combination of colour, pattern and behaviour makes it surprisingly difficult to spot as it waits in the dappled shade under a tree. The older the lizard gets, the darker it becomes.

Burmese python

TERROR OF WETLANDS OLD AND NEW

The Burmese python has several claims to fame, or rather, infamy. With a native distribution across much of mainland South East Asia, and also the island of Java, it is a snake of significant size, indeed one of the largest of all snakes. Females exceed 5 metres (16 feet) in length and weigh more than an adult human. Tales abound of them attacking young sheep, goats and similar-sized livestock, even young children, as well as a variety of other animals, from fish to frogs, lizards, smaller crocodiles and alligators, and birds.

These adaptable snakes, equally at home on land, in water or in trees (provided they are not too heavy), have also invaded the marshes and swamps of Florida, USA. Despite huge attempts at removing them, they now number tens of thousands, devastating the ecosystems of the Everglades and similar habitats. One of the chief reasons for difficulties with controlling their numbers is their amazing camouflage.

The python's usual coloration consists of squiggly-edged, haphazard, dark brown patches along the body, separated by narrower, pale brown-yellow, olive or creamy borders. The dark patches fade to a lighter tint towards their interior. The seemingly total randomness of the markings prevents our eyes, and presumably those of many animals, from discerning a regular, repeating pattern, which is the hallmark of seeing and identifying so many creatures. When the snake coils up, as it often does when resting or waiting for prey, this effect multiplies. Experienced python patrol rangers in Florida, who develop trained eyes to spot the invaders, describe how they scan pools and vegetation so carefully for these snakes, yet still almost step on them.

DISTRIBUTION MAP

- **LOCAL COMMON NAMES**
 Rock python, Tiger Python; Barmee ajagar (Hindi)

- **SCIENTIFIC NAME**
 Python bivittatus

- **SIZE**
 Length up to 6m (19ft 8in), weight up to 100kg (220lb 7oz) (males are significantly smaller than females)

- **HABITATS**
 Subtropical but varied, from upland forests to lowland pastures, scrub, wetlands of various kinds

- **DIET**
 Many kinds of animals up to the size of pigs, small deer

- **CONSERVATION STATUS**
 IUCN Vulnerable
 (See key page 8)

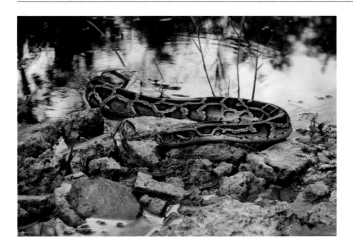

INVASION OF THE GIANT SNAKES

In their native South East Asia, Burmese pythons do not have things their own way. They compete for food with, and are sometimes victims of, reticulated pythons and other large snakes, as well as cats such as tigers and leopards. In Florida there are far fewer natural controls. From early sightings there in the 1970s, of individuals presumably released by irresponsible exotic pet owners, Burmese pythons have become established and now breed freely.

Whether it's leaves, grass, twigs and
branches, as above in Laos, or rocky
reflections from a watery surface (opposite)
in Florida's Everglades, the Burmese python's
random, arbitrary markings fit into many
different surroundings.

Painted sandgrouse

PLUMP AND TASTY

To a potential predator, such as an eagle, buzzard, large monitor lizard, leopard or Indian wolf, a plump gamebird like a grouse, sandgrouse or pheasant represents a desirable, nourishing feast. This is why such birds have some of the best camouflage. However, there is a conflicting need in many of these bird species for the male to appear strong, active, biologically fit and a suitable mate, by conspicuously showing off to females. So, the male has to find a balance between being concealed enough to aid his survival, but showy enough to make him desirable. In evolutionary terms, these conflicting needs are known as selection pressures. Hunters will pick off the least well-suited males and leave the best adapted to breed.

PAINTED BY NUMBERS

The male painted sandgrouse's plumage has a back and sides distinctly barred in contrasting shades from cream through buff and brown to almost black, a black forehead with a crossways white stripe, and a plain buff, sandy or pale brown neck and undersides. His sharply demarcated markings resemble our human 'painting by numbers' artworks. In the open he is conspicuous, but in his typical hiding posture of staying quite still among his habitat's sandy soils, pale rocks, grassy tussocks, scrub and rough vegetation, he is remarkably difficult to spot.

Meanwhile the female's plumage is much more restrained browns and greys, but again with finely demarcated bars and speckles, varying from white and cream through buff, dark brown, chocolate and black. This means she is even harder to detect in the predominantly pale, sandy-brown, arid landscape.

DISTRIBUTION MAP

- LOCAL COMMON NAMES
 Close-barred sandgrouse; Bhat teetar (Marathi); Chitrit teetar (Hindi, several dialects)

- SCIENTIFIC NAME
 Pterocles indicus

- SIZE
 Bill–tail length 25–30cm (10–12in), weight 150–230g (5oz–8oz)

- HABITATS
 Drier woods and forests, grassy stony plains, rough vegetation in rocky bush and scrub

- DIET
 Seeds, other plant matter, occasional small invertebrates such as insects, snails, worms

- CONSERVATION STATUS
 IUCN Least concern
 (See key page 8)

WATER-CARRYING PARENTS

Sandgrouse are well known for flying a long way to gather at scarce waterholes in their dry terrain and drinking very quickly. Also, during the breeding season, they dip in their breast feathers, which soak up water like a sponge. The adults then fly back to their chicks, who are not yet capable of flight, but who can drink from their parents' feathers.

▶ Female sandgrouse mimic the light, dry soils and browny vegetation of their dry habitats. Crouched low, their shadows are minimized and they are even harder to pick out.

Bittern

LIFE IN A VERTICAL WORLD

The great or Eurasian bittern, often referred to simply as 'the' bittern, is a mid-sized heron with a very reclusive, retiring approach to life. Rarely seen in the open, it inhabits marshes, swamps and mires, the fringes of lakes, rivers, canals and drainage dykes, also rice fields and similar cultivations. These wetlands usually have tall, dense, coarse, rank vegetation of reeds, rushes, sedges and other aquatic plants. Here the bittern can skulk, shy and unseen, as it forages for all kinds of small animal prey – insects such as dragonflies, crustaceans like crayfish, also water snails, fish, frogs, small lizards and snakes, birds and mammals like mice and voles.

BLOWING IN THE WIND

Much of the bittern's immediate habitat is vertical, being the tall, thin stalks and stems of reeds, grasses and similar plants. This is the prime influence that has shaped its camouflage adaptations. Its predominant colour is buff or a similar beige or fawn, with sets of dark streaks and bars on the neck, body and wings. There is a black 'cap' on the head and a darker 'moustache' streak from the lower eye and angle of the mouth along the neck; the chest and underparts are lighter pale creamy- or yellowy-buff with long, interrupted streaks. Overall, this guise of upright, alternating markings mimics the stems and stalks of the bittern's close surroundings. Its only horizontal or angled elements are its bill, head and neck when hunting. But sensing danger, especially from predators such as larger cats, foxes, mink, big snakes and birds of prey, the bittern points its bill and head skywards and stands motionless, to complete the vertically orientated appearance and make itself barely discernible. When the vegetation sways in the wind, so does the bittern.

DISTRIBUTION MAP

- LOCAL COMMON NAMES
 Eurasian bittern, Great bittern; Rördrom (Swedish); Butor étoilé (French); Avetoro común (Spanish); Rohrdommel (German); Boerdomp (Dutch); Bukač velký (Czech); Built (Russian); Sangkano-goi (Japanese); Da may'an (Chinese)

- SCIENTIFIC NAME
 Botaurus stellaris

- SIZE
 Bill–tail length 65–80cm (2ft 1in–2ft 7in), wingspan 1.2–1.4m (4ft–4ft 7in), weight 0.8–1.8kg (1lb 12oz–4lb) (males are larger than females)

- HABITATS
 Wetlands with plentiful tall reeds, rushes, sedges and similar plants

- DIET
 All kinds of small prey, especially fish, also snails, insects, worms, amphibians, reptiles, suitable-sized birds and mammals

- CONSERVATION STATUS
 IUCN Least concern (See key page 8)

HEARD, NOT SEEN

Bitterns are visually secretive but audibly emphatic. When courting and breeding, the male emits unexpectedly loud calls, including a noise like a vehicle airhorn or foghorn, various grunts, and characteristically, short sequences of deep, resounding 'booms', sometimes likened to drawn-out canon fire. The calls are certainly loud, but because they are deep or low frequency, they spread out widely and seem to come from all around. This makes it difficult to locate their source, and the male bittern retains his privacy.

▶ The bittern's classic camouflage involves stretching its whole body, neck, head and bill into a narrow, upright form, and remaining quite still. In this posture it mimics the reed stems and other tall, erect plant growth of its wetland habitats.

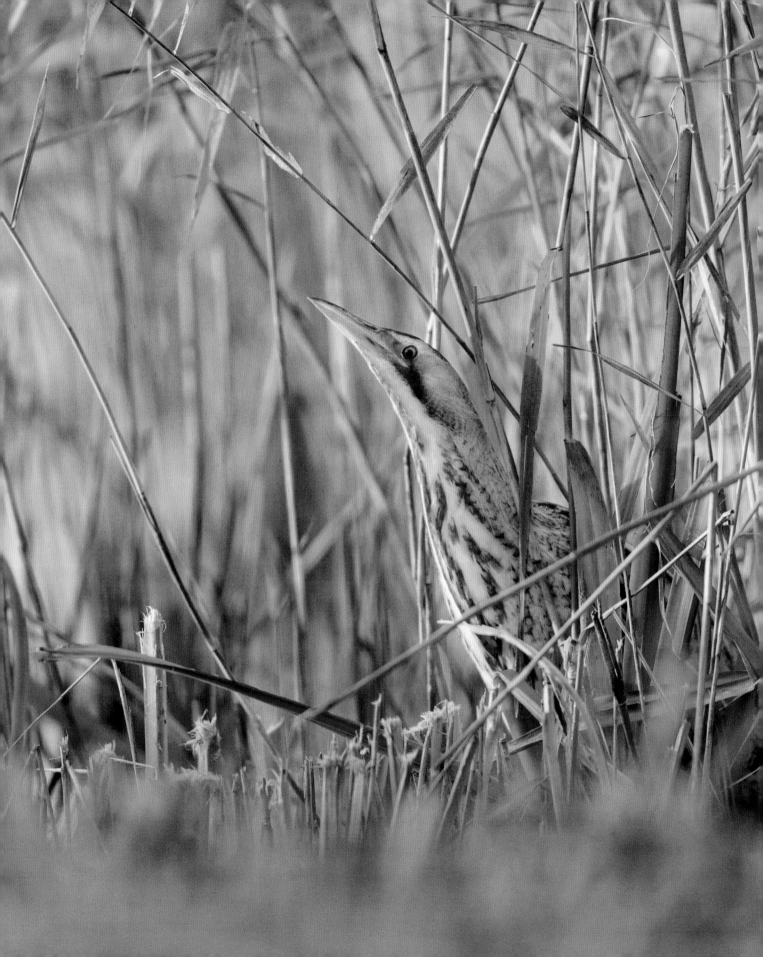

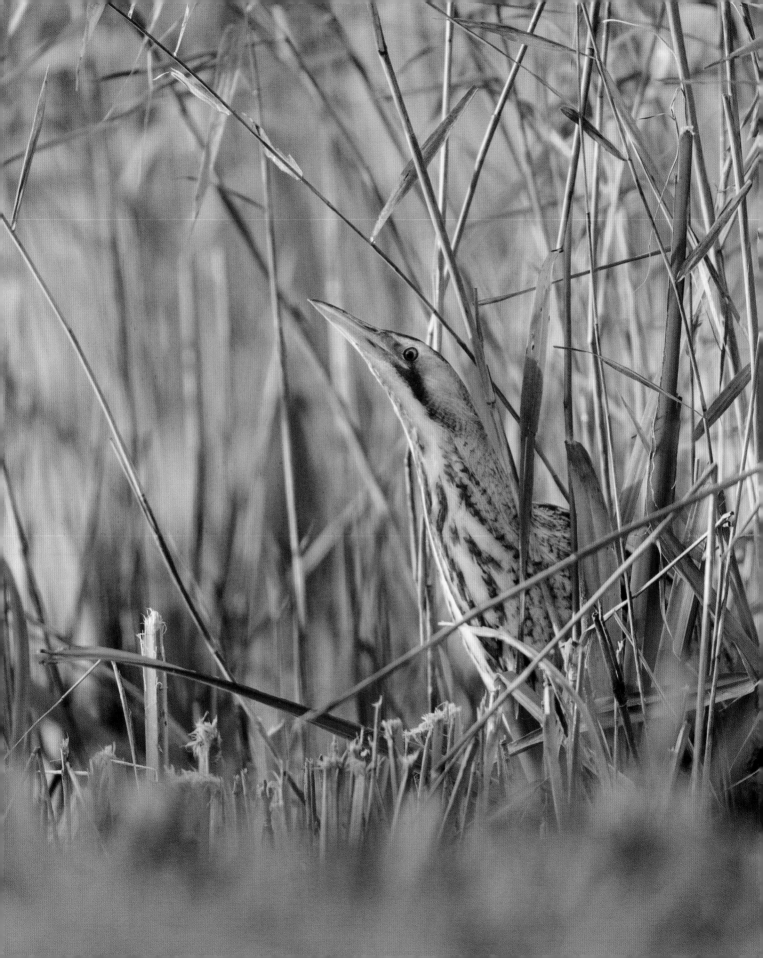

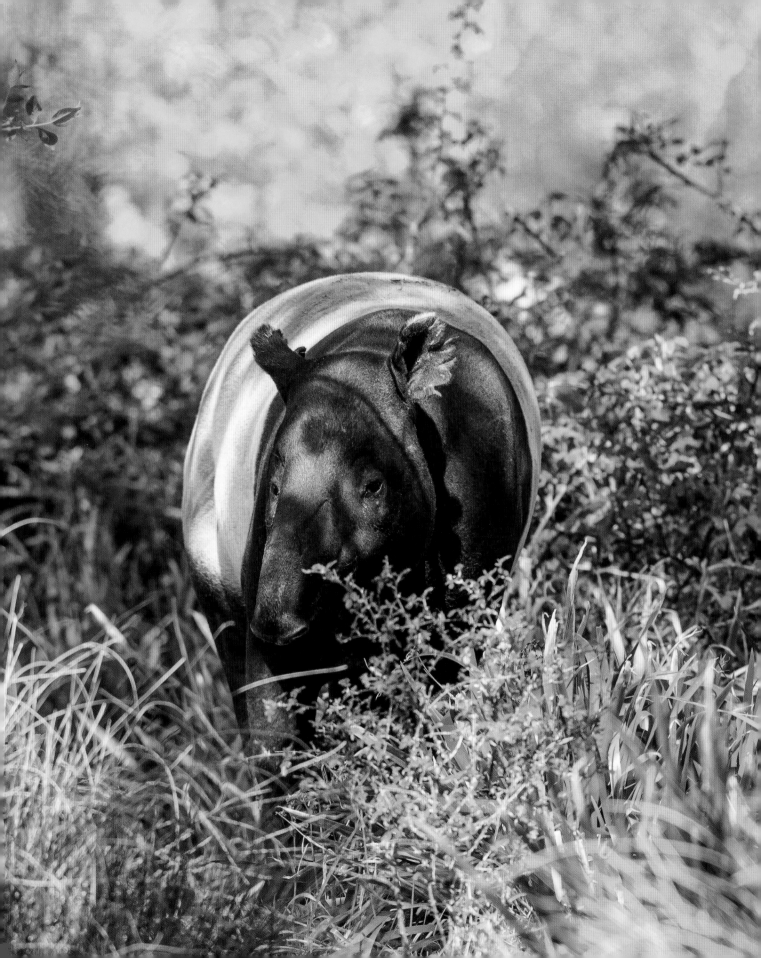

Malay tapir

CLEAR AS BLACK AND WHITE

There are few better examples of the form of disguise known as disruptive camouflage or disruptive coloration as the Malay tapir. Its two-tone, black-and-white pattern is instantly recognizable. The head, neck, shoulders and forelegs are virtually black, as are the lower hips and hindlegs. Between, is the almost white main body and rump, a shape often called the tapir's 'saddle'.

- **LOCAL COMMON NAMES**
 Malaysian tapir, Asian tapir, Asiatic tapir, Oriental tapir, Indian tapir, Piebald tapir; Badak tampung, Cipan, Tenu, Kuda arau, Babi alu (Malay/Indonesian)

- **SCIENTIFIC NAME**
 Tapirus indicus

- **SIZE**
 Head–body length 1.8–2.4m (5ft 10in–7ft 10in), shoulder height 0.9–1m (3ft–3ft 3in), weight 250–350kg (551lb–771lb)

- **HABITATS**
 Moist tropical forests and rainforests, wetlands

- **DIET**
 Plants, especially soft shoots, buds and leaves, also twigs, fruits, aquatic plants

- **CONSERVATION STATUS**
 IUCN Endangered
 (See key page 8)

At first thought, disruptive coloration may well seem paradoxical or counterintuitive. There are no subtle shadings that help the animals to 'melt into the background'. Rather, there are bold, contrasting shapes and colours that are designed to be noticed. But importantly, the shapes are not those of the whole animal, of its outline or overall three-dimensional form. The aim is to draw the eye to the shapes themselves, and away from the profile – in this case, the mammal-like profile of the tapir (see also, Delacour's langur, pages 160–161).

DEEP AND DARK

Out in the open, the Malay tapir seems totally obvious and blatantly undisguised, with its maximized, contrasting pigmentation. But this big, heavy member of the horse and rhinoceros group, the perissodactyls (odd-toed ungulates), does not dwell in the open. It is an unobtrusive inhabitant of dense forests and other tall, thick vegetation. At ground level here, the sun rarely penetrates. It is gloomy by day, and deeply dark at night, when the tapir is active and feeding. In such light, the black parts of the animal are all but invisible. All there is to notice is the white 'saddle' with its un-tapir-like shape. By the time a predator, such as a tiger, has looked again, the tapir has usually smelled and heard the danger (its eyesight is poor) and has moved away through the forest with surprising stealth.

◄ The tapir's long snout is its nose and upper lip combined. It curls around and pulls in all kinds of plant foods. Out in the open sunlight is a relatively unusual setting; the tapir seeks deep shade and is active mainly at night.

UNSEEN IN THE DARK

The Malay tapir's nocturnal habits and successful camouflage contribute to one of its main causes of death: roadkill. The animals wander out on to lanes and highways since it is easier to get around using them than pushing through forest undergrowth, or when they wish to access a new browsing area of forest or plantation. Vehicle drivers often see only the white marking and do not recognize a tapir to be avoided – which is entirely the aim of the camouflage – until it is too late.

Painted bat

DISRUPTIVE DISGUISE

With a common name that refers to its almost unnaturally bright swathes of wing colour, as if daubed by a paintbrush in not-too-skilled human hands, the painted bat belongs to the vesper or 'evening bat' family.

At first glance, when in the air or with wings spread, the painted bat's coloration may hardly seem to qualify as camouflage. It has orange, yellow, even scarlet fur on the underside of the body, and similar colour skin on its tail and along its wing finger (wing) bones, while the skin between the fingers is a sharply contrasting midnight blue-brown or black.

IN AMONG THE BROWN CURLS
But when roosting upside down by day in small groups, the story is very different. With wings folded so these smallish bats present their rusty orange or brown back, and again at first glance, they may well be overlooked. They resemble old, browning leaves, withering past-their-best flowers, dried foliage and tendrils of vines and creepers, bits of bark, or similar miscellaneous, non-nutritious items found in a wide range of habitats.

A favoured roost site is in among very large, ageing leaves, such as those of banana trees and sugar canes. The bats crawl among the folds and look precisely like the ageing, curling edges of the leaves. Another roosting preference is on the woven, suspended nests of birds such as weavers and sunbirds. Again, the bats blend with the twigs, vines and shrivelling leaves used for the nest construction. Painted bats have also been found under the eaves of huts, sheds and other buildings. Should the bat's spread wings be seen, their contrasting colours break up and distract a predator's attention away from the typical bat wing-like outline, which is known as disruptive coloration.

DISTRIBUTION MAP

- LOCAL COMMON NAMES
 Painted woolly bat, Painted vesper; Komola–badami chamchika (Bengali); Dơi mũi nhan dom vàng (Vietnamese)

- SCIENTIFIC NAME
 Kerivoula picta

- SIZE
 Head–tail length 6–10cm (2¼–4in), wingspan 15–20cm (6–8in), weight 4–6g (⅛–¼oz)

- HABITATS
 Woodlands and open forests, also banana and other plantations, farmland, parks, gardens, human habitation

- DIET
 Small insects, spiders and similar, taken from foliage and in mid-air

- CONSERVATION STATUS
 IUCN Near threatened (See key page 8)

EVENING BATS
Numbering more than 300 different kinds or species, vesper or evening bats live around the world. Some, like pipistrelles, are familiar flitting through the evening in our parks, gardens, woods and local nature areas. The painted bat's vivid wing colours make it a popular wild-caught, killed and preserved item for thoughtless tourists and the taxidermy business, even though these trades are incomprehensibly pointless to so many people.

▶ A favoured roost site – here to a pair – is in among very large, ageing leaves, such as those of banana trees and sugar canes. The bats crawl among the folds and look precisely like the browning, curling edges of the leaves.

◀ The contrasting colours between the bat's fur covering its finger bones, and the stretched skin between them, is still a puzzling adaptation.

Delacour's langur

LIFE ON THE CLIFF EDGE

Langurs or lutungs are leaf or colobine monkeys, about sixty kinds of mainly tree-dwellers, whose main diet is leaves, flowers, fruits and buds in the woods and forests of Asia and Africa. Many species are brown, grey or similar nondescript colours to merge with their habitat, perhaps with some light and dark contrasts mainly around the face. However, Delacour's is certainly distinctive. This excessively rare monkey is mostly black but with white on the cheek ruffs and ears, and a block of white or very pale grey on the hip and lower thigh area. Unlike numerous other monkey species, males and females are not dissimilar in size and look.

DISTRACTION METHOD

Delacour's langurs give an excellent impression of the monkey version of another Asian mammalian vegetarian, although one much bulkier and heavyweight, the Malay tapir (see pages 156–157). The key to this is known as disruptive coloration. Visual attention is drawn to the white or the black shapes, thereby disrupting or distracting the viewer's attention away from the more recognizable outline or form of the whole creature – in the langur's case, the head, body, limbs and tail of a monkey.

This interpretation of the langur's appearance and camouflage, however, has been disputed. How does it help in the Delacour's habitat? In the species' tiny remaining range, the scenery is open, scattered woods and forest among especially rocky, steep hills, cliffs and pinnacles, known as limestone karst. The proposal is that as these langurs scramble and jump from one set of food and hiding trees to another, they must traverse exposed cliffs and stony scree. Being in the open at this time, they benefit from disruptive camouflage. On this idea, overall, expert biological opinions are divided.

DISTRIBUTION MAP

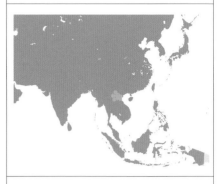

- LOCAL COMMON NAMES
 Delacour's lutung (sometimes spelled luntung), Black-and-white lutung; Vooc mong trang, Voọc quan dui trang (Vietnamese local dialects)

- SCIENTIFIC NAME
 Trachypithecus delacouri

- SIZE
 Head–body length 57–62cm (1ft 10in–2ft), tail length 82–88cm (2ft 8in–2ft 10in), weight 6–10kg (13lb 3oz–22lb) (males are slightly larger than females)

- HABITATS
 Hilly, open tropical woods and forests with plentiful cliffs, pinnacles and steep, rocky slopes

- DIET
 Mostly young leaves and buds, also flowers, fruits

- CONSERVATION STATUS
 IUCN Critically endangered (See key page 8)

SITUATION CRITICAL

Delacour's langur is named after French-American zoologist, avid ornithologist, and early proponent of conservation, Jean Delacour. He would no doubt be saddened to see its current plight. Perhaps only 200 individuals are left in the wild, chiefly in Vietnam's Van Long Nature Reserve, which was established in 2001 to try and save the species.

◄ On an open cliff face, the langur's disruptive camouflage may work to harmonize with the pale and dark angular rock faces, helping to avoid recognition, especially by airborne predators such as eagles and buzzards.

► The white rump and hip 'saddle' of Delacour's langur is highly reminiscent of a similar colour scheme in the Malay tapir.

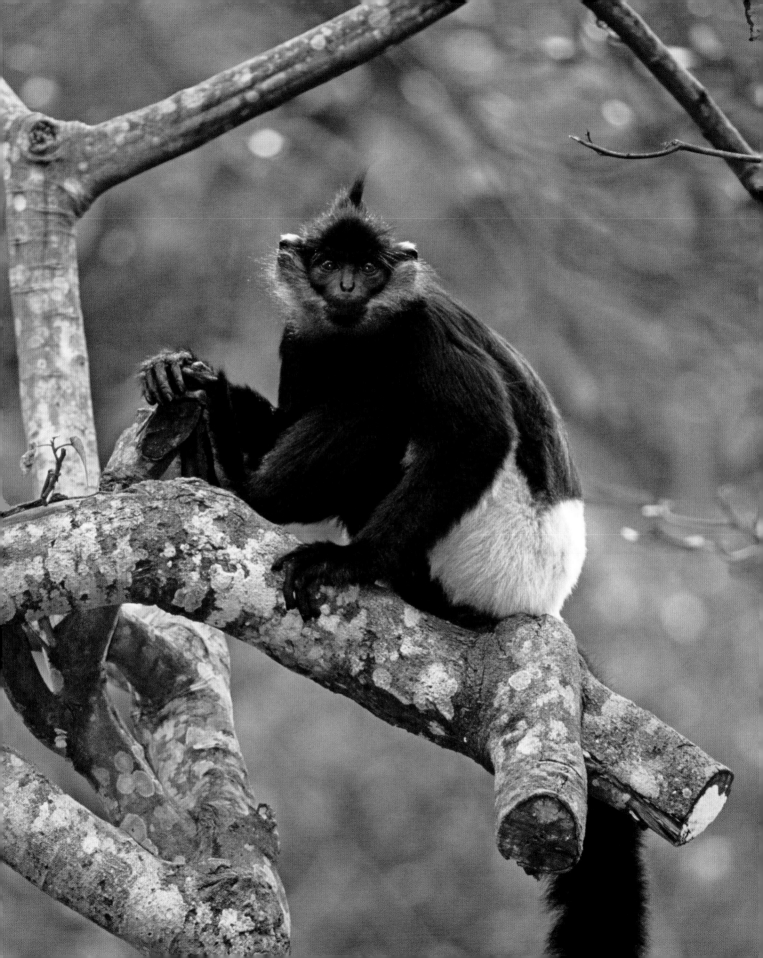

Banded palm civet

CAT-LIKE BUT NOT A CAT

About the size of a pet cat, the banded palm civet has several cat-like abilities and features. With great skill, it can leap, climb and stalk prey. Its sharp claws partly withdraw or retract into its toes. Its long tail aids balance. Its sharp teeth make short work of small animal meals. It has good night vision and is mostly active during darkness. By day it curls up, cat-like, and sleeps in a tree hole, crevice, cave, under roots, inside an old log, or in an equivalent den in outbuildings and dwellings.

As the civet emerges at dusk, hunting mainly on the ground, in low light levels its camouflage is particularly effective. The background fur is variable between individuals, from dark brown or grey through lighter shades or tan to yellowish or cream. Distinctive are its dark, often black markings: three prominent stripes on the face, and about 6–8 bands curving around the body and tail base, widest across the back and tapering to fade away on the flanks; the undersides are pale. The tail also darkens towards its tip. The total effect merges well into the undergrowth, branches and leaves, as the civet begins its night's work.

CIVETS AND CATS

Despite their cat-like traits, civets are not part of the cat family. They are in an equivalent or 'sister' group among mammal carnivores known as the viverrid family, along with the also vaguely cat-like genets, linsangs and oyans. Viverrids number some thirty-five species, found from Africa across Southern to South East Asia. Also, unlike most cats, banded palm civets are not exclusively carnivorous and occasionally eat fruits, berries, flowers and other plant material.

DISTRIBUTION MAP

- LOCAL COMMON NAMES
 Banded civet, Banded Asian civet, Palm civet; Hemigalo franjeado (Spanish); Musang berjalur (Malay)

- SCIENTIFIC NAME
 Hemigalus derbyanus

- SIZE
 Total length 45–65cm (1ft 5in–2ft 1in), weight 1.5–4kg (3lb 4oz–8lb 13oz)

- HABITATS
 Forests, woods, plantations, around human habitation

- DIET
 Mostly small animals such as worms, insects, frogs, lizards, mice and rats; occasional plant matter

- CONSERVATION STATUS
 IUCN Near threatened
 (See key page 8)

CIVET COFFEE

A very expensive beverage is kopi luwak coffee – made from coffee cherry (berry) fruits eaten by civets. The fruits are slightly digested and altered in the animal's intestine, excreted mostly whole, gathered by people and roasted to make coffee. The taste is much prized by some. But the drink's production can involve great animal cruelty. The civets, usually Asian palm civets, may be 'farmed' in horrendous conditions, confined in bare cages and fed a totally unnatural diet.

▶ Banded markings work well among vegetation like branches, bushes and shrubs; the banded civet's patterns cover most of its body. Its large eyes indicate its nocturnal habits.

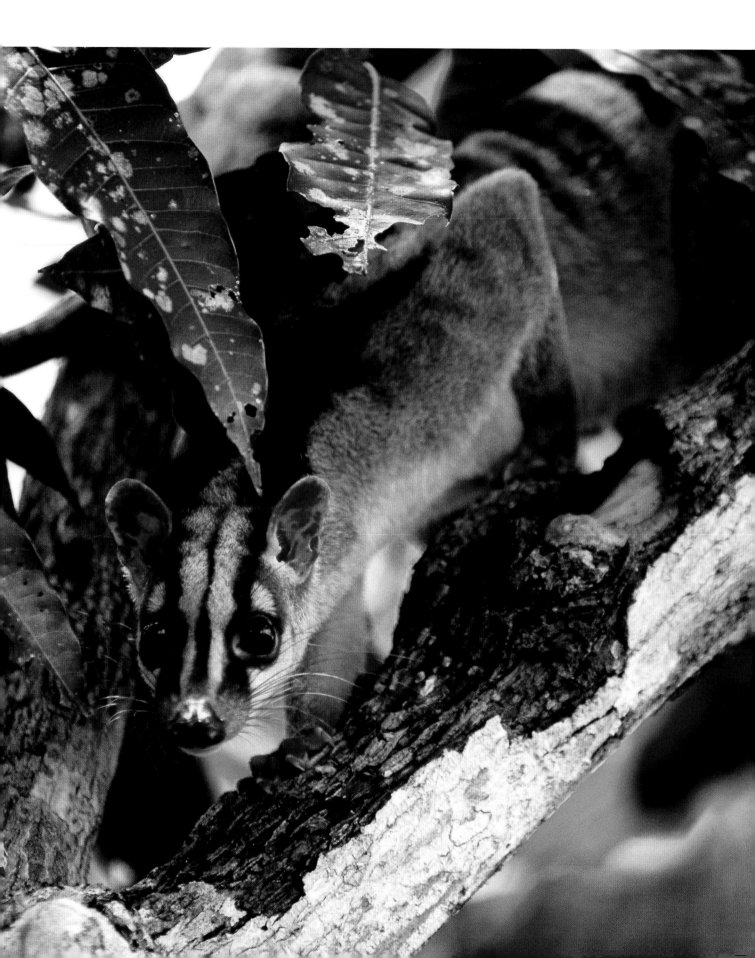

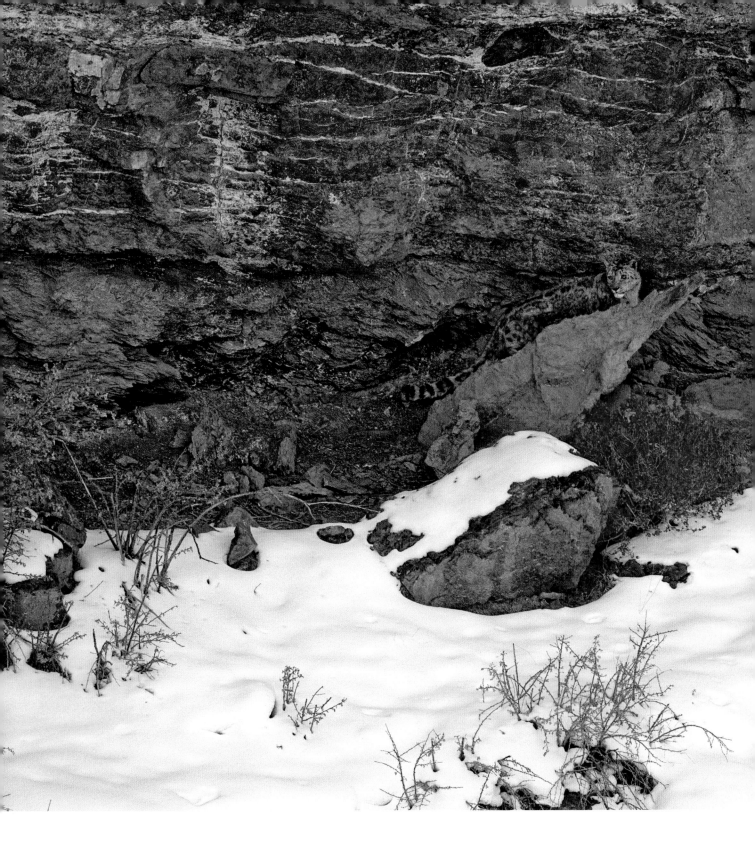

Snow leopard

GHOST OF THE HIGH HIMALAYA

Smallest of the five *Panthera* big cats, and also the most secretive, the snow leopard inhabits vast regions of high-altitude Central Asia. Its thick, furry coat is a marvel of camouflage and insulation. With winter temperatures regularly falling below –30°C (–22°F), this hunter may have to rest in open areas with little shelter from biting winds and fierce blizzards. During these months the strong, thicker, woollier outer hairs on the body, more than 10 centimetres (4 inches) in length, provide excellent protection, while the compact underfur retains body warmth. The cat can also wrap its even hairier tail – almost as long as the body – around itself to double the effect. The coat's background colouring at this time is cream, light tan or pale grey, with less pronounced greyish spots on the head and legs, and less contrasting rosettes on the body, all to heighten the camouflage effect when most of the habitat is covered in drifting snow.

DARKER FOR SUMMER

The spring moult produces slightly less dense, woolly fur, although still amazingly warm, with duskier, more pronounced spots and rosettes against a likewise darker, smoke-grey background. This suits the visually more patchy, snow-free terrain of debris-strewn rocky outcrops, alpine plants, and sparse, scattered trees and shrubs.

Despite such a massive overall geographical range, the snow leopard's population numbers are small, probably fewer than 3,000–3,500 in total. Because of its harsh, usually cold habitat, prey animals are few and far between. So, each individual leopard needs a large area for hunting, up to 200 square kilometres (77 square miles) in some regions. Ranges are marked with urine and other scents so that, in such expansive, sparsely populated wilderness, males can find females during the mating season.

DISTRIBUTION MAP

- **LOCAL COMMON NAMES**
 Ounce; Irbis (Russian, Mongolian); Sah, Shen (Tibetan); Barjani/Barfani chita (Hindi, Urdu); Heung chituwa (Nepali)

- **SCIENTIFIC NAME**
 Panthera uncia

- **SIZE**
 Head–body 1.2m (4ft), tail 90cm (3ft), weight 30–60kg (66lb 2oz–132lb 4oz)

- **HABITATS**
 Hills and mountains 500–6,000m (1,600–20,000ft) altitude, including forests, high scrub and grasses, rocky cliffs and gorges

- **DIET**
 Animals from large sheep, goats, deer to small rodents, hares, birds

- **CONSERVATION STATUS**
 IUCN Vulnerable
 (See key page 8)

◄ The spring thaw wipes away the snow leopard's white landscape to reveal a multitude of small dark and light areas, heightened by the bright sun at high altitudes. The leopard can crouch unseen by a likely victim until hardly metres/feet away, then spring into action and pursue with marvellous agility.

GOING DOWN

Like other large cats, the snow leopard's numbers are on a downward trend. Threats include degraded habitats due to mining and livestock overgrazing, retaliatory killings by livestock farmers, and, of course, escalating climate change as their panoramas become less white. And despite having full protection under wildlife laws since 1975, tragically there is still poaching to supply an illegal trade in bones, furs and other body parts.

Tiger

LEGEND IN STRIPES

Exceptionally famous and feared around the globe, the tiger is a symbol of so much: strength and power, stealth and cunning, endangered wildlife, and as wearer of perhaps the most recognizable apparel in the animal kingdom. This biggest of the cats has lent its name to dozens of other striped creatures, from tiger worms and tiger prawns, to tiger sharks and tiger snakes.

There are about forty-one kinds, or species, of cats. Most have coats with spots, rosettes, or broken bars or streaks. Only the tiger has such clear, unambiguous stripes. These are usually very dark or black and continue as rings around the tail and the upper parts of the legs. Their backdrop varies from creamy-yellow through orange or light rust to mid-reddish-tan. Facial fur between the stripes is white, as are the undersides. Every tiger has a unique stripe pattern.

REDS AND GREENS

Exactly how do stripes work for camouflage? The usual explanation is that the tiger hunts mainly during twilight and at night. It tends to be an ambusher or stalk-charge-pouncer, lying part-obscured in wait for prey, or creeping close enough to dash forward and deliver a killer bite. In low light levels, the alternating pale and dark stripes intermingle with vertically orientated vegetation grasses, undergrowth stalks and shrub stems.

But do they? Orange does not seem a 'foresty' colour. However, many tiger prey, such as wild deer and boar – and indeed, many mammals overall – do not see colours as we do. Their eyes work differently, with only two main kinds of colour receptors (dichromatic, green and blue receptors). This compares to three (trichromatic, with red as well as green and blue) in humans, apes, monkeys and other primates. It means these prey are effectively red-green colour blind, with a much more limited ability to clearly distinguish reds – including the tiger's orange – from greens. So, for them, a tiger's orange stripes blend into the generally green-brown vegetation.

DISTRIBUTION MAP

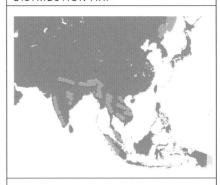

- LOCAL COMMON NAMES
 Regional and subspecies names such as Bengal tiger, Sumatran tiger; huge number of local names including Vyāghraḥ (Sanskrit); Baagh, Sher (Hindi dialects); Con hổ (Vietnamese); Harimau; Macan (Indonesian); тигр, Tigr (Russian), 'Hu', 'Lǎohǔ' (Chinese)

- SCIENTIFIC NAME
 Panthera tigris

- SIZE
 Head–tail length 2–4m (6ft 6in–13ft), shoulder height 0.8–1.1m (2ft 7in–3ft 7in), weight 70–300kg (154lb 5oz–661lb) (males are larger than females, also subspecies differ in size)

- HABITATS
 Forests, woods, scrub, grasslands, wetlands, farmland

- DIET
 Usually medium–large mammals, but many other kinds of prey, from fish, birds, rats and hares to the biggest buffaloes and rhinoceros

- CONSERVATION STATUS
 IUCN Endangered
 (See key page 8)

TIGER THREATS

The tiger is a top predator and 'headline' species. Each individual represents the health and welfare of a huge ecosystem area, often mixed habitat. Wretchedly, even today, a major threat is poaching for fur and body parts, reputed – utterly without scientific foundation – to have medicinal powers. Such is the species' illegally traded importance that its numbers are manipulated up or down by corrupt officials. Total tiger population estimates range from fewer than 3,000 to more than 5,000.

▶ Stripe orientation looks helpful here for a tiger among upright grasses including bamboos. But what about colour? Tiger victims have different sight systems to ourselves and see orange as less red-yellow and more green-brown.

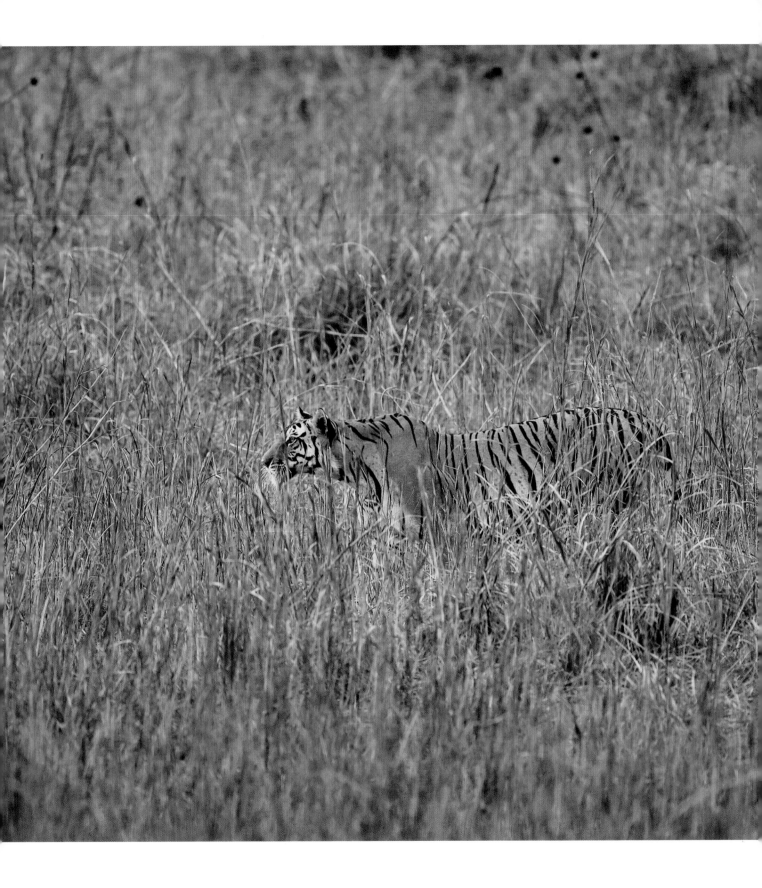

6

Australasia

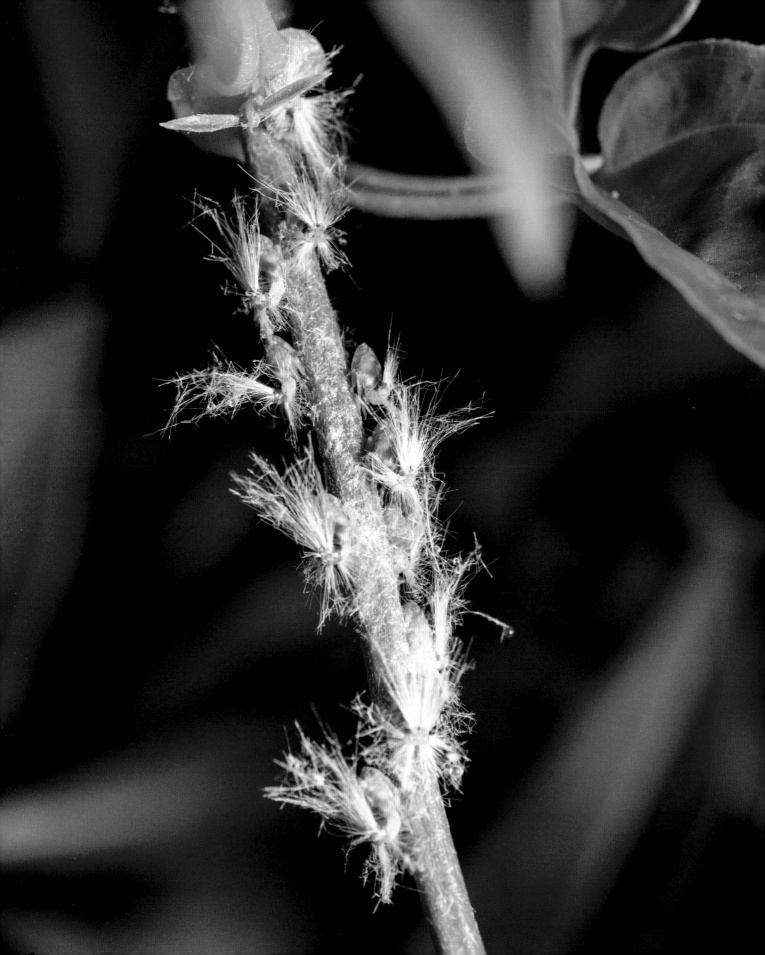

Wax-tailed planthopper

FUZZY BUTTS AND WAXY BACKS

Greenfly and blackfly aphids, thornbugs, spittlebugs, froghoppers and similar plant bugs are familiar chiefly as sap-sucking pests. Like cicadas, thrips and shield bugs, they are all members of the insect group Hemiptera, 'true bugs'. Many are well camouflaged, such as thornbugs on rose stems. Others manufacture various kinds of protection, such as the frothy bubbles of cuckoo spit around spittlebugs (froghoppers).

DISTRIBUTION MAP

● Scolypopid planthoppers (general distribution)

- **LOCAL COMMON NAMES**
 Troll bugs, Leafbugs, Treehoppers, Wax-tails, Hair-tailed bugs, Torpedo bugs

- **SCIENTIFIC NAME**
 Flatid bugs, members of the planthopper bug family Flatidae

- **SIZE**
 Mostly less than 7mm (¼in)

- **HABITATS**
 Tropical forests

- **DIET**
 Saps, nectar and other plant juices

- **CONSERVATION STATUS**
 IUCN Not evaluated
 (See key page 8)

DISGUISED BY WAXWORKS

Perhaps the most bizarre camouflage-protection among hemipterans belongs to the planthopper family, Flatidae. Like other bugs, they hatch from eggs as young forms called nymphs, which resemble adults but are smaller and wingless. They greedily suck plant fluids with their piercing mouthparts. Through several moults, they grow larger and more like the adult each time. But during their nymphal stages, many kinds of wax-tailed planthoppers emit remarkable, almost plastic-looking, lengthy filaments, strands, hairs, tendrils or fuzz from their abdomens (rearmost body parts). These exudations are produced by specialized wax glands towards the upper rear of the abdomen.

The results are truly remarkable sights. In some cases, the waxy extrusions cover the entire nymph. The effect may resemble a small patch of moss or fungus, a fluffy dandelion-like seed, a patch of fur left by a passing mammal, or a downy bird feather. Some wax-tailed planthopper species even fabricate a spray of fibre optic-like strands from the tail which may arch all over the body, so that the nymph itself seems dead and rotting away by a mould that has erected stalks bearing spore sacs. Overall, these flatid bug nymph disguises look truly unappetizing to predators such as birds, who would only grab a beakful of unpalatable, unwholesome stickiness.

◀ Much to the gardener's annoyance, passionvine planthoppers or leafhoppers (*Scolypopa australis*) – nicknamed 'fluffy-bums' – infest a jasmine vine.

▶ Springy and difficult to chew and digest, a flatid nymph's 'tail' filaments are a deterrent to many small predators such as birds and lizards.

COLLATERAL BENEFITS

Waxy exudates help planthopper nymphs in more ways than providing a cryptic cloak and physical protection. The wax itself is hydrophobic, which means it repels and sheds water, so the nymph does not drown in rainstorms. When it attains adult status – or rather if, since the vast majority die – the wax glands still work to provide an all-over, water-repelling layer.

Children's stick insect

STICKING WITH ITS LEAFY COSTUME

Stick insects or walking sticks are found almost worldwide in forests, woods, scrub – indeed, anywhere there are trees, bushes and shrubs. Their insect group, the phasmids (Phasmatodea), also embraces leaf insects and numbers more than 3,000 species. The vast majority are totally dedicated to mimicking visually almost all types of plant material, including twigs, stalks, stems, leaves, buds and other parts, whether healthy or broken or rotting away. The phasmids must regard camouflage among plants as an extremely worthwhile area for adaptation.

DISTRIBUTION MAP

- LOCAL COMMON NAMES
 Children's walking stick, Yellow-winged spectre, Stick bug

- SCIENTIFIC NAME
 Tropidoderus childrenii

- SIZE
 Head–body length 10–15cm (4–6in), wingspan 7–10cm (2¾–4in)

- HABITATS
 Woodlands, especially eucalyptus trees

- DIET
 Leaves, especially those of eucalyptus

- CONSERVATION STATUS
 IUCN Least concern
 (See key page 8)

AT HOME AMONG GUMS

Bulky and strong, the typical children's stick insect has several aspects to its disguise, which help it to stay concealed as it rests by day and feeds at night. Its shades of pale green tune into the eucalypt (gum) tree leaves among which it lives and feeds. The forelegs and the lower sections of the rear two pairs of legs resemble long green stalks or stems. The upper sections of those rear legs have smallish flaps that look like emerging or curled eucalypt leaves. The two pairs of wings, when held at rest along the sides of the main body (abdomen), also copy the leaves, even to details such as the difference in shade between the leaf's upper and lower surface, and the prominent paler, yellowish, lengthways, rib-like strengthening vein along each wing and the body.

There are colour variations, however. Children's stick insects are also found that tend towards pink, red, brown, even cream. These hues depend on the age and gender of the insect and the types of eucalypts where it lives.

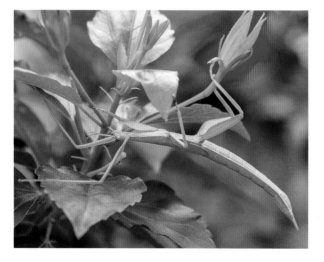

WHAT A PERFORMANCE

If its leafy costume is exposed and a predator such as a bird investigates, the children's stick insect has a few surprises. It kicks out with its long, sharp-clawed legs, bashes its rear legs together, rocks and vibrates its whole body which shakes the adjacent vegetation, and raises and flaps its wings to reveal the full extent of the large, lacy, fan-like hindwings, as well as displaying blue-purple blotches near the wing bases. Since this phasmid is a relatively substantial, powerful insect, many predators are put off by such an abrupt defence.

▶ The name 'phasmid' is derived from old Greek meaning ghost, phantom or apparition, referring to the way these insects suddenly move after being undetected among corresponding greenery.

◀ The children's stick insect is closely adapted to its leafy gum-tree home, unlike other species that have a more generalist, 'any-old-twig' appearance.

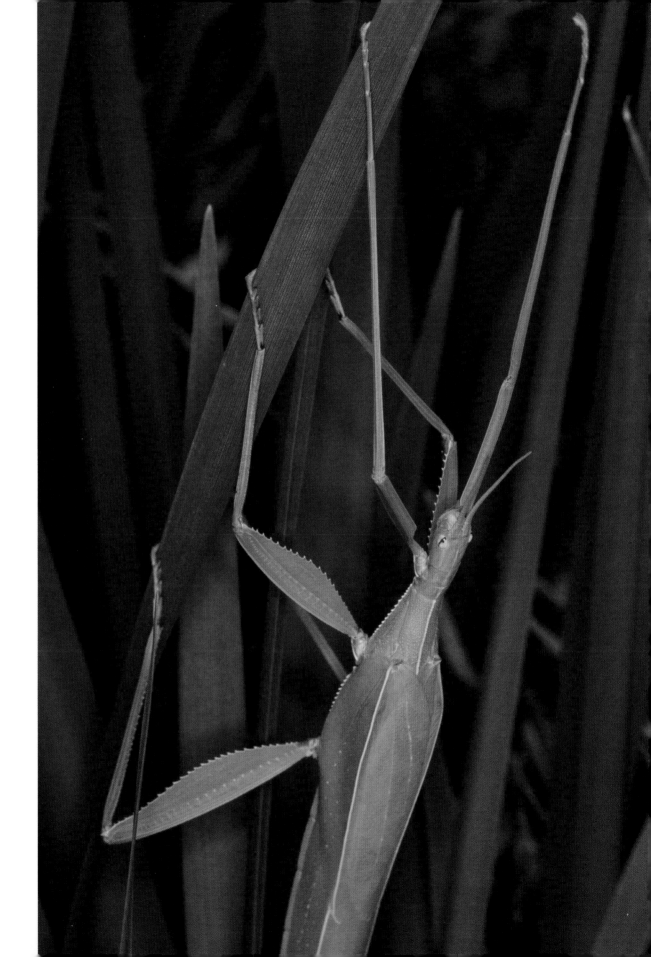

Leaf-tailed gecko

BIG TAIL, SMALL HEAD

Eastern Australia is home to several kinds of leaf-tailed geckos (*Saltuarius*), all fairly similar in their size, appearance and habits. 'Leaf-tail' may conjure up an image of a bright green tail, wide and flat, mimicking the leaf of a forest tree. In fact, the leafy shape for the tail is correct, but the coloration is very different. These geckoes are patterned to match tree bark or rocks covered with lichens, moss, moulds and similar patches of colour and texture.

Each species of leaf-tailed gecko is found only in a small area. For example, the granite leaf-tailed gecko (*Saltuarius wyberba*) is from the Granite Belt of south-east Queensland and north-east New South Wales. As the name suggests, granite rocks and outcrops are common in the region, and the lizard's tones blend in with this background. Kate's leaf-tailed gecko (*S. kateae*) lives in an area of the Richmond Range hills and mountains farther south and is more suited to camouflage on mossy tree bark and rocks in this damper habitat.

HEADS OR TAILS?
Leaf-tailed geckos are relatively large, up 20 centimetres (8 inches) long. They tend to sit and wait in their camouflage position, flat against suitable bark, rocks or a similar carefully chosen surface, on the lookout for insects and other prey. In some species the gecko's tail is considerably larger than the head, and predators such as quolls (marsupial 'cats'), big lizards and snakes, and birds of prey may mistakenly target this to kill the gecko prior to devouring it. But, like many lizards, the tail is detachable, falls away with little overall harm to the gecko, and gradually regrows. The new tail still has camouflage patterns, but these do not always match those of the body as accurately as its predecessor.

DISTRIBUTION MAP

● Southern leaf-tailed gecko

- **LOCAL COMMON NAMES**
 Leaf-tailed lizard, Rock gecko

- **SCIENTIFIC NAME**
 About 7 species in the genus *Saltuarius*

- **SIZE**
 Length up to 20cm (8in), weight up to 30g (1oz)

- **HABITATS**
 Mostly woods, forests, especially with rocky outcrops, boulders, cliffs, gorges and canyons

- **DIET**
 Insects, spiders, centipedes and similar small creatures

- **CONSERVATION STATUS**
 IUCN ranges from Least concern to Endangered (Cape Melville species) (See key page 8)

ADDITION TO THE LIST
In 2013 biologists reported a newly identified species of *Saltuarius*. This is the Cape Melville leaf-tailed gecko, *S. eximius*. Only a few individuals were found in this remote area on Queensland's Cape York Peninsula. Similar in camouflage appearance to other leaf-tailed geckos, the details of their body shape and genetics were distinct enough to warrant their own classification. The next-nearest species, the northern leaf-tailed gecko, lives some 200 kilometres (124 miles) south.

▶ A southern, Border Ranges or Swain's leaf-tailed gecko (*Saltuarius swaini*) is fully at home as it complements the bark, creepers, strangler figs and lichens of host trees in north-east New South Wales and south-east Queensland. This is one of the species whose flattened, leaf-shaped tail is larger than its head.

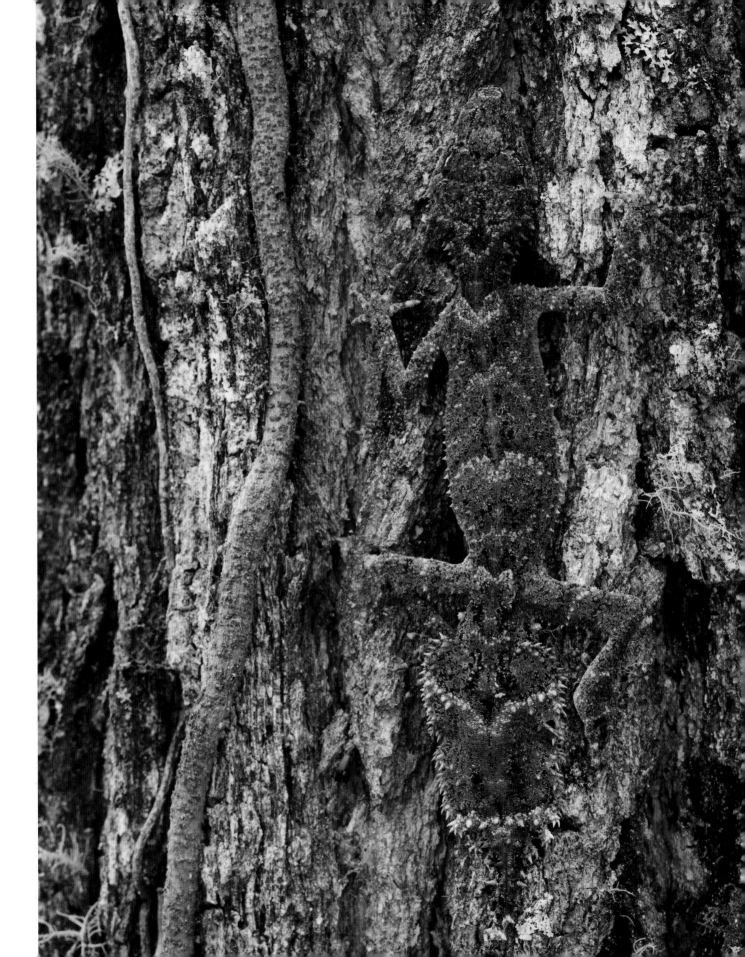

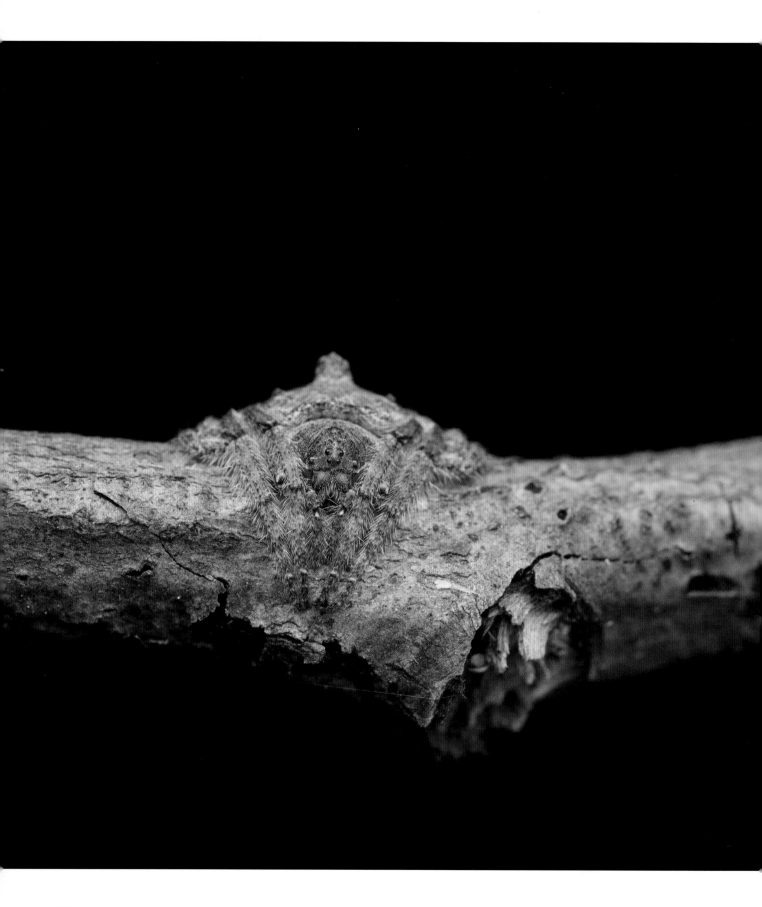

Wrap-around spider

WHEN BARK SUDDENLY BITES

The sudden change of an innocent, static patch of flat tree bark into an animated, hairy, scuttling spider is a sight that some humans might dread. The wrap-around spider can do exactly this, although size-wise it is not in the tarantula class; being less than 1 centimetre (⅝ inch) long, it could comfortably sit on a thumbnail. Also, like most spiders, it has a venomous bite, at least to its small insect prey, but its tiny fang size and relatively weak venom mean it is harmless to humans.

TWO-DIMENSIONAL SPIDER

By day the wrap-around spider flattens itself and neatly curves around a thick twig or fairly narrow branch, usually up to the width of a human arm. It selects the branch covering to match its own skin and hair coloration, which varies among individuals from stringy dark brown to patchy, flaky mid- or lighter brown, to paler, mossy grey-green. The legs are wide but very thin from above to below, so that as they are drawn to the sides of the body, they flatten almost imperceptibly onto the bark's surface.

The spider's rear main part, or abdomen, is slightly concave or hollowed-out on the underside, and curved from front to back, so it too presses down smoothly. The body's upper surface has a series of disc-like units (hence an alternative name of leopard spider) that help the body flex for greater or lesser curvature, and the body and leg hairs are relatively long and smooth over the bark surface. All this helps to confuse and disrupt the typical spider-like shape and make the wrap-around spider almost two-dimensional.

DISTRIBUTION MAP

- LOCAL COMMON NAMES
 Bark spider, Leopard spider

- SCIENTIFIC NAME
 Genus *Dolophones* includes *D. conifera*, *D. turrigera* and about 15 other species

- SIZE
 Head–body length females up to 1cm (⅜in), males up to 6mm (¼in)

- HABITATS
 Woods, bush, scrub

- DIET
 Small insects and similar invertebrates

- CONSERVATION STATUS
 IUCN Not evaluated
 (See key page 8)

◄ The spider's flatness means that the bark's surface hardly seems raised. Even with the sun at a low angle, the spider casts no shadow. It keeps a keen eye (or eight) on approaching danger. But it is wary of racing away to possible shelter, such as beneath flaking bark – since these crevices may be occupied by its own predators, such as centipedes and larger spiders.

WEB OF DEATH

As dusk progresses, the wrap-around spider rises from the bark and becomes active. It spins a surprisingly large orb web among the vegetation. On this or just to the side, it sits and waits. Eventually a gnat, mosquito, small moth or similar victim becomes trapped. The spider then rushes across to bite and subdue the victim, wraps it in a silk case, drags it to a hideaway nook, and feasts at its leisure.

Kōkopu

A STAR AMONG FISH

Camouflage markings take many configurations, from stripes, specks and smears to bars, belts and bands. But very few animals have cosmic tracery – pale, faint, wandering blobs, streaks, pinpoints and contours resembling stars and galaxies (star clusters) in the night sky. The giant kōkopu or giant galaxia is one such creature. Its decorative effect is almost like looking through a powerful telescope into deep space. It ideally matches the dappled shade, shafts of light and tangled vegetation in its pool, creek or slow stream near to New Zealand's coast. The kōkopu is thus secreted both from its prey, and from its enemies such as native longfin eels.

In adulthood the main body colour is brown-green, grey or olive, darker in some individuals than others. The delicate markings are usually light yellow, yellowy-cream, golden or silvery (the scientific name *Galaxia argenteus* means 'star clusters of silver'). The markings appear gradually as bars in young giant kōkopus, then spread and fragment through to old age – which may be twenty-plus years.

SMALL GIANT

New Zealand has three species of kōkopus found nowhere else: the giant, banded and shortjaw. At about 30 centimetres (1 foot) in length, the 'giant' kōkopu is extremely modest in size compared to truly giant freshwater fish such as the arapaima and wels, which may be more than ten times longer and hundreds of times heavier.

Kōkopus are 'diadromous' fish. They live in fresh water as adults and breed in autumn, laying eggs in bankside vegetation near the coast. The new young or larvae float downstream and on receding high tides, out to sea. Here they feed on plankton, then move back upstream the following spring and summer.

DISTRIBUTION MAP

- LOCAL COMMON NAMES
 Giant galaxia, Maori trout, Native trout

- SCIENTIFIC NAME
 Galaxias argenteus

- SIZE
 Length up to 40cm (1ft 3in), rarely more than 50cm (1ft 7in), weight 0.5–2.5kg (1lb–5lb 8oz)

- HABITATS
 Still or slow waters such as lakes, streams and wetlands, usually near the coast, always with plentiful aquatic, bankside and overhanging vegetation

- DIET
 Aquatic and terrestrial insects, spiders and other invertebrates, small fish

- CONSERVATION STATUS
 IUCN Vulnerable
 (See key page 8)

WHITEBAIT

About five species of New Zealand fish have a similar life cycle where the larvae float out to sea. They include the three kōkopus, the inanga or common galaxia, and the kōaro or climbing galaxia. When the young fish, now about 5 centimetres (2 inches) long, return upstream the following year in mixed shoals, they are caught as 'whitebait', a traditional New Zealand delicacy. In modern times whitebaiting has come under ever-stricter controls to preserve the species.

▶ The kōkopu's camouflage is heightened because it lacks a noticeable pattern of shiny scales. Its skin is tough, leathery and slimy, rather like that of catfish. By day it hides among plants, old logs, bank overhangs and general debris.

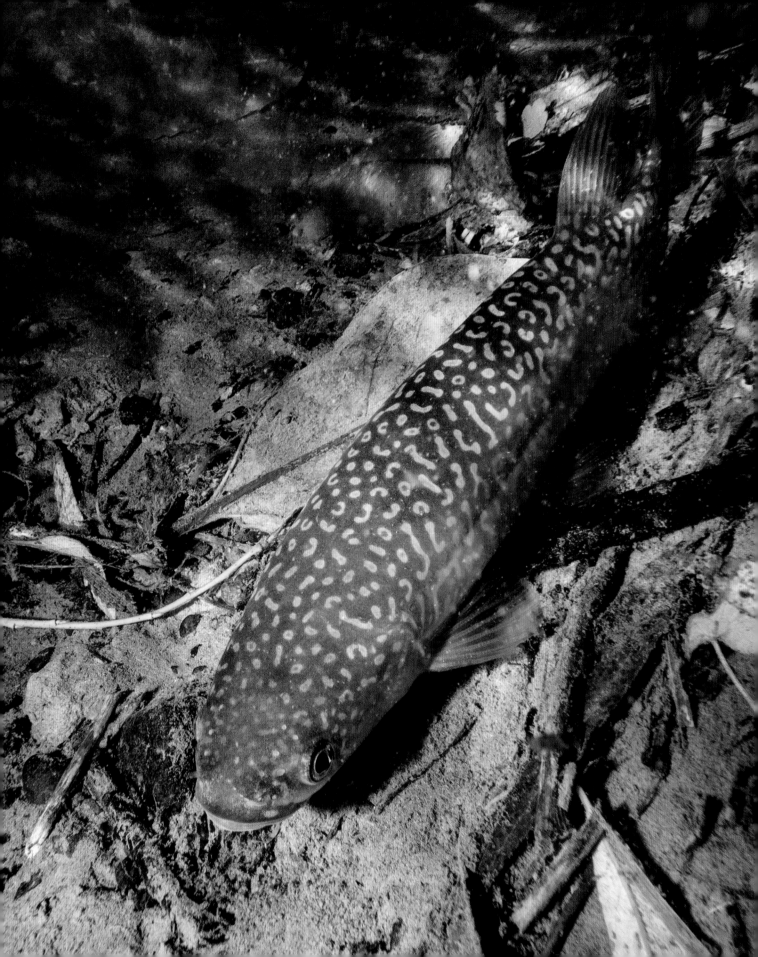

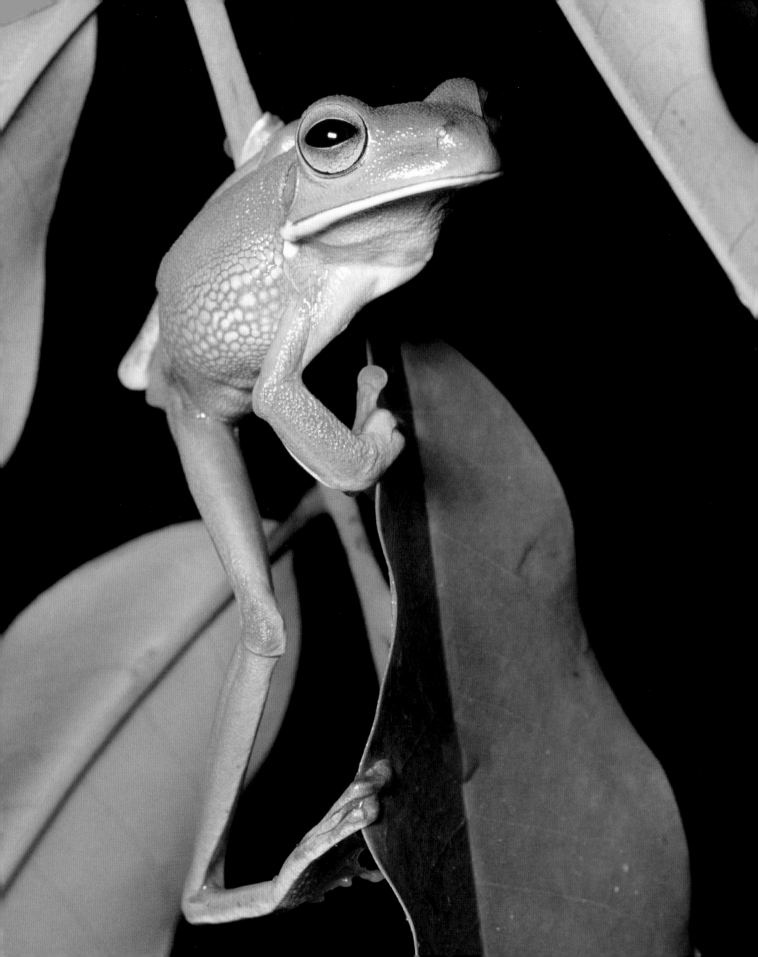

White-lipped tree frog

LARGE, CHUNKY AND LEAFY

Often cited as Australia's largest frog, and one of the biggest of all tree frogs, the white-lipped or giant tree frog is a considerable amphibian. Like other tree frogs, it has wide, sucker-like toe-tips that grip even the wettest, slipperiest leaves and twigs in its forest home. Here its bright, light to mid-green upper surfaces, glistening even when its skin is not especially moist, are superbly camouflaged among the generally vivid green foliage – although its appearance may tend towards olive or brown depending on humidity, temperature, its regular diet and background colours.

The skin along this frog's body sides is slightly granular or pitted, which scatters light and makes it glint even more in bright light. From its common name, its species identifier is the well-demarcated white or cream line along the lower lip, extending to the jaw joint in the cheek area. Being relatively bulky, the white-lipped avoids small leaves on thin twigs, and keeps to larger, stronger leaves and compact leafy bunches.

WELCOME GUEST?

White-lipped tree frogs have moved out of, and adapted well to, unnatural habitats that lack the verdant colours of their original homes. They frequent farmland, gardens, outbuildings and houses, wherever their adaptable diet crops up. Part of this success story may be that their natural predators, especially tree snakes and lizards, are less common in such modified habitats. Also, most people welcome their ability to eat flies, cockroaches and other irritants and pests, while the frogs themselves cause few problems. However, they cannot persist in these new environments unless, like most amphibians, there is a body of water nearby where the female and male can get together and produce fertilized eggs which hatch into tadpoles.

DISTRIBUTION MAP

- LOCAL COMMON NAMES
New Guinea tree frog, Australian tree frog, Giant tree frog, Giant green frog

- SCIENTIFIC NAME
Nyctimystes infrafrenatus
(formerly *Litoria infrafrenata*)

- SIZE
Head–body length 10–15cm (4–6in), weight 30–60g (1–2oz) (females are larger than males)

- HABITATS
Wide variety, including tropical rainforests, damp woodlands, moist scrub, also human-modified farmland, plantations, parks, suburbs, gardens and buildings, with nearby water for breeding

- DIET
All kinds of invertebrates, such as worms, insects, spiders, centipedes, snails, occasionally very small reptiles, birds and mammals

- CONSERVATION STATUS
IUCN Least concern
(See key page 8)

CATS AND DOGS

Sometimes more heard than seen, white-lipped tree frogs make several vocalizations. One is a cat-like 'mee-ow' when startled or stressed. Another is the male's mating call, likened to a dog's bark. On warm, humid nights, these sounds can be heard coming from garden ponds, drainpipes, water tanks – even sinks, basins and toilet bowls.

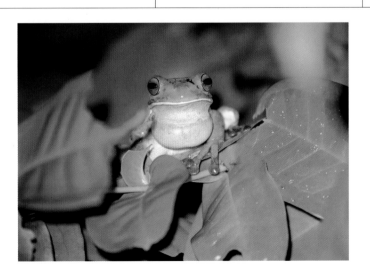

◀ Despite its size, the white-lipped tree frog is agile among foliage. Its limbs resemble twigs and the stems of leaves and flowers.

▶ A male inflates his chin and throat sac in order to vocalize, making his barking sound to call for a mate.

Thorny devil

AUSTRALIA'S SPINY ANTEATER

The desert devil, moloch or simply 'thorny' is truly one of the strangest lizards, if not one of the oddest of all animals. It is certainly spiky, with conical, sharp-tipped scales like rose thorns over much of its body. Desert-inhabiting, ground-dwelling, day-active and slow-moving, this devil usually strolls along casually, searching for ants to eat. But when it senses danger, it abruptly freezes, even stopping in mid-step with one or two legs off the ground. As a result, the weird, un-animal-like body shape, outline and posture, its multicoloured and multi-sized patches and blotches of white, cream, yellow, orange, tan, brown and almost black, and its lack of movement, all combine to make it virtually undetectable among pebbles, shingle, dry shrubs and grasses, and other bits of old vegetational debris littering the parched ground.

TWO HEADS ARE BETTER THAN ONE

Should it be noticed by a predator, such as a bird of prey, dingo, red fox, big snake or large goanna (lizard), the thorny devil has further defences. Of course, there are its dozens of spikes and spines. If the lizard lowers its real head down between its forelegs, it presents to the molester a curious bristly hump on the back of its neck that looks like its head. Should this 'second head' be assaulted, it is formed mainly of tough flesh and the result is little overall harm. The real head is further defended by sharp, extra-tall, rear-pointing, horn-like thorns above the eyes, making it a very difficult mouthful to tackle. Also, like many of its lizard cousins, the devil can swallow air to puff itself up, making it even more awkward to harass.

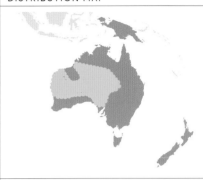

DISTRIBUTION MAP

- **LOCAL COMMON NAMES**
 Moloch, Thorny dragon, Mountain devil; Arnkerrth, Ngiyari and others (Australian Aboriginal dialects)

- **SCIENTIFIC NAME**
 Moloch horridus

- **SIZE**
 Total length 17–20cm (6¾–8in), weight 30–80g (1–3oz)

- **HABITATS**
 Arid and semi-arid soft-soil areas, such as bush, scrub, sandy and shingly desert

- **DIET**
 Ants, also termites and similar small insects

- **CONSERVATION STATUS**
 IUCN Least concern
 (See key page 8)

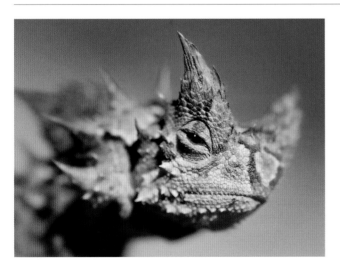

DO-IT-YOURSELF WATER ACCUMULATOR
Surviving in even the driest Australian deserts, the thorny devil has its own water collecting system. Grooves and channels between its scales conduct water by capillary action, like a wicking fabric. Early morning dew condensing on its body, rain, patches of dampness in the ground, dew or rain on rocks and plants, and any other water source are all used. The water is attracted and conducted along the network of grooves to the devil's head and mouth.

◄ (Opposite) The thorny devil's body coloration changes from paler during sunny, hot conditions, as here, to match its brightly lit surroundings. During cold, overcast weather, the lizard likewise becomes darker and duller. (Left) Tall eyebrow spikes, cheek thorns and general all-over prickliness deter most creatures who might consider the devil a tasty meal.

Common death adder

BEWARE THE WRIGGLY 'WORM'

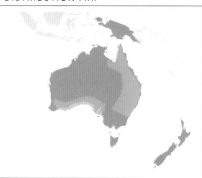

Australia is famed for its highly venomous creatures. Near the top of its list, and indeed one of the most venomous snakes worldwide, is the death adder. In fact, there are about seven species of death adder in Australia, all potentially lethal to humans. The common death adder is the most numerous and also the most frequently encountered, dwelling in the north-east, east and south-east – Australia's most populated regions – as well as along the southern seaboard.

Common death adders nearly all have a similar circular banded pattern of markings, with small and complex gradations and merging of the bands due to the slightly differing hues of individual scales. But they vary in their main colours, and in the contrasts between the light and darker bands, mostly according to location. In drier areas they are paler, in shades of black, brown, tawny, tan and cream, while in moister locations they tend to be darker, with more greys, olives and greens. Occasional brightly coloured individuals are found, in red and orange and even yellow, and also specimens with more prominent lengthways stripes rather than hoops.

CAUDAL LURING

Death adders are masters of lie-still camouflage, coiled, draped or hidden among pebbles, stones, soil, leaf litter, twigs and similar bits and pieces covering the ground. But they do not have to wait for a chance passer-by such as a mouse, skink or bird. The snake's rear or caudal end tapers abruptly to its last few centimetres and looks rather like a rat's tail or worm. The adder can twitch this to interest small animals nearby, a technique known as caudal luring. Even though the adder's head and body are adjacent, the victim may not notice until the deadly fangs strike.

- LOCAL COMMON NAMES
 Deaf adder, Aussie viper

- SCIENTIFIC NAME
 Acanthophis antarcticus

- SIZE
 Length up to 1m (3ft 3in), weight 1–4kg (2lb 3oz–8lb 13oz)

- HABITATS
 Varied, from forest to bush, grassland, heath and dunes, including human habitation

- DIET
 Small mammals, birds, reptiles such as lizards, and similar creatures

- CONSERVATION STATUS
 IUCN Least concern
 (See key page 8)

FATAL FOOD

In the 1930s, large South American amphibians called marine or cane toads were released in Australia to eat cane beetle pests in Queensland's sugar cane plantations. The toads soon spread and began to devastate local wildlife. Still spreading west and south, they cause untold damage. They are eaten by native snakes such as the death adder, also lizards, birds, and mammals such as quolls. These predators may well die after the meal, due to the powerful poisons in the toad's skin. The death adder's caudal luring is especially successful with cane toads, and so the snake's populations are severely reducing in some areas.

▶ (Top) Coiled and ready to strike, the common death adder watches and also feels vibrations passing through the ground. (Bottom) It regularly inspects its worm-like tail or caudal lure. This can wriggle and flick to attract hungry small carnivores, including birds and lizards.

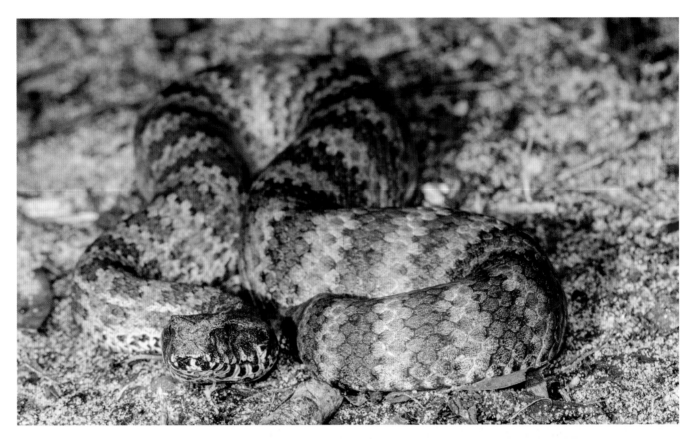

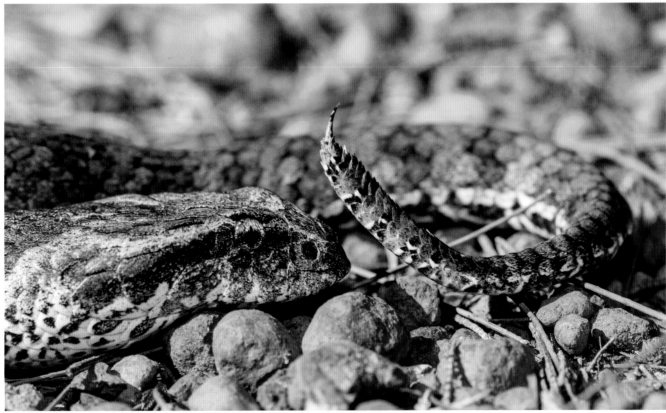

Red-capped plover

NEST-FREE NESTING

Camouflage is a widespread survival strategy, not only for adult animals. Many youngsters or immature forms use it, some with a very different guise to their parents. Green caterpillars become brown butterflies; dappled fawns grow into mainly brown-coloured deer; and striped boarlets mature into plain-coated wild boars.

DISTRIBUTION MAP

Some birds also use the strategy, especially for their eggs and nestlings. If the eggs and babies are secreted in a nest, such as in a tree hole or deep-woven grassy cup, camouflage is not so vital. But out in the open, it can be crucial. The red-capped plover, like many other plovers, dotterels and similar small waders, occupies open, treeless habitats. The red-cap lives mainly on shingly, stony and coarse sandy beaches, coastal and tidal flats, estuaries and saltmarshes. It travels extensively and takes advantage of inland marshes, salt lakes and other wetlands, especially after heavy rains.

MINIMAL NEST

In these wide-open places, there are no tree holes or big bushes. So, the plover lays its two eggs in a 'nest', which is literally the bare minimum – a shallow scrape with little grass, moss or other lining. However, the pale browny-greyish-yellow eggs, with random small dark speckles and spots, fit wonderfully into the bits-and-pieces, debris-rich landscape. When the adult is on the nest, its grey and pale brown upper parts, rufous cap (more prominent in the male) and stripy face also match the landscape. When the nestlings hatch, apart from being fluffy, they have a similar colour scheme to the eggs, although they soon leave the nest area. So, at all life stages, the red-cap's camouflage is effective against predators such as crows, gulls, marauding lizards and snakes, and introduced hunters such as the red fox.

- **LOCAL COMMON NAMES**
 Red-capped dotterel, red-necked plover, sand lark; Dirundirr (eggs), Bungobittah, Malunna (nest) (Aboriginal dialects); Corriol cap-roig (Catalan); Sieweczka rdzawoglowa (Polish)

- **SCIENTIFIC NAME**
 Charadrius ruficapillus

- **SIZE**
 Bill–tail length 13–16cm (5–6in), wingspan 28–33cm (11–13in), weight 30–60g (1–2oz)

- **HABITATS**
 Open areas along coasts, estuaries, inland wetlands

- **DIET**
 Small invertebrates such as worms, shellfish, snails, some plant material

- **CONSERVATION STATUS**
 IUCN Least concern
 (See key page 8)

LOOK OVER HERE, I'M INJURED

Around the world, plovers and related birds show behaviours known as distraction displays. If a predator or other danger approaches, especially near the nest, the adult feigns injury such as a broken wing. It runs awkwardly, or pretends to try and flap, but fails. The predator, enticed by this apparently easy meal, follows – and is led away from the nest. When it has been duped to a safe distance, the plover 'recovers' and flies off.

◄ A female red-capped plover stands over her nest with its chick and egg. All are camouflaged to match their sandy, scrubby habitat.

► The distraction or diversion display involves faking injury, such as a damaged wing, to draw a possible predator away from the nest.

Tawny frogmouth

BRANCHING OUT

For birds that are busy hunting at night, daylight is the time to rest and roost. Some nocturnal species, such as the tawny owl, usually hide away among thick vegetation or in a hole or crevice. The tawny frogmouth looks very similar to an owl, but it is not in the owl group. Nor does it generally hide away by day. It rests out in the open, pretending to be part of a tree, such as a stump or broken branch. Its mottled and streaked plumage includes shades of brown, grey, white, silver and black in various sizes. These markings blend fluently with the tree bark of the tawny's roost, so it is difficult to see where the wood ends and the bird begins.

The frogmouth also adopts a suitable attitude, body angle and flattened bill to blend with the boughs and branches around. It can stay still for hours if necessary, to make its guise even more effective. Only if danger comes within a metre or two does the tawny frogmouth suddenly burst into life and rapidly flap away.

SWOOP AND SEIZE
Frogmouths are cousins of the potoos in the Americas (see pages 60–61), and the nightjars which are found in most parts of the world.

Like these relatives, frogmouths fly and feed at night. The tawny frogmouth sometimes catches prey in mid-air, such as moths, but it usually swoops from a perch down to the ground and snaps up a meal in its beak. Its food comprises almost any creature of suitable size, including all kinds of insects such as beetles and cockroaches, also spiders, scorpions, millipedes, centipedes, slugs and snails, worms, and lizards, frogs, small birds and mammals such as mice.

DISTRIBUTION MAP

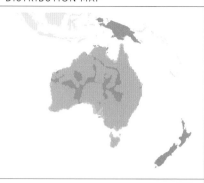

- LOCAL COMMON NAMES
 Mopark, Mopoke, Morepoke (names also applied to other Australian birds)

- SCIENTIFIC NAME
 Podargus strigoides

- SIZE
 Bill–tail length 55–75cm (1ft 9in–2ft 5in), wingspan 70–90cm (2ft 3in–3ft), weight 200–400g (7–14oz)

- HABITATS
 Most habitats with trees and bushes including woods, scrub, bush, farmland, urban areas such as parks and backyards; rare in dense forest and desert

- DIET
 Any creatures of suitable size, from worms and insects to small frogs, birds and mammals

- CONSERVATION STATUS
 IUCN Least concern
 (See key page 8)

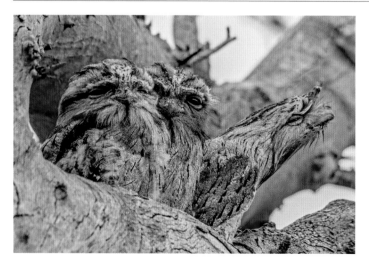

LIKELY PREDATORS
Frogmouths need their camouflage to avoid the attention of a range of predators. Among their long-time enemies are pythons, big lizards, dingoes, and larger birds such as butcherbirds, falcons and eagles. Since European settlement of Australia these have been joined by red foxes, dogs and cats. Another hazard is being hit by a vehicle as the frogmouth chases after flying insects illuminated by headlights.

▶ Many kinds of tree bark have rough channels and irregular grooves, which the streaks and bars along the tawny frogmouth's body aim to mimic. It keeps watch through hardly noticeable eye slits.

◀ Trees and wood vary greatly in colour, and the frogmouth tries to choose a roost that visually matches itself.

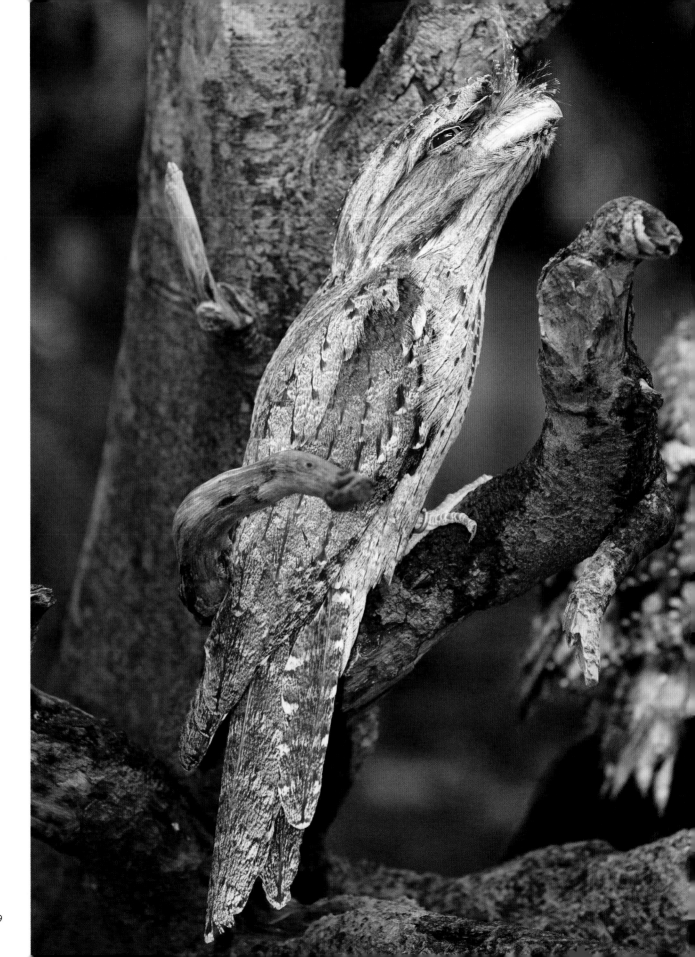

Green catbird

BOWERBIRD WITH NO BOWER

As might be expected with such a leaf-green appearance, these catbirds dwell in wet and moist forests and woods, especially with eucalypts (gum trees), along the subtropical and temperate east coast of Australia. The usually emerald green plumage, brighter on the wings, is speckled with small white and cream spots on the chest, back and slightly darker head, and lines of similar small, pale patches on the wings and tail, allowing the bird to mix in with many kinds of foliage.

TOGETHER FOR LIFE

Found in New Guinea and Australia, the twenty or so kinds of bowerbirds are named from the male's breeding behaviour. He constructs a bower or courtship structure to attract the female. Bowers range from just a few twigs and leaves in a heap, to elaborate arches and tunnels painstakingly decorated with colourful petals and other items.

The green catbird is a member of the bowerbird group – but the male is an exception. He does not build a bower. However, he does preen, dance, call and display to court a female, and presents her with bright-hued items like flower petals and berries. Once the two form a bond, they are a pair for life. As in many birds, only the female builds the cup-shaped nest and sits on the eggs; the male joins in to help her feed the young.

Green catbirds are mainly herbivores, consuming flowers, fruits and other plant matter. However, they are stout and strong enough to catch insects, small reptiles and amphibians, and baby birds, usually to feed their own nestlings at breeding time.

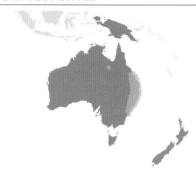

- LOCAL COMMON NAMES
 Spotted catbird

- SCIENTIFIC NAME
 Ailuroedus crassirostris

- SIZE
 Bill–tail length 26–33cm (10in–13in), wingspan 45–50cm (1ft 5in–1ft 7in), weight 180–220g (6–8oz)

- HABITATS
 Forests and woods with high to medium rainfall

- DIET
 Flowers, fruits, buds, other plant parts; some insects and other small animals

- CONSERVATION STATUS
 IUCN Least concern
 (See key page 8)

'MEE-OW'

Catbirds are named after their calls, which often sound like a cat's miaow. Some people liken them to a baby's subdued, plaintive wailing. The pair use these calls to keep track of each other's positions in their breeding and feeding territories. They may exchange calls frequently in a 'duet' – which often sounds like two cats caterwauling.

▶ As green as the leaves around, the catbird displays its slightly darker head and delicate speckles on the body. The stout beak can tackle many items, from seeds and nuts to soft fruits.

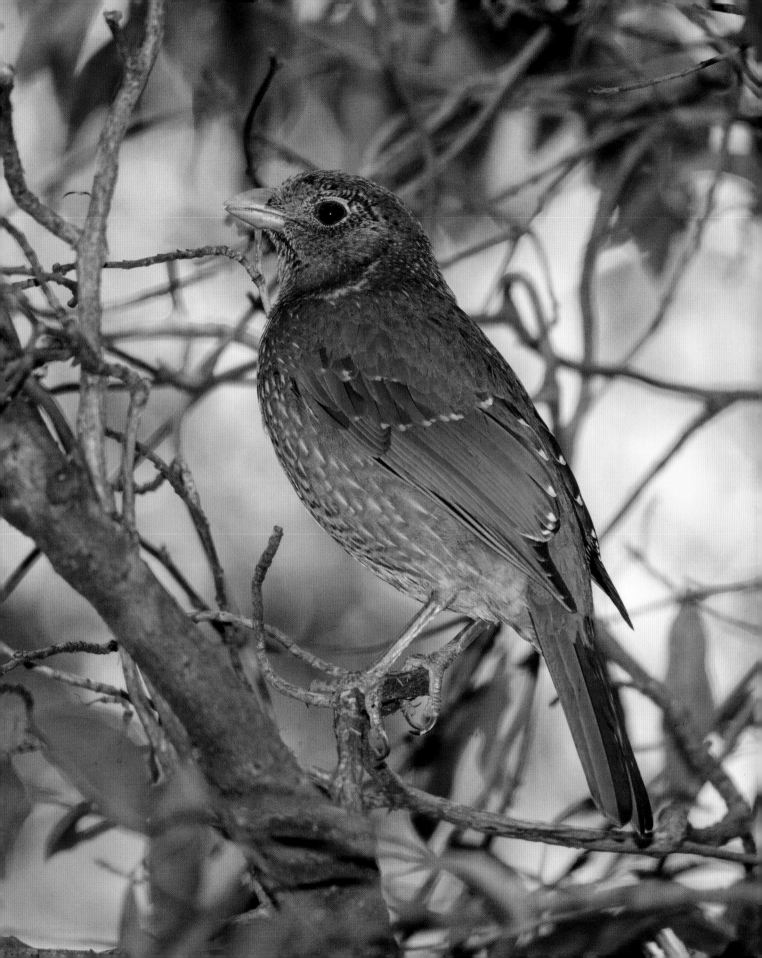

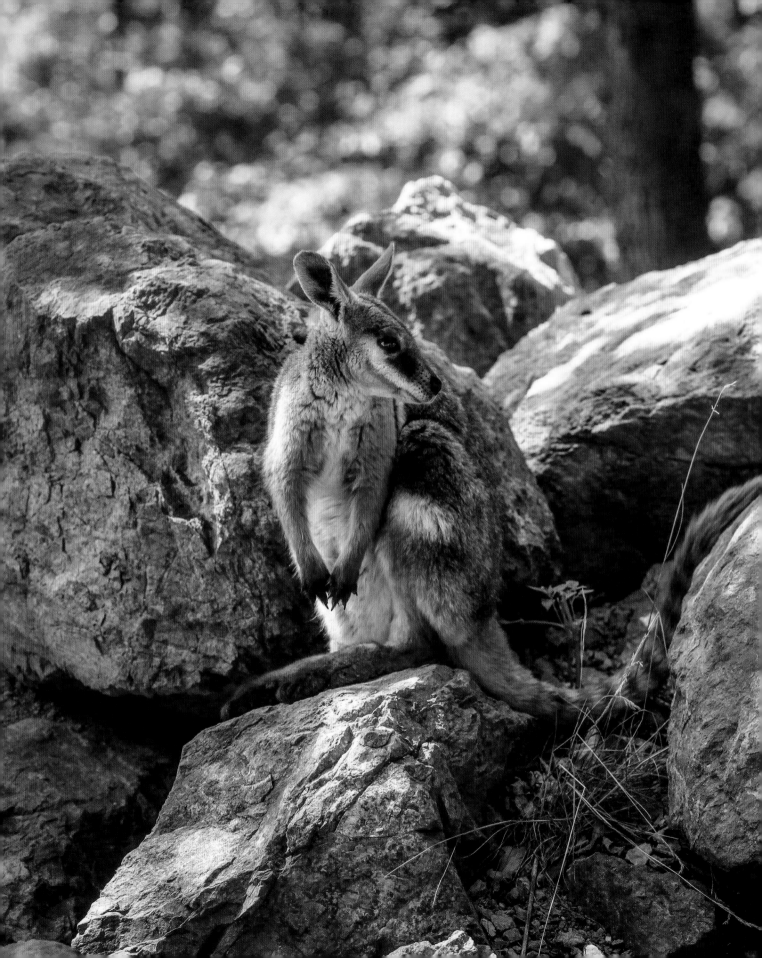

Rock wallaby

STANDING SMALL

Numbering about eighteen different kinds, or species, rock wallabies resemble their wallaby and kangaroo cousins but are considerably smaller, ranging from the size of a small domestic cat to a cocker spaniel. They do indeed like rocks of all kinds – cliffs, outcrops, gorges, stony hills, piles of boulders, scree and anything similar. Here they hide away by day in caves, crevices, overhangs, bushes and other cover, emerging for a time after sunset and again before sunrise to feed on nearby grasses and other plants.

LOCAL ADAPTATIONS

Most rock wallaby species are found in relatively few numbers isolated in quite small areas, even just one minor range of rocky hills, where the single species is highly adapted to the local environment. It's thought that from probably one kind of common ancestor, over the past few million years these wallabies have spread to new and separate locations, developed into different species, and the thick fur of each species has evolved to match the type, colour and shading of the rocks there. These rock-and-fur colours range from chocolate, dark brown, grey or silver to lighter brown, golden, red and even orange. For example, Rothschild's rock wallaby of Western Australia is almost golden brown on the body; while the Mareeba rock wallaby of north-east Queensland is more of a speckled grey when newly moulted, fading to browner tones over the months that follow.

Camouflage helps these small marsupials to remain unseen among their rocks by native predators such as dingoes, big lizards and snakes, and birds of prey. However, animals introduced by Europeans, such as red foxes and feral cats, have caused a drastic decline in many rock wallaby species, while rabbits, sheep and goats compete for their food.

DISTRIBUTION MAP

● Yellow-footed rock wallaby

● Rothschild's rock wallaby

- LOCAL COMMON NAMES
 Vary with species; for example, Black-flanked wallaby is also known as the Warru, Kimberley rock wallaby as the Monjon, yellow-footed rock wallaby as the Andu

- SCIENTIFIC NAME
 Up to 18 species in the genus *Petrogale*

- SIZE
 Larger species head–tail length 1–1.2m (3ft 3in–4ft), weight 8–10kg (17lb 10oz–22lb); smaller species head–tail length 55–70cm (1ft 9in–2ft 3in), weight 1–1.5kg (2lb 3oz–3lb 4oz)

- HABITATS
 Rocky areas of many kinds with suitable vegetation nearby

- DIET
 Grasses, leaves, shoots, ferns, mosses, other plant matter

- CONSERVATION STATUS
 IUCN most species are Vulnerable, Near Threatened or Endangered (See key page 8)

◄ The yellow-footed or ring-tailed rock wallaby (*Petrogale xanthopus*) is found in several small, isolated areas of south-east Australia. Most of these populations and their habitats are legally protected.

AMAZING ACROBATICS

Rock wallabies have developed amazing abilities to bounce, climb, leap and turn in mid-air, giving them incredible agility among the cliffs, crags and boulders. With relatively short but strong legs and feet, small claws to prevent slipping, high-grip sole pads, and a long counterbalancing tail, they spring up almost vertical faces with ease and ricochet between rocks at great speed – all the better to escape predators who enter their rocky stronghold.

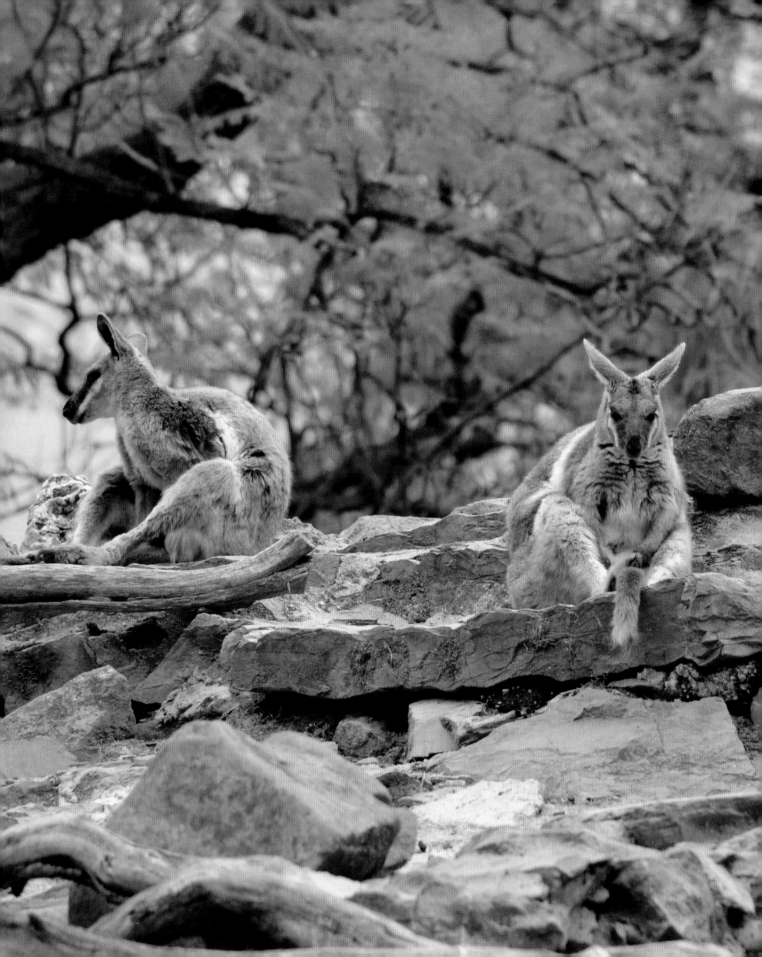

Tiger quoll

SPOTS IN REVERSE

Also known as the spotted-tailed quoll, this is one of six kinds, or species, of quoll found in Australia and New Guinea. The quolls are sometimes referred to as native cats. They are certainly native, but they are not members of the cat family, Felidae. They belong to the marsupial group, along with kangaroos and koalas, in which most females have pouches where they nurse and carry their young.

However, quolls do have a rather cat-like lifestyle, being night-time hunters of smaller creatures, both on the ground and in the branches. Being the largest species, the tiger quoll takes the biggest prey, up to the size of rabbits, wombats and small wallabies, although it eats almost anything down to the size of cockroaches and beetles. Hunting is where its spotted coat comes in useful.

'NEGATIVE' CAT

Cats tend to have coats with a pale background and dark markings. Quolls are, in a sense, a 'negative' version. The tiger quoll's background colour is darker, brown, tan or red-brown, perhaps rusty or chocolate, with tinges of orange or grey, and the irregular sizes and shapes of spots are cream to white. The tail in this species is spotted, unlike other quolls, while the face is usually a lighter brown-grey and spot-free. In the half-light of dawn and dusk, these markings break up the animal's shape and outline, and are ideal for staying undetected as the quoll stalks though undergrowth or prowls along branches, in its preferred habitats of woods and forests. By day the tiger quoll rests in a den such as a cave or a hollow under tree roots, away from its own predators, which include large snakes, lizards and birds of prey such as eagles.

DISTRIBUTION MAP

- LOCAL COMMON NAMES
 Native cat, Tiger cat, Spotted-tail dasyure; Kuull (Australian Aboriginal dialect source of 'Quoll'); Tjilpa, Kuningka (other Aboriginal dialects)

- SCIENTIFIC NAME
 Dasyurus maculatus

- SIZE
 Head–body length 35–60cm (1ft–2ft), tail 35–45cm (1ft 2in–1ft 5in), weight 1.5–5kg (3lb 4oz–11lb) (males are larger than females)

- HABITATS
 Chiefly woods and forests with high rainfall; also scrub, heath, coastal dunes and mangroves

- DIET
 Any animal it can overpower, from insects to small wallabies, including farm poultry; also carrion

- CONSERVATION STATUS
 IUCN Near threatened
 (See key page 8)

SPLIT POPULATIONS

Tiger quolls today are found in two regions separated by hundreds of kilometres. The north-east tiger quoll (*Dasyurus maculatus gracilis*) is smaller and slimmer than the south-east subspecies (*D. m. maculatus*). Long ago, the range of these quolls was probably continuous along all of Australia's east and south-east coasts, from Queensland to South Australia. But long-term natural changes in habitat, accelerated by drastic habitat loss and coupled with many other threats since European settlement, has meant quolls are now in dire need of vigorous conservation.

▶ The quoll's light spots match a variety of pale items in its forest home, such as mushrooms, patches of lichen or mould, bark-free bare wood, small flowers that bloom under the shading canopy and shafts of moonlight or sunlight.

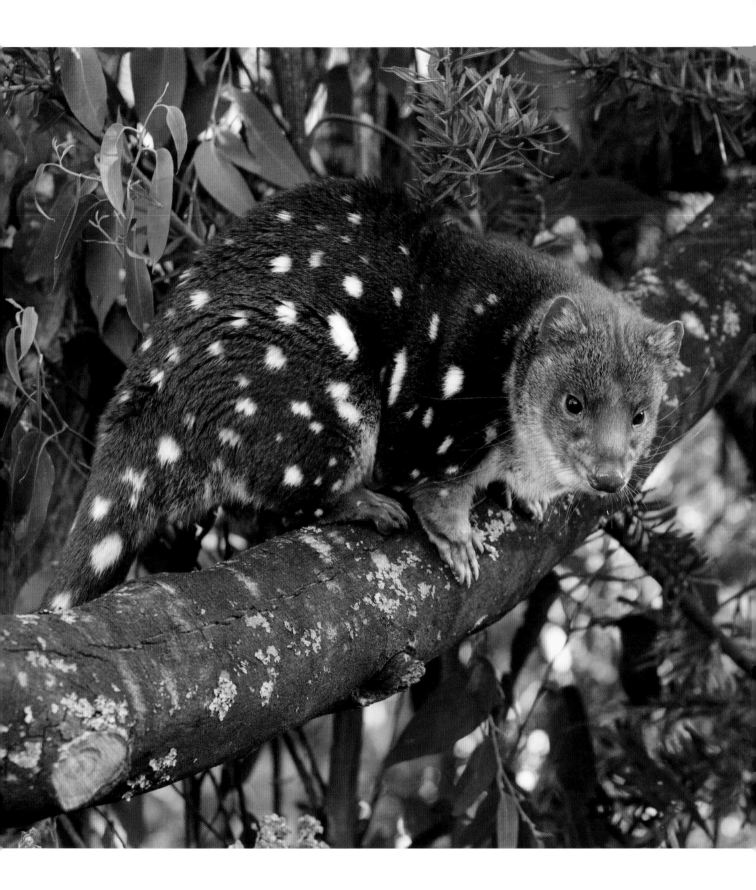

Tasmanian devil

DEAD-OF-NIGHT PROWLER

Australia is the world centre for marsupials – mammals where the female cares for her young in a pouch, or marsupium. Kangaroos, wallabies, koalas and wombats are all well-known examples, and are all sizeable herbivores. Meat-eating marsupials are generally smaller, such as the tiger quoll (see pages 196–197). In fact, the biggest carnivorous marsupial is only about the size of a small dog: the Tasmanian devil.

DISTRIBUTION MAP

- **LOCAL COMMON NAMES**
 Tarrabah, Purinina (Aboriginal dialects)

- **SCIENTIFIC NAME**
 Sarcophilus harrisii

- **SIZE**
 Nose–tail length 0.75–1m
 (2ft 5in–3ft 3in), shoulder height
 35–40cm (1ft 2in–1ft 3in), weight
 5–10kg (11lb–22lb) (males are larger
 than females)

- **HABITATS**
 Woods, forests, scrub, bush, heath,
 farmland, outer suburbs

- **DIET**
 Carrion; also live prey from insects to
 frogs, reptiles, birds, even mammals
 larger than the devil itself

- **CONSERVATION STATUS**
 IUCN Endangered
 (See key page 8)

'Devils' are extremely capable, strong, power-biting, and nocturnal hunter-scavengers. Their brown-to-black fur means they can slip undetected through the darkness of their habitats, ranging from woods and forests to coastal heaths and ranges, farmland and even suburbs. The only non-black parts are the white or pale, rather haphazard stripes or streaks on the chest and rump, plus the skin-coloured muzzle and ear interiors. Some devils lack the white markings and also have very dark skin, so they are truly all-black, which is ideal for night forays.

BLACK AS MIDNIGHT

After sleeping by day in a hollow log, burrow or other den, the devil's coloration allows it to sneak up on prey, such as lizards, snakes, birds and mammals up to the size of wombats and wallabies. However, much of its diet comes from carrion, which the devil chews through and crunches up with its enormously powerful jaws.

In modern times, a full-grown devil has few natural predators, perhaps only big birds of prey. In the past, however, it could well have been the victim of the thylacine – the Tasmanian 'tiger' or 'wolf', an animal which was not a member of either of these groups. This was an even larger marsupial meat-eater, which the devil's midnight camouflage would have helped it avoid. However, humans had hunted thylacines to extinction by the 1930s.

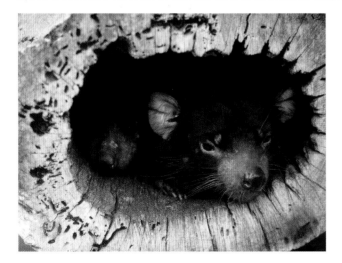

THREATS AND HOPES

Faced with dingoes and human disturbance, Tasmanian devils probably became extinct on the Australian mainland 3,000 years ago. In 1941, Tasmanian populations, declining due to human persecution, were protected by law and recovered. However, from the 1990s they have declined again due to a horrific form of transmissible facial cancer – devil facial tumour disease. In 2020, as part of a conservation programme, small groups of healthy devils were reintroduced to the Australian mainland, to a wildlife sanctuary near Barrington Tops National Park, New South Wales.

▶ As shadows lengthen, a young or joey devil prepares to forage for food.

◀ By day, devils snooze in dens among rocks, under roots or inside hollow logs.

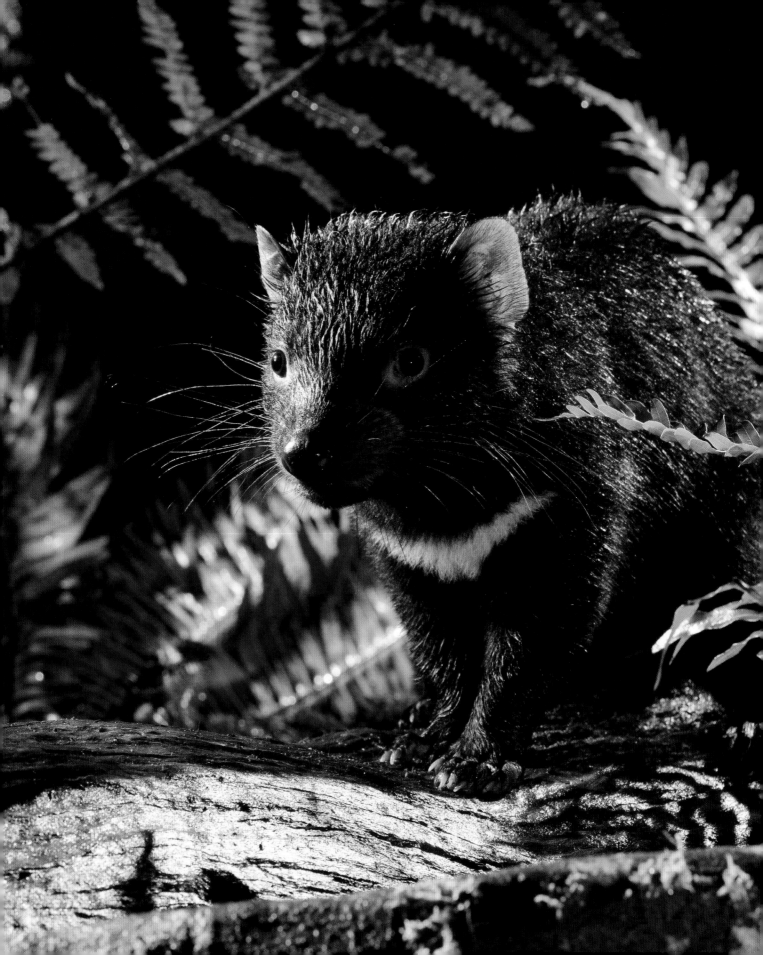

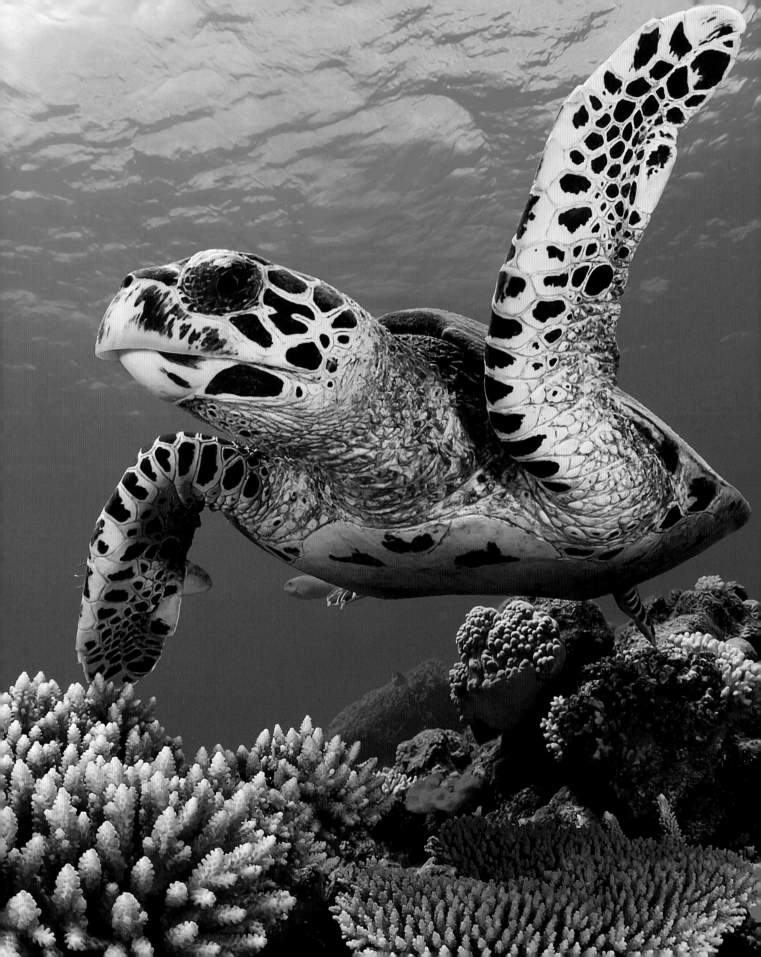

7

Seas and Oceans

Decorator crab

HIDING IN A LIVING CLOAK

Crabs are vastly successful animals. More than 6,500 kinds populate every marine environment, most coasts, many freshwater habitats and even the land. Their variety and adaptations are astonishing, and the majority have patterns and colours that merge into their background. However, the undisputed camouflage experts are decorator crabs. There are dozens of kinds, from several crab groups, but their skill is actively to cover or decorate themselves with items from their environment.

Most decorator crabs are fairly small and would fit easily within a human hand; some are less than thumb-sized. Their typical method is carefully to choose objects around them, which they loosen and pick up with their pincers, and place in a specific location on their 'back' – the part of their shell called the carapace. This has tiny curved bristles, setae, which work like our hook-and-loop fasteners (Velcro) to keep the objects in position.

CAREFUL SELECTION

Items chosen may include bits of rock, non-living coral, gravel and shell – and also small live organisms, such as seaweeds, sponges, sea anemones, sea fans, bryozoans (sea mats or moss animals), sea snails, barnacles, sea urchins and coral polyps (the small anemone-like creatures that build coral reefs). Some kinds of decorators have favourite items, such as sponges or sea anemones, while others gather a wider range. Certain decorator crabs adorn their legs and pincers in the same way. With their 'living cloak', they really do become part of the surroundings.

Being fairly small creatures, decorator camouflage offers an excellent disguise to avoid their many predators. As the crab crawls about, scavenging for any edible bits and pieces, it will suddenly freeze when a threatening fish, octopus, crab or lobster approaches, and become an indistinguishable part of the living seascape.

DISTRIBUTION MAP

● Graceful decorator crab
○ Seaweed decorator crab

- LOCAL COMMON NAMES
 Many descriptive names from decorative items chosen, such as Seaweed decorator crab, Moss crab, Sponge decorator crab, Sandy crab

- SCIENTIFIC NAMES
 Various groups, such as *Camposcia retusa* (Harlequin crab), *Loxorhynchus crispatus* (Masking crab), *Hoplophrys oatesii* (Soft coral decorator crab)

- SIZE
 Mostly main shell less than 5cm (2in) across, total legspan less than 12cm (4¾in); some are only pea-sized, larger species span 30cm (1ft)

- HABITATS
 Most marine environments, from upper shore rockpools to great depths

- DIET
 Generally pick and scavenge for anything edible

- CONSERVATION STATUS
 IUCN most Not evaluated (See key page 8)

TIME TO REDECORATE

Crabs increase in size by moulting or shedding their shells and growing while the new shell underneath is still soft and flexible, before it hardens. When decorator crabs do this, they become temporarily unornamented. However, as the new shell is hardening, they quickly gather their next set of decorations, often picking off and recycling items from their old shell.

▶ The corallimorph decorator crab (*Cyclocoeloma*) specializes in a coat of sea anemones. The latter's stings deter predators, which benefits the crab, while the anemones help themselves to edible bits and pieces as the crab messily consumes food. This reciprocal benefit for both partners is known as mutualism.

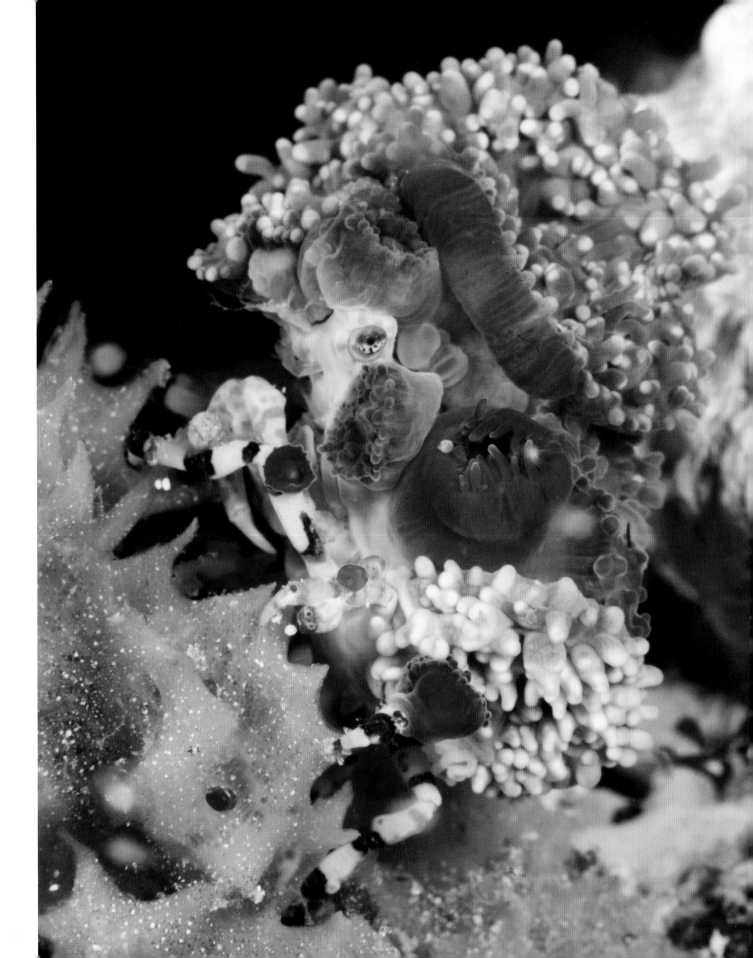

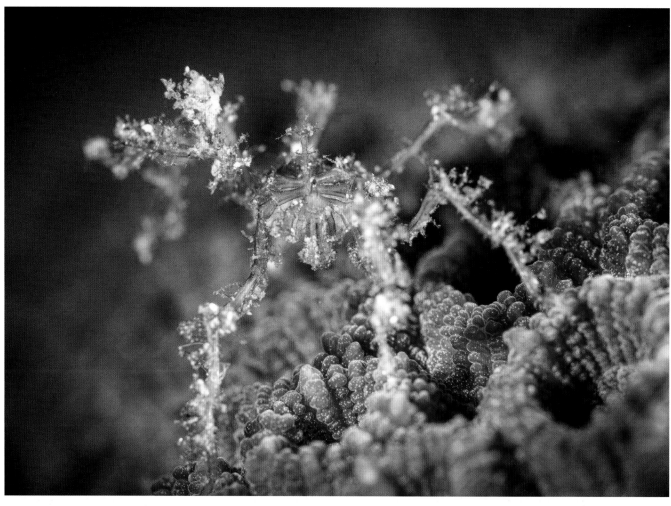

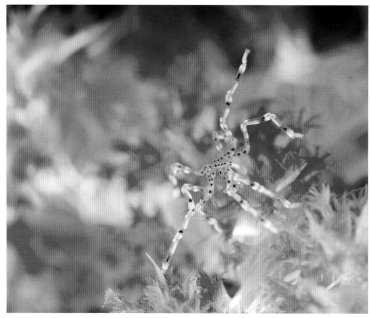

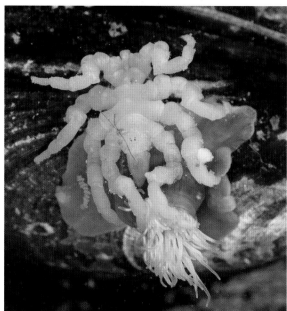

Sea spider

ALMOST ALL LEGS

Sea spiders, known scientifically as pycnogonids, are some of the most overlooked creatures in the sea – literally, because many have such marvellous camouflage, merging into the corals, or the rocks, pebbles, sand or mud of their particular habitat. Also, they somewhat miss out biologically. Compared to, for example, crabs, octopuses or sharks, the sea-spider group as a whole has not been studied in enormous detail. It is not even clear where sea spiders fit into the lists of animal categories and classifications. They are certainly not true spiders, but they do have similarities with the spider-and-scorpion group, arachnids. They are usually regarded as distant cousins of arachnids and horseshoe crabs, and even more distantly, insects.

MULTI-TASKING LEGS

Sea spiders are found in all the world's seas and oceans, and there are 1,400-plus kinds, or species. Like their land namesakes, they are predators of smaller creatures, and many have eight legs. However, the body is relatively tiny compared to the legs, or even practically non-existent. The legs have tasks other than walking, such as working as gills to take in oxygen from the water, and also digesting food in the pouch-like bags inside them, which are offshoots from the main stomach.

Sea spiders such as the ghost hedgpethia are small, pale, almost see-though and merge beautifully with the light-coloured corals around them. The yellow-kneed sea spider is vividly red with yellow bands around the leg joints, yet blends beautifully with equally colourful corals, sea squirts and sponges. The purple-kneed endeis has a similar pattern, while the shore sea spider sometimes hides in sea anemones of the same colour. Stearns' sea spider is another that resembles the sea anemones it hides among and feeds on – like spiders – by sucking up their body fluids.

DISTRIBUTION MAP

● Short-necked sea spider
● Stearns' sea spider

- LOCAL COMMON NAMES
 Yellow-kneed sea spider (*Pseudopallene harrisi*), Shore sea spider (*Pycnogonum litorale*), Southern sea spider (*Pentanymphon antarcticum*); many other kinds lack common names

- SCIENTIFIC NAME
 Members of the group Pycnogonida, meaning 'thick-kneed'

- SIZE
 Legspan from 1mm ($^{1}/_{32}$in) to more than 60cm (24in), mostly 0.5–5cm (¼in–2in)

- HABITATS
 All marine habitats, from shallow shore to deepest sea

- DIET
 Soft-bodied, fixed-down animals such as coral polyps, anemones, sponges, bryozoans (sea-mats), sea squirts

- CONSERVATION STATUS
 IUCN Not evaluated
 (See key page 8)

LEGS MORE OR LESS

Most sea spiders should have eight legs, but some have fewer. They can detach or self-amputate a leg, in the way that lizards lose their tails. Called autonomy, this usually occurs when grabbed by a predator. Depending on where the leg breaks, it may not regrow, or may regrow as one or, perhaps, two. Also, during early development a sea spider may undergo polymerization, meaning it gains one or more body segments (sections), complete with legs – twelve-legged individuals are not unknown.

◄ (Clockwise from top) A downy sea spider tiptoes across its coral polyp food, which is the same colour, a shore sea spider, about the size of a thumbnail, feasts on a yellow anemone, and a purple-kneed endeis is camouflaged on soft coral.

False cowrie

YOU ARE WHAT YOU EAT

False cowries are also called allied cowries. As these common names suggest, they are not actually true cowries. The latter are sea snails with what looks like a rounded, domed or elongated shell, rather than the typical snail-like, twisted one, and also one long, narrow, slit-like opening on the underside. False cowries are also sea snails, and cousins of true cowries, but differ in parts of their anatomy and shape. The false cowry family has the scientific name Ovulidae. There are probably more than 200 kinds, or species, although marine malacologists (experts on sea molluscs) debate the exact number. Most live on reefs and the rocky seabed in warmer seas.

PARASITIC LIFESTYLE

False cowries have an unusual lifestyle. They literally live on their food. They are regarded as obligate ectoparasites; that is, they live on only one kind of host organism, and they gain shelter and nourishment from it. For each cowrie species, the host is a particular kind of coral. The cowrie eats the small, anemone-like animals called polyps that build the whole coral colony. In particular, many false cowries consume the polyps of soft corals, including the kinds known as sea fans and gorgonian corals.

As the cowrie feeds, it takes the pigments and other substances of the polyps into its own body. It relocates the pigments into its mantle, which is the soft, muscular, colourful 'cloak' of flesh that envelops and covers the actual hard shell beneath (the shells of many species are plain white). Thus, the mantle precisely matches the coral colours around it. Also, the cowrie's overall shell shape physically replicates the main contours and branches of its coral colony host, while the mantle muscles can create mounds, ridges, puckers and projections to emulate the host's details even more precisely.

DISTRIBUTION MAP

● Spotted little egg cowrie

- LOCAL COMMON NAMES
Many local names according to shell shape, mantle colour, and host coral, such as Spindle cowrie, Soft coral false cowrie, Egg allied cowrie, Pearl cowrie

- SCIENTIFIC NAME
Family Ovulidae, many species such as *Pseudosimnia punctata* (Egg cowrie), *Diminovula punctata* (Spotted little egg cowrie), *D. culmen* (Ridged pearl or Egg cowrie), *Phenacovolva recurva* (Spindle cowrie), *Volva volva* (Shuttlecock cowrie)

- SIZE
Shell length mostly 1–10cm (⅜in–4in), some exceed 20cm (8in)

- HABITATS
Tropical and subtropical coral reefs

- DIET
Coral polyps

- CONSERVATION STATUS
IUCN most Not evaluated, although some have local protection against shell collectors
(See key page 8)

DEFINITELY NOT CAMOUFLAGE

Some false cowries adopt the opposite of camouflage. They advertise themselves with bright warning colours that stand out vividly from the coral background. This is because they take into their flesh noxious or toxic substances from their host, to which the cowrie is immune. Potential predators, such as fish and crabs, may try to eat this type of cowrie but soon learn about the horrible, even poisonous taste, and so they avoid other similar ones in the future. Warning coloration is common in nature and known as aposematism, 'go-away sign'.

▶ (Top) The ridged egg cowrie has transferred colour pigments from, and so is visually unified with, its food of red carnation coral (*Dendronephthya*). (Bottom) Sowerby's spindle cowrie has a much slimmer shell shape but is likewise camouflaged among tiny coral polyps with their star-like feeding arms.

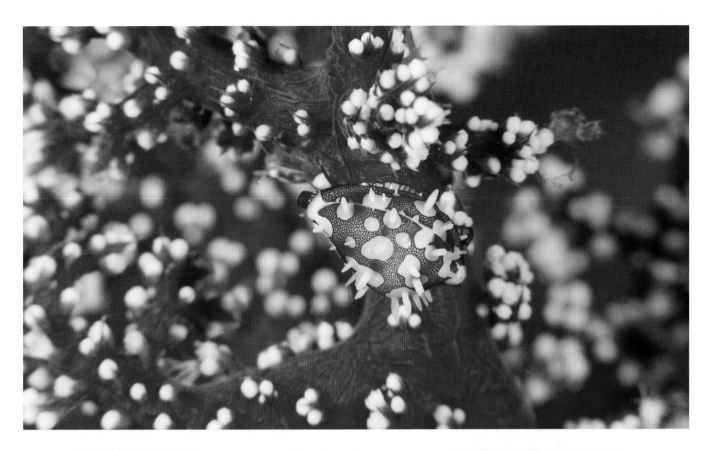

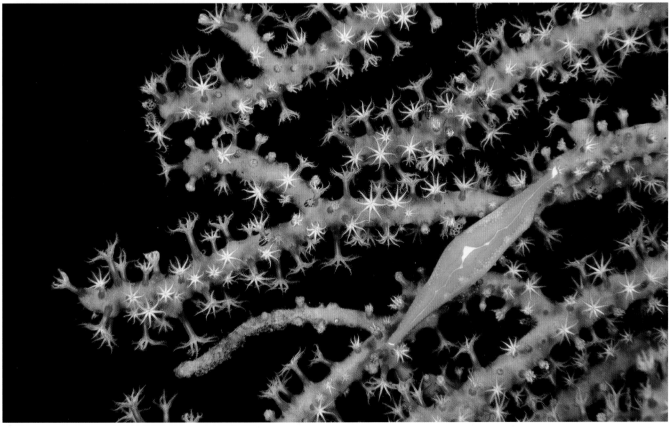

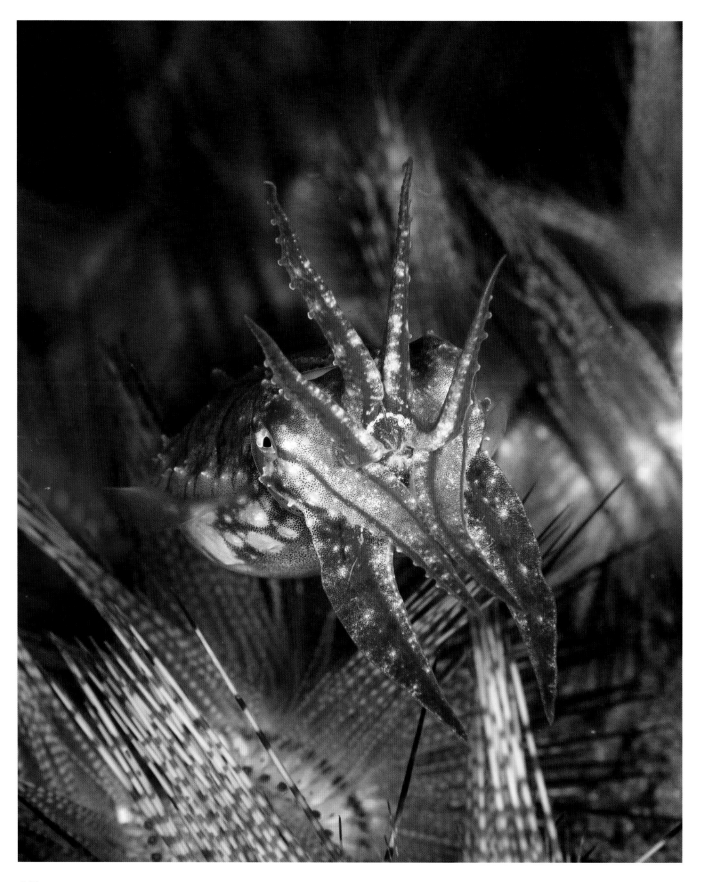

Broadclub cuttlefish

VIRTUOSO OF MASQUERADE

Cuttlefish are sometimes called 'chameleons of the sea', referring to the colour-change powers of both these marine molluscs and the land lizards. However, in both cases, colours have other purposes, often overriding camouflage. And compared to chameleons (see pages 114–115), cuttlefish are astonishingly rapid quick-change artists, altering their appearance several times in a few seconds.

Cuttlefish are predatory decapods, a name meaning '10 feet', with eight shorter arms and two long feeding tentacles. More than 100 kinds live in almost all the world's oceans. Common across tropical coral reefs in South East Asia and North Australia is the broadclub cuttlefish, named from the expanded, club-like ends of its two feeding tentacles. Like most cuttlefish, it is an expert not only at changing its hues and markings, but also modifying the texture of its skin, which it can spread out smoothly or pucker into raised mounds, circles or ridges.

CLOAKS OF MANY COLOURS

The broadclub has a wide repertoire of costumes. When young, small and more vulnerable, it blends in with the rocks and corals of its home. When adult, and a sizeable creature, the male flickers mid- to dark brown to defend his territory and attract a female. When hunting, the cuttlefish shows its true camouflage skills by impersonating almost any colour of sand, rocks, corals or weeds, to hide from and ambush passing prey – or avoid a predator such as a shark or dolphin. Or, approaching a victim, it flashes multicoloured stripes and bands along its body and arms, like a fast-moving video display. This is thought to 'hypnotize' the prey, momentarily delaying its escape, thereby allowing the broadclub to shoot out its two long feeding tentacles.

DISTRIBUTION MAP

- **LOCAL COMMON NAMES**
 Broadclub cuttle, Common reef cuttlefish; Milengoll (Palauan); Gemeiner (German); Sepia mazuda (Spanish); Seiche grandes mains (French)

- **SCIENTIFIC NAME**
 Sepia latimanus

- **SIZE**
 Mantle (main head–body) length 50cm (1ft 7in), length with tentacles extended 1m (3ft 3in), weight may exceed 7kg (15lb)

- **HABITATS**
 Tropical and subtropical coral reefs

- **DIET**
 Crabs, prawns, fish, worms, similar prey

- **CONSERVATION STATUS**
 IUCN Data deficient
 (See key page 8)

COLOUR CELLS

In each square millimetre of skin, the cuttlefish has 100 or more microscopic cells called chromatophores (see page 9). These cells harbour grains of different pigments. Responding to nerve messages, each cell can spread or clump its grains, while surrounding muscle fibres uncover, cover, stretch or squeeze the cell. Also, the chromatophores comprise a number of layers, and as light rays pass through them, the rays are reflected and refracted – split into their own constituent hues, like raindrops forming a rainbow. It is a sophisticated, virtually lightning-fast system.

◀ Nestling among the long and venomous spines of banded sea urchins, a broadclub cuttlefish splays and colours its arms to copy their shapes and also to expose its fierce, beak-like mouth as a show of defence.

Mimic octopus

SHAPE-SHIFTER SUPREME

The mimic octopus was only discovered by biologists in 1998 and awarded its official scientific name as recently as 2005, thereby indicating its elusive powers. Many animals include body shape in their camouflage, but it is relatively fixed apart from changing pose. However, this smallish predator, which, including its eight finger-slim arms, is hardly the total length of your arm, possesses astonishing flexibility. The ability is a hallmark of its mollusc group, which includes slugs, snails, cuttlefish and squid. It has virtually no hard body parts, apart from its parrot-like beak for crunching prey, and its dozens of muscle systems can squeeze, stretch and contort virtually every region of its physique.

QUICK-CHANGE COLOURS AND FORMS

While resting undisturbed, the mimic has a typical octopus shape and is light brown to beige, tinged with yellow or grey. But within a second it can assume the forms and patterns of an amazing number of animals and inanimate objects, including fish such as horrible-tasting flatfish, sea snakes, crabs, jellyfish, sponges, coral configurations and rocks. As in cuttlefish, and vertebrates such as reptiles and amphibians, colour change is achieved by groups of microscopic cells that contain tiny grains of pigments. The way the grains spread out or cluster into groups determines which colour light rays they reflect (see page 9).

Close observation shows the mimic octopus adopts mainly defensive camouflage. Depending on the threat, it may copy an inert feature on the seabed, or an enemy of the menacing animal, for example, a venomous sea snake or lionfish, or the mimic's deadly cousin, the blue-ringed octopus. It may also adopt aggressive camouflage, such as impersonating a crab innocently to approach another crab – and then attack.

DISTRIBUTION MAP

- LOCAL COMMON NAMES
 Miracle octopus; Imiter le poulpe (French); Meniru gurita (Indonesian); Polvo maravilha (Portuguese)

- SCIENTIFIC NAME
 Thaumoctopus mimicus

- SIZE
 Length 50–60cm (1ft 7in–2ft) including straight arms, weight 500g (1lb)

- HABITATS
 Shallow, sandy, tropical seas down to 40m (130ft)

- DIET
 Small creatures such as crabs, shrimps, prawns, fish

- CONSERVATION STATUS
 IUCN Least concern
 (See key page 8)

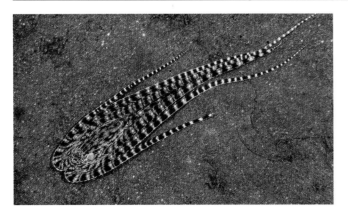

CLEVER AND WELL-ARMED

Ongoing research continues to expand the reputation of octopuses as intelligent creatures with admirable memory and the capability to learn fast and adapt quickly to novel settings. Using both innate and learned skills, the mimic octopus seems to choose the most suitable guise for each situation. For example, when encountering one of its predators, the damselfish, the mimic usually impersonates a sea snake, since damselfish are regularly hunted by sea snakes.

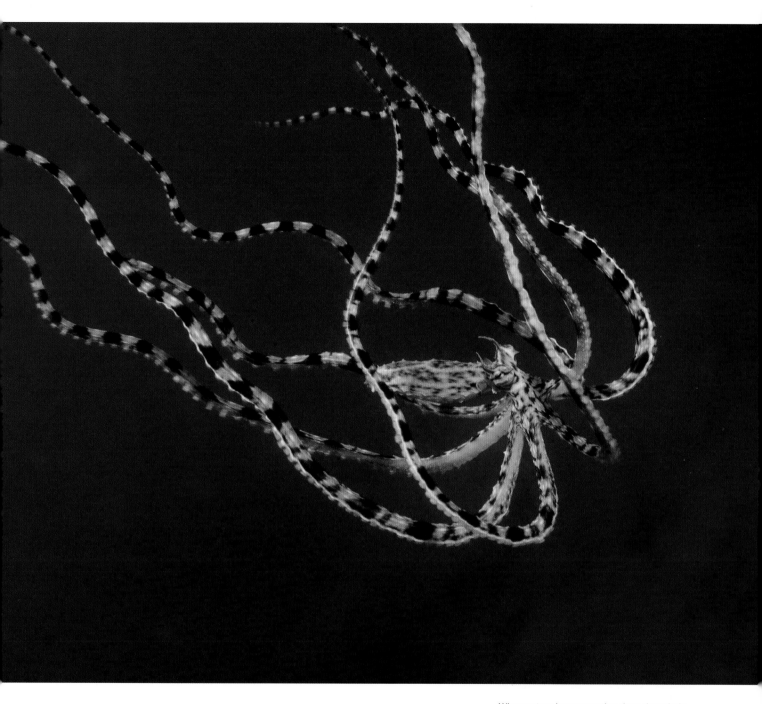

When not on impersonating duty, the mimic octopus looks much like other octopus species, albeit with a slimmer body, lengthy slender arms and variable stripes. But gliding across the sea floor, arms held tight to its body (opposite), the mimic greatly resembles a flatfish, such as a banded sole or striped flounder – which themselves are colour-change experts.

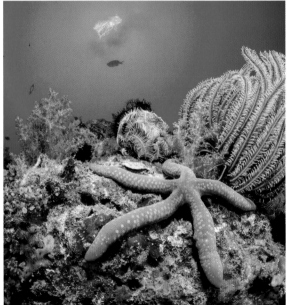

Reef starfish

SLOW AND SAFE

They have no proper brain, heart or ears, and not many have proper eyes. Few can swim, and they creep along only at snail's pace. Yet starfish, sea stars and sun stars, all known as asteroids, are hugely successful. More than 1,500 different kinds inhabit every sea and ocean, from frigid poles to sultry tropics, from shallow shores to the deepest of deep-sea trenches. Admittedly, they have defences, such as spines or spikes, tough hardened skin, and unpleasant-tasting or even toxic substances in their skin and flesh. But they still have many enemies – and they cannot swim or run away. Flatfish, sharks, rays and other fish, big crabs and lobsters, porpoises, dolphins, sizeable predatory sea snails like whelks, and also larger starfish and their cousins, sea urchins, all feed on them. This is why some starfish are highly camouflaged.

INTEGRATED INTO THE SEASCAPE

The spiny starfish of the East Atlantic Ocean and Mediterranean Sea lives mainly on temperate rocky reefs and also flatter, rubble strewn sea floors. On a plain background, the rows of pale spines along its arms show up against its skin colour, which varies from brown to green to grey, sometimes with tinges of red, orange or yellow. However, in among stones, seaweeds, shellfish and other random, jumbled, seabed fragments, it is remarkably difficult to pick out.

On brightly lit tropical coral reefs, starfish that camouflage need to be brightly coloured too. The linckia blue starfish has an intense blue hue, appearing almost backlit, that varies among individuals from sky- to midnight-blue. It is popular in aquaria, where it often stands out almost as if glowing. Yet in its natural reef habitat, it merges with other equally colourful inhabitants, many of these blue too, such as corals, fish, crabs and shrimps.

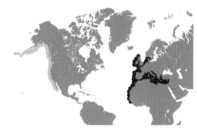

DISTRIBUTION MAP

● Spiny starfish
● Sunflower sea star

- **LOCAL COMMON NAMES**
 Sea star, Sun star, Cushion star; many regional names according to location, colour and habits, such as Firebrick starfish (*Asterodiscides truncatus*), Common sun star (*Crossaster papposus*), Mediterranean red starfish (*Echinaster sepositus*)

- **SCIENTIFIC NAME**
 Camouflaged species include *Marthasterias glacialis* (Spiny starfish), *Echinaster callosus* (Warty sea star)

- **SIZE**
 Spiny starfish may exceed 50cm (1ft 7in) across including arms, weight up to 2kg (4lb 6oz)

- **HABITATS**
 Various species occupy all marine habitats from coral reefs and sandy shallows to abyssal trenches

- **DIET**
 Most are predators, with food ranging from sponges, tiny coral polyps and worms to sizeable shellfish such as mussels, clams, whelks; some eat algae or scavenge for anything edible

- **CONSERVATION STATUS**
 IUCN most Not evaluated, however the Sunflower sea star (*Pycnopodia helianthoides*) of North America's Pacific coasts is Critically endangered (See key page 8)

'CIRCULAR' CREATURES

Starfish and other echinoderms – brittlestars, sea lilies, sea urchins and sea cucumbers – are among the few main animal groups with a radial or 'circular' body plan. Most starfish have five arms or a multiple of five, but this is by no means a rule. These animals are famed for being able to regrow or regenerate arms lost to predators, rolling sea boulders and other dangers. Depending on where the break occurs, they may grow two or three arms where previously there was only one.

◄ (Clockwise from top) A warty sea star crawls slowly across a similar-hued coral mound, a linckia blue starfish navigates past a Bennett's featherstar or crinoid on a tropical coral reef, the spiny starfish is both self-protected and concealed among scroll or ear sponges.

Salp

INVISIBLE (ALMOST) OCEAN WANDERERS

Perhaps one of the purest forms of blending in with the surroundings is literally to be unseen; that is, transparent. Few creatures do this as comprehensively as salps. They are jelly-like relations, not of jellyfish, but of the barrel- or vase-shaped, leathery-bodied, fixed-down, sea and shore animals known as sea-squirts. Salps belong to the same group, tunicates, but apart from their hollow, barrel- or tube-shaped bodies, they are very different.

Salps are virtually colourless and see-through, or nearly so, and soft and squishy. They pass sea water though their body and filter it with a mesh-like strainer for tiny particles of planktonic food. Up to fifty different kinds, or species, of salps are spread across all oceans at various depths. They are amazingly common yet seldom noticed, floating along passively, or swishing themselves actively with a pulsating, jetting, squirting motion.

NECKLACES AND FANS

As individuals, most salps range from the size of a baked bean to a can of beans. But part of their life cycle is a colonial or aggregate phase. Dozens, even hundreds, of them form one long, almost crystal-clear, necklace-like chain, or loop, or fan-like branching shape. These colonies, sometimes called 'giant sea-worms', may extend more than 20 metres (65 feet) through the water. The only parts visible inside each salp are usually food concentrated in its orange-brown stomach, the gonads (sex organs), or offspring salps forming like buds within the parent salp's body. Their cloak of invisibility hides them from predators, such as fish, sea turtles, seabirds including penguins and albatrosses, seals and whales. However, these animals do not often target salps, which are 95 per cent water and so have little nutritional value.

DISTRIBUTION MAP

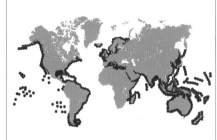

● Giant salp

- LOCAL COMMON NAMES
 Many regional names according to size and habits, such as Common salp (*Salpa fusiformis*), Big or Giant salp (*S. maxima*), Southern Ocean or Thompson's salp (*S. thompsoni*), Twin-sail salp (*Thetys vagina*), Pointed salp (*Ihlea punctata*)

- SCIENTIFIC NAME
 Group name Salpida; genera (species groups) include *Salpa, Thalia, Pegea, Thetys, Ihlea, Soestia*

- SIZE
 Most species in the height range 0.6–35cm (¼in–1ft 2in)

- HABITATS
 All oceans

- DIET
 Tiny food particles of the plankton

- CONSERVATION STATUS
 IUCN Not evaluated
 (See key page 8)

LIFE CYCLE

Salps have a two-part life cycle. The solitary phase is an individual scientifically called an oozooid. By itself, with no need for mating (asexual reproduction), it forms and releases chains of small offspring. These grow as the aggregate phase, called blastozooids. As it grows, each is first a female, then it matures into a male. With different ages in the aggregation, a male releases his sperm into the water, and this may fertilize the egg in a nearby female (sexual reproduction). The egg grows and is released as a solitary oozooid. And so on.

▶ A colony of spiral or pegea salps (*Pegea confoederata*).

◀ Usually the only conspicuous part of a salp, here *Salpa*, is the yellow, orange, red or brown, ball- or egg-shaped digestive organ called the visceral nucleus – the salp's version of our stomach and intestines.

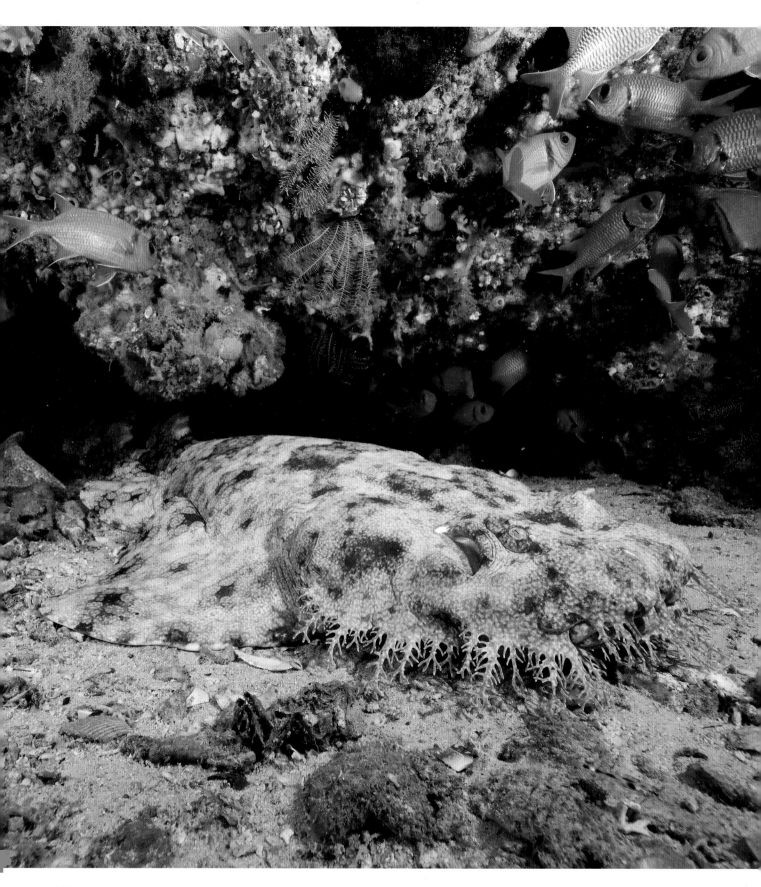

Tasselled wobbegong

BEARDIE OF THE SHARK FAMILY

The tasselled 'wobby' belongs to the twelve-strong group of sharks known as carpet sharks or orectolobids. Not quite as flat as a carpet, it is certainly compressed from top to underside, and consequently wide from side to side. It also has tassels or tufted fringes, mainly around the mouth and front body, as far as the pectoral (front side) fins. These fins are also flat and broad, as are the middle body, the pelvic (rear side) fins, and the low-set tail with its two dorsal (back) fins, which are set well to the rear compared to most fish.

SEABED FLAPJACK

This flapjack-like form is ideal for lying on the seabed, where the elaborate tassels further obscure or disrupt the usual shark-shaped front end. Allied to its build is the wobby's ornate yet subdued coloration. It is a complex miscellany of dots, spots, rosettes and backgrounds, in various browns, greys, yellows, creams and other muted hues, almost like mosaic tiles. On some individuals these patches are arranged into low-key bands, zigzags and other semi-geometric shapes. Some individuals are overall much lighter, almost milky, while others are darker and ruddy.

The tasselled wobby thoroughly corresponds to its habitats of coral and rocky reefs interspersed with areas of sand, silt, mud, gravels and pebbles. Here it lies by day, often curled in a cave or beneath an overhang. But it is ready any time to lurch with surprising rapidity at a small fish, crab, sea snake, seabird or similar, which happens to approach, unaware of the wobby's voluminous mouth. As darkness arrives this shark hunts more actively, although it then becomes a target for even larger sharks, groupers, saltwater crocodiles and other sizeable reef predators.

DISTRIBUTION MAP

- LOCAL COMMON NAMES
 Bearded wobbegong ('wobbegong' is probably an Australian Aboriginal term meaning 'bushy beard'), Ogilvy's wobbegong; Iga tao (Solomon Island dialect); Requin-tapis barbu (French); Tapicero barbudo (Spanish)

- SCIENTIFIC NAME
 Eucrossorhinus dasypogon

- SIZE
 Length up to 2m (6ft 6in) (unsubstantiated reports claim over 3m/9ft 10in), weight 40–80kg (88lb 2oz–176lb 5oz)

- HABITATS
 Reefs, lagoons, shallow coastal shelving, rarely found deeper than 50m (164ft)

- DIET
 Fish, shellfish, crabs, octopuses and similar prey

- CONSERVATION STATUS
 IUCN Least concern
 (See key page 8)

HOW SHARKS BREATHE

A common myth tells how, if a shark ceases swimming, it dies. It no longer has a flow of oxygen-containing water over its gills – in other words, it cannot breathe and so suffocates. For many active and regularly swimming sharks, this is partly true. But others, like wobbegongs, spend hours motionless on the ocean floor. Actually, they are not quite motionless. To breathe underwater, they have buccal pumping. Their head, throat and neck muscles regularly work to draw water through the mouth – and in wobbies, through an opening, the spiracle, behind each eye – and then over the gills, and out.

◄ This tasselled wobby is hardly evident on a sandy sea floor strewn with shells, bits of coral, sponges, seaweeds and other reef fragments. The wide, flat, right pectoral fin is visible where the tassel-disguised mouth and head end.

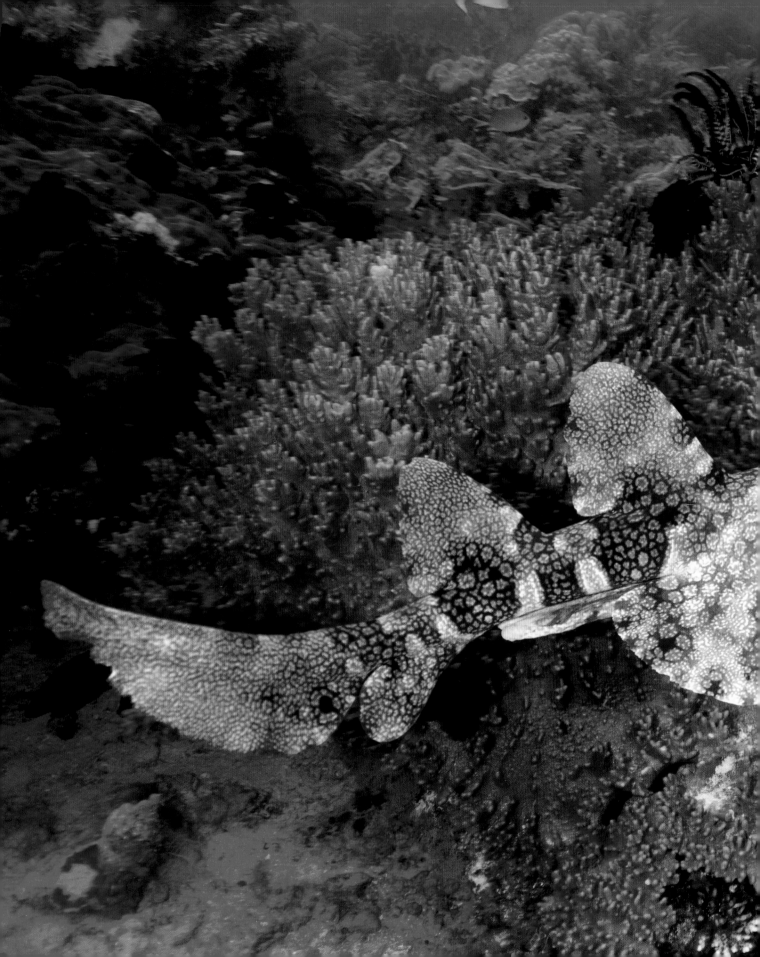

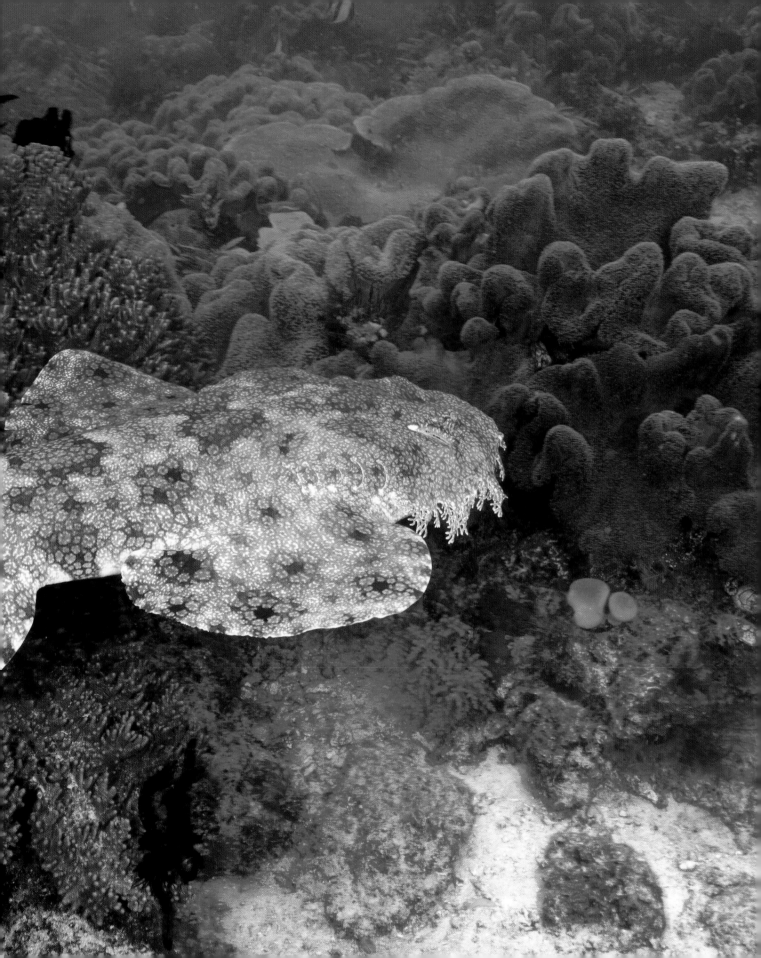

Peacock flounder

SECRETED ON THE SEABED

There are more than 800 kinds of flatfish, distributed around most of the world's oceans. As a group, they are acknowledged colour-change experts. They cruise pancake-like along the seabed, lying not on their belly but on one side (their left or right), and actively changing their colours and patterns as they go to blend into the immediate surroundings. In this way they elude the gaze of small prey, which they suddenly grab. They also evade visual detection by predators, from prowling sharks to octopuses and dolphins.

The peacock flounder is one of the most impressive and most-studied specialists at colour change. Smoothly skimming along from one kind of substrate to another, it can look like speckly sand, splodges of pebbles and rocks, seaweed wafting over rocks, or a coral collection, all within seconds.

GLIDING AND CHANGING

The peacock flounder lies on its right, so its upper surface is its left side. The default colour here is some shade of brown grading into grey, with blue circles, spots and splotches mainly around its edges, these being the head, fins and tail. But its body colour and pattern adjust as it moves along. The changes are initiated by the flounder's eyes. They detect the shades of the immediate environment, then nerve and hormonal messages are sent to the fish's skin. There, each microscopic pigment cell either gathers together its pigment grains into a clump so they have little visual effect to an onlooker, or spreads out the grains to reflect light and make a coherent tone. However, if the camouflage fails, the flounder frenziedly flaps away, stirring up the seabed to cloud its flight.

DISTRIBUTION MAP

● Atlantic peacock flounder

- **LOCAL COMMON NAMES**
 Plate fish, Sole fish, Flowery flounder; Arreves, Eslanguao pancho, Eslanguao redondo, Lenguado (Spanish); Linguado ocelado, Solha (Portuguese); Rambou lune (French)

- **SCIENTIFIC NAME**
 Bothus lunatus (Atlantic species, see opposite), *B. mancus* (Indo-Pacific species, see below left)

- **SIZE**
 Length 30–45cm (1ft–1ft 5in), weight 1–3kg (2lb 3oz–6lb 9oz)

- **HABITATS**
 Shallow to medium depth on seabeds ranging from sandy or gravelly to weedy mangroves, rocks and reefs

- **DIET**
 Small worms, shellfish, fish

- **CONSERVATION STATUS**
 IUCN Least concern (See key page 8)

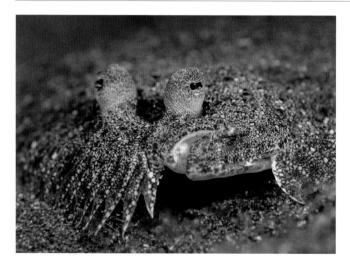

FLAT ON THEIR SIDE

'Flat' fish, like angel sharks, are compressed from top to bottom and swim in the normal way, upright. 'Flatfish' are a specific group, pleuronectiforms, and lie on their sides. These fish hatch with an eye on each side of the head, as normal, but early in their development, one eye moves or migrates around the head to the other, which becomes the upper side. For peacock flounders this is the left side. Halibuts are also flounders and the largest flatfish – 3 metres (over 9 feet) long and 200-plus kilograms (440 pounds) – but they are 'right-eyed'.

▶ Frilled or pleated fins add to the difficulty of defining where the peacock flounder ends and the visible seabed begins.

◀ A skewed mouth reveals how the flounder lies on its right side, the right eye having migrated around the head close to its left counterpart.

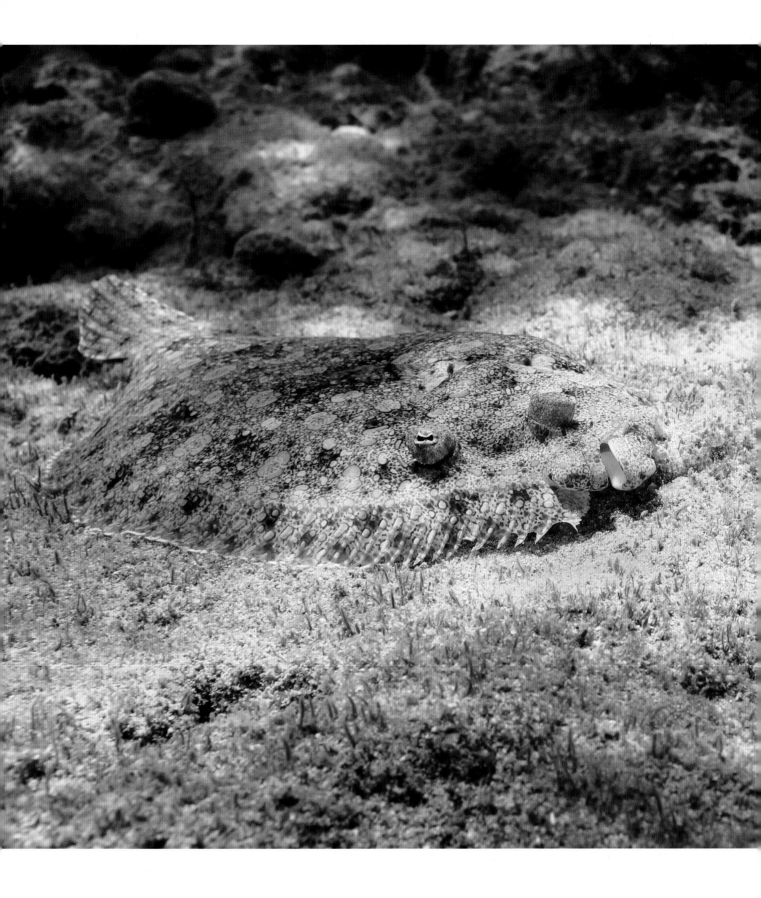

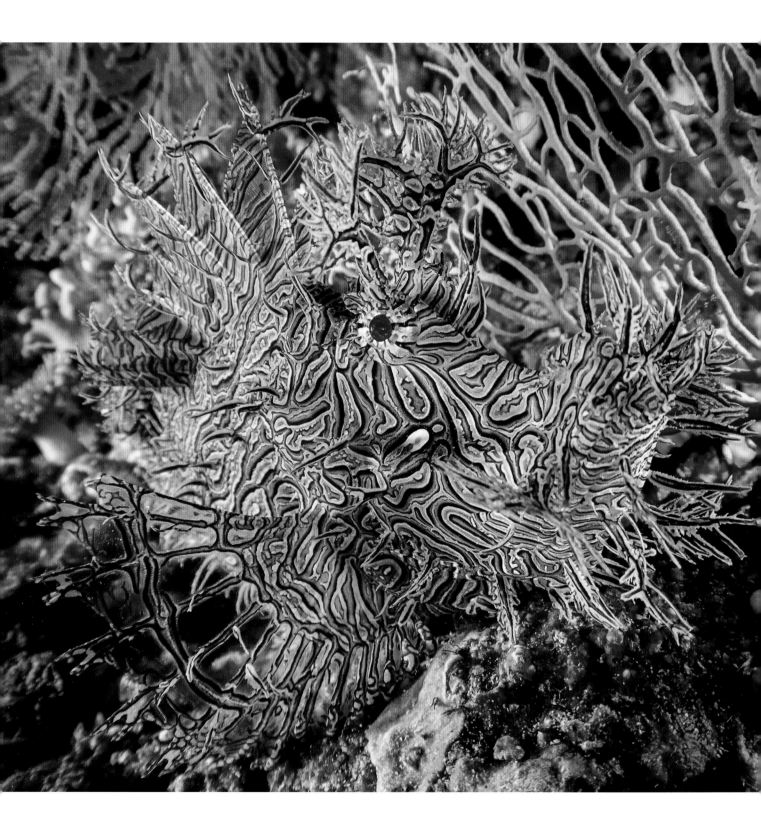

Lacy scorpionfish

A DANGEROUS ADVERSARY

Also known as Merlet's scorpionfish, the 'lacy' is an extraordinary creature in many ways. It belongs to one of the most dangerous fish groups that includes variously named scorpionfish, lionfish, firefish and stingfish, referencing the powerful venom that can be stabbed into an enemy by the spines of the fins on the back (dorsal) and lower rear (pelvic and anal). Some scorpionfish are incredibly well camouflaged, like the stonefish (see pages 222–223). Others are vividly coloured to stand out from their surroundings as a forewarning that possible predators should not mess with them. If a predator such as a shark or ray does try, it usually suffers greatly from the venom and so learns to avoid similar warning colours in future.

BLEND IN, STAND OUT

The lacy scorpionfish can adopt both these strategies: blend in and stand out. Individuals are found in various colour forms, although the general pattern and distribution of the particular colours is very similar between individuals. This pattern is a background colour with curving darker or black lines that surround elongated, rounded 'islands' filled in with a darker or perhaps lighter shade of the background hue. Colours vary among individuals from pale green, yellow or pink through to dark olive, grey and brown.

However, the fish's colour plan is massively confused by the profusion of lacy, spiny fins, and various fleshy flaps and tree-like branching extensions over the body, eyes and mouth that hugely bewilder the overall fishy shape. Against a matching seascape of weedy boulders, vibrant corals, gaudy sea fans and sea lilies, glowing anemones and other bright hues, the lacy scorpionfish may be either excellently camouflaged – or the opposite, advertising its warning colours and venomous capabilities.

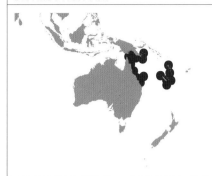

DISTRIBUTION MAP

- LOCAL COMMON NAMES
 Weedy scorpionfish (although this name is often used for closely related species)

- SCIENTIFIC NAME
 Rhinopias aphanes

- SIZE
 Length up to 25cm (10in), weight 2–4kg (4lb 6oz–8lb 13oz)

- HABITATS
 Tropical and subtropical reefs, lagoons, rocks, shallow coasts, rarely deeper than 30m (98ft)

- DIET
 Small prey such as fish, shrimps, crabs

- CONSERVATION STATUS
 IUCN Least concern
 (See key page 8)

◀ Its standard fishy shape so modified as to be virtually unrecognizable – especially by the prominent, upturned, snout-shaped mouth – a lacy scorpionfish drifts past corals and other reef inhabitants.

WALKING AWAY

The scorpionfish's tubby shape, upturned mouth, protruding eyes and enormously complicated, lacy fins do not lend it great speed or athleticism. Usually the fish rests on the reef or seabed at night waiting for prey to come near. It then lunges at them and rapidly opens its relatively large mouth to draw them in. If threatened, the scorpionfish tends to use its fins like 'limbs' to clamber, waddle, hop or bounce away.

Stonefish

THE DEADLIEST 'ROCK' IN THE SEA

There are several kinds of stonefish: estuarine, reef, Red Sea and midget (pygmy). Each kind is known in its local region simply as 'the' stonefish. And it is certainly known by people. Stonefish have the reputation of being the world's deadliest fish. Their venom is jabbed in by the stiff spines of the dorsal fin on the fish's back. For humans, this usually occurs when a stonefish is trodden on or brushed against – its camouflage is so effective, it is often unobserved even by the most experienced divers, swimmers and beachcombers. Depending on the amount and injection depth of the venom, the outcome varies from a sharp, lasting, forceful sting, to intense and excruciating pain that lasts for days, and without medical treatment, perhaps leads to death.

As their name suggests, stonefish look like stones. As members of the scorpionfish group (see pages 220–221) they have a large head and upturned mouth, a stout, rounded body, sharp spines in their expansive fins, and knobbly skin with fleshy lumps and bumps. Their habit is to lie on the seabed, choosing a location where they can rely on exquisite camouflage to be overlooked by their predators such as big sharks, rays and octopuses, and also by passing potential meals of small fish, crabs and similar.

The estuarine stonefish tends to be a motley, blotchy, banded assortment of muddy reds, browns and greys, perhaps highlighted with creams or whites, exactly like the rocks around, and even with growths of hair-like or encrusting algae (weeds), again like the rocks. The slightly smaller reef stonefish has brighter patches in hues of red, orange, yellow, pink, even scarlet, suited to the brighter background of its coral reef home.

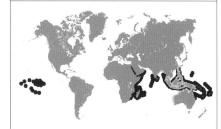

DISTRIBUTION MAP

● Reef stonefish
◯ Estuarine stonefish

- LOCAL COMMON NAMES
 Usually simply called 'Stonefish', including species such as Reef stonefish, Estuarine stonefish; Nofu, No'u (Polynesian dialects); Dornan (Australian Bboriginal)

- SCIENTIFIC NAMES
 Synanceia horrida (Estuarine stonefish), *S. verrucosa* (Reef stonefish)

- SIZE
 Length 20–55cm (8in–21in), weight 1–2.5kg (2lb 3oz–5lb 8oz), depending on species

- HABITATS
 Estuaries, bays, shores, reefs, rocky and rubble areas, depending on species; rarely below 30m (98ft)

- DIET
 Small animals such as fish, shrimps, crabs

- CONSERVATION STATUS
 IUCN Least concern
 (See key page 8)

STINGER ON THE SHORE

Stonefish live in shallow waters and rarely venture deeper than 30 metres (98 feet). They may dwell in the shallowest pools of stones or weeds, and also use their large pectoral (side) fins to flick or scoop sand and mud over themselves. This is why people walking along shorelines in the areas where stonefish are found are always advised to wear stout reef or similar shoes.

▶ Covered by algal and shelly growths, its face peeking out from a coral nook, the stonefish reveals its beady eyes and upturned mouth. These are designed to see and grab prey passing above when the fish is on the seabed.

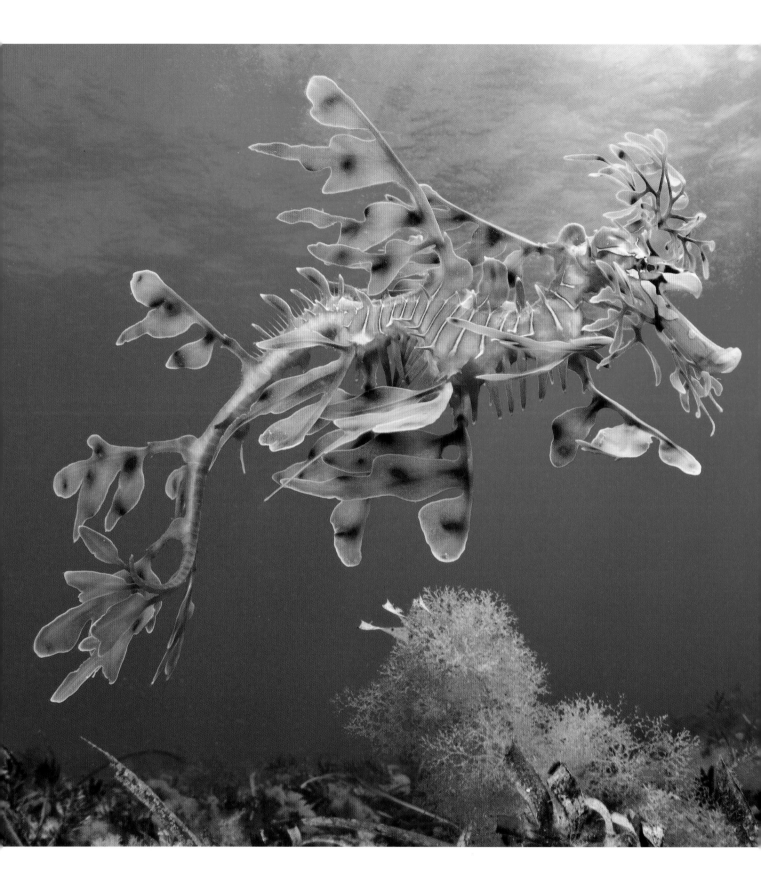

Leafy seadragon

A FROND OF ANIMATED SEAWEED

One of the natural world's most spectacular cases of camouflage is the leafy seadragon of Australia's south-west and south coastal waters. Its shape, appendages, coloration, behaviour and lifestyle are almost totally devoted to being visually part of its background. The seadragon is named after its head's resemblance to our mythical fire-breathing dragon representations. Its main body is relatively stiff and tough, with hoop- or rib-like bony reinforcement and sharp spines. In complete contrast are its appendages, which are amazingly thin and almost transparent, in shades from light green-yellow, through darker green or olive to light and mid-brown. They emanate from all body areas, including the head. As they waft and undulate in the slightest current, they are shaped and coloured to match exactly the waving fronds of seaweeds and other plants around.

TUBE-MOUTH

The 'leafy' is a member of the seahorse and pipefish family. Unlike typical seahorses, but like other seadragons, it lacks a prehensile tail to twirl around objects to keep itself steady. Rather it simply floats in clumps of real seaweed, or 'rows' with the small fins on either side of its cheek–neck area.

The long, horse-like snout with an expanded tip is unlike a typical fish. The toothless upper and lower jaws are actually joined or fused along their length to form a tube with a small upward-slanting hole for the mouth. (The family name Syngnathidae means 'jaws together'.) So, the leafy cannot bite or chew, yet it is a carnivore of sorts. It feeds by darting its head forwards or sideways in a bird-like pecking motion, or using its suction powers to take in tiny sea creatures known as plankton, most just a millimetre or so in size.

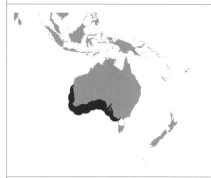

DISTRIBUTION MAP

- **LOCAL COMMON NAMES**
 Weedy seadragon, Leafy seahorse, 'Leafy/Leafie', Glauert's seadragon

- **SCIENTIFIC NAME**
 Phycodurus eques

- **SIZE**
 Length 20–25cm (8–10in), rarely more than 30cm (12in), weight 30–60g (1–2oz)

- **HABITATS**
 Kelp beds, seagrass meadows, sponge gardens, similar seaweed-rich rocky and sandy reefs and coasts, rarely below 40m (130ft)

- **DIET**
 Tiny sea creatures, especially fish larvae, crustaceans such as sea lice and shrimps, general planktonic creatures

- **CONSERVATION STATUS**
 IUCN Least concern, although legally protected in its native range (See key page 8)

DRAGONS IN PERIL

The leafy seadragon is the marine emblem of the state of South Australia. Like many bizarre, extra-glamorous creatures, it has suffered from collection for the live aquarium trade, as a source of so-called but utterly ineffectual 'traditional medicines', and for the wretched business of selling preserved and dried curios and exotica from nature. It is now fully protected by law in Western Australia, South Australia and Victoria.

◄ Drifting slowly above weedy reefs, with limited swimming powers, the leafy seadragon only has to sink slightly to join the seaweed scenery. This fish also has a limited ability to change colour and pattern over days and weeks, according to its local environment.

Camouflage grouper

THE 'COD' THAT ISN'T

Up to a metre (over 3 feet) in length, the camouflage grouper is exactly what its name suggests. It has a predominantly cream or pale brown background, with random mid brown smudges or blotches on the body, and many smaller dark brown spots all over, including the fins. It is an ideal appearance for merging into the coral reefs, seaweeds and rocky sea floors of the Indian and Pacific Oceans, with a wide range from the Red Sea to the Eastern Pacific.

No two individual camouflage groupers are the same. The browns may be tinged with grey or olive; the spots may be relatively large and spaced out, or much smaller and more numerous; the smudges may merge into larger patches, especially on the lower body; some fish are more than 50 per cent pale background, while others are less than 20 per cent; also, some individuals have more organized arrangements of smudges and spots giving the impression of vague diagonal or zigzag lines.

CRUISING THE REEF

The camouflage grouper has a raft of common names. Among the more frequent are blue-tailed cod and marbled rock-cod. However, although it has a passing resemblance to cod, especially at the front end, it is a member of the grouper and bass family, the serranids. In general, groupers – sometimes spelled 'gropers' – are stout-bodied, sturdy, strong, wide-mouthed predators that can reach great age, more than fifty years. When not cruising reefs to grab victims, the camouflage grouper tends to hide in crevices and caves and among coral formations. It specializes in crab dinners but will take any creatures that fit into its broad jaws and capacious mouth.

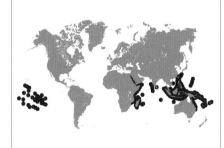

DISTRIBUTION MAP

- **LOCAL COMMON NAMES**
 Marbled grouper, Camouflage cod, Camouflage rock-cod, Small-toothed cod, Snout-spot grouper; Kerapu (Malay); Kulapo, Lapu-lapu (Philippines dialects); Okke (Indonesian dialect); Loche marbrée (French Polynesian)

- **SCIENTIFIC NAME**
 Epinephelus polyphekadion

- **SIZE**
 Length up to 1m (3ft 3in), weight 20–30kg (44lb–66lb 2oz)

- **HABITATS**
 Warm lagoons, coral and rocky reefs, especially around islands, and with caves and large crevices, rarely deeper than 50m (164ft)

- **DIET**
 Crabs and other crustaceans, sea snails, small octopus and cuttlefish, fish

- **CONSERVATION STATUS**
 IUCN Vulnerable
 (See key page 8)

A GIANT FAMILY

The grouper family includes some of the biggest and weightiest of all bony fish (that is, excluding sharks and rays). The Queensland giant grouper may exceed 2.5 metres (over 8 feet) and 300 kilograms (661 pounds). In some regions, groupers are valuable food fish, caught with spears and lines. Their habits of gathering to breed in traditional spawning areas at regular times of year make them easy targets and many species suffer from overfishing.

▶ Biding its time, a stationary, rock-resembling camouflage grouper eyes a shoal of silversides passing above. At any moment it may charge upwards with savage speed and ferocious power.

◀ Each grouper has a number of favourite lairs among its local coral formations, where it can rest yet scrutinize events in the vicinity.

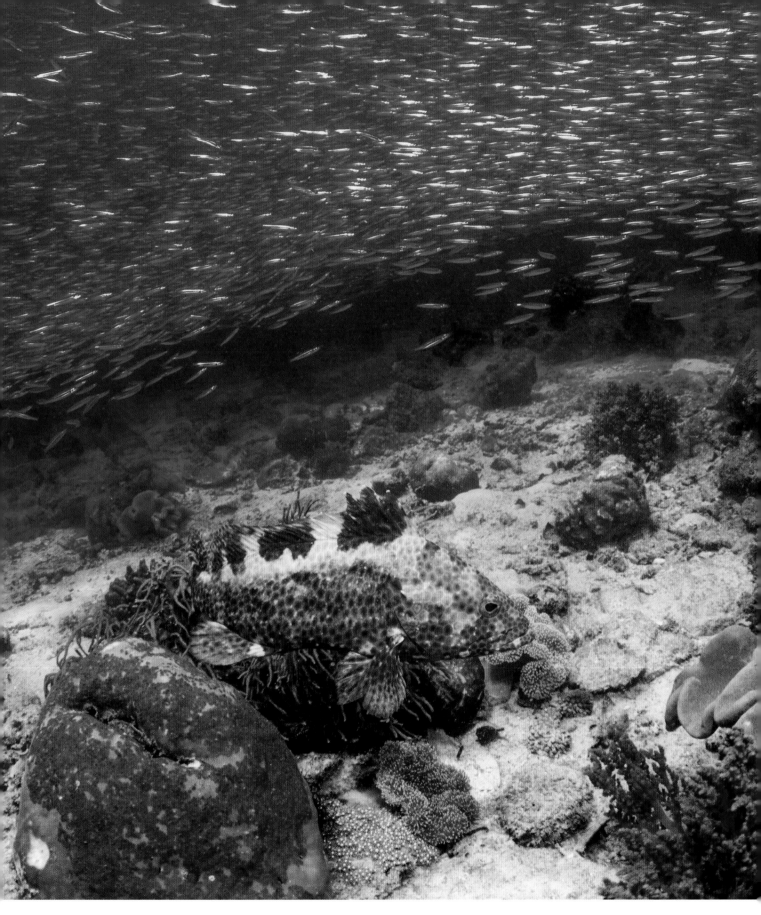

Harlequin filefish

CAN YOU SEE ME – OR SMELL ME?

The harlequin or orange-spotted filefish has the distinction of being the first vertebrate (animal with a backbone) that biologists discovered using olfactory camouflage linked to its food. That is, it matches its edible background – not only visually, but also by smell. The background for this fish is the bright colours of a coral reef. More specifically, the corals are acroporans, which are major builders of rocky reefs. They are a group of more than 200 kinds of stony corals that form shapes variously known as staghorn, elkhorn, antler and table corals.

CHEMICAL CAMOUFLAGE

The harlequin filefish's bright colours include orange-red spots on an electric blue-green background, an orange, beak-like mouth and facial stripes, and a tail with one dark spot near the rear. This appearance blends into some types of coral setting, but not others. However, as the filefish nibbles polyps as its food, it takes in certain chemical substances from them, incorporates them into its body, and releases them to diffuse or spread into the surrounding water. Many fish sense their surroundings by detecting waterborne bodily chemicals more readily than by vision, which is often limited in cloudy or muddy conditions. The chemicals are like a combination of our smell and taste and convey huge amounts of information.

Experiments showed that predators such as cod tended to ignore the filefish even if it was visually obvious (to our eyes, that is), because its cloak of waterborne coral scent masked its presence among the corals around it giving off the same scent. If the filefish was placed on a different coral to the one it had just eaten, its odour was different to the surroundings, and the cod soon sniffed it out.

- LOCAL COMMON NAMES
Orange-spotted filefish, Longnose filefish, Beaked leatherjacket; Sagoksok, Pakol, Panitan (Philippines dialects); Barat-barat, Jagungan (Malay); Muraka rondu (Maldivian)

- SCIENTIFIC NAME
Oxymonacanthus longirostris

- SIZE
Length 8–12cm (3¼–4¾in), weight 30–60g (1–2oz)

- HABITATS
Coral reefs and lagoons, rarely found deeper than 30m (98ft)

- DIET
Acropora coral polyps

- CONSERVATION STATUS
IUCN Least concern (See key page 8)

MORE SMELL DISGUISES

Olfactory camouflage or chemical crypsis has been known for some time among invertebrates (animals without backbones), especially insects. The giant geometer moth caterpillar looks like a broken twig and also smells like one, due to eating leaves of its food tree, to avoid predatory ants. A kind of eelgrass limpet does the same, absorbing and emitting scents from its plant food to mask itself from hungry crabs, sea snails, cuttlefish, octopuses and fish.

◄ Orientated parallel to their setting of coral fingers with edible polyp animals, harlequin filefish achieve a reasonable degree of visual camouflage. Added to this is olfactory concealment by emitting the same odours as their polyp food.

Hawksbill

WELL PROTECTED, BUT NEEDING PROTECTION

There are only seven kinds, or species, of marine or sea turtles. They are heavily protected by wildlife regulations in most parts of the world. Even so, their populations continue to be tremendously threatened and their numbers are still decreasing at alarming rates.

Hawksbills are found in all temperate and warm oceans. When fully grown they are big, powerful reptiles, protected by their strong shells and thick, scaly skin. Yet they still have predators such as sharks, groupers and other big carnivorous fish, saltwater crocodiles and large octopuses. And when newly hatched from the beach, with shells as small as a human thumbnail, their enemies are legion, from crabs and cuttlefish to various fish, lizards and snakes, gulls and other shorebirds, and rats, foxes and racoons.

PART OF THE REEF

A turtle's shell has two main layers. One is made of flattened, fused bones of the skeleton. Overlying this is the visible layer of plate-like scutes, composed of keratin, the hard, horny substance that forms scales, claws and nails. The scutes have a pattern and coloration distinctive for each turtle species. The hawksbill feeds mainly on reefs in lagoons and shallow water, and its appearance is designed to blend in. The shell is amber or yellow with irregular mottled, spotty streaks of dark green, brown and even black; these colours are more marked when young. The head and flippers are contrasting and could almost come from a different creature, with a similar dark background overlain by a giraffe-like, reticulated network of pale to white lines. Also, the V-edged scutes at the sides and rear of the shell form a saw-like or serrated outline. All of this confuses or disrupts the appearance of such a big, bulky animal among rocks, weeds, corals, boulders and other reef paraphernalia.

DISTRIBUTION MAP

- **LOCAL COMMON NAMES**
 Hawksbill sea turtle, Hawksbill marine turtle; also dozens of different language names due to worldwide distribution, from Abu gudr, Baga Sugr (Arabic), to Kasa (Swahili), Taku (Fijian), and Vonu (Solomon Islands)

- **SCIENTIFIC NAME**
 Eretmochelys imbricata

- **SIZE**
 Shell length up to 1.1m (3ft 7in), weight 60–120kg (132lb 4oz–264lb 8oz)

- **HABITATS**
 Shallow reefs and rocky areas in temperate and warm seas, rarely below 20m (66ft)

- **DIET**
 Sponges, anemones, coral polyps, jellyfish; also generalist on seaweeds, fish, shellfish, worms

- **CONSERVATION STATUS**
 IUCN Critically endangered
 (See key page 8)

CAMOUFLAGE CAN'T SAVE THEM

Sea turtles are one of the most at-risk groups of large animals. They are deliberately hunted (usually unlawfully) for their meat, bones, eggs and shells, and they are often the so-called 'accidental bycatch' of fishing operations. Their 'tortoise'-shell is made into ornaments, trinkets and decorations usually purchased illegally by unthinking people, since under the CITES (Convention on International Trade in Endangered Species) agreement, trade in these animals, their body parts and products is prohibited.

▶ Heading to the surface for a breath or two of air, a hawksbill leaves behind its camouflaging backdrop of reefs and mixed sand, shingle, pebbles and boulders.

Beluga

WHITE, WHITER, WHITEST

Many Arctic animals are white. The polar bear is one famous, big, powerful example. Another, weighing perhaps five times more, is also a mammal, but a full-time sea-dweller – the beluga or white whale. A medium-sized member of the whale and dolphin family, cetaceans, it is found all around the Arctic region. It is often called the beluga whale, to distinguish it from the beluga sturgeon fish.

At the water's surface, a beluga's backdrop is usually land snow and ice. Underwater, the submerged parts of pack ice and icebergs are never far away. So white is a sensible option, especially against visual location by the beluga's two main predators. These are killer whales and – when a beluga becomes old or sick – polar bears. The camouflage may also be effective for remaining undetected by the beluga's prey, mainly fish and other smaller animals.

NAKED WHALE
The adult beluga's whiteness is achieved in a very different way to the polar bear. The latter has a fur coat (see pages 42–43). The beluga is virtually hairless and so effectively naked. With very few dark pigments, the beluga's skin is naturally pale

and reflects all the colours, that is, white. However, not all belugas are totally snow-white. Some have slightly shadowy looking, lightly pigmented areas along the flipper and tail fluke edges. Others have a vague, all-over grey tinge, or perhaps faint yellow-green due to tiny plant-like algae growing on the skin.

Like many mammals (including ourselves), small patches of the beluga's skin rub or slough off through the year. In summer, this whale has a more marked seasonal skin shedding, which helps to remove skin parasites such as whale lice (actually tiny cousins of shrimps). The belgua helps itself by active dermabrasion – rubbing against rocks, gravel or pebbles on the bottom of the sea or river.

- LOCAL COMMON NAMES
 Beluga whale, White whale, Whitefish, 'Sea canary'; Belukha (Russian, 'white', origin of Beluga); also Beluga in many northern languages such as Finnish, Swedish, Icelandic; Hvithval (Norwegian); Béluga (French), Siqsuaq, Qilalugaq (Inutit dialects); Shiroiruka (Japanese)

- SCIENTIFIC NAME
 Delphinapterus leucas

- SIZE
 Length 3–5.5m (9ft 10in–18ft), weight 500–1,700kg (1,100lb–3,750lb) (males are larger than females)

- HABITATS
 Arctic Ocean and cold northern seas, especially around ice; also estuaries and rivers in summer

- DIET
 Varied, including fish, shellfish, crabs, shrimps, octopus, squid, sea urchins, worms

- CONSERVATION STATUS
 IUCN Least concern
 (See key page 8)

NOT QUITE WHITE
A puzzle discussed by biologists is why baby belugas, or calves, are not white. They are generally pale brown-grey or brown-blue when born, becoming greyer and then gradually whitening by sexual maturity, from around eight years. The calf feeds on its mother's milk for up to two years and stays near her for another year or two, so she can offer protection. Also, mothers and young continue to associate in pods (groups) and so gain safety in numbers.

◄ With a pearly white glow that is just another pale shape in the ice-strewn Arctic Ocean, a beluga demonstrates its slim, flexible neck. This allows its head to nod, shape, turn and twist – an ability restricted to very few cetaceans.

Index

(Page numbers in **bold** refer to main named entries)

Picture Credits

1 Minden Pictures / Alamy Stock Photo; 2/3 Getty Images; 4 Minden Pictures / Alamy Stock Photo; 11 Don Johnston_BI / Alamy Stock Photo; 12 Katja Schulz; 13 Jeff Lepore / Alamy Stock Photo; 14BR Kirk Hewlett / Alamy Stock Photo; 14BL LS Photos / Alamy Stock Photo; 14T LS Photos / Alamy Stock Photo; 16 JERZY GUBERNATOR / SCIENCE PHOTO LIBRARY; 17 @alex Hyde / naturepl.com; 19 KIKE CALVO / Alamy Stock Photo; 21 Phil Degginger / Alamy Stock Photo; 22 Minden Pictures / Alamy Stcok photo; 25 Minden Pictures / Alamy Stcok photo; 26 Rolf Nussbaumer Photography / Alamy Stock Photo; 27 Creeping things; 29 JEFFREY LEPORE / SCIENCE PHOTO LIBRARY; 30 Gillian Lloyd / Alamy Stock Photo; 31 All Canada Photos / Alamy Stock Photo; 33 Rolf Nussbaumer Photography / Alamy Stock Photo; 34 Joe Mcdonald/ Science Photo Library; 36/37 BIOSPHOTO / Alamy Stock Photo; 38T Nature Picture Library / Alamy Stock Photo; 38B Donald M. Jones/ Minden/ naturepl.com; 40 SuperStock / Alamy Stock Photo; 41 S.R. Maglione/ Visuals unlimited/ Science Photo Library; 42 Gillian Lloyd / Alamy Stock Photo; 43 Ariadne Van Zandbergen / Alamy Stock Photo; 45 imageBROKER / Alamy Stock Photo; 46 Nature Picture Library / Alamy Stock Photo; 47 Pete Oxford/ Minden/ naturepl.com; 48 Minden Pictures / Alamy Stock Photo; 50 Anton Sorokin / Alamy Stock Photo; 51 Francesco Tomasinelii/ Science Photo Library; 52 Lucas Bustamante/ naturepl.com; 53 Buiten-Beeld / Alamy Stock Photo; 54T Nature Picture Library / Alamy Stock Photo; 54B Michael S. Nolan/ Alamy Stock Photo; 56 Sebastien Lecocq/ Alamy Stock Photo; 57 M. LUSTBADER / SCIENCE PHOTO LIBRARY; 58 Arterra Picture Library/ Alamy Stock Photo; 60 Chien Lee/ Minden/ naturepl.com; 61 Corbin17/ Alamy Stock Photo; 62 Art Wolfe/ Scienece Photo Library; 63 Kumar Sriskandan/ Alamy stock photo; 64 RobertHarding/ Alamy stock photo; 65 Danita Delimont/ alamy stock photo; 69 ImageBROKER/ alamy stock photo; 70 Heiti Paves/ alamy stock photo; 71 Lucas Bustamante/ naturepl.com; 73T Galyna Andrushko/ alamy stock photo; 73B Gabriel Rojo / naturepl.com; 75 Octavio Campos Salles / alamy stock photo; 77 imageBROKER / Alamy Stock Photo; 78 Henri Koskinen / alamy stock photo; 79T Ed Brown Wildlife/ alamy stock photo; 79L thatmacroguy; 79R Panther Media GmbH/ alamy stock photo; 80 Sleepyhobbit; 81 Alex Hyde / naturepl.com; 82Andy Sands / naturepl.com; 83 blickwinkel / alamy stock photo; 84 Jon Davidson / Alamy stock photo; 85 BIOSPHOTO / Alamy Stock Photo; 86 Frank Hecker / Alamy stock photo; 87 Nature photographpers Ltd / alamy stock photo; 89 blickwinkel / alamy stock photo; 90 Malpolon; 91 Jacobo Quero; 92 imageBROKER/ alamy stock photo; 93 ImageBROKER/ alamy stock photo; 95 Eric Medard / naturepl.com; 97 agefotostock / alamy stock photo; 98 Luke Massey / naturepl.com; 100 Javier Trueba / Msf/ science photo library; 102 Photomecan / Alamy Stock Photo;105 Bernard DUPONT (CC-BY-SA-2.0); 105 Paulette Sinclair / Alamy Stock Photo; 106 Dave Hunt / alamy stock photo; 107 Louis Nicholls / alamy stock photo; 109T Podolnaya Elena; 109B Karel Zahradka; 110 Cyril Ruoso / Minder / naturepl.com; 111 Meunierd; 112 reptiles4all; 113 Minden Pictures / alamy stock photo; 115T Klein & Hubert / naturepl.com; 115L CGF Collection / alamy stock photo; 115 blickwinkel / alamy stock photo; 116 Francesco Tomasinelii/ Science Photo Library; 117 Minden Pictures / alamy stock photo; 118 Luiz Claudio Marigo / naturepl.com; 120 wildnerdpix / alamy stock photo; 122/123 Fabio Pupin / naturepl.com; 124 RobertHarding/ Alamy stock photo; 125 Phil Crosy / alamy stock photo; 127 wildacad; 129T Jean-fr@ncois Ducasse / alamy stock photo; 129B Karel Bartik; 130 Rich Lindie; 131 Ondrej Prosicky; 133 Paulette Sinclair / alamy stock photo; 136 Matee Nuserm; 137 Antony Ratcliffe / alamy stock photos; 137 aaprophoto; 138 Mohid Zaidi Razak / alamy stock photo; 141 Igor Mojzes / alamy stock photo; 142 Muhammad Naaim; 143 MisFit/ alamy stock photo; 144 Michelle Gilders / alamy stock photo; 145 Minden Pictures / alamy stock photo; 146/147 RobertHarding/ Alamy stock photo; 148 RobertHarding/ Alamy stock photo; 150 Heiko Kiera; 151 Sam Yue / alamy stock photo; 153 agefotostock / alamy stock photo; 155 Oscar Dewhurst / naturepl.com; 156 Mark Malkinson / alamy stock photo; 158 MerlinTuttle.org/science photo library; 159 MerlinTuttle.org/Science Source; 160 Terry Whittaker / alamy stock photo; 161 Mathew Maran / naturepl.com; 163 Art Wolfe/ Scienece Photo Library; 164 Shivaram Subramaniam; 167 Sourabh Bharti; 169 Nature Picture Library / Alamy Stock Photo; 170 Chris moody; 171 Genevieve Vailee / Alamy stock photo; 172 Gary Bell/OceanwideImages.com; 173 Tropidoderus childrenii (CC-BY-2.0); 175 Marc Anderson / alamy stock photo; 176 Melvin Yeo / Science photo library; 179 Rob Suisted / Nature's Pic Images; 180 Michael & Patricia Fogden/ minden/ naturepl.com; 181 Crystile RF / alamy stock photo; 182 Bert Willaert / naturepl.com; 183 Kristian Bell; 185T Ken Griffiths; 185B Ken Griffiths; 186 Dave Watts/ alamy stock photo; 187 Minden Pictures / alamy stock photo; 188 Andew Haysom/ alamy stock photo; 189 imageBROKER/ alamy stock photo; 191 Rick & Nora Bowers / Alamy Stock Photo; 192 Lubo Ivanko / alamy stock photo; 194/195 Susan Flashman; 197 Suzi Eszterhas / minden / naturepl.com; 198 Peter b. Kaplan / Science photo library; 199 Minden Pictures / alamy stock photo; 203 Steffen Binke / Alamy Stock Photo; 203 Reinhard Dirscherl / science photo library; 204T Stocktrek images, Inc/ alamy stock photo; 204L Louise Murray / Science photo library; 204R blickwinkel / alamy stock photo; 207T Jurgen Freund / naturepl.com; 207B Minden Pictures / alamy stock photo; 208 Franco Banfi / naturepl.com; 210 Alex Mustard / naturepl.com; 211 Waterframe / alamy stock photo; 212T stocktrek images, Inc/ alamy stock photo; 212L BIOSPHOTO / Alamy Stock Photo; 212R BIOSPHOTO / Alamy Stock Photo; 214 reinhard Dirscherl / science photo library; 215 Alexander Semondy / science photo library; 216 Avalon.red / alamy stock photo; 217/218 Images & Stories / alamy stock photos; 220 Sascha Janson / Alamy stock photo; 221 Seaphotoart / alamy stock photo; 222 Blue planet archive / alamy stock photo; 223 Ricahrd Whitecomb; 225 Georgette Douwha / Science photo library; 226 Nature Picture Library / Alamy Stock Photo; 228 Shane Gross 229 Jane Gould / alamy stoch photo; 230 Richardom / alamy stock photos; 233 Pulsar Imagens / alamy stock photo; 234/235 Richard Eaker / alamy stock photo; 236 Waterframe / alamy stock photo